The Hunt for Big-Time
ART FAKES

Thomas Hoving

SIMON & SCHUSTER

New York ◆ London ◆ Toronto ◆ Sydney ◆ Tokyo ◆ Singapore

# fALSE
# IMPRESSIONS

SIMON & SCHUSTER
Rockefeller Center
1230 Avenue of the Americas
New York, NY 10020

SIMON & SCHUSTER and colophon are registered trademarks
of Simon & Schuster Inc.

Designed by Elina D. Nudelman
Picture research by Carousel Research; Laurie Platt Winfrey, Robin Sand.

Manufactured in the United States of America

10   9   8   7   6   5   4   3   2   1

Library of Congress Cataloging-in-Publication Data
Hoving, Thomas.
    False impressions : the hunt for big-time art fakes / Thomas Hoving.
        p.   cm.
    Includes bibliographical references and index.
    1. Art—Forgeries.   I. Title.
N8790.H68   1996
702'.8'7—dc20                                                    95-53800
                                                                      CIP

ISBN 0-684-81134-0

# ACKNOWLEDGMENTS

To become a fakebuster you've got to heed two groups of teachers: human beings and works of art.

In the preparation of this account of my experiences in the universe of art fakes I have relied on my recollections of my teaching at the hands of some of the most brilliant connoisseurs and art forgers who ever lived. I single out the following with special affection: the late Frank X. Kelly, master faker of Impressionists; the late Professor Kurt Weitzmann who was my Ph.D. docent at Princeton University; the late James J. Rorimer, director of the Metropolitan Museum of Art from 1955–66, who first plunged me into the complex, murky, and thrilling world of art forgery and who stands unsurpassed in his courage in admitting to being stung as we professionals sooner or later always are; Dr. Erich Steingräber, the former head of all art museums in Bavaria and the man who guided me by hand through the real world of fakes; and Dr. Hubert von Sonnenburg, now the conservator of paintings at the Metropolitan, who is probably the canniest fakebuster in the world today.

Over the years I have read virtually every key book and manuscript on the subject of art fakes—dozens of them. In preparing this book I returned to my favorites and rereading them happily gained a whole new set of insights into the tortuous realm of forgery. I have given what I hope is full and enthusiastic credit to these authors and scholars whose books were key

influences and whose revelations about fakes I have borrowed from extensively in the chapter notes at the end of this book.

Perhaps even more significant in my training as a fakebuster were the thousands upon thousands of genuine works of art spread throughout the globe which I have held in my hands or scrutinized for hours. When you get down to it, it's only the study of authentic masterpieces, those clarions of quality and artistic genius, that can truly form a true fakebuster.

To my colleague Geraldine Norman, the sales room correspondent of the *London Independent,* and my partner and the driving force in countless researches into questions of forgeries and shenanigans at the Getty Museum and for invaluable aid in tracking down the tale of the model of David by Michelangelo, I am profoundly indebted. Much of the credit for stunning revelations in these stories is owed to her.

This book would never have come about without the devoted help of my wife, Nancy, and my dedicated assistant Marianne Lyden who kept the multiple drafts in order when I was assembling my material. I thank also Daniel Berger of the Metropolitan Museum of Art for his invaluable liaison work with the dean of fake hunters, the Italian fakebuster extraordinaire, Margherita Guarducci. Also fond thanks to Daniel Crow for thinking up the title *False Impressions*.

I am especially indebted to the most caring, punctilious, and intelligent editors an author ever was blessed to work with: Robbie Capp, Elizabeth Stein, and, above all, Alice Mayhew, who brings a combination of sensitivity, strength, and a deep sense of empathy to every professional endeavor.

Finally, I want to thank my literary agent, Robert Lescher, for his gentle and caring criticism and his staunch support of all my writing efforts since 1978.

TO MY WIFE, NANCY,
THE MOST SENSITIVE TEACHER
OF MY LIFE

*He who knows a thousand works of art, knows a thousand frauds.*

—HORACE

# CONTENTS

# INTRODUCTION

Art forgery is as old as mankind and will last as long as humanity. Not a week goes by in the world of the fine arts without a news story of some spectacular forgery being unmasked. Or someone getting rooked by acquiring a fake.

At the height of a spring auction season a couple of years ago, when the two principal houses struggle to win the year's financial sweeps, Christie's was red-faced to have to announce that a painting by the Colombian artist Fernando Botero called *Dancing Couple*, evaluated in the hundreds of thousands of dollars and illustrated on the cover of its sales catalogue, was a fake.

Those who happened to see the work before the sale and knew Botero's pictures, laughed at the piece. The paint was so thin that you could almost see the back of the canvas poking through. The fat figures were ugly and bulbous, not Botero's sleek, softly inflated caricatures. This couple was a stevedore and his "dame." Yet they danced as if their feet were fluttering off the ground. Their too-even, rotund faces looked like smile buttons. The colors were uneven. Besides, every Botero expert knew that a smaller, tighter, thoroughly radiant version existed in a private collection in South America and had been published several times. Fakebusters of contemporary art knew that Botero never made a copy of anything he painted.

Christie's announcement was accompanied by a press release that told an antic story of how the painter had been brought to New York to study the daub. He dismissed it in a second and, in the heat of the moment, made

a grievous mistake: Botero stated that the picture had only a single coat of oil paint and that he always painted three. Not long afterward, rumor had it, the fakery workshop in Paris churning out "Boteros" began to make their next ones with three layers of paint.

A few weeks later in the same season, Christie's again had to make the embarrassing announcement that yet another choice painting gracing the cover of another key sales catalogue might be a fake. This time the piece was an oil by the Swedish artist of the nineteenth century who is making a nostalgia comeback, Anders Zorn. The Swede was known for his slick portraits of notables and his luminous, *zaftig* nude peasant girls whose skin stretching over their statuesque bodies glistens like well-worn gilded silver.

The "Zorn" in question was a portrait of no less a potential American best-seller than Mark Twain. Yet the face of the author looks as if it had been painted too swiftly—as if it had emerged from a blender. There was no provenance. The picture had never before been exhibited or published.

The sassy gossip page of one New York tabloid heralded the twin gaffes by publishing a cartoon showing a beret-wearing faker in a Christie's back room frantically trying to complete a *"Mona Lisa,"* with the auctioneer begging him, "Finish it! The sale has already begun."

In both the Botero and the Zorn, however, a close scrutiny wasn't even necessary. Thirty seconds would have told the story to a fakebuster. The scams were so banal. Both had all the hallmarks of quickie fakes. No histories. Both trendy artists. Both rising in price. The subject of Mark Twain was superappropriate for the American market, far better than a portrait of some Norwegian count in naval uniform. For a painter known for the translucence of his skin tones, the Twain in this "Zorn," who uttered the memorable phrase, "The reports of my death are greatly exaggerated," looks like an Egyptian mummy.

I tend to look upon works of art as partly spiritual and mysterious and partly human and fragile. Their lofty nature helps me break free from the mundane. They provide a defense against all the cultural trash that threatens to inundate me. They keep me in balance. I need great works of art for the uplift of my soul. Their exalted character clears my brain. I harbor the secret hope that some of the genius they possess for eternity will rub off on me. Their all-too-human characteristics teach me something about humility. They enable me to fall in love with mankind.

Falling in love is what it's like living with fine works of art. I look upon certain choice paintings, objects, sculptures, and even architecture as dear friends whom I adore and have to visit as frequently as possible. Because of

this complex mixture of humanity and divinity in works of art, it's vital to me that they are what they are supposed to be. It's a matter of human trust. I have to know the true condition of everything I come across. I have to know that they are real. So, in my search for the finest, I subject all works to a doubting eye. I'm wary of most experts, unless they are those hypersensitive people I call fakebusters. I have found through long experience that art experts can be ignorant, unseeing, arrogant, and foolish. The great majority wouldn't recognize or acknowledge a fake if the faker himself gave them a private showing of his works.

The fact is that there are so many phonies and doctored pieces around these days that at times, I almost believe that there are as many bogus works as genuine ones. In the decade and a half that I was with the Metropolitan Museum of Art I must have examined fifty thousand works in all fields. Fully 40 percent were either phonies or so hypocritically restored or so misattributed that they were just the same as forgeries. Since then I'm sure that that percentage has risen. What few art professionals seem to want to admit is that the art world we are living in today is a new, highly active, unprincipled one of art fakery.

One reason there are so many fakes around today is owed to the get-rich-quick attitude of the times and the raw commercialism of so much of contemporary life. When art became a breathlessly expensive commodity in the go-go seventies and eighties, fakes flourished. The youthful, instant millionaires or billionaires coveted art as investment items or marks of prestige or social superiority. Originals were not plentiful enough and fakes or totally repainted old masters filled the gaps. And despite the general crash of the art market, fakes continue to flourish.

The increase in fakery in the past generation is linked not only to the general fudging between what's real and virtually real but also to the ineptness of the art profession. Today there are hardly any fakebusters at work. All too few experts and scholars devote a proper portion of their time to exposing and publishing fakes or revealing questionably restored works of art. All too many have no idea of how to dissect a fake. A handful dare to express their suspicions. Fakebusters tend to be looked upon as unwelcome whistle-blowers who disturb the idyllic landscape of art and upset the market apple cart. One of the fiercest of all, the Italian Giuseppe "Pico" Cellini, now in his early eighties and still exposing all sorts of artistic garbage, believes the tendency of most American museums to keep their fakes quiet or secret is due to their having sold out to their wealthy donors and trustees. Perhaps he doesn't exaggerate.

It's time to realize that there are vast numbers of incredibly clever fakes out there, some that are of the supersubtle class and need a wholly new, far more questioning and skeptical eye to be detected. Yet despite the cleverness of these fakes, each one possesses at least one silly mistake—whether some physical property that didn't exist in ancient times or a kind of aging that cannot be natural or amusing errors of style—mistakes that should have been detected instantly. Most forgers' blunders are so obvious and laughable that I find it a mystery why seasoned art collectors and museum professionals continually get stung.

Accompanying every fake and every fakebuster is a highly entertaining tale. What follows are some of my favorites.

# FAKEBUSTERS, FAKERS, AND HOW TO TELL A FAKE

*F*akebusters are a rare breed of cat. They are connoisseurs who have the singular ability—call it a sixth or seventh sense—to detect a forgery instantaneously in almost every field.

These people, who are primarily not book scholars and certainly not theoreticians, describe the feelings as a pull in the gut or a warning cry from a voice deep inside them. The talent cannot be studied and applied. It is nurtured and refined only by saturation.

If one were to study every work of art created by Pablo Picasso during his lengthy career—and by study, I mean holding, feeling, touching, passing one's fingers over the surface of the work of art (and the backs of canvases, too)—and then soak up all the pieces said to be by the master including the attributed works and the phonies, then, presumably, one ought to be able to tell from fifty feet away if a particular work is magnificent, good, fair, rotten, or outright forgery. But saturation may only produce a fine historian or scholar on Picasso, not necessarily a fakebuster.

Bernard Berenson, the flamboyant and amoral art historian of the early twentieth century who held court in Florence at villa I Tatti, was a natural fakebuster. He sometimes distressed his colleagues with his inability to articulate how he could see so clearly the tiny defects and inconsistencies in a particular work that branded it either an unintelligent reworking or a fake. In one court case, in fact, Berenson was able to say only that his stomach felt wrong. He had a curious ringing in his ears. He was struck by a momentary

depression. Or he felt woozy and off balance. Hardly scientific descriptions of how he knew he was in the presence of something cooked up or faked. But that's as far as he was able to go.

At one point he said, "It is very largely a question of accumulated experience upon which your spirit sets unconsciously. . . . When I see a picture . . . I recognize it at once as being or not being by the master it is ascribed to; the rest is merely a question of how to fish out the evidence that will make the conviction as plain to others as it is to me."

The truth was that Berenson had been so fully immersed in the works of the early Florentine Renaissance that unconsciously and immediately, he could detect dozens, even hundreds of things good or not so good in every work he examined. In Berenson's monumental brain, no doubt, were stored, like some contemporary hard disk, hundreds of thousands of associations, observations, artistic subtleties, colors, hues, the shape of all but undetectable lines, which flooded into his mind the instant he looked at a picture.

Without thinking about it, Berenson could see that the hair on the forehead of a figure of Saint James in a certain picture was too curly for the artist, or not curly enough. Or the cerulean in the sky of the picture by, say, Fra Angelico, wasn't quite as deep as in other panels. Or the placement of objects on the windowsill in a painting supposedly by Carlo Crivelli was too perfect and precise to be truly by the master.

The fakebusters I've interviewed all describe a kind of mental rush, a flurry of visual facts flooding their minds when looking at a work of art. One fakebuster described the experience as if his eyes and senses were a flock of hummingbirds popping in and out of dozens of way stations. Within minutes, sometimes seconds, this fakebuster registered hosts of things that seemed to call out to him, "Watch out!"

I know when I scrutinize a work I can hear myself rapidly cataloguing the stylistic elements I know I should expect from the artist, and those that seem incongruous. It's automatic. Sometimes I think I'm hearing someone talking to me, making an inventory of the expected artistic episodes and emphasizing the unexpected or inexplicable. When I describe to myself a work I begin to suspect is a fake, I find myself sometimes using obscene language.

Every curator and fakebuster has a checklist by which he is reassured that a fundamental and constant technique of examination is being followed. Most of the time the list is raced through mentally, although in particularly puzzling cases, many fakebusters follow the list point by point or even go to the extreme of following it ponderously in writing.

While working at the Metropolitan, I drafted such a list as the basis for the standard printed acquisitions form so as to force curators to face up to every art historical vicissitude. It also showed the trustees that every base had been covered in the purchase of a work (which often involved several millions of dollars). The checklist had fifteen steps of which eleven are critical.

First: Within seconds of first catching sight of a new work, write down the first words or phrases that come to mind. This should be the quintessential, kinetic, first impression. Seasoned fakebusters know first impressions are almost always right. The phrase can be as banal as "I love it!" or as tortuous as "Looks lighter in weight than the material should be and the peak of the roofing seems too low and stubby with a sheen of odd dark beige" or as quirky as "Her forehead doesn't belong to a highborn lady."

Second: Make a deliberately detailed and pedantic description of what you see. This is intended to help you look at every millimeter of the object.

Third: Describe the condition of the piece, noting every bump and scrape.

Fourth: Ask what the thing was used for. Until fairly recently, works were utilitarian. That is, some altar paintings were created for the purpose of curing plagues, and their surfaces have been gently abraded by tens of thousands of kisses of believers. No forger can simulate such devotion.

Fifth: Determine if the condition of the piece backs up how it was used.

Sixth: Describe the style of the work. Is there a single, homogeneous style or many?

Seventh: Establish if the supposed date and style agree.

Eighth: Assemble all the documentary information. Remember that these are very easy to fake.

Ninth: Gather up all published references, exhibitions, collections, etc. Do these make sense? Ask the vital question: Does this work have a provenance, one that can be proven?

Tenth: Subject the piece to a scientific examination using a wide number of methods, ranging from carbon 14 to thermoluminescence, ultraviolet, X ray, the relatively new system called autoradiography (which evaluates particular pigments, supplementing the information obtained through normal X rays), and above all, the common magnifying glass. Then discount everything you find.

Eleventh: Assess the "street talk," rumors in the marketplace about what the piece really is.

If all the information recorded in each category supports the first flash-

ing impression, no doubt the work is okay and worth acquiring (depending on the price, which is an entirely different scenario). If doubts begin to crop up, make a "Doubts List" and track down every hesitation and uneasiness until each has been furnished with a full explanation.

Forgeries are never static, never formulaic. One work of art can be proven a fake because the drapery is too nervous in style; another because the drapery is not nervous enough. A statue of the fourteenth century can be a fake because it is too refined, too beautiful. Another statue of the same period can be condemned because it is not sweet and pretty enough. One Baroque jewel is a fake because it is mushy; another because it isn't mushy enough. Art is infinitely subtle. Some fakes are, too. Some may never be detected. Still others will probably always rest uneasily in a nervous limbo with no proof ever coming forward one way or the other.

Why do knowledgeable collectors and experienced curators get fooled anyway? Three words tell the whole story: *need, speed,* and *greed.* You've been waiting for that Degas pastel for years; it's the one that will flesh out your heady collection of the master. Get it quick! Before the competition hears about it. You've been given a special two-day window of opportunity to make up your mind. You've simply got to snag it; it will be known and published as the cap of your holdings. You know you should be calm, but this is a sure thing and you are dying to own it. Go for it.

That road leads to likely disappointment. The only consolation when one has purchased a forgery is the knowledge that every courageous collector has been stung from time to time.

Where do art forgers come from and who are they? Most will tell you that they aren't crooks, but deft, witty, jolly good fellows who intend no harm and who only create fakes as practical jokes. But these are few. The history of art forgery is crammed with self-proclaimed, to-be-pitied characters who claim they had to turn to fakery because the insidious art world spurned their genuinely creative efforts. And it is populated by miscreants who say they fake only to show up how stupid, blind, and pompous the art establishment is. Both justifications are as phony as the works they have fobbed on the world of art. Money is the root motive for art forgery. Most forgers are money-grubbing confidence men, delighted to cobble up something that will get by in the rush for big profits at little expense.

What do art forgers need to do to be successful? As literary fakebuster Anthony Grafton has nicely described, forgers have a limited range of tasks they must perform. They must impart to the work the aura of credibility and the physical appearance of something dramatically older than it is. They

must keep in mind what the work would have looked like when it was originally made and what it should look like now that it's been "found." They must also provide a plausible explanation of where the piece came from and how it fits into the jigsaw puzzle of other surviving works by the same artist as well as similar or comparable works of the same period.

Tough job? On the surface, no. Yet the second requirement—the pedigree, the provenance—is as vital as it often is elusive. As fakebuster Grafton writes, "The forger needs to give his work an air of conviction and reality, a sense of authenticity . . . and must distract the world from the worn spots and defects that might arouse alarm and suspicion." That's when it gets rough. Knowing the faker's needs is half the fight for dedicated fakebusters.

Forgery is the slipperiest game of all and the practitioners the most elusive of players. Their conspiracies are deliciously labyrinthine, artfully confusing, and mendacious. Once a forger is unmasked, it is rare that he will confess to any misdeed at all and it is almost certain that he will boast of having created at least a score of works that are actually genuine. Just to muddy the waters.

We fakebusters have two fundamental things to say about art forgery.

One, the world wants to be fooled.

Two, the best way to learn about fakes is to get in touch with a forger.

# THE GIDDY ANCIENT WORLD

rt forgery is as old as mankind itself. The earliest fakers appear to have been the Phoenicians, who knocked around the Mediterranean and the Adriatic from the second millennium until the sixth century B.C. They were a people who traveled far and fast, trading everything from foodstuffs and olive oil, wine, glass, and pottery to semiprecious stones. The Phoenicians had no artistic heritage or inclination of their own. They gobbled up a mélange of images from Syria, Egypt, and Greece and thrust them almost willy-nilly into their ceramics, ivories, and metalwork. There are several examples of works of art that indicate they deliberately trafficked in art fakes.

Take, for example, a delicate and beautifully made terra-cotta bowl found in the nineteenth century in a deep level at a dig near the early Roman site of Palestrina, twenty miles east-southeast of Rome. Given the archaeological data where it was found, this bowl is indisputably extremely old. It excited scholars of Egyptian art at the time of its discovery because the object seemed to be ancient Egyptian but carried the name of its Phoenician owner in Phoenician script proudly incised into its surface. It was, or seemed to be, one of the rare imports of Egyptian art into ancient Italy.

On this bowl a pharaoh, perhaps Sesostris I, is depicted in a chariot, wiping out his enemies with his bow and arrows. The style is, at first glance, of the twelfth dynasty, roughly about 2000–1786 B.C. But a more penetrating look reveals a number of hilarious visual miscues. The horses are not

attached to the racing chariot. The pharaoh seems to be killing as many of his own men as the enemy. And the accompanying hieroglyphs are gibberish.

It is easy to imagine some wily Phoenician trader/art dealer, his pack filled with "Egyptian" treasures, all so precious that he had his own name inscribed on each one, but which he's willing to part with for what really is too little money; for such a true art lover, a real connoisseur, it'll only cost _____fill in the blank.

This early fraud is an archetype of frauds valid for the rest of time. It's made cheaply, quickly, almost slapdash—what the hell, the sucker is a long way from Egypt. It's full of mistakes, the writing isn't even readable—so who in *Italia* reads hieroglyphs?

Coming into possession of a fake can lead to a touch of fraudulent behavior on the part of the collector, too. Quite possibly the new owner of the Phoenician bowl prided himself on an advanced skill in reading Egyptian or convinced the people he was trying to impress that he did. I once was astounded by the reaction from a wealthy art collector whose expensive Impressionist I had just suggested could not be real: "I don't care, I'm sure not going to tell anyone and I doubt if many people will know or care, either."

As we shall see, there are several breeds of fakers. There's the faker who knowingly makes the fraud; and the person who finds some work and deliberately claims it to be something far more exalted than it really is for profit; and the person who buys a work, learns it's fake, and passes it off as genuine anyway.

In ancient Babylonia there was considerable art chicanery. A sprightly historian of art fakes, Fritz Mendax (amusingly, *Mendax* is a pseudonym which is the Latin word for *liar*) claims that written instructions exist from about the first millennium to craftsmen charged with repairing images that the common folk believed to be ageless and indestructible and immensely sacred, that warn, "Your labor is to remain hidden from the eyes of the ignorant."

A premier forgery made in Babylonian times came to light in 1881 when a British Museum archaeological team was excavating the sixth-century-B.C. neo-Babylonian remains of a temple at the site of ancient Sippar in modern-day Iraq. A black stone cruciform object was found covered with inscriptions that seemed to date from the reign of a monarch who lived in about 2275 B.C. The message went on exhaustively about the renovation of the temple of Shamash and discussed the greatly increased revenues received

from the king because of the refurbishment. The last line reads, amusingly, "This is not a lie, it is indeed a truth. . . . He who will damage this document let Enki fill up his canals with slime." The defensiveness betrays the thing. The area excavated could not possibly date to the second millennium. The British archaeologists look upon the stone as a classic example of what the scholarly world calls a *fraus pia*, Latin for "pious fraud." This one was produced by sixth-century-B.C. priests to show how venerable and spiffy their temple was.

There are literally thousands of such "pious frauds" dating from pagan times. In Christian times the phenomenon becomes a torrent and so many crop up that one begins to think the term *pious fraud* is a fraud itself. In fact, there's nothing "pious" about 99 percent of them.

Modern fakes of ancient Egyptian statuary, paintings, papyri, and especially gold jewelry are legion. During the nineteenth century there were virtual factories spewing the junk out when Egyptomania first struck the Western world. After 1922, when King Tut's tomb was found, everybody had to have an example of something Egyptian, whether a mummy's hand or tooth or a "royal" scarab.

It seems that the discoverers of Tut's tomb, Howard Carter and Lord Carnarvon, were involved in the game of Egyptian fakes. Among the most charming pieces of Egyptian jewelry are the three gold headdresses in the Metropolitan Museum. For some seventy years the museum believed that they had been created for three princesses of the eighteenth dynasty (ca. 1570–1342 B.C.) named Menhet, Menwi, and Merti. In 1986 the Egyptian department's experts branded them as mostly phonies, made of a majority of modern gold pieces added to a few truly ancient ones.

The amusing thing about these golden decorations is that they were bought in Egypt and smuggled out by none other than Howard Carter and Lord Carnarvon themselves, who, in the gloomy days before the discovery of all those "wonderful things," carried on a clandestine and informal art dealership. One wonders if Carter was really fooled by the 1920s' fakers of the headdresses or was himself the purveyor of fakes to the Met. Knowing that he and Carnarvon later swiped some precious objects from Tut's tomb and concealed others for eventual clandestine export, chances are he knew the pieces were forgeries.

In their three-thousand-year history of producing art, the ancient Egyptians probably produced more fakes than all the modern fakers combined. They were exceptionally skillful forgers and con artists. During the later dynasties of Egypt, beginning in about the eighth century B.C., either whole-

sale forging swept the land or there was a heavy passion for nostalgia. Probably it was a bit of both.

One object in the British Museum exposed during its recent fine exhibition entitled "Fake?" is the *Shabaka Stone*. It's a three-by-two-and-a-half-foot hunk of basalt covered with hieroglyphs some of which explain that most of the accompanying inscriptions were faithfully copied on the stone by order of Pharaoh Shabaka of Nubia (ca. 715 B.C.) from a worm-eaten papyrus, hoary with age, offering unique and sacred insights into the creation of the universe—which happened to have taken place at the ancient city of Memphis. The type of hieroglyphs and archaic peculiarities of their grammar and spelling are far, far older than the time of Shabaka, thousands of years older, but the stone cannot be earlier than the eighth century B.C. It's a classic phony.

The reason for the fakery seems to be a bit of electioneering by the king. A Nubian, he wanted to make an alliance with the powerful Memphis priests. The tale of the "ancient, worm-eaten" document suddenly appearing and being copied is, it turns out, a standard late-Egyptian faker's ploy, which will, incidentally, appear thousands of times later on in history as a handy device to drum up some sort of provenance.

An Egyptian papyrus in the Stockholm Museum—also of the late period and absolutely genuine—is filled with detailed instructions to apprentice forgers on how to fashion precious and semiprecious stones out of glass. Hundreds and thousands of the stones were made.

The masses of what appears to be precious and semiprecious stones decorating King Tut's jewelry are all glass. But in this case glass is a good sign—and it's genuine. When the jewelry in the Tut exhibition was being examined and photographed by Egyptian technicians back in 1976 just before the departure of the objects to the United States for the tour, the curators learned apparently for the first time that what they had thought were rubies, turquoise, and other real gemstones were only glass. For a frantic moment or two these specialists thought someone had substituted the precious materials for glass in recent times. That was before they got out the Howard Carter inventory cards describing everything found in Tut's tomb and saw that he had called the stones glass. Had ancient fakers tricked King Tut? We'll never know for certain. Has Howard Carter pulled off a big one on us? In this instance, no. The glass jewelry is indisputably ancient, having been scrutinized and tested with care.

◆ ◆ ◆

The Phoenicians, Babylonians, and Egyptians weren't the only fakers of the ancient world. The Greeks were sensational forgers. What else to call the Trojan Horse? They were bedeviled by fakes, both of documents and works of art. The ancient Greek word for fakes is *nothoi*, literally *bastards*, which might have first been used to describe the fakes, then the fakers.

Among the most entertaining escapades in Greek fakery, though not a work of art, are extensive sections of the Old Testament Book of Daniel which relate to very detailed prophecies. According to two perspicacious ancient-text fakebusters in the third century A.D., one a pagan by the name of Porphyry and the other a Christian, Julius Africanus, these segments could not have been written in the sixth century B.C., which is when the passages should have been composed, but rather in the second century B.C. The faked passages in Daniel are rather cheeky fakes, too.

The early textual fakebusters argued that the intriguingly precise prophecies in Daniel, which happen to be much more accurate than those in any other Old Testament book and which were supposedly written during the exile of the Jews in the sixth century B.C., had to be phony history. Porphyry reasoned that if Daniel was able to foretell four hundred years in advance such precise events as the partial destruction of the Temple in Jerusalem by the Greeks, this only proved that whoever the writer was, he had to have written the text after the events had taken place.

Both critics pointed to the suspicious nature of the story of Susanna and the elders which appears at the outset of the Greek, but not the Hebrew, text of Daniel. Africanus reasoned that it could not have been written when the Jews were in exile because in the tale, they were described as being freer than was logical during the actual grim time of the Babylonian captivity. Furthermore, the Daniel in the Susanna story prophesied by speaking out directly rather than by angelically inspired visions. But the smoking gun is as simple as it is definitive. Susanna and the elders contains a number of elaborate word games that cannot be understood in Hebrew—only Greek. The appearance of these plays on Greek words proves that there was never an older text in the Hebrew language that was translated into Greek in the second century B.C.

Greek gods, according to mythology, were not any more immune to forgery than were mortals. Plato claims the god Haphaestus made fake men that were so convincing they not only moved around athletically but had to be put in chains so that they wouldn't run away and mingle with real humans, fooling everyone.

In ancient Greece, temple relics were routinely faked. There's the tale about a collar around the neck of a lively deer sacred to Artemis with a magical inscription that recorded the information in an extremely archaic text stating that the creature had been a fawn during the Trojan War. The acerbic Roman historian Pausanius, who was writing in the second century A.D. and saw this deer, remarked sarcastically that all the inscription proved was that the deer had to be three thousand years old.

The rhetoric schools in ancient Greece trained their pupils to create undetectable pastiches—fakes of the works of earlier writers, particularly their private letters. The acquisition-hungry libraries at Alexandria and Pergamon built in Hellenistic times from the fourth to the second century B.C. possessed huge acquisition funds and their librarians collected vast numbers of fake texts and histories. The "official" Athenian texts of the great playwrights Aeschylus, Sophocles, and Euripides considered authentic in late Hellenistic times are now thought by the majority of contemporary textual critics of the period to have been 90-percent bogus.

◆ ◆ ◆

Although Rome was to become the Capital of the Fake, a distinction the city still holds today, pre-Rome was a Circus Maximus of art fraud, too. The legendary birthday of the city is the year 753 B.C., when Romulus and Remus showed up on the Capitoline suckled by the giant she-wolf. (Incidentally, the bronze babies Romulus and Remus, who are about to suckle from the spectacular fourth-century-B.C. Etruscan wolf on view in the Capitoline Museum, are seventeenth-century "additions.") Not long after the twins had been assumpted to heaven, Romulus's successor, Numa Pompilius, is recorded about 700 B.C. as having commissioned an eminent faker of armor named Veturis Mamurius to forge the most sacred of Roman sacred items, the shield of the city called the Ancile, which according to legend had fallen out of the sky. It was known to be a cure for all kinds of diseases, apparently working better than today's antibiotics. Numa ordered twelve Anciles, and the forger delivered.

Numa gave one each to a dozen priests of the Salii order, and a national health plan was born. Presumably none of the priests happened to mention to anyone else that he had gained possession of the miraculous shield. Numa's motive seems to have been to encourage pilgrims to come to Rome to receive cures, something that was tried repeatedly later on by the Christian church with the relics of Christ and various saints.

The heyday of art forgery in Rome began shortly after Consul Claudius Marcellus sacked the Greek colony of Syracuse in 212 B.C. and galleys heaped with plundered Greek art, silver, and jewelry deposited their treasures in Rome, then a city of mud brick and populated by a gamy, thuggish crowd whose appreciation of aesthetics was meager. Yet "Grecomania" was born and continued unabated until the Roman empire collapsed in A.D. 746. Contemporaneous historians observed with astonishment the impression these masterworks had upon the common folk as well as the rich nobles, the educated, the antiquarians, and especially the social climbers, who historians and satirists tell us were legion. Even emperors were not immune from the craze. The desire to get one's hands on an original Greek work became insatiable. Having a prime Greek piece was the mark of a gentleman, one who, presumably, was educated and sensitive, possessed clear eyes, a balanced psyche and a beautiful mind.

The demand for authentic Greek works was so crazed that as expected, the sources soon dwindled. Craftsmen who had been churning out statuary for temples and state buildings by the ton discovered a lucrative sideline, and forgery soon took on the characteristics of an early Ford Motor Company assembly line. As Horace put it so well, "He who knows a thousand works of art, knows a thousand frauds."

In old Rome the forging of documents carried severe penalties, but art seems to have been exempt. At least nothing has been found in ancient laws that mentions paintings, sculptures, or the decorative arts. Yet one can guess the forgers nonetheless didn't exactly go about trumpeting their accomplishments. Still, there are a surprising number of recorded stories about fakers, their creations, and their suckers in ancient Roman writings.

One of the most accomplished fakers, Pasiteles, wrote a best-seller about his career in the first century B.C. Sadly, the text is lost. From what can be gleaned from reports on his book, Pasiteles seems to have been the Picasso of his time when it came to fakes, a dynamic innovator. He laid claim to the invention of precisely measured copies by use of molds. This is the first time in recorded history the technique is mentioned. Up to that moment all other forgers were making sloppy freehand replicas of Greek originals. Pasiteles lambasted them for their slovenly efforts. His criticism seems to have been a sales pitch, and a highly successful one, too. After that, no one wanted freehand copies.

By the first century A.D. it was joked that the most eagerly sought-after Greek statue of all, a breathtaking bronze Hermes in the Agora of Athens (it's long gone so we have no idea what it looked like), was encased for the

convenience of fakers in a semipermanent mold. It is doubtful that the many
eager buyers of the Hermes, who was among other manifestations the god of
thieves, were told that what they got was not the original.

Greek gems, glasses, even textiles, were faked by the tens of thousands.
The volume was so great that Seneca the Elder (ca. 55 B.C.–A.D. 39) is
recorded by a contemporaneous historian as remarking that there were no
fewer than half a dozen workshops in the first century A.D. working full time
in Rome on just colored gems and intaglios. Today it's almost impossible to
tell what's genuinely ancient Greek and what's Roman fakery, because those
gems and intaglios are made of material that dates to ancient times and the
style is near perfect.

During the tumultuous reign from A.D. 54 to 68 of the dissolute art
connoisseur Nero, countless Greek sculptures were faked. Nero got stung
and in a famous auction of his collections he'd become bored by, saw to it
that one of the richest dupes in the empire got taken. The unfortunate buyer
happened to fall asleep during the sale and Nero's minions saw to it that all
the phonies suddenly came on the block and every time the old man's head
nodded, another fake was knocked down to him.

The forgers of ancient Rome were ambitious and signed their creations
with the names of the finest artists of the past—artists like Myron, Polycli-
tus, Phidias, Praxiteles, and Lysippus. Myron worked in the fifth century B.C.
and was noted for his depictions of stolid athletes and heroes. Polyclitus,
also of the fifth century B.C., was renowned for his canon of proportions.
Phidias was the gifted fifth-century sculptor who produced the incomparable
sculptures of the Parthenon. Praxiteles, of the fourth century B.C.—Hellenis-
tic times—introduced a compelling sinuosity to his figures. And Lysippus,
the most praised sculptor of Greek antiquity, worked in the fourth century
B.C. for Alexander the Great and caused a revolution by making human flesh
appear truly soft on statues of men and women that almost breathed, they
were so full of life.

There are intriguing references to forgers who could copy marbles by
these famous creators so dexterously that no expert could tell they were not
the works of the masters.

One faker of the first century B.C., Zenodorus, was said to be able to ape
the stalwart, athletic, somewhat primitive style of the sculptor Kalamis so
skillfully that no antiquarian of the day could tell the difference between
the fakes and the real thing.

Admittedly, art experts and collectors during Nero's time were all
slightly daft—it was a mad epoch, but some of the art shenanigans were

around the bend. Faced with a flood of fakes, one connoisseur-for-hire advertised his special expertise in detection, saying that he could establish the authenticity, origin, and date of any bronze by simply smelling the metal. According to him, Corinthian bronze had the most distinctive bouquet of all.

Perhaps the nose test isn't as bizarre or unlikely as it sounds. I once studied early Christian architecture in Rome under the late professor Richard Krautheimer of the Institute of Fine Arts of New York University. He swore he could date, infallibly, the brickwork in fourth-and fifth-century churches by tasting the mortar. I saw him do it several times and he was always right—once even on a blind test we pupils demanded he take. I have also talked with one fakebuster who is convinced that he can authenticate old varnish by taking a small slice and chewing on it for several minutes.

Anyone who has studied Roman sculpture knows that there is a large body of marbles of the "archaizing" style, which is an art historical term for works of art made in the first centuries B.C. and A.D. that ape the early primitive stylistic manner of the seventh and sixth centuries B.C. These works only very generally look like the stiff, hardy Greek work of the sixth century B.C., made in the so-called Archaic style. The general assumption is that they were executed for the most part in the first and second centuries A.D. for the delectation of sophisticated art lovers who knew they were getting evocations of the past, not true Archaic pieces. These days no one would be confused, for the "archaized" statues readily betray what they are. Some of their anatomy, especially their hands and feet, are far more advanced than real works of the sixth century B.C., while the draperies all are but approximations of the stark, zigzag folds of the Greek Archaic style.

But, being aware of the massive quantity of Roman fakes, I question whether these pieces were merely nostalgic approximations. I suspect that the majority of these so-called archaizing marbles are the products of deliberate chicanery. One reason is that what we see today is not what the Roman collectors saw. All of these "archaizing" works were, in ancient times, covered with a fairly thick coating of gesso or plaster and cleverly painted. What we see today is the marble stripped of this highly deceptive finishing surface. The impression of these statues now is that they are clearly later than the seventh or sixth centuries B.C. But back in Roman times, with their gessoed and painted surfaces, stained and distressed to look extremely old, they could easily have looked quintessentially Greek sixth century B.C., the kind of sculpture that every serious Roman collector would have killed to obtain.

There are also several spectacular "Archaic Greek" bronzes that were

indisputably made in the Roman period to fool unsuspecting collectors. One, as we shall see in detail later, is the notorious "Greek" horse at the Metropolitan Museum of Art, which was once thought to be seventh century B.C., then a true ancient work of the fifth century B.C., then a twentieth-century fake, and now a Roman fake of the first century B.C.

Another bronze is a renowned *kouros*, or boy or nude male youth, in the Louvre, which was found at the bottom of the charming bay of Piombino in central Italy in 1830 and purchased by the Louvre in 1834. The boy is about five feet tall and occupies a privileged post in the ancient Greek collections. He stands alone on a high pedestal with a spotlight giving him a dramatic accent. At present the label states, GREEK 475 B.C. When I first saw the statue in the early sixties, the label asserted the piece dated about 520 B.C. Those forty-five years may not sound like much, but in ancient Greek art vast stylistic changes took place every decade.

Back then I wasn't impressed at all with the masterpiece, though I knew at the time I should be. After all, the bronze was illustrated in most primers on Greek art and was shown in hundreds of beginners' art-history courses throughout American universities. After my first view of the piece, which is called the *Apollo of Piombino*, I happened to write down my first impression:

> Blah! This is a simpering Cupid. The anatomy is too flat, but not the kind that might have been squashed down by years of submersion in the waters off Piombino. The muscles are far too flabby for an athlete and the stomach is a muddy landscape of flesh, not the firm, tortoise-shell shape one sees all the time in original Greek sculpture. The face is saccharine. The smile is not the determined, proud, courageous "archaic smile" of a warrior who could don heavy armor, run a thousand yards at top speed, and close with an enemy in a death struggle. This is a weak and prettified dandy, a lounge-lizard Casanova type. No Greek statue of the late sixth century is pretty! Wonder what gives?

Some years later I heard an amusing story about the statue. In 1966 and 1967, the story went, when the piece was being examined by scholars and conservators, they found on the back of one of the bronze, silvered eyes, a sassy inscription in Greek, written by the ancient forger of the bronze proudly claiming authorship in the first century B.C. The story itself seems to be bogus. No one I spoke to in the Louvre recalls such an event and the

eyes were missing when the statue was found in the bay. Yet the tale does murkily reflect what really did happen. In the late sixties two young American scholars, Dr. Brunilde Ridgway, now a professor of classical art at Bryn Mawr College, and a colleague, the epigrapher L. H. Jeffrey, studied the bronze and concluded, not at all to the pleasure of their French colleagues, that there were enough stylistic features to indicate that the Apollo could not possibly date to the sixth century B.C. From inscribed lead tablets found inside the statue and from an inscription on one of the feet, it could be determined that the piece was a forgery of the first century B.C. made by Greek craftsmen from Rhodes, deliberately creating an image of something far, far older and, of course, much more precious.

The French have, somewhat understandably, been reluctant to agree. They still insist that the Apollo is in a category of Greek art known as the "severe style." But I've been told that soon the old label will be substituted for a new one that will call the flabby piece first century B.C. and will explain the circumstances. The Louvre has also allowed a cast of the Apollo to be made for the town of Piombino.

The Apollo might not be the only survivor from the forger's shop. The scholar R. Goodlet has recently singled out a bronze table leg found in the eighteenth century at Pompeii which he suggests from stylistic grounds was made by the same fakers whose studios were on the island of Rhodes.

Few original Greek sculptures in stone have survived, so our impression of the works of the sublime geniuses of the fifth and fourth centuries comes from ungainly Roman copies, most churned out by second-raters. Nothing has survived by the likes of Polyclitus, Myron, or Lysippus. Only one piece —the Hermes at Olympia—exists by Praxiteles. And even that Praxiteles sculpture is hotly contested.

This lamentable lack of Greek originals has thrown generations of Greek art experts into a state of paranoia, rendering some of them incapable of believing that few genuine Greek marbles of the period have survived. These legions of doubting Thomases, unable to use their eyes, have become pseudofakebusters, condemning everything in sight.

One of the most sensational archaeological discoveries of all time was made on May 8, 1877, at a site in Greece that used to be ancient Olympia. In a building known to archaeologists as the Heraion, an exquisite marble was unearthed—a statue depicting the god Hermes carrying the baby Dionysus—of the most subtle invention and brilliant execution with skin so supple and smooth that the surface looked like real flesh, not stone. Hermes, a young, lissome man, holds the child Dionysus in one arm, his cloak lying

over the stump of a tree. The baby reaches out and up to something the god is holding in a missing right hand, possibly a bunch of grapes. The legs and right forearm of Hermes and both arms of the baby Dionysus were broken off and have been restored but otherwise the statue is in extraordinary condition. Nothing like it had ever been found before. It was, and still is, one of the very few surviving Greek original marbles of the high Hellenistic age and a breathtaking example of the work of Praxiteles.

The archaeologists who discovered the work were stunned by its quality. At once they were able to identify it as the very one the Roman historian of the second century B.C. Pausanias had described, albeit somewhat casually. Writing about the gifts made to the Heraion at Olympia he observed, "In later times other offerings were dedicated in the Heraion. Amongst those was a Hermes of marble bearing the infant Dionysus, the work of Praxiteles." Never before had a Greek work been found precisely in the spot a historian had specified.

Fifty years later, scholar Carl Blumel condemned the gracious marble on technical grounds, as a Roman copy. This was a curious charge, especially since there existed no other works of the fourth century B.C. with which to compare the technique. Blumel's opinion set off a controversy that still sputters on to this day.

Not too many years later another scholar, Oscar Antonsson, stated that the gorgeous Hermes wasn't Hermes at all, but a genuine ancient statue of Pan, definitely by Praxiteles but recut in Roman times.

In 1931 the art historians of ancient Greece Gisela Richter and William Dinsmoor rushed to defend the authenticity of the Hermes.

Subsequently, in the sixties, the classical scholar Sheila Adam published her view that Hermes could not possibly be Greek, again on technical grounds. Yet she, as Blumel before her, had nothing with which to compare it.

Following this latest trashing, Blumel returned to the fray, this time with an even more entertaining theory. He argued that the statue is Greek and by Praxiteles, after all, but by a Praxiteles who worked in the second century B.C., not the famous Praxiteles of two hundred years earlier.

The most recent critic is Rhys Carpenter, who in 1968 came forward with the wildest theory of all. He thought the marble was unquestionably a Roman copy, but done in marble after the original fourth-century-B.C. bronze Hermes by Praxiteles.

Most in the know who have spent sometime actually looking at it feel the piece has to be a genuine Praxiteles if only because of the sheer glory of

artistic quality and execution. The naysayers have all singled out the subtle, almost three-dimensional drapery folds of Hermes's cloak falling over the tree stump as a type and style of drapery never seen in any other marble of the fourth century in support of the notion that the Hermes could not be of this early date. The argument is ridiculous, for the simple reason that this is the only drapery of the fourth century found at least in a sculpture of this level of distinction. The other "fourth-century-B.C. Greek" pieces are mere Roman copies. The very fact that Hermes's face is breathtakingly more delicate than all those Roman copies and his cloak is something the likes of which Leonardo da Vinci might have created had he been a sculptor are sure signs of genuineness. That, plus, of course, the persuasive fact that Pausanias described the work as being right where it was found almost two thousand years later.

In classical studies there are, as in many fields, the nervous ones, the doubters, the all-too-clever conjurers of silly theories. At times in fakebusting, one has to defend what common sense tells you is genuine against the incompetent skeptics.

# THE SHROUDED MIDDLE AGES

*D*uring the struggle between paganism and Christianity that rocked the world roughly between the second and fourth centuries, hundreds of "pious frauds" were committed on both sides, though the early Christian church was responsible for most of them. Relics were concocted by the hundreds, because in early times the faithful had to be shown physical proof of miracles. Another reason for the wholesale creation of forgeries was to smear their pagan opponents.

The dying embers of paganism occasionally flickered into intense flame, most notably during the brief tenure of Julian the Apostate in the middle of the fourth century A.D. and again at the end of the century, when the Roman senatorial noble families were mounting their final struggle against the inevitable takeover of the empire by the Christians. Rabid Christian emperors Honorius and Theodosius, about A.D. 400, promulgated laws banning any making of pagan idols or their worship. The pagans tried to get around this by commissioning forgers to make pagan altars and images of the Olympian gods in the style of the great age of Augustus—three hundred years earlier in time—when high classicism was in style. The remains of these pitiful creations are paltry and distinctly mediocre aesthetically, with the exception of two examples.

They are both ivory carvings, and exceptionally beautiful ones. One has a place of honor in the Victoria and Albert Museum in London and the other an equally distinguished place in Paris's fine museum of the Middle

Ages, the Cluny. Both are large, about eight inches high and six wide, and depict priestesses in flowing gowns preparing sacred altars for sacrifice. The names of the noble families Nichomachorum and Symmachorum are prominently inscribed at the top of the plaques, families who are mentioned countless times in histories of Rome.

The style is evocatively Augustan and the sensuous priestesses look like those who attend the procession in the famous *Altar of Peace* Augustus erected at the beginning of the first century A.D. It's only when you look hard at the anatomy and try to figure out where it goes under the flowing robes that you begin to suspect a far later date than the first century. The draperies themselves, at first sight so sinuous and correct in the classical mode, soon begin to break apart and look very much as they really are— knotted, kinked, arbitrary, and largely misunderstood. The "mistakes" are so prominent in the ivory in the Cluny that one art expert today who has spent years pondering these ivories, the art dealer Jerome Eisenberg, has told me that he's convinced that the Cluny one is a modern fake after the one in the Victoria and Albert. Not so. Both carvings are poignant attempts to reconstruct the "glory" of ancient times when Christianity was thought to have been condemned to a certain death and its practitioners routinely slaughtered.

Christians manufactured all sorts of fakes, and as we've said, many of them intended to blacken the reputations of their pagan enemies, present or past. Text scholars believe that a fair 20 percent of historians of the early Christian period either made up the scurrilous stories about the emperors or used forged sources of a decidedly unflattering kind.

One of the more ambitious, and delightful, efforts at Christian spin-merchantry is called *Scriptores historiae Augustae*, which means, "writings on the histories of the emperors." The materials date to the fourth century and include some astounding tales of sexual degradation, acts of cruelty, and the recounting of loathsome sins that are steamy even by today's standards. Few, if any, emperors are let off the hook.

These "histories" were exposed as fakes only as late as the sixteenth century, during the High Renaissance, a time when, after centuries, serious textual criticism began again. Six fake ancient authors were identified by the Renaissance text fakebusters as having concocted these muckraking tabloid lives of the Romans. The fakers of the lurid histories invented some of what later became standard gimmicks in the trade. One is the mentioning in highly specific terms of precise sources used. In one instance a faker even named the very shelf mark of the library where he'd "found" one nonexistent

text. In another, there's a note that refers to a so-called ivory book containing a bogus proclamation signed by the emperor Tacitus. It is referred to as being in bookcase number six at the Ulpian library where the "linen books" containing the deeds (or rather misdeeds) of Emperor Aurelian were also found. How can one doubt the authenticity of a text when such details are spelled out?

Among ambitious early Christian literary and art forgeries that survived many centuries are the letters, faked up around A.D. 300, that Christ exchanged with King Abgar of Edessa, who reigned from 4 B.C. until A.D. 50. The king wrote Christ imploring him to come and cure him of a mysterious disease. Christ replied that he was busy, but that apostle Taddeus was nearby and might be able to help. The king invited Taddeus, who promptly cured him. This miraculous happenstance impelled Christ to write and say that Abgar was thrice blessed, since the king had believed Christ without seeing him, had believed Taddeus would help him, and had been fixed up by the apostle. By the end of the fourth century the tale had become embroidered with the appearance of a portrait of Christ. The first letter from Christ had been delivered to Abgar by his court painter, who had painted Christ's portrait on cloth. This would become the basis for the proliferation during Byzantine times and in the West in the twelfth through fourteenth centuries of all sorts of "holy" images of Christ on linen, all supposedly painted while Christ was alive.

The so-called Dark Ages, from the late fifth century to the time of Charlemagne in the late eighth century, were plagued by forgeries. Most of them involved manuscripts or documents. Textual scholars believe that fully half of all documents created during the Merovingian dynasty's rule of France in the seventh and eighth centuries are not genuine—some two thousand out of four thousand in all. According to textual fakebuster Anthony Grafton, it's taken for granted that two-thirds of all legal documents and papers issued to ecclesiastics before the year 1100 are forgeries—and of these there are tens of thousands. The majority have nothing to do with "pious frauds" either, being promotions, land grants, and various other moneymaking scams.

Some of the fakes went unexposed for a long time, like the *Donations of Constantine* concocted in the eighth century to help prove that Rome, not Byzantium, was the seat of the Catholic church, and was only demolished in the Renaissance by the humanist Lorenzo Valla, though many others had doubted the document before his indisputable proofs. The texts relate the tale of how Constantine (A.D. 288–337), the first Christian Roman emperor,

was cured of leprosy by Pope Sylvester and in gratitude handed over the entire Western Empire to the pope in Rome and established the church's right to rule over secular matters. The form of the *Donations* is shrewd, full of exhaustive and accurate-sounding references (not unlike the bogus, steamy *Histories of the Caesars*) and is laid out like a legal contract, attested to by named witnesses. In short, the *Donations* seems to be Constantine's will handing everything to Rome and cutting out Constantinople and the East, which Constantine had founded. The fake was exposed owing to Valla's rooting out hosts of errors of fact and phrasing.

When Emperor Charlemagne in the early ninth century invented the Holy Roman Empire, he turned to the deeds, art, and architecture—even the script, speech, poetry, and plays of the time of Constantine the Great. Rome, specifically the Rome of the great emperor who signed the Edict of Toleration permitting Christianity to be another one of the state-sanctioned religions, was Charlemagne's sourcebook. The legible uncial letters prevalent in inscriptions of the high classical periods that abound in Rome were resurrected; thus for the first time in centuries it became easy to read texts. In the Merovingian epoch, which preceded Charlemagne's, the letters, though highly decorative, were all but indecipherable.

Intellectuals of the early Charlemagne period—ca. A.D. 800–820— appear to have copied, even deliberately forged the essence and some artifacts of what they thought was the ancient Rome of the time of Constantine. In some instances they copied whole buildings. Charlemagne's curious church in Aachen is an exact replica of the baptistery attached to the Constantinian church of San Giovanni in Laterano—with identical proportions.

In the case of the basilica-type churches in Rome built by Charlemagne's architects, it takes a specialist in brickwork and mosaic styles to tell that what for all outward and inward appearances is an early Christian church of the fourth or fifth century is actually of the ninth. S. Prassede, near the church of Santa Maria Maggiore, for example, is a direct copy of an early Christian church near the Forum dedicated to the saints Cosmos and Damian. The apsidal mosaics in S. Prassede are all but identical to those in the earlier church.

Was it that after a centuries-long drought of artistic endeavor, Charlemagne's architects had to make slavish copies and his artists were forced to evoke the art of Constantine's time because they had lost design traditions over the Dark Ages? That's part of it. But, far more significantly, Charlemagne and his ministers embarked upon a deliberate program to ape the

cultural paraphernalia of Constantine the Great, who solidified the Roman world and held off the invading pagan enemies.

Charlemagne's court workshop for art produced a series of luxurious ivory carvings—ivory was considered a material of value almost beyond imagining, far more precious than gold or silver or semiprecious stones. Spectacular ivory book covers draw closely, sometimes slavishly, upon early Christian models, of which a half dozen of the original early Christian examples survived (lovingly preserved and protected, no doubt, by the Carolingians). The similarities are striking, particularly in the early efforts of the carvers. A decade into the manufacture of their ivories, the Carolingian artists came up with their own nervous, hectic style as full of energy as a broken high-tension wire, and stopped copying.

In every artistic period when we know there was a conscious effort to use as models works of earlier times, we encounter examples of the models themselves having been forged. This is true during the High Renaissance and it seems to have occurred in the Carolingian epoch, too. There's one beautiful early Christian ivory called the *Andrews Diptych* (after the collector who once owned the pair of eight-inch-tall plaques and are today in the Ashmolean museum at Oxford), which depicts in a dynamic and expressionistic style various miracles of Christ. The iconography, or the way in which the subjects are portrayed, seems indubitably early. But a host of details, from decorative elements carved into the borders, to faces, drapery, and anatomy are far too wild for the stodgy, somewhat plodding style of the fifth century A.D. It's tempting to believe that this is an "early Christian" Carolingian fake, used itself as a model by later Carolingian artists who didn't realize what they were using.

There's an amusing story about fakery connected with Charlemagne's top minister, Einhard. One winter's night, the emperor's daughter Imma slipped over into the rooms where Einhard was staying, for a tryst. A few hours later the lovers were dismayed to see that although the sky was clear, a large quantity of snow had fallen and it would be impossible for Imma to return to her quarters without her footprints being noticed. So, Einhard, the man responsible for overseeing the court workshop of ivory carvers, came up with the canny idea of faking other footprints. He picked up his love and carried her backward through the snow to her rooms and returned, carefully stepping into his footprints on the way back.

During the Age of Relics—roughly from the eleventh to the fourteenth centuries—when it became fashionable and economically profitable to possess pieces of holy evidence, everything was rounded up for reliquaries and

shrines. One hears of pieces of the true cross, the crown of thorns, the nails, Longinus's lance, Christ's robe, even one of the dice thrown by the Roman soldiers, a lock of hair from Mary Magdalene, fragments of bone from every saint conceived in Christendom, chains that bound Saint Peter in his cell in Rome, wooden chunks from the cradle of Christ, several of those portraits of Christ on linen made by King Abgar of Edessa's painter, and all sorts of shrouds and veils.

Many of these relics performed curative deeds which have been attested to so vividly that we cannot have any doubt that they worked for the faithful. Whether real or fake didn't seem to matter. There are some amazing accounts of the "wondrous" goings-on of a wooden figure of Christ of the fourteenth century, an English contraption called the Boxely Rood. The statue shed tears, rolled its eyes, and foamed at the mouth. It generated a host of miraculous cures. The power of the Rood lasted for about fifty years, it would seem, until some unknown fakebuster sneaked into its sanctuary alone and had a good look. He discovered certain engines and old wires and a bunch of rotten sticks in the back which got the Rood crying, rolling, and foaming. Thereupon the Rood was retired from miracle-making.

From Switzerland in late medieval times there's a tale of relic and miracle skullduggery that competes with the more imaginative chicanery on today's TV. A poem written by Thomas Murner in the early sixteenth century describes what dire events came to pass.

> The scheme was fraudulent and deep:
> To make the Virgin's image weep
> With varnish drops beneath her eyes
> In place of tears, and gull the pious . . .
> And Doctor Steffan from behind
> Had guilefully contrived a kind
> Of pipe, through which he then intoned
> So credibly to all around
> That many afterwards averred
> Every syllable they heard
> Came from the lips of the Queen of Heaven
> Though really it was just Doctor Steffan.

The doctor was Steffan Boltzhurst, and he along with three colleagues in Bern, Switzerland, at the turn of the sixteenth century, conspired to create a very effective sound machine through which they would intone sayings in the voice of the Virgin Mary. Many who heard the voices believed

the miracle and the phenomenon gained considerable renown. There's a woodblock depicting the fraud and in it one can see Dr. Steffan lurking behind the altar on which the statue of the Virgin is placed. An accomplice can be seen kneeling on the altar, and a crowd of citizens and ecclesiastics look on in wonder.

The conspirators were Dominicans. They wanted to bring luster and entice pilgrims to visit their church and at the same time, discredit their rivals the Franciscans, who had no miracle-making statue of the Virgin. This event had serious repercussions upon art, for it gave ammunition to those conservatives in the church who reviled the making of any image at all of Christ or the Virgin Mary or indeed any religious imagery of any kind. The anti-image proponents were strong, determined, and unprincipled and caused great harm right up through the Renaissance. As for Doctor Steffan and his co-conspirators, they were all burned at the stake in 1509.

◆ ◆ ◆

If art forgery had been a capital crime as well, then hundreds would have been burned at the stake in Venice from the eleventh through the thirteenth centuries, from high officials, possibly the doge himself, to ecclesiastics, architects, and considerable numbers of artists. The fact is that much of early Venice is a fake—deliberate, conscious, beautifully thought-out—a fake of high political import.

The historian of Byzantine art Otto Demus, who spent much of his career in the 1950s and 1960s studying the architecture of early Venice, which was founded only in the late fifth century A.D. by Christians fleeing barbarian hordes, writes:

> Venice, in the beginning lacked a past and a hinterland. She appeared comparatively late in the history of the Mediterranean world. Being without a past was, however, in the Middle Ages very much like being a man without a shadow. To cure this defect, the statesmen of the Middle Ages developed a remedy—the same that is being used by states and individuals these days. If one had no past, one could always fake one. . . . It was easy. The forgers of the Middle Ages were not as hampered as we are, by existing records, proofs and counterproofs. They could fake freely and to measure.

From 1050 onward whenever the need arose for the Venetians to bolster up their slowly developing independence and strengthen the history of their church, they fabricated an intricate web of forgeries. The entire Holy

See of Venice was made to appear through a huge number of faked documents as the legitimate successor of the city of Aquileia, which traced its origin, also by faked papers, back to a saint by the name of Hermagoras and through him directly to Saint Mark himself.

In large measure the great church of San Marco is itself a replica, if not an outright fake. Its starting date is 828–829, which is the moment the relics of the apostle Mark were liberated from his shrine in Alexandria and transported to Venice. The church was built as the closest replica conceivable to the church of the Holy Apostles in Constantinople. By the end of the eleventh century San Marco was vaulted in brick and was, as Demus puts it, "one of the most successful imitations of a famous model the history of architecture knows." The architects of Venice were not satisfied "forging" its principal church. The palaces that surrounded it before the neoclassical structures we see today were built in the piazza were precise copies of palaces of the fifth century A.D. The whole district was therefore supplied with an aura of venerability.

In the thirteenth century, just after Venice's successful rape of Constantinople when those dynamic Greek bronze horses were brought back as booty, the city fathers embarked upon an effective campaign to archaize and fabricate out of whole cloth hosts of documentary and artistic materials. The doge genuinely believed he had become the heir to and successor of the Byzantine empire. He had to show that he and his city were steeped in the ancient past of that awesome empire.

The documents are fabulous and highly entertaining. The first is a forged document, known officially as the *Praedestinatio*. According to this, Saint Mark had a vision telling him he'd be buried in San Marco on the Rialto. This bit of fakery was inserted into the older legends of the peregrinations of the saint to establish a "prehistory" of the church and to allow the Venetians the right to call themselves "the children of Saint Mark," living and worshipping in a place assigned to them by divine will. Other forged documents established "indubitably" that Venice had possessed numerous links with ancient Rome.

Painters, mosaic makers, and sculptors were enlisted to create works that made the great church look really old, fourth or fifth century, despite the obvious fact that the structure wasn't started until the ninth century. Among the most beautiful mosaics are those in the atrium illustrating Genesis. All their scenes were copied from illustrations in a now-missing manuscript of the fifth century. Scholars have known this for years. The facade of the church has imbedded in its walls between arches a number of mythologi-

cal scenes showing the labors of Hercules which look superficially like Byzantine work of the sixth century A.D. but which scholars now believe from stylistic comparisons and the type of stone are Venetian of the thirteenth.

There are a number of other sculptures that until very recently were assumed to be part of the Byzantine treasures captured from Constantinople but which are, in fact, either archaizing works or outright fakes manufactured in the thirteenth century. Most amusing is a crowd of rotund little figures on the doorway of the cathedral. Dedicated to San Allipio, it's the sculpture to the far left of the facade, depicting in "early Christian" style various miracles of Christ. The eleven fragments of sculpture here have no cogent story line; they look as if they were gathered from some other place and inserted on the doorway, just as the fakers intended them to seem. But they are part of the original fabric of the church. A close look shows that these "early Christian" reliefs had to have been made when the facade of San Marco was made, in the thirteenth century. A framing pillar on the left-hand side of one of these reliefs is inclined to the right to fit the slant of the adjoining architrave and this can only be a part of the facade encrustation which dates to about 1230.

Until a few years ago many of the capitals in the holy of holies of San Marco were thought to be Byzantine work of the sixth century. Today, none are. Two decades ago churches in Venice were thought to be filled with Byzantine stones all looted from Constantinople. Today they are all considered products of the superactive fakery workshops. Scholars now concur that there are only four works taken from Constantinople or the ancient Eastern world: the four horses; the so-called *Tetrarchs* in porphyry at the corner of San Marco; the huge white marble pillars from Acre in the piazza of San Marco; and a piece of sculpture called the *Carmagnola Head* after the collector who once owned it and today is in the Archaeological Museum in Venice.

What about the most famous Venetian early Christian sculptures of all, those four white marble columns that support the great ciborium or canopy that rises above the great altar in San Marco and the resplendent Pala d'Oro —thin, tensile, delicate as flowering stalks? They are carved with a welter of scenes showing miracles and the lives of obscure saints. For hundreds of years the pair of columns on the front were thought to be fourth or fifth century and of consummate early Christian style created by the best artists who came specially from Rome. The pair of columns on the back, which are less accomplished, a bit hesitant, even sloppy, in technique, were thought to be Syrian works of the sixth century.

That was until a young, gifted fakebuster by the name of Elisabetta Lucchesi Palli from Prague began to examine these masterworks just before the war with an appropriately skeptical eye. She wrote a revealing treatise on the carvings of the ciborium published during the darkest years of 1941–42 in Prague which, to many art historians, is still virtually unknown. She proved convincingly through a host of stylistic comparisons with authentic Roman and Syrian works of the fourth through the sixth centuries A.D. that all four columns had to be works of a gifted thirteenth-century Venetian forger. Perhaps because her work has not been published widely, many popular books and guidebooks persist today in calling these columns early Byzantine.

I happened to meet with the specialist in Venetian art and architecture Otto Demus in his late years. He tipped me off to the ingenious discoveries of Lucchesi Palli and voiced his frustration that her findings have not been more broadly disseminated. With a laugh he added that while poring through documents in the archives, looking for something else, he had found actual invoices sent by the thirteenth-century fakers of the columns, and a number of other fakes in Venice, to the ecclesiastical and administrative authorities. They had been paid promptly and well for their services.

No relic of the Middle Ages is more famous than the holy shroud of Turin. Virtually none has had its authenticity more discussed, published, or squabbled over. At times through history, being for or against the authenticity of the shroud has meant being good or evil, politically acceptable or condemned. In the past generation, while the Cold War was still raging and ripples of McCarthyism were continuing, being a doubter of the shroud signaled that one was an enemy of democracy, possibly even a Communist or fellow traveler and most surely an atheist.

The shroud is linen and nearly seven feet in length. It first showed up in the years 1353–56 in the small church in the old French town of Lirey, a gift from a local seigneur named Geoffrey de Charny. The shroud came into possession of his son, then his granddaughter Margaret, who exhibited it in a church in Liège in 1449. Thence it went to the house of Savoy in 1453. It was venerated at the Savoy capital of Chambéry for more than a century when it passed on to Turin in 1578.

The relic didn't cause much of a fuss until 1898, when Turin lawyer and amateur photographer Secondo Pia was given permission to take photographs of the murky, soiled linen coverlet. To Pia's and everyone else's surprise the negative plates were astonishingly clear and showed, almost miraculously, details that no one had ever seen before. These photographic

plates reversed all the light values. They were not the muddled and confus-ing shadows and dark areas that photographic negatives normally seem to show. They offered a lucid, positive, double image of a man, back and front, bearing the marks of scourging and crucifixion, eerily like those Christ had suffered. The negatives showed that whoever this man was, he had been pierced by nails through the wrists, not the soft palms of the hands, which would never have supported the weight of an adult on a cross. That detail alone had many of the faithful convinced that this had to be the shroud that had been wrapped around the dead body of the Savior when he was removed from the cross. No painting or sculpture of all of Christendom showed the wrists pierced, or so it was said.

Soon all hell broke loose. The press flooded the public with the illustra-tions. Legions of experts proclaimed that the shroud was no doubt the very cloth that had surrounded the body of Christ and in which he had lain in the tomb of Joseph of Arimethea.

In 1931 the furor over the shroud increased when additional, finer photographs were taken by a noted surgeon of the day, Giuseppe Enrie. These seemed to confirm the anatomical evidence that the shroud had, like some miraculous litmus paper, soaked up and retained the signs of the torture and execution of someone who must, at the very least, have dated during the time of Christ.

In 1969 modern science was called in to tackle the difficult problem of dating the shroud. The results of a battery of tests were inconclusive. But, most important for the growing number of believers convinced that this was the holy shroud of Christ, no traces of pigment were found. Whatever the shroud was, it seemed impossible that it could have been painted. And, equally vital, the tests were said to have established that the cloth itself could well be a linen cloth from Palestine and that it almost certainly dated to the first century.

The desire to have science prove that this was the most holy relic ever found became intense in the 1970s. Two devout United States Air Force captains, John Jackson and Eric Jumper, lobbied for the use of America's most advanced equipment at NASA's Jet Propulsion Lab at Los Alamos, and the government gave in to the pressure. What was examined then was not, however, the linen itself or fibers taken from it or the traces of dirt said to be found imbedded in it, but merely Giuseppe Enrie's photographs.

Using something called "The Interpretation System's VP-8 Image Ana-lyzer" plus an IBM 360–50 computer, it was learned that the shroud pos-sessed "a natural three-dimensionality." And on the eyes of the figure were

what was interpreted as coins, the widow's mite of ancient times. The officers proclaimed that the image—indeed the double image showing the back and front of the figure—could only have been "printed" on the cloth by a short burst of radiation during which the impression of the body of Christ had been scorched indelibly on the shroud.

Reporting on the findings, the press became at times hysterical. Countless Christian magazines and millions of believers were convinced that the shroud was genuine. A Holy Shroud Society was formed in New York City and many of the most prominent figures in America joined and gave significant amounts of money. One of the leaders of the group was my father, who contributed many times to the cause, which urged the complete testing of the shroud to still the voices of the few, dogged skeptics. I was one of the skeptics, for I'd heard somewhere in my medieval studies of an early description of the shroud way back in the fourteenth century that muddied the miraculous waters. The shroud soon became the banner of rectitude for the radical religious right of the United States.

By 1977–78 the money had been raised for one hundred and twenty hours of rigorous scientific testing by an organization called the Shroud of Turin Research Project, or STURP. The church had at last agreed to every test but carbon 14, for that would have meant a tiny fragment of the cloth would have to have been clipped off and vaporized. (Today there are far more sophisticated carbon-14 processes that avoid damaging the material to be tested.) The shroud came to Albuquerque on October 8, 1978, and for five days got the works.

The findings of STURP were cloaked in militarylike secrecy. The agreement called for a platoon of specialists in every possible field to take the tests and, at their leisure, analyze them. It was intended that in due time, the results would be published. A long time passed before any findings were aired. One of the few statements made at the time whetted the appetites of the believers. One of those present at the tests said, "There's no doubt this is a grave cloth, for we have found dirt at one of the footprints." After that, silence.

Yet bits and pieces of contrary information began to leak out. One researcher, Walter McCrone, whose laboratory in Chicago was one of the best for high-powered microscopic work, announced, "Those of you who are a bit emotionally wrapped up in the shroud had better relax your feelings a bit." McCrone had found a high concentration of iron oxide throughout the samples. That could mean only one thing—paint. Not dried blood or a

radiation burst. McCrone was attacked by some of the more dedicated be-
lievers.

Then, in the 1980s, the respected Jesuit New Testament scholar Robert
A. Wild voiced further, less mundane problems about the shroud's authen-
ticity. He never said the shroud was a fake, but stated simply that it was "an
unfinished puzzle." He showed that the bloodstains, if they were blood, were
rather odd in that there wasn't a trace of smearing. No blood had been
smeared during the entire act of deposition of the body from the cross, its
transportation to the tomb, or its laying in the tomb. And there were two
odd demonstrations of what could only be defined as "artistic modesty." The
buttocks of the figure were outlined in a way that suggested they were not to
be seen. More to the point, the hands of the figure perfectly concealed the
genitals. That couldn't be right, Wild observed gently, for no matter how
one arranges a body after rigor mortis, the hands can be made to cover the
genitals only if the elbows are propped up on top of the body and the hands
bound tightly in place. The shroud's image showed nothing like that.

The controversy over authenticity sputtered on for some years until, at
last, the critical carbon-14 test was made. It showed conclusively that there
was no dried blood on the shroud, no burst of radiation. The shroud had
been painted, and its various pigments dated to about the first quarter of the
fourteenth century.

The date accorded perfectly to what a fakebuster had long ago learned
and published in 1356, albeit in Latin and in an obscure letter to an Avignon
pope, one of those of the so-called Babylonian Captivity.

Geoffrey de Charny of Lirey, the first owner, had bequeathed the linen
to his son. The father had died in the battle of Poitiers. He had wanted very
much to show his prize in the parish church. But the bishop of the region,
Pierre d'Arcis, didn't. He wrote to the pope in Avignon about his annoyance
at the pressures to have a "scandalous exposition of a certain cloth cunningly
painted, upon which by clever sleight of hand was depicted the twofold
image of one man, that is to say the back and the front, they [the canons of
the church at Lirey] falsely declaring and pretending that this is the actual
shroud in which our Savior Jesus Christ was enfolded in the tomb."

Bishop d'Arcis also wrote that his predecessor Henry of Poitiers "after
diligent inquiry and examination" had declared the Lirey cloth to have been
"painted," the truth being "attested by the artist who had painted it, to wit,
that it was the work of human skill and not miraculously wrought. . . ."
Henry of Poitiers had ordered the exposition of the cloth by Geoffrey's wife,

Jeanne de Virgy, stopped, and was having a terrible time with the son, who also wanted to give it an exhibition. But in fakebusting, politics and the powerful sometimes intervene.

Jeanne de Virgy remarried. Her new husband was one Aymon of Geneva, uncle to the future pope. Through him Jeanne bypassed both Bishop Henry and Bishop d'Arcis. The pope effected a cover-up. He wrote a letter stating that Geoffrey's son could show the shroud, if he stated openly that the piece was a "figure or representation" of Christ. And that Pierre d'Arcis should keep quiet and speak to no one about its true nature—on pain of excommunication. And all other bishops in the vicinity of old Lirey must agree to keep silent as well.

It was, of course, nothing more than a license to show the shroud and eventually to call it a miraculous relic, which happened. It took centuries for Henry of Poitiers' fakebusting to come in line with the hard facts of contemporary science.

# TRICKS OF THE RENAISSANCE AND
# SHAMS OF THE BAROQUE

$\mathcal{T}$ he Renaissance of the late fifteenth and early sixteenth centuries was, for Western civilization, the single most powerful and exciting artistic watershed since the age of Pericles. The period was tumultuous and quirky and doesn't lend itself readily to neat definitions. But if it's possible to characterize it, I suppose the great cultural historian Erwin Panofsky did. To him the Renaissance differed from all other cultural revival movements, "renascences" as he called them, in that the intellectuals of the time realized, virtually for the first time in history, that classical antiquity had died and had to be forcibly resurrected and studied hard to be fully appreciated. An untrammeled and uncritical delight in antiquity and its art and architecture in all forms is one of the hallmarks of the Renaissance. Another is a discreet humanism, practiced always with the fear of what vengeance the church might wreak.

This creative time was also a watershed for fakes. Not only did they explode in numbers and virtuosity, but for the first time serious fakebusters came into being and began to solidify their methods of how to expose forgeries, especially textual forgeries. Some of these methods were so effective that they are still being used today.

In the fifteenth and sixteenth centuries the great body of faked classical materials were coins, carved gems, medals, and inscriptions supposedly found on "real" ancient stones. The passionate nostalgia for the golden age of the ancient Romans gave birth to a virtual production line of fakery. Text

fakebuster Anthony Grafton states that "some 10,576 of the 144,044 inscriptions in the great Corpus of Latin inscriptions are faked or suspect; many of them are the work of imaginative Renaissance antiquaries."

During the Renaissance even famous artists got into the act, faking ancient sculptures, vases, frescoes, and old-master drawings. They faked their contemporaries. They were faked themselves. One sublime master is said even to have made a fake to avoid paying a routine hotel bill.

This supposed "grifter" was the "divine" Raphael (1483–1520) or so the story goes. When Raffaello Sanzio was young and poor (though poor he may never have been), he realized he didn't have the cash for his hotel so he stayed up late one night and painted a still life in dazzling trompe l'oeil. Its subject was a canvas depicting one of the hotel's napkins on which were laid the right number of coins to cover his bill. At dawn he scooted, leaving the fake coins on the table where the innkeeper would be fooled for at least as long as it took Raphael to make his getaway.

That Raphaelesque "magic realist" piece of chicanery, which, of course, never existed, has been bought and sold a half dozen times since the late fifteenth century and was spotted as recently as two years ago in Spain. It has since vanished. It will for sure turn up again.

What distinguishes many of the Renaissance and Baroque fakes from those of today is that they were created not so much to make a quick buck, but for the poetry of it all and to indicate to lesser artists how skilled the faker was and how well he understood the styles and psyche of the ancients. Some could be spine-tingling.

In 1485 on the Appian Way, which to a humanist in Renaissance times was virtually a time machine leading back into sacred antiquity, a tomb was found containing the perfectly preserved body of a beautiful young girl. A Latin inscription on the sarcophagus identified her as none other than Tulliola, Cicero's gorgeous only child, who had died at a young age. Cicero's words in the inscription were painfully poignant: "To Tulliola, his only daughter, who never erred except in dying, this monument was raised by her unhappy father Cicero. *Quae nunquam peccavit nisi quod mortua fuit.*"

The discovery was a sensation and accepted by everyone, even hardened skeptics. No one seemed to care that the quote belonged to a non-Ciceronian but wholly authentic ancient Latin source. Or that a bunch of other Tulliola tombs were found around Rome not long after and subsequently in Florence and Malta—each one with a well-preserved body of a young girl. As Anthony Grafton observes, "Tulliola's death scene continued to be a crowd-pleaser for a hundred years." Who these young girls were, how

they died, or for precisely what reason, is almost too chilling to think about, but the perpetrators of the grim hoaxes have never been identified.

Once the passion for antiquity had taken hold, the forgers' productions took off exactly as it had happened in ancient Rome. The reason was the limited supply and burgeoning demand for the real thing. Early in the Renaissance Roman sculptures were left pleasingly scattered around where they had lain for centuries. But when serious gardens, art collections, and galleries began to be formed, the restorers and fakers appeared. The land where many of the finest ancient pieces were lying about were private reserves; antiques were not available to everyone.

Renaissance tastes ran to the important historical personalities; collectors wanted the most famous men and women of antiquity. Prime targets for forgery were marble or bronze portraits of notable authors, especially Cicero, Seneca, and above all, Julius Caesar. Then the morbid fascination of the nineteenth century in having a memento of the more decadent emperors had as yet not begun.

Gems and cameos, medals and coins began to appear by the hundreds. Some, especially the cut cameos, are so fine that experts figure that whole bunches of them are resisting arrest even today. Lorenzo de' Medici bought "ancient" cameos by the kilo and many for prices that would compete with the most exaggerated sums shelled out for Impressionists in the roaring 1980s.

There's a story reported by Judy Rudoe of the British Museum in the fascinating 1990 exhibition catalogue "Fake?" that "Pope Paul II (1464–71), learning that the city of Toulouse owned an ancient cameo of outstanding beauty [we have no idea if it was authentic] offered, besides a large sum and privileges for the basilica of St. Saturnin, to build them a substantial bridge in exchange for it."

Nothing refines fakes better than the constant employment of their creators. By the late fifteenth century there was a frantic demand for "specialty items" made out of rare and semiprecious stones carved with the more popular mythological scenes.

One of the cleverest fakers of this material was Pietro Maria della Brescia. He made his mark creating rare and highly expensive porphyry vases, porphyry being that gorgeous purple marble found only in Egypt. The stone was considered "imperial" because of its purple hue, and the Caesars had sought it for their portraits and sarcophagi. The most extraordinary examples are the sarcophagi of Constantius and Costanza in the Vatican Museums. Pietro stands out in the annals of high-class forgery for having

"invented" a ploy still used by forgers to this day. Up to his time, practically everybody knew they had to stick their work in a dung heap or in mud on a bank of the Tiber to age it. But Pietro went one brilliant step further. He deliberately broke his porphyry heads and vases—not so seriously, of course, that the price would be affected—and then he made "ancient repairs," using bands of corroded copper or beaten-up lead plugs. The result was that his fakes looked like precious ancient heirlooms, slightly damaged and lovingly fixed. They fooled everybody. Some still do. Ever since, fakebusters have looked upon signs of "ancient repair" with considerable suspicion.

Pietro, equally deft in setting up a scam, made "an exquisite porphyry cup with three handles and a spout—cracked so that it was necessary to put a copper band on it—and buried it together with many other of his "Roman" works at the time of King Charles VIII of France's invasion of Rome (1495). This cup was sold several times as an antique at very high prices."

The best forgers in the Renaissance were praised. Giorgio Vasari, the sixteenth-century chronicler of artists and the arts in Florence, commented approvingly about Tomasso della Porta, who was a specialist in counterfeiting antique heads in marble which have been sold as antiques: "he worked marble exceedingly well and not one of our imitators was superior."

Other noted antiquities fakers of the High Renaissance include the great Venetian sculptor Tullio Lombardo (ca. 1455–1532). He created a bronze nude girl without arms and slathered her with a spectacular "antique" patina that fooled everyone.

The architect and text editor Pirro Ligorio (ca. 1500–1583) invented a wonderful green surface that he applied to his forged Roman coins, imparting to them an instant semblance of undetectable age. Ligorio also made a habit of completing dramatically (or at other time forging outright) hosts of inscriptions he "found" on Roman stones and decorative marble vases.

Both Donatello and Verrochio are mentioned as part-time fakers of antiquities. Sadly, none of the bogus works by these geniuses have survived.

And a Paduan goldsmith by the name of Giovanni da Cavino, working with the humanist Alessandro Bassiano who furnished him with the appropriate antique "program," created hundreds of medals representing famous classical personages. Bassiano was apparently the first of a string of crooked scholars who lent their expertise to skilled fakers, making the product of their combined dexterity all but undetectable. In fact, the best frauds ever fashioned are those created by a collaboration of a super "hand" and a crooked scholastic or connoisseur.

The great Benvenuto Cellini (1500–1571) was the short-lived victim

of a forger. He had made some drawings of what he imagined Roman silver vases might have looked like. A faker, Jacopo da Carpi, got his hands on them, fashioned them in silver, and passed them off as genuine. He was caught when Cellini saw the objects in the collection of a proud owner and recognized that they could only be his drawings transformed into three dimensions. While the collector watched in dismay Cellini made drawings of similar "ancient" vessels and swore he was the master behind the design of the pieces da Carpi had so cleverly wrought and aged. (Another version of the story is that Cellini was a knowing participant in the fraud and that when Carpi began to spill the beans, Cellini fingered him.)

There are several accounts of Michelangelo Buonarotti (1475–1564) acting as an unscrupulous forger. There's the oft-repeated tale, first recorded by Condivi, the chronicler of a number of Renaissance artists, that in order to impress Lorenzo de' Medici, the youthful Michelangelo carved a "Roman" sleeping cupid and the head of a faun and buried the pieces in the Medici gardens where they were discovered and taken for genuine works until Michelangelo confessed to their manufacture. Later on when he had become famous, Michelangelo is said by Condivi and the sixteenth-century art historian Giorgio Vasari to have produced clever restorations of antiquities, virtually making them whole and neglecting to point out where the real piece stopped and the restored parts began. These are supposed to include one of the legs of the statue *Hercules Slaying the Hydra,* which is now in the Capitoline Museum, legs which the sculptor-restorer Guglielmo della Porta used. Another combined work with della Porta is said to have been a terra-cotta leg designed by Michelangelo and used in the restoration on the *Statue of Hercules* owned by the Farnese family now in the Naples Museum. And Michelangelo is said to be responsible for the restoration work on the famous *Dying Gaul* also in the Capitoline, plus significant parts of the monumental figure personifying the river Tiber in the Vatican—even Laocoön's arm raised in a futile attempt to stop the snake from biting him, and the famous sculpture *Dionysus and a Faun* in the Uffizi.

Yet none of these sculptures exhibit the slightest hint of the genius's hand, for the restored parts are slapdash and journeyman additions. One "Roman" sleeping cupid has turned up—it's in the museum in Turin—and although it's certainly a sixteenth-century fake of a Roman sculpture, there's not a scintilla of Michelangelo's style in it. The critic Leandro Alberti wrote of this cupid in the sixteenth century, "If you compare it with an antique figure, it quickly loses its appeal." Such a mundane and lifeless thing is hardly what Michelangelo could have done.

Vasari, who recorded some invaluable information about the great artists, also engaged in yellow journalism. He branded Michelangelo a forger: "He also copied drawings of the old masters so perfectly that his copies could not be distinguished from the originals, since he smoked and tinted the paper to give it the appearance of age. He was often able to keep the originals and return the copies in their stead." According to Vasari, who got the account from Condivi, Michelangelo's teacher, Domenico Ghirlandaio, gave his pupil a drawing of a head created by another artist, which the youth reproduced so well that the copy was indistinguishable from the original. The owner got the copy back and Michelangelo is said to have kept the original, but made the mistake of boasting about his scam to other pupils. They told the owner, who brought in his copy and demanded the real drawing back. When they were placed side by side no one could tell the difference. From this episode, Vasari said, Michelangelo gained "great fame."

Unlikely. The idea that one of the single most gifted artists in Western civilization gained renown because of his gifts as a forger and a confidence man stretches the limits of credulity. Michelangelo may have been temperamental at times, but, as is known from his writings and characterizations by contemporaries, he was a man of unquestionable Christian morality who would never have stooped to fakery.

Yet there have been men of rectitude and piety who have been known to have created a fake or two—"pious" ones, of course. Erasmus of Rotterdam, in his fourth edition of the works of Saint Cyprian, "found" a "heaven-sent" supplement called, On the Two Forms of Martyrdom. This one, Erasmus claimed, he'd dredged up "in an ancient library," a standard textual forger's ploy for cloaking a nonexistent provenance. Interestingly, in this literary snippet, Cyprian takes a position that echoes Erasmus's own views that suffering should never be equated with virtue. This was, as text fakebuster Anthony Grafton observes, an "uncharacteristic act of fakery, proving that . . . the desire to forge . . . can infect almost anyone: the learned as well as the ignorant, the honest person as well as the rogue."

What concerns fakebusters these days are not the fake "Roman" antiquities jimmied up in Renaissance and Baroque times, for they are not all that challenging, at least not the obvious ones. It's the Renaissance works of art faked in the sixteenth and seventeenth centuries that are dangerous. These are nearly impossible to detect. They are now far closer in time to the date of what they faked than they are to our times. In addition, they were created using materials that because of their age, today almost invariably test out as exceptionally old.

The number of documents from the fifteenth through the seventeenth century that mention contemporary forgers cooking up fakes of the great masters of the day are voluminous and, if one takes the extraordinary numbers of forged pieces seriously, and I believe one should, then today we are accepting without suspicion hundreds of works by people we assume are the grand masters.

One of these fakers of the late Renaissance, Denys Caelvert (1540–1619) worked out of Naples and faked spectacular drawings by Michelangelo, Raphael, and dozens of others. His productions insinuated their way into the collection of Cardinal d'Este among many other notable collectors. I may have been partly responsible for one of them entering the collections of the Metropolitan Museum of Art while I was director.

It was back in 1967, during my first months on the job, and a favorite curator, Hyatt Mayor, who was in charge of the prints department, raced into my office one day with a sheet of pencil drawings showing episodes from the Sistine ceiling, mostly segments featuring some of the famous personages, Sybils, and the like. He was breathless. He told me that a runner had popped in to show him the drawing and that it had to be by Michelangelo and we had to buy it instantly even if the curator of drawings, who was in Europe, was not handy, since it cost a mere ten thousand dollars. Mayor had, I knew, a feud going with the drawings curator and wanted not only to snag a gigantic treasure for the museum but to best his rival.

My first impression of the piece, which I wrote down, was: "Slow-moving hand, and why should Michelangelo be so cautious?" The lines were all too careful for a grand master. I assumed the drawing had to have been done by some art student of the nineteenth century.

Mayor was obsessed with not letting the treasure escape and badgered me about using special acquisitions funds the trustees had set aside for me to play with. So, more to please someone I admired—and to get him out of my office, I suppose—I said, sure, buy it. Today I'm beginning to think that what the Met has with this "Michelangelo" may not be nineteenth century at all, but since the paper looks genuinely old and not made to appear old, a genuine sixteenth-century forgery perhaps by Denys Caelvert and thus of considerably more value than the paltry sum spent so many years ago.

Doménikos Theotokópoulos—El Greco (1541–1614)—invested in a large studio with many helpers, including his son. Inventories made just after his death list as many as five or six versions of the most noteworthy originals, all made in differing sizes, all of which the master could not have painted himself. They sold and still sell today as originals.

The great sixteenth-century Venetian painter Jacopo Robusti, known as Tintoretto, left so many incomplete drawings and oils after his death that his sons, daughter, and son-in-law turned out finished-up works for fifty years. They fooled the experts back then and are still fooling them today.

Albrecht Dürer (1471–1528) was so faked in his lifetime, especially his engravings, that for ten years after his death the state created a unique imperial copyright privilege that protected against all faked woodcuts and engravings. With the lapse of these special rights there was a flurry of fakes, some believe as many as five thousand were made. The grandson of Dürer's best friend made and sold dozens and dozens of faked books, watercolors, drawings, and engravings which fetched fabulous prices. He confided to a partner in crime, "It may well be doubted if many of my pieces were actually made by Dürer." *None*, would be a better word.

Correggio, born Antonio Allegri (1494–1534), was an especially hot target for forgers. His chief counterfeiter was a man named Pietro della Vecchia, who also served up "incomparable" pictures by Giorgione and Titian, Pordenone and Palma Vecchio. His fakes of Palma were said to be finer than some of the artist's originals. Guercino, the seventeenth-century Bolognese master, was forged by the hundredfold in his lifetime and for a hundred years afterward, especially his drawings. Each year an antique dealer in some distinguished art show boasts about his new Guercino, who seems to be the favorite *seicento* artist with today's collectors, but one wonders how anyone could believe that such an abundance of paintings and drawings by one artist could all really be by him. Undoubtedly, many of them are fakes made during the lifetime of the artist or not long afterward.

Perhaps the top faker of the seventeenth century in Italy, a hothouse for practitioners then and now, was Terenzio da Urbino. His prodigious career jigging up old masters and the works of his famous contemporaries produced hundreds of canvases that are extremely hard to detect today.

The seventeenth-century art historian and biographer Giovanni Baglione described Terenzio's favorite techniques in faking up a Raphael:

> He hunted for worm-eaten and dirty old pictures and frames which showed some painting, however badly done. He repainted these, inspiring himself by some old drawings and he mixed his colors in such a way that the old things began to look like something worthwhile. Once the painting was finished, he blackened his work by smoke and made it look a hundred years old with the help of colored varnishes. Once Terenzio got hold of a fine antique frame, carved

and gilded and used it for a Madonna and other figures copied after an old drawing, and he took so many pains and so mixed the colors that he succeeded in turning out what looked antique.

All would have gone well, had not Terenzio gotten greedy and offered his Madonna to his principal patron, Cardinal Montalto. This prince of the church was an accomplished fakebuster. He became wary about some discrepancies and showed the picture to another art expert, who confirmed his suspicions. They pointed out that Terenzio had made a *pasticcio* (an Italian word meaning both a paste-up and a cookie), borrowing from several original Raphaels to make a "new original." The cardinal muttered darkly that if he'd wanted a *pasticcio* he'd have ordered one from his chef. The picture disappeared and, who knows?—may be in a distinguished collection somewhere.

How difficult it is to spot centuries-old fakes and restorations can best be illustrated by two special commissions undertaken by Guercino's contemporary, the Bolognese painter Guido Reni. While not a forger, Reni seems to have executed a total repaint job on two of the most renowned frescoes of the High Renaissance, the equestrian portrait of *Giovanni Acuto* (*John Hawkwood*) of 1436 by Paolo Uccello and that of *Niccolo da Tolentino* by Andrea del Castagno of 1456 in the Duomo of Florence, a job that no expert or scholar has yet detected.

An acquaintance of mine was researching military history in the ragged and disorganized Archives of Florence some ten years ago when he discovered misfiled documents about Reni having been hired to make massive restorations on the two paintings which by the seventeenth century had faded into mere ghosts of their former selves. Fascinatingly, Guido Reni has never been known as a restorer in any of the writings on his works—his life was extensively chronicled by Baglione in the seventeenth century. One wonders if he was called in from Bologna to Florence because the price was right? Or perhaps because Reni, whose artistic style is one that delicately combines the straightforward with the lyrical, was therefore a painter who could maintain that tough, almost primitive, feeling of the early Renaissance works yet at the same time add a touch of sweetness to them. That would have been much desired in the age of the Counter-Reformation, which wanted to appeal to the masses who have always appreciated a little honey in art.

Guido Reni's contemporary Luca Giordano of Naples was a talented artist and an even more talented faker. He was also a skilled manipulator

when it came to getting away with his crimes. In 1653 he painted an Albrecht Dürer *Christ Healing the Cripple*, a creative invention, not a slavish copy of one of the artist's cherished masterworks. Dürer would have painted it around 1514. Luca, having thought up one of the more clever scams in forging history, deliberately signed the work in his own name and covered his signature with a layer of paint. He placed the piece on the market and encouraged Dürer experts to examine it. They all proclaimed the work to be genuine and a prime example. The man who bought it was told by Luca of its true nature and he sued. The judge, in a landmark ruling, which apparently Luca had expected, said Luca was not guilty because his signature was there and ruled that "nobody could blame Luca for painting as well as the famous Dürer." The judgment was, in a real sense, a judicial blessing of the doctrine *caveat emptor*. Amusingly enough, this picture turned up on the New York art market in the 1950s signed, "Luca, 1653" and was presumably bought by a collector as the Neapolitan's effort. It has disappeared.

A few years later Luca created another bogus Dürer, this time a popular *Adoration of the Magi*. Another court absolved him for the same reason as the first. It seems likely that these virtual "licenses to steal" granted by the courts caused the forger to embark upon a virtual rampage of faking. His "honest" products, each one signed with a hidden "Luca" signature, included convincing works by Giuseppe Ribera, Giovanni Lanfranco, the Carraccis (specifically the food-shop scenes by Annibale Carracci), Paolo Veronese, Tintoretto, Peter Paul Rubens, Rembrandt van Rijn, Jacopo Bassano, and especially Michelangelo Merisi da Caravaggio.

In the past five years a large number of Caravaggios have appeared on the art market. Some are perhaps Caravaggio, others, certainly looking like products of the sixteenth century, may be Luca Giordano. To my knowledge no expert in any museum has probed for the telltale hidden signatures.

For a Bassano sold to Charles II of Spain, Luca obtained a Venetian canvas that was the precise size of the original picture hanging in a private collection. He made a perfect copy which he treated with soot and gall, a mixture he called *chiochio*. Again Luca owned up to the fraud and the king praised him for his incredible talent.

◆ ◆ ◆

Everyone who has any familiarity with art history knows that Peter Paul Rubens (1577–1640) supported a vast studio with enough assistants to churn out dozens of commissions a year. Most, by contract, did not specifically call for the master himself to design and complete every centimeter of the works

for which he was paid lavish sums by the most astute collectors in the world. Some of them, queens and kings, knew enough about Rubens's activities to insist in writing that at the least he paint every figure, man, god, *putto,* and animal.

Rubens on occasion made copies of the works of earlier masters for pay —a curious sideline for such an exalted artist. They are all Rubens, as most connoisseurs can tell. But in the days he made them they were apparently not so easy to spot.

Rubens was commissioned in 1601 to make copies of sixteen pictures in the collection of Cardinal Montalto (the *pasticcio* man) for the duke of Mantua; they were acknowledged as excellent copies and were well received. Then Pietro Facchetto was commissioned by Cardinal Gonzaga to make replicas of sixteen paintings plus some of the mosaics in the Chigi Chapel in the church of Santa Maria del Popolo in Rome. The lot was sent to Spain for the pleasure of the duke of Lerma, but they got badly mashed up during a stormy crossing from Italy. Though some thought was given to hiring a crew of Spanish painters to make wholesale repairs, in time Rubens was called in by the ducal envoy Annibale Iberti to carry out the work. Rubens himself spells it out in his letter to Annibale Chieppo:

> Quite apart from the incredible indolence of these Spanish artists, and their style and technique (God forbid that I would ever produce work like theirs) . . . the matter would never remain a secret if I accepted their assistance, as they would never keep their tongues still. My share of the work would be treated with disdain, and they would take credit unto themselves. All the more so, since the pictures are intended for the Duke of Lerma, they know full well that they are destined to hang in a public gallery. This fact means little enough to me, but because of the freshness of the colors, it will at once become obvious that they were painted here, either by these Spaniards or by my own hands or by our united efforts, thus revealing an attempt to deceive, which would be deserving of little thanks, and a thing that at no time I would be prepared to do.

Despite the posturing in the letter, which never got to the duke of Lerma, it seems clear that the duke was never informed either that the paintings had suffered badly or that Peter Paul Rubens, at thirty years of age, had been anywhere near them.

In his workshop Rubens seems to have qualified his artistic contracts

like a Hollywood lawyer. About the difference between a work made com-
pletely by him and the works by him that he called "not mere copies," he
stated that the "not-mere-copies" by assistants "are so skillfully retouched
by my brush that they are barely distinguishable from the originals and have,
moreover, the great advantage of costing so much less and for the price, they
are really magnificent." Rubens also kept silent when works he knew had
been painted by others were called his, except when exposing it himself
meant he'd shine. One time the king of England purchased a work by the
Antwerp hack Verhulst which was ascribed to Rubens and only then did
Rubens blow the whistle.

Rubens himself was faked massively during his career and is still, espe-
cially his drawings. One faker, Nicholaes Pieters, working in the late seven-
teenth and early eighteenth centuries, took Rubens's engravings, supplied
them with colors, and sold them to dupes, mostly in England, who thought
they were getting his splendid colored sketches. At the time, one observer
remarked, "Thousands of pictures have been painted from engravings by
Rubens, and still are today by the Friday Market men of Antwerp [an art
market in business since 1547] who produce paintings as a sow gives birth to
a litter of pigs, and whose bogus canvases are passed off on Poles and Ger-
mans as genuine."

◆ ◆ ◆

Like Rubens, Rembrandt van Rijn (1606–1669) was assiduously faked. Some
of the more accomplished replicists of his own time were Jakob Backer,
Jacob Lavecq, Heiman Dullaert, and Jan de Biskop, who also liked to dash
off some stunning phonies of Tintoretto, Bassano, the Carraccis, Rubens,
and Anthony van Dyck. Today, distinguishing the subtle differences be-
tween these near-contemporary phonies and the real ones today is extremely
difficult.

All too few curators or art historians even seem to know the extent of
the fakery going on in the seventeenth and early eighteenth centuries. There
are only a few contemporary documents that have survived on the subject
of fakes and they are shocking. In the seventeenth and eighteenth centuries
in Rome there were numbers of bucket shops called "painters' galleys" in
which old masters and pictures by contemporary masters were copied by the
thousands, especially landscapes and floral pieces. The activity seems even
greater than during the Renaissance.

One late seventeenth-century court case in Holland—with incomplete

records so that we have no idea of the outcome—charged a well-known dealer with having hundreds of the most clever forgeries created for him to sell to his distinguished clients, including the elector of Brandenburg. The fakes included works by Michelangelo, Titian, Palma, Gorgione, Raphael, Hans Holbein the Younger, and Ribera. One of the witnesses for the prosecution, who had worked in the "painters' galleys" as a "fake slave," testified that he had produced hundreds of fakes, none of them ever identified by the so-called experts of the day. He scandalized the country by spotting most of these works and telling where in Holland they had gone.

The eighteenth century, the age of the encyclopedia, was a period extremely susceptible to artistic overrestoration of a kind that today would be deemed outright fraud. The clearest example of this is the wholesale polishing up, recutting, adding heads, arms, legs, even entire additional figures to antique sculptures found all over the Roman Campagna and in the south at Herculaneum and Pompeii. There were special, renowned restorers of antiquities who were quite proud of their renovation efforts, and the keenest collectors, whether the wealthy Germans, the rich British, or the superrich ecclesiastics of Rome wouldn't think of buying a Roman statue that had broken limbs or a missing head.

One of the most accomplished of these "near forgers" was Bartolomeo Cavaceppi of Rome (1716–1799). He trained with the French sculptor Pierre-Etienne Monnot at the prestigious Accademia di San Luca and apprenticed in restoration under the sculptor Francesco Albani's personal restorer, Enrico Napoleone. He worked extensively on the hundreds of antiquities that ended up in the Capitoline Museum where they can still be seen today. Cavaceppi is described by his contemporaries as being dedicated, earnest, blessed with a solid education in the classics, a man of a rare intellect, high ambition, an indefatigable worker, and a technician with almost incredible manual skills. In short, this is a man whose works were all but impossible to detect, back then. Today this is no longer the case, for the passage of time and the inevitable discoloration of differing kinds of stone have made it easy to detect where the real antiquity left off and the Cavaceppi began.

Purists today tend to characterize all of Cavaceppi's restored pieces as hoaxes or fakes because they pretend to be something that they are not. But it's not as simple as that. What Cavaceppi did, a largely acceptable practice in the eighteenth century, was to turn ancient fragments and large, unconnected bits and pieces into tasteful decorative furniture. As Mark Jones

points out in the British Museum catalogue for the recent show on fakes, this was a time when old-world concepts of the fanciful existed side by side and began to combine with a gradually emerging historical thirst for authenticity and yearning for archaeological responsibility. Cavaceppi's restorations were, as Jones puts it so well, like modern dentistry (or plastic surgery).

Cavaceppi's reworked pieces are legion. Most of the classical pieces in the Hermitage are his. The famous *Lansdowne Boxer*, formerly of the Hearst Collection and now in the Los Angeles County Museum of Art, is his. Today, Cavaceppi's additions to the *Landsdowne Boxer* have been either removed or stippled so that the observer can readily tell—an excellent way of preserving and tipping us off at the same time. A good number of the thousands of Roman sculptures in the vast Pius-Clement section of the Vatican and the impressive Roman sculptures in the Villa Albani in Rome were extensively worked on by Cavaceppi. All the Roman sculptures at Potsdam restored for Frederick II are Cavaceppi's handiwork, as is the gleaming, polished, smooth and thoroughly unconvincing *Newby Venus* in the collection of Mr. and Mrs. R. E. J. Compton of Newby Hall, North Yorkshire, England. The latter was acquired from the Barberini family by Gavin Hamilton, an English art dealer and collector, and Thomas Jenkins, an English banker and antiquities dealer living in Rome. The head, at least, is ancient but even that seems to have been recut down to its antique core. Elsewhere the statue was extensively reworked by a colleague of Cavaceppi's, Pietro Pacilli. The result was an extremely expensive and highly touted production. Today, we'd call this one an outright phony.

One of the driving reasons why many eighteenth-century sculptors in Italy started "restoring" was that Italian patronage of sculptors suddenly collapsed in a mammoth art recession. In order to eat, the artists either "copied or faked antique statues for the English milordi." A keen observer of the antiquities scene, Pierre-Jean Grosley wrote in 1758, "Sculptors have now little to do at Rome besides copying antiques for foreigners."

One talented Englishman trying to work in Rome and unable to find commissions was Francis Harwood. He succumbed to copying and forging. Others, like the young Antonio Canova, who was to become the spectacularly successful sculptor of neoclassical motifs, resisted the temptation and refused to go into the business, lucrative though it was. Harwood was known variously as Harowood, Harovood, Hawood, Kawood, and Erwort. His works populate the world. In 1762 he made a spectacular copy of a bust of the Roman emperor Caracalla after a superb antique model which is today in

the collection of the English writer and fakebuster Hugh Honour. Images of Caracalla were immensely popular in England, not only because the Roman original is a beauty but because Caracalla was made emperor in York. Harwood is also known to have copied a Venus for Lord Northampton; it is called the *Medici Venus* and resides now in Castle Ashby. Harwood made other spectacular copies of Roman imperial busts, characters like Marcus Aurelius in 1762 or Seneca in 1763 or Homer in 1764, most of them signed and dated. Other fine examples of these eighteenth-century "near fakes" are an Apollo and Venus of 1765, both at Gordon Castle, and a Seneca and Homer in the Victoria and Albert Museum.

Many of the famous interior architects in England employed copyists and fakers. Robert Adam in the eighteenth century ordered many copies for Syon House, in Middlesex, for Lord Northumberland. One lifesize piece replicated perfectly the so-called Apollino in the Uffizi, which is relatively small in scale. His lordship complained that he was getting nothing but a piece that had been enlarged, a mere blow-up. Eventually, Adam convinced him it would be almost impossible to obtain six antiques of the same size or with "attitudes that would harmonize with the setting." Lord Northumberland was pleased with the explanation.

Not everybody looked the other way when it came to the works of restorers and copiers. About Harwood, Horace Mann wrote bitterly to Horace Walpole in 1780: "Here is neither painter, engraver nor sculptor above the most common class. The best of the latter is a drunken Englishman whose sole employment is to make chimney pieces for the Palace and some for Russia, whose Empress buys everything good and bad that her emissaries can find in Italy." The particular empress was Catherine the Great, and Mann's diatribe refers to the large Roman sculpture collection in the palace of Tsarkoe Selo. The "Palace" referred to is no doubt the Pitti in Florence where ballrooms and other apartments were redecorated in the neoclassical style and furnished with dozens of recut or manipulated antiquities.

In the last quarter of the eighteenth century the laissez-faire attitude about wholesale recutting, refitting, and restoration came to an abrupt halt. In a sense modern thinking about massive restoration began. The catalyst was the arrival in England of the infamous Elgin Marbles stripped from the Parthenon. A debate ensued over whether these treasures should be refitted to look as they did when they had just emerged from the studio of Phidias. The decision was, thankfully, to let the grandeur of the ancient shine through the bumps, bruises, and amputations. From that time on, the practice of massive restoration faded fast.

The result of the production-line efforts in overrestoration and fakery carried out by the Cavaceppis, the Monnots, and the Harwoods is that 90 percent of all the magnificent Roman statues in the rich collections of the Vatican, the Capitoline Museum, the Hermitage, and in some of the most stately homes of England are almost completely eighteenth century.

# 5

# VICTORIAN SHENANIGANS

*A*lthough there are no scientific statistics for the number of forgeries made in a given century, it does appear likely that from Egyptian times to the modern era there was a steady growth in the numbers of fakes and occasional times when fakes virtually exploded—the phony relics of the Middle Ages, for example. Another explosion took place during the nineteenth century, a geometric growth in fakes of all kinds—scientific, artistic, literary, documentary, and as soon as it had made its debut, photography. Part of the reason was that art education suddenly burgeoned for the masses. Art publications became popular for Everyman and the forgers, too. The Victoria and Albert Museum formulated the philosophy that a knowledge of the fine arts made a better citizen. Casts and reproductions were actively manufactured by the Victoria and Albert and sold to schools and individuals. Forgers made very good use of those casts.

As Mark Jones perceptively points out in his book *Fake? The Art of Deception*, there was also a discernible shift in the perception of the relationship of Western culture to the past. "Lost" and primitive cultures became almost equally appreciated as classical antiquity. And most important, the collecting of exceedingly old relics, which earlier had consisted primarily of Greek and Roman artifacts gathered up by a small class of aristocrats and scholars, began to spread to other social classes and involve diverse types of objects, too. Art collecting in a sense became democratic. And with democracy came an increase of fraud.

The early nineteenth century was gripped by an art-collecting mania. People wanted to have a bit of the chivalry of the Middle Ages. Metalwork of Gothic times became the rage. The art of exotic peoples like the Etruscans or the Sarmatians was exhibited, collected, and faked. India roared into fashion, with the subsequent forging of marvelous pieces from that far-off land. And in due course the art of Southeast Asia, the Americas, even Eskimo Inuit art and pieces made by the Maoris of New Zealand were forged. The more unusual the art and the harder it was to put one's hands on it, the more accommodating and busy the forgers became.

Jones states:

> The collecting mania created a paradise for dishonest dealers. As each new craze took off a sudden imbalance between supply and demand created the perfect opportunity for such people to peddle their wares before a pool of expertise had been created. Craftsmen, and some artists, were themselves bemused and sometimes embittered by the fact that the work of their predecessors had so suddenly become many times more valuable than their own. Faking provided not only a living but also an opportunity for revenge on those who showed so unjust a preference for anything old.

Whenever a discovery was made, the forgers were quick to follow up.

When in 1822 Jean-François Champollion deciphered Egyptian hieroglyphics, the romantic Egypt of Mozart's *Magic Flute* vanished. Instead, the Nile Valley became of huge significance in what was believed to be the formation of mankind as the cradle of human civilization. Fakers went back to the source of it all, the legendary founder of ancient Egypt, King Menes, and cobbled up sensational items representing his reign.

There used to be in the New-York Historical Society—today it seems to have vanished—something dazzling from the most ancient times of Egypt called the "Necklace of Menes." It's a keystone piece in this "new age" of exploration, and symbolic of the nineteenth-century's thirst for ancient times. It is also a milestone in fakery. The name of Menes, the legendary pharaoh who united Upper and Lower Egypt in about 3100 B.C., is stamped eight times on the hunk of jewelry. The forger conjured up the image of genuineness by creating an attractive stew of authentic beads from differing dynastic periods. The necklace was bought by the New-York Historical Society in 1846 and lasted well into the nineteenth century as real. Then a group of eminent Egyptologists proved that the style of the inscriptions

was inconsistent with the supposed date and various of the findings of Champollion. Certain of the hieroglyphs were nonsensical.

By the end of the nineteenth century the tomb robbers digging places like the Valley of the Kings began to work double time faking. Often they would create several bogus sets of an original find. They did their homework and kept abreast of the literature.

Fakebusters of Egyptian art tried every means of detection imaginable. There was one renowned expert of the nineteenth century by the name of Richard Wakeling who proclaimed that he could detect fakes of wooden Egyptian sculptures by their smell, or to be more precise, by the lack of an aroma of ancientness. This led an enterprising Egyptian faker to boil down peasant-class mummies, which were being sold as fuel for the railroads, and mix the brew obtained into his wood figures, fooling Wakeling's nose and everyone else.

The Bedouin forgers were blessed with incredibly sharp eyes and a keen sense of scientific inquiry. Their studies and discoveries were shared with their colleagues and passed down to their children. They learned that in ancient Egyptian gold there are slight traces of a distinctive type of reddish corrosion, which one should look for in out-of-the-way crevices. They would "mine" tiny amounts of this material and imbed it in their new creations. They also learned that the dusts covering ancient woods had their own characters: Those from the Mediterranean shore contained minute fragments of shells; those from Aswan were rich in granite particles; Nile sand contained much silica; desert sand contained lime.

Russia was almost as captivating as Egypt when it came to exoticisms. In St. Petersburg it became fashionable to collect the superb jewelry and gold objects made by Greek craftsmen for the Scythians and the Sarmatians. And lo and behold, almost every time such a fashion flowered, a quantity of Scythian or Sarmatian items conveniently turned up in some unregulated excavation or in an anonymous and unpublished family collection.

One such is called the Maikop Hoard and was supposedly a Sarmatian treasure found near Sofia, Bulgaria. It contains a large number of gold, silver, and silver-gilt belts and necklaces, all embellished with attractive enamel inlays. The Hermitage purchased the material in 1916 for a prodigious amount of money so that it would not fall into alien hands abroad. The date was said by all experts to range from the late fifth to the third century B.C. Other pieces were smuggled out of Russia and did go to private collectors, mostly English. These eventually found their way into important collections in Britain and Wales. I had the chance to examine a belt owned by the

Hermitage, and other minor pieces not too many years ago and was let down, for none of the raw, awkward power that one finds in true Sarmatian gold objects was evident. The pieces looked safe, Fabergé-like, and clearly made up of a number of ancient fragments stitched together with fresh—shockingly fresh—items.

Because of the turmoil that overtook Russia in the revolution and Second World War, no one other than a few curators studied the hoard with a critical eye. Until 1961. That was the year the Russian fakebuster A. A. Iessen revealed that the objects were all phonies, made up, in part, of real gold links and bits and pieces of original enamel. The scholar needed to be courageous to publish his findings, for the Communist state did not look kindly on any kind of criticism, especially that directed against "indigenous works by an ancient people who populated the lands that would form the Soviet Union." Iessen tracked the Maikop Hoard down to two Sofia antique dealers, S. and L. Gokhman. He established that they commissioned the fakes around 1890. They had hired skilled craftsmen to make the pastiche jewelry out of real old and damaged fragments filled in by new pieces.

The model for the works was decidedly simpleminded. All these magnificent "new" treasures were rip-offs of genuine ancient goldwork lavishly illustrated in a monumental study published in 1891 by the scholars Kondakof, Tolstoi, and Reinach. It was accepted practice for fakers in the nineteenth century to seize upon recently arrived art publications and plumb them for their models. It's astonishing that no one noticed the coincidence.

It is amazing how casual forgers can sometimes be in finding models for their scams. In one of the more sublime examples of sloth there is the bronze boy attributed to the Florentine early-Renaissance master Desiderio da Settignano purchased in the nineteenth-century by Florence's premier sculpture museum, the Bargello. Not only did the bronze turn out to be a fake, but for his model the forger had traveled no farther than two blocks away to the Uffizi, where he had fallen in love with a Roman marble of a youth of the second century A.D. and had made a bronze version.

The nineteenth century was also a time when truly comical forgeries were made. Whole languages of lost peoples were invented, carved on rocks, and thrust into caves in the most unlikely places. Chastity belts were a captivating Victorian sex curiosity. The scholar E. J. Dingwall, writing in the early 1930s, theorized that such devices were invented around 1400 in Italy and were used well into the seventeenth century, yet the sole evidence for authentic chastity belts is anecdotal or found only in burlesque fiction. Actual old belts may never have existed. Those that have survived—the

most perfectly preserved are in the British Museum—date to the eighteenth and particularly the nineteenth centuries.

Some of the attempted fakes of exotic peoples and tribes are cartoonlike. Take the so-called *Sacro Tesoro*, which ended up in the collection of Cavaliere Giancarlo Rossi in the late nineteenth century. It was touted to be early Christian Langobardic and consisted of an ambitious number of sacred items: ten embossed book covers, thirteen crosses, all made of gold or silver, and two silver miters, plus trays and beakers and other church paraphernalia. They were said to have been stumbled upon by an unnamed peasant in an unnamed bishop's tomb. In truth, they were made by fakers working in Orvieto, Italy, who made a specialty out of Langobardic bronzes, gold and silver jewelry, and on occasion, monumental Roman bronzes.

One silver tray has a centerpiece that is supposed to be the lamb of God, but looks more like a hen clucking at her brood. In another tray with the Last Supper a fish waits on table and serves up the bread and wine with his fins for twelve grotesque apostles. The fish holds the bread in front and sort of hides the wine behind his back with his other flipper. The Crucifixion is designed in such a way that two lambs stand on the outstretched arms of Christ. How can anyone be fooled by such tripe? Sometimes *everybody*, at least for fifteen minutes.

Then there's the delightful tale of the progeny of the inscribed stone of King Mesha of Moab (ca. 850 B.C.) in the Louvre. The object was found by the French archaeologist professor Charles Clermont-Ganneau, who presented it to the Louvre in the late nineteenth century. In the 1870s the Berlin Museum bought for a hefty sum a large amount of Moabite pottery said to be related in some manner to the Louvre stone. The stuff was crude, decorated with nothing but seven dots or garbled inscriptions. The pottery had figural representations, but these "Moabites" have mere blobs for heads. Their bodies are rough cylinders lacking arms and legs.

Clermont-Ganneau became suspicious when he noted that the clay was so lightly baked that it could not have sustained burial and they had all purportedly been buried a very long time. An enterprising fakebuster, Clermont-Ganneau bribed a workman to reveal what dig the vessels had really come from. The workman told him that there was no dig. The creator of the pottery was one "Shapira of Jerusalem" who, in turn, had employed an Arab named Selim-el-Gar who'd bowdlerized the inscription on the Louvre stone.

Berlin Museum officials hotly defended the phony pottery despite learning the full story. This is the normal first reaction to the exposure of a massive fake and is quite understandable. Eventually, the pieces were quietly

removed from exhibition. The enterprising "Shapira" later made fragments of the Book of Deuteronomy on strips of leather and offered them to the British Museum. Luckily, Clermont-Ganneau had been tracking this effort, too, and saved the institution an embarrassment, although the curators there were not rushing to buy the spurious Old Testament remnants.

Speaking of oddball early Christian fakery, I recall a time when a curator at the Metropolitan Museum raced in to my office, holding aloft a silver plate easily three feet across and almost an inch thick that he had been offered by a Swiss art dealer. It was, he claimed, a magnificent plate of about A.D. 400, representing Adam and Eve on each side of the tree in the garden of Eden with the snake and the apple and everything, including fig leaves decorously hiding the genitals of the archetypal couple. We had to buy it, he insisted. I decided against the purchase until I could get an explanation as to why fig leaves could appear on the figures in a late antique object, since such prudish devices became prevalent only in the late Renaissance. When the forger's blunder was pointed out to the curator, he got a good laugh. The huge plate, patently nineteenth century, is still out there somewhere on the art market or in some private collection.

The prize for the most prolifically faked item of the nineteenth century goes to the makers of thousands of pretty terra-cotta Greek fifth-to third-century-B.C. figurines said to have come from the ancient factories at Tanagra in Boeotia, at Ephesus and Myrina in Asia Minor, and in southern Italy and Sicily. Tanagra figurines, which represent characters from Greek myths and the gods and goddesses, are usually under six inches in height, often covered with a delicate white slip, and some even have painted draperies, hair, eyes, and lips. The genuine ones, which were used as both temple offerings and as items of aesthetic pleasure, are charming, and were manufactured by the tens of thousands in the ancient world.

In 1957 I was excavating a tiny sacred room, no more than five feet square in size with a three-foot-wide columnar altar in its center, located in the ancient, buried Greek town of Morgantina in central Sicily. Once I had removed the red roof tiles and reached the clay floor of the chamber, I must have plucked a hundred or so fifth-century-B.C. "Tanagra" terra-cotta statuettes, mostly of the goddess Demeter.

Every Tanagra-type god and goddess in the Olympian panoply was faked in the nineteenth century, plus a host of subjects that by their sentimentality and romantic flavor stamps them as Victorian—such subjects as Cupid, Charon's barge, Ulysses tempted by the Sirens, Priam and Helen, Oedipus and Antigone. The forgers had to work harder than the genuine

artisans because the scenes were far more complicated, a sort of mix of ancient Greek and Meissen personages.

Clay is a most convenient medium for forgers. The stuff isn't all that difficult to age—modern clay is hard to detect unless one brings in the heavy and expensive scientific artillery. Most of today's phony Tanagras are broken into small pieces and patched up again, making them look as though they had been hidden for centuries in the depths of a sacred room with a column altar. In Victorian times, because of the prevailing taste for completeness and perfection, no part could be missing. The fact that the nineteenth-century Tanagras are all complete right down to the fingertips, despite being badly crunched, is a sure sign of their real nature.

Because of their diminutive size, these fake Tanagras seem to have remained above suspicion far longer than more ambitious attempts to re-create the works of the grand ancient masters. One series of pseudo-Tanagras was even successfully palmed off as Phidias's "sketches" in terra-cotta for the sculptures of the Parthenon, including the statues on the tympana, the metopes, and the frieze. Depending on their point of view, the scholars who were duped called these pieces either Phidias's preliminary studies or Roman copies of the master's works made during the classical revival under emperor Augustus.

Today, top-quality Tanagra fakes are highly valued, sometimes more than real Greek pieces of the fourth or third centuries. At one auction I attended at Parke-Bernet on Madison Avenue in New York, I had arrived early so as not to miss bidding on a rare Gothic capital from the cloister of Bonnefont for The Cloisters, the only one missing out of our series. I passed time examining the odd lots for the sale. Among the junk were one real Tanagra of some goddess and two nineteenth-century prissy fakes with the telltale fussy drapery and overelaborate hairstyles of Victorian times. When the latter two terra-cottas were brought to the podium, the auctioneer told the audience that he wanted to correct the catalogue and called the pair what they were. The genuine piece went for about eight hundred dollars. The fakes went for about three to four thousand dollars each. The man sitting next to me had worked himself into a lather competing with another bidder across the room for the two fakes. At the end of this incredible charade I impetuously asked the gentleman if he were mad and asked why he'd paid five times for the admitted phonies. He agreeably explained that he was an antique dealer with a shop in Athens and that his government wouldn't allow him to sell authentic Tanagras, but laughed along with him every time he peddled Victorian fakes, all dirtied up with genuine soil from

the Acropolis. He told me he spent a good amount of time attending auctions in which fake Tanagras were for sale.

◆ ◆ ◆

After Tanagras, the most frequently faked works of art in the nineteenth century seem to have been drawings, gouaches, and paintings by Jean-Baptiste-Camille Corot (1796–1875), especially his wispy landscapes with the dreamy groves of feathery trees at dusk. The director of the Metropolitan Museum in the 1920s, Sir Casper Purdom Clark, used to get laughs with the story he was told by a U.S. Customs official who told him that twenty-seven thousand Corots had entered America since the artist died in 1875. Clark's punchline was, "When I repeated that to one Corot expert he told me the figure was shy by ten thousand." In 1934 *Time* trumpeted that Corot had painted two thousand pictures of which ten thousand were in American collections alone. In 1940 *Newsweek* stated that out of twenty-five hundred paintings Corot produced in his lifetime, seventy-eight hundred had made their way to American collections. The Corot fake situation was never that bad, but there are dozens still rattling around out there.

A considerable body of phony Corots were palmed off on a French collector named Dr. Jousseaune. When he was in his eighties the old man bought numerous works by the artist, each for less than a hundred francs. By his death in 1923 he had assembled no less than 2,414 of them. The representative of the ring of forgers who made them claimed he'd obtained them from an armoire that Corot had abandoned in the house of a friend. To set the hooks into poor Dr. Jousseaune the confidence men seeded the armoire with numbers of oils, all daubs, picked up in the flea markets of Paris. The tip-off on the Corot drawings was that they were primarily what is called distempers, or *detrempes*, a technique similar to gouache, but one that Corot is never known to have used. Dr. Jousseaune owned a thousand *detrempes* alone.

What especially appealed to the doctor, who seems to have been obsessed by facts, history, chronicles, and documents, was that almost every one of the fake Corots possesses a note in the handwriting of the artist. Some of them are as antic as the impossible-looking style of the works. One, on a landscape, translates as, "Shall I turn to the right or to the left?" Another specifies, "Near the village of Lignières, I just completed two sketches which are very similar to each other; this happens to me often enough." The one Dr. Jousseaune liked the best because he could proudly supply the answer was: "Valley near Gallardon, I am asking myself what will

become of all my sketches after my death? Well here I am giving away my melancholy ideas; I shall be happy if somebody profits by them." Yet many supposedly fake Corots are in fact legitimate works of the obscure painter Paul Desire Trouillebert (1829–1900), who worked in a similar style and never faked a painting in his career. He got his bad rap when in 1883 the son of Alexandre Dumas bought one of his landscapes as a Corot.

For forged painters, Corot holds the nineteenth-and early twentieth-century record. He is closely followed by the great French painter and printmaker Honoré Daumier (1808–1879). The standard forgery is a repetition of his watercolors and book illustrations in the form of oil paintings, and they number in the hundreds. Some of these bogus oils are ambitious, being two or three times the size of small illustrations printed in books. There are some Daumier fake paintings that attempt to copy in full color his black-and-white engravings of the denizens of the Paris law-court system. They can be readily spotted because their colors are so garish.

Sometimes it's hard to tell the difference between a fake made during the lifetime of an artist and one of his own copies of his own work. This is true in the case of the famous Impressionist Pierre-Auguste Renoir (1841–1919). He seems to have inherited those Corot "statistics," but the fact is that Renoir was, and is, not all that often faked. He himself made many lackluster copies of what he thought were his best pieces, and sold them. When these rather sloppy copies are questioned as phonies, it's wise to recall the quip once made by the German Impressionist Max Liebermann (1847–1935): "Thank God for all those art historians who make it their business to root out fakes. They make it easier for all my bad paintings to be attributed to forgers." Anyone who had the pleasure of seeing the Barnes Collection on its worldwide tour in 1995 or who had the rare opportunity to visit the Barnes Collection in Merion, Pennsylvania, in the old days when all the Renoirs were on the walls, knows how rotten Renoir could be.

I suspect that some of the supposed fakes of Claude Monet (1840–1926) are in fact his own near-copies of his own compositions. He is known to have placed ads in local French newspapers in the late nineteenth century offering for sale works of haystacks, poplars, and the facade of Rouen Cathedral that he guaranteed to make different by changes in light and shading. And all the long we thought Monet was dutifully recording the subtle variations in light and hue for the grand experiment of Impressionism! More practically, it was to keep him in the style to which he had become accustomed.

Maurice Utrillo (1883–1955), the primitive painter of Paris active in

the early twentieth century is documented as having been proud of creating several copies of a particularly popular canvas and telling the buyer of each he was getting the one and only.

Another artist who either copied or "faked" his own works is the Italian Futurist painter, Giorgio di Chirico (1888–1978). His early career in the 1910s and 1920s was brilliant and his paintings, avidly sought-after by collectors, are stunningly poetic and haunting Surrealist landscapes and scenes of barren city squares. By the 1950s his creative fire had all but burned out and di Chirico was painting lifeless neoclassical clichés, which excited few collectors. To supplement his dwindling income di Chirico simply "faked" examples of his earlier successes, dating them to the golden years.

◆ ◆ ◆

All the same it's hard not to agree with the sentiment expressed by *The New York Times* in 1873.

> No form of swindling has been more frequently exposed than that involved in the sale of worthless copies of good pictures at auctions, for prices immeasurably above their value. Exposures have appeared a 1,000 times in all the journals, but the vagabonds still find fools in plenty. Never was there a time in the history of swindling in this good city of New York when copies were sold in such numbers and with such audacity.

Yet although it's the fashion these days to pooh-pooh the skills of nineteenth-century forgers and to call their products "obvious and uninspired," there is a sizable body of work created by gifted forgers that fooled the experts in the Victorian Age and still fools some people today. One of the best fakers was Louis Marcy. Even his name was a fake; he was born Luigi Francesco Giovanni Parmeggiani in Reggio nell'Emilia in 1860. Marcy was apprenticed first to a printer and then to a jeweler, where he picked up the fine points of working in silver and bronze gilt. In 1880 he traveled to France, Belgium, and England and lived in London from 1888 to 1903. He saw to it that he became close friends with the curators of metalwork at the Victoria and Albert Museum and officials at the British Museum. He sold his friends some of his "medieval" works made in a sort of romanticized Spanish style in 1894–95. Marcy's specialty was ecclesiastic ornaments: caskets, purse mounts, and crosiers of which the Victoria and Albert has a

fine enameled version. He crafted a fancy holy-water bucket and sold it to the British Museum.

He returned to Paris in 1903 and was arrested as an anarchist and spent five months in prison. While in jail his house was searched for leftist literature and bomb paraphernalia. No bombs were found, only some strident political tracts and dozens upon dozens of beautiful medieval church implements and objects of decorative arts, all obviously centuries old from their knocks and bruises. For a while Marcy, who seemed to have links to Spain, was investigated for being either an art thief or a fence for ecclesiastic art stolen from Spain.

His mistress, the daughter of one of the three women arrested with him, was the wife of a distinguished genre painter, Ignacio de Leon y Escosura, who was also a collector of antiques. But, try as they did, the French police could not find any Spanish or indeed French or any other medieval piece that had been stolen from any church or cathedral that matched any of the medieval objects in Marcy's Paris house. Why the police didn't ask Marcy where he'd gotten them is a mystery.

He remained in Paris after being released and from 1907 to 1914 edited *La Connaisseur*, a magazine that editorialized against capitalist art collectors, dealers, and art forgers, the latter no doubt to throw the possible investigators off his trail. He continued to create his forgeries. Returning to Reggio, he sold his collection to the municipality where they remained "medieval" and cherished as such until the 1920s, when scholars began to question them. They are now correctly attributed to Marcy.

The phenomenal success enjoyed by Marcy was due to his skills and lucky timing. It happened that Spanish medieval art was experiencing a phenomenal vogue in the late nineteenth century, probably because in Madrid in 1882 there had been a monumental exhibition of church treasures, most of which had never been seen before either by the general public or most experts. The contents of the show became a sensation, exotic works from exotic lands being the rage. Marcy merely supplied the growing demand for church decorative arts.

Marcy's work is superior. He was something of a genius when it came to fabricating patinas. He created a startling new universe of authentic-looking scratches, wears and tears and damages. He never made the mistake of directly copying a casket, holy-water bucket, purse, or lectern from an existing example. He was one of the most dangerous type of forgers: he "intuited" the style of the past and delivered it exuberantly. The tip-off, as Marian Campbell of the Victoria and Albert writes in the British Museum catalogue,

*Fake?* is "an indomitable predilection for motifs derived from architecture—pinnacles, turrets, gateways, and windows, often assembled to whole castles and facades, with cylindrical turrets with pointed tops being the leitmotif."

Yet despite the fact that Marcy's style has been well described and the body of his works exhibited in Reggio, some of his works avoid detection still. One, a beauty, is a miniature cradle reliquary in silver and silver gilt, and is on exhibition at the Richmond Art Museum in Virginia, for the curators there haven't yet come around to believing that the object is not medieval. There are also two or three fine Marcy productions at the Metropolitan, for J. P. Morgan relished a fine Spanish flavor. These are not on view and have been relegated to the medieval department's study collection for aspiring curators to examine and learn the Marcy signature.

At times the collecting wars can become so intense that a collector can encourage the fabrication of fakes not for his rivals to waste their money on, but for himself so that he can amass pieces of incredible nature in never-before-known quantities. Such was the case with Mikhail Petrovich Botkin of St. Petersburg (1839–1937). It seems he wanted to best a Count Aleksandr Zvenigorodskoi, who had found some gold Byzantine enamels of the eleventh and twelfth centuries featuring the most delicate depictions of Old and New Testament personages. Zvenigorodskoi published his pieces in 1892 and they were highly praised. Botkin managed to find more Byzantine gold cloisonné enamels, in better condition—astonishing portrayals of Saint John the Baptist, Saint Bartholomew, and Saint John Chrysostom. Botkin published a competing catalogue in about 1911 of his one hundred and fifty discoveries, calling them Byzantine of the tenth to twelfth century.

Botkin's enamels were eventually sold at auction and made their way into the collecting bloodstream of Europe and America. Although none of the hundred and fifty pieces had any known history and they all seemed to have a marked similarity of style, they eluded universal condemnation until the 1980s when several scholars at Baltimore's Walters Art Gallery produced a large body of stylistic and technical evidence that proved they were made in all likelihood in the studios of Fabergé and other jewelers in Saint Petersburg, where enameling was being produced in quantity.

Botkin's fakers, naturally, tried to produce sexier items than the ancient Byzantines. The models seemed to have been no more arcane than the color lithographs published between 1866 and 1892 in a book describing the Pala d'Oro in Venice and the reliquary of the *True Cross* in the cathedral treasury at Limburg an der Lahn, Germany—all objects made in Constantinople

during the tenth century. The Botkin pieces are far larger, they are cleaner, showing no signs of burial, and they are virtually undamaged. The designs are clearer and more vibrant than the original material and so are the colors of the enamel masterfully set into the little fences of the gold cloisonné. The faces are distinctive, insipid, smooth, with impossibly high temples and pointed chins. Every Saint John or Saint Bartholomew bears a silly expression, and the irises are snapped to the extreme right or left of the eyes. The draperies are awkward and form meaningless abstract patterns. The mystery is, how could any one of them have generated the buzz of authenticity for so long?

One might ask the same question about the absolutely dreadful lead knickknacks and "pilgrim" vials found in the Thames in the middle of the nineteenth century and believed by many to be valuable relics of the eleventh century. Medievalists affectionately call them "Billies and Charlies" after their creators William Smith and Charles Eaton.

The two men were mudlarks who would search the shores of the Thames for anything of value. Finding little, they started around 1857 to have foundries cast a range of "medieval" medallions and badges decorated with figures, animals, and garbled inscriptions. They made crude hand-cut plaster molds and sold their castings at the site where a new dock was being constructed.

The savvy art dealers William Edwards and George Eastwood bought up most of them and seem to have been convinced that they were the real thing. But with other experts the "Billies and Charlies" aroused suspicion. In 1858, only months after they had started to come out of the river, the medieval historian Henry Cummings denounced them as fake, largely on the basis that the inscriptions were gibberish, a very sound argument.

But Eastwood, convinced they were authentic, decided to sue for libel. An eminent scholar by the name of Charles Roach was eager to testify that they could not possibly have been faked. Roach's theory, which he eventually published, was that they dated from the reign of Queen Mary. The pieces had been imported, he tried to establish, as substitutes for the thousands of religious objects destroyed during the Reformation.

This outlandish explanation got another skeptical scholar, Charles Reed, into the act. A true fakebuster, Reed let the arguments about history, dating, and style bubble and boil and went to the bottom of the pot. He visited every foundry he could find and eventually discovered some of the plaster molds for the "Billies and Charlies" and the scam was over. Well, almost over. Billy and Charlie, undaunted, continued to make their lead bits

and pieces until Charles Eaton died in 1871. Today they are in growing demand, but not as eleventh-century pilgrims' souvenirs. Every ten years or so contemporary versions of "Billies and Charlies" are "found" in the Seine or the Po or the Danube and enjoy a firefly existence until the news of what they are gets into the popular press.

# THE GOLDEN AGE OF FAKES—NOW!

*I*n 1903 the government of Italy passed laws prohibiting the export of national art treasures, in answer to the growing concern about the depletion of cultural patrimony. The art dealers were the real targets, however, since "night diggers" and smugglers of antiquities were rare back then. The smugglers would come into their own as a direct result of the draconian export laws that were thrust through the government machinery.

The dealers, meanwhile, enraged at the decrees, issued a statement that was part condemnation, part confession. It's a fitting description of what would take place during the rest of the twentieth century.

> The advocates of this bill ignore the fact that everything sold is not the product of the art of the past, that innumerable objects have lain for years, for centuries indeed, despised, dust-bitten, and worm-eaten, until he, the dealer, discovered them thus half destroyed, and restored them with his enlightened patience, supplying missing parts, polishing them up, completing them with fragments of other objects, and recomposing the whole in fashion so pleasing and artistic as to excite the fancy of the foreigner, who pays for such work with clinking gold.

By 1914 the number of foreign fakes shipped into America to quench the lust of the new art collectors had become a tidal wave. *McClure's* maga-

zine noted in an editorial in 1917 that art forgery had turned into a "factory industry" because of the demand and because faking was "so much safer than highway robbery, so much more lucrative than safe-blowing, so much more respectable than coining false money, so considerably ignored by the District Attorney and the police."

The recipients of the new wave of fakes were the superrich, untutored industrialists and media moguls who equated art collecting with social distinction, righteousness, and the American Way, like William Randolph Hearst, Philip Lehman, Collis Potter Huntington, Henry Clay Frick, Walter Chrysler, Andrew Mellon, and J. P. Morgan. Though they got hustled for works that were not exactly what they were supposed to be, and most surely got stung by overly restored examples of the old masters' faded supplies, overall they fared exceedingly well and avoided the large number of forgeries on the market, because they hired some of the better fakebusters of the day, listened to them, and had the courage of their collecting convictions.

J. P. Morgan was an especially gutsy collector and may have been less involved with soaking up fakes than in making them himself, or, more accurately, having them generated by and through his agents. At the Metropolitan in the Medieval Treasury there's a breathtaking silver-over-wood reliquary head that comes from the St. Yrieix church in Saint-Yrieix-la-Perche in central France. Until fairly recently a silver reliquary head had also been on view in the treasury of the church that bears the saint's name and was for all intents a measurably identical reliquary—unlikely.

To learn who got flimflammed, the parish priest of Saint-Yrieix or J. P. Morgan, I dissected the head in New York taking apart its dozens and dozens of pieces of silver and ornamentation off its wooden armature. After my dissection, I had no doubt at all that what is in the Met is the original of the thirteenth–fourteenth century and that in Saint-Yrieix there's an adroit copy made by a world-class copyist. Had Morgan hired him? No one knows.

The Morgan medieval collection came to the Metropolitan in 1914 and was made up of thousands of treasures of enamels, gold and silver, sumptuous ivory carvings, and sculpture. Although no other reliquary Morgan gave to the Met has turned up in identical form in some other medieval sanctuary, it is suspected that a number of Morgan's sculptures were copied cleverly and the copy put in place in France. The technique of choice was concrete cast in such a deft way that it can fool one into believing the statue must be ancient until one is less than a yard away.

Morgan had great fortitude when it came to collecting. He acquired

around 1900, against the advice of certain experts, half a dozen lavish silver plates, some a foot and a half wide decorated in repoussé, showing scenes from the life of David. The main plate is dramatic and bloody, depicting the fight between Goliath and the youthful David (who's no skinny wimp in this depiction, but a muscular and eager killer) and the victory, celebrated by the hacking off of the giant's head.

The plates were said to have come from an illegal dig in Cyprus. Other plates with similar scenes are still on the island, pieces that haven't gotten out through the smugglers' network. These plates are variously dated from the fourth to the early sixth century and on the backs there are a number of minute silver stamps that were scrutinized by every specialist of the early Middle Ages without anyone arriving at an acceptable identification of them.

The figures were most peculiar. They seemed to have been fashioned in the robust and slightly awkward "renascence" style in vogue during the time of Emperor Theodosius I (ca. A.D. 39), who deliberately mimicked the style of Constantine the Great's time, but there were marks of other styles deep down in the figures, showing the figures and especially the fluttering drapery as flat, ironed-down, semiabstract patterns, not clothing that surrounded real anatomy. The naysayers pointed to these disturbing features as the "misunderstandings" of a forger. The fact that more than one artistic style was present was interpreted as a sure sign the plates were fake.

When Morgan heard the condemnations he is said to have snorted and remarked something like, "When you find the man who made my silver plates, please send him congratulations and the message that he should get in touch with me, for I want to buy what else he has in his pack."

Art history tends to move at its own pace, usually a snail's, and so it wasn't until the 1970s when Erika Cruikshank Dodd, a scholar working at the Byzantine Institute at Washington's Dumbarton Oaks, published her decipherment of the many tiny silver stamps on the bottom of the Morgan "Cyprus" plates in the Met. She proved conclusively that they had been affixed when the plates were first worked and that they were in fact the stamps of the official court workshop of Emperor Heraclius (ca. A.D. 610).

Dodd gave an eloquent explanation for the curious mixture of styles and the choice of subject matter. Heraclius was a usurper. Wanting to put the correct spin on his reign, he had instructed his artisans to illustrate David, another "usurper," and to render the story in a much earlier artistic style than that prevalent in the early seventh century to give it the appear-

ance of legitimacy. With the "Cyprus" David plates, Heraclius became a forerunner to the thirteenth-century Venetians who wanted their cathedral to look as old as any in Rome.

◆ ◆ ◆

The Roaring Twenties was a great time for art fakery. In 1924 London's Royal Academy mounted one of the first serious exhibitions on fakes in Burlington House. The show was essentially a primer for how not to get stung. The differences between the genuine and the phony were driven home by comparisons between real and fake works of art supplemented by well-written labels and a detailed catalogue.

Ivories, bronzes, and furniture were given special attention. Gothic ivories of the thirteenth and fourteenth centuries had become one of the objects of choice around 1920 and workshops in Paris were turning them out by the dozens—standing Madonnas, plaques with the Virgin and Child, and the Passion. Ivory mirror cases, combs, and cosmetic boxes featuring saccharine scenes of Chivalry and the Court of Love were especially popular. Fakers had to work into the night to keep up with the orders.

In my early museum days I became acquainted with one former faker of Gothic ivories who turned legitimate in his forties. He told me stories about having to carve so many hours a day that his hands were afflicted with near-permanent cramps, and his eyes had begun to fail. This reformed faker claims that fully 50 percent of all Gothic ivory carvings collected by any Western institution after about 1890 came from his and other workshops in France, Italy, and Spain. He also claims to be responsible for a group of puzzling ivories thought by many of today's scholars to be Byzantine, or Syrian, of the eleventh century. His favorite way of aging those "older" pieces was by wrapping them in the skins of rabbits and burying them until the pelts decayed. He showed me a sample, clearly bogus from the style, yet I was taken aback to see that under the standard ultraviolet test, his ivory looked unquestionably like ancient Romanesque ones.

One of the most sensational forgeries of the twenties involved Vincent van Gogh (1853–1890), who was just beginning to become popular. Starting around 1925, a Berlin art dealer and ballet dancer by the name of Otto Wacker offered for sale through a variety of outlets thirty-three canvases by the master: four titled Self Portrait; a Sunflowers; Sower in Sunlight; several flamelike Cypresses; and a seated Zouave. They were enthusiastically certified and published by the gifted art historian J-B de la Faille in his monumental catalogue raisonné of 1927, the first for Van Gogh.

But when the "new" pictures were shown next to Van Goghs that had been in public and reputable private collections since not long after the artist died, they looked smudged, hesitant, weak, and doubtful—and if there is anything Van Gogh was not in his art, it was hesitant.

Questions were immediately raised about the provenance of the works, and gradually every one of them was traced back to Otto Wacker. When asked where he, a relatively modest art dealer, had gotten them, he would say only that he'd bought them from a Russian émigré living in Switzerland and Egypt. He said he didn't dare identify the owner because if he did, the remaining members of the man's family in the Soviet Union would be placed in danger. The owner had spirited the paintings out of the Soviet Union illegally.

Otto Wacker went to trial, which became an Alice-in-Wonderland farce with experts giving uproariously conflicting opinions. What was a real and a faked Van Gogh became so muddled by what seemed to the general public a bunch of madmen, not art experts, that Wacker all but got off. De la Faille, who repeatedly gave conflicting testimony in the trial, prepared a new edition of his catalogue raisonné in which all of the presumed "Wackers" were expunged.

But a few other art historians swore to the authenticity of five of the "Wacker" thirty-three, and a controversy still bubbles about the authenticity of these few.

The early years of the twentieth century also saw a love affair with the works of Leonardo da Vinci (1452–1519). It seems to have been fueled by several luxurious publications of his work, Sigmund Freud's somewhat bizarre essays about the artist, and the theft of the Mona Lisa from the Louvre in 1911.

There are legions of "true" stories about the theft. The most persistent one holds that when the picture was in hiding in Florence, it was copied by talented fakers and that one of the copies was returned to the Louvre. However, the body of data that proves the Mona Lisa hanging in the Louvre is the genuine article would fill volumes. Another story states that the painting was stolen so that these clever fakers in Florence could make, say, a half dozen copies which would be hawked around the world, especially in America, to collectors willing to sign an agreement never to tell anyone that they had the original.

Every year it seems that another one of these "real" "Mona Lisas" comes to the surface loudly heralded by the press. Many of these paintings have cleverly faked documents that place them in the early sixteenth cen-

tury. Some seem to offer evidence that the paint and the wooden panel are ancient. And some possess internal "proof" of authenticity in the form of fingerprints on the paint surfaces of such nature and placement that they could only be Leonardo's. The only flaw with this "proof" is that no known Leonardo carries the sign of any of the master's fingerprints and even if any did, how would one be sure that they aren't an assistant's or some restorer's?

Along with the phony "Mona Lisas," there are at least four oil paintings —some on canvas, some on panel—depicting a fragment of Leonardo's renowned unfinished wall painting in the Palazzo della Vecchio in Florence of the Battle of Anghiari, which was covered over and presumably destroyed in the sixteenth century. There are also sundry drawings and one sculpture in wax of a horse said to be studies for the *Battle of Anghiari*. All have only the most tenuous similarity to Leonardo. There are but two known Leonardos in America: a drawing in silver point of a bear in the Lehman Collection at the Metropolitan and the spectacular portrait on panel of the young woman Ginevra dei Benci in Washington's National Gallery of Art.

◆ ◆ ◆

Every year since the 1920s has set more records of fakery than whole decades of past centuries. The 1950s was an especially hot decade for art fakes, including some highly inventive ones. The best of the decade was an entire fresco cycle of the thirteenth century in one of Germany's most venerable churches, the Marienkirche in Lübeck, on the edge of the former Communist zone. During restoration work in preparation for the seven-hundredth anniversary of the shrine, conservators uncovered beneath centuries of grime a cycle of rare and dramatic medieval wall paintings. It was almost as if near the heart of communism and atheism, the presence of the Almighty was making itself manifest. Because of that, the event gained world press. The cycle was admired by art lover and collector Chancellor Konrad Adenauer.

Within several months it was discovered that a faker, Lothar Malskat, had created the pieces as a pious fraud with the connivance of the chapel's conservator Dietrich Fey. The frescoes were unmasked by other conservators who saw that the technique of painting was ridiculously inconsistent with medieval examples. Why it took even months to expose them is odd, since a number of art historians specializing in the field of early medieval art and several restorers of frescoes had complained vociferously when Fey had been picked for the ticklish restoration task, claiming that in other jobs he had repainted extensively.

*"Der Alte"* Adenauer was something of a fraud himself when it came

to the fine arts. Count Hans Heinrich Heine von Thyssen-Bornemisza, a flamboyant collector whose father had initiated the family collection of old masters formerly on view in the family seat, the Villa Favorita in Lugano, Switzerland, and now rented to the Spanish government, recounts how the chancellor paid a visit in the 1960s to his mother to give her a high award.

The chancellor was given a grand tour of the great array of old masters by the ninety-year-old countess. He kept returning to one gallery to admire a diminutive painting on wood of a strikingly beautiful image of the Virgin hovering inside a ring of rosary beads. It had been painted by Geertgen Tot Sint Jans, a great Flemish master of the generation after Rogier van der Weyden (ca. 1399–1464.)

The countess, a member of the old school when it came to politesse, had the masterwork taken from the wall and presented it to the chancellor. "Heine" Thyssen was startled and angered at his mother's gesture, but said nothing.

Some months later, a dealer who had found special treasures for Thyssen in the past called to say that he had just acquired a small work that was perfect for the collection. It was, of course, the Geertgen and a bargain, at just under half a million dollars. "Heine" Thyssen bought it and put it back on the wall where it had once been. When his mother saw it in its old spot, she said nothing.

Thyssen used all his wiles to get the chancellor back to the villa so he could observe his reaction on seeing *Virgin of the Rosary* back in place. Finally, *"Der Alte"* returned. During the tour, he stopped dutifully before the Geertgen and admired it. Just before getting into his limousine, the chancellor pulled "Heine" Thyssen aside and asked the young count if he minded telling him what he had paid. As Thyssen tells it, Adenauer was prudently checking up on whether or not he had been taken by his dealer.

Fakes follow the fashion of the marketplace: They emerge after notable finds in newsworthy excavations; they slip in behind lavish publications; they track the notoriety of artists, even movies based on artists' lives; and they align themselves with major artistic or historical celebrations. The United States bicentennial spawned a welter of bogus Americana. Phony paintings by Gilbert Stuart (1755–1828) and Colonel John Trumbull (1765–1843) sprouted up everywhere, as did silver supposedly by Paul Revere and other noted early-American silversmiths.

Revere silver seems to have been faked starting days after his death in 1818. The Revere expert Clarence Brigham wrote in 1969 that he had met an antiques dealer in Worcester, Massachusetts, who prided himself on his

ability to buff out a silversmith's mark and substitute it with the mark of "P. Revere." This manipulator had a collection of over twenty silversmith's dies, which he would press into any piece for twenty-five dollars a shot. He worked on consignment, supplying several of the better-known Boston antiques dealers. He got rid of his spurious dies when one of the dealers was indicted for fraud, but he was never caught.

In the 1980s mischievous dental students in Genoa "seeded" the Arno with crude stone carvings of abstract heads which attempted to re-create some early works the sculptor Amedeo Modigliani (1884–1920) had said he'd thrown into the river because they displeased him. These truly wretched hunks of stone hewn deliberately into the most unsightly human faces were "discovered" by an art critic who was in on the practical joke. When they were shown on national television several respected scholars praised the "stupendous discovery." That's when the students who had carved them were introduced on the air and proceeded to carve, howling with laughter the whole time, a number of similar "Modiglianis."

In the 1970s an art dealer working for John and Yoko Ono Lennon "invented" an Egyptian tomb hidden under camouflage tents out in the desert so that he could peddle dozens of second-rate Egyptian antiquities to the wealthy and gullible couple.

When the Lennons insisted on traveling all the way to Egypt with the dealer to see "their" tomb, he saved himself by having the Lennons' tarot-card reader telephone them in their Cairo hotel and tell them there was a dangerous man in Egypt who would track down the tomb and cause terrible trouble and they should return to New York at once, which they did, after only a day in Egypt. That man happened to be me, who knew nothing of the plot. Needless to say, the tarot-card reader was in on the scam. Thankfully, the Lennons didn't buy any of the supposed Egyptian treasures.

The seventies was also when a daring faker who had created an ancient linen scarf with a gold-beaded border and a faded dark spot directly in the middle made a deal with the fortune teller of the minister of culture of France, André Malraux, to convince the minister that the linen was that in which Alexander the Great had coughed his final breath. The plan worked. Malraux sought desperately to purchase the fabric for the Louvre—the price was said to be in the millions of dollars—but, unaccountably, the man offering the scarf for the faker disappeared with it. Chances are that the Alexander linen will turn up again.

Of all the thousands of art forgery conspiracies launched in the twentieth century, the most entertaining has got to be the "Etruscan" warriors at

the Metropolitan Museum of Art, because of the downright ridiculous nature of the fakes and the absolutely stupid actions on the part of those who purchased the bogus goods. The story has been told numerous times, but best of all by Lawrence Jeppson in his book on art fakes published in 1971.

The story starts in Orvieto, Italy, in the last couple of decades of the nineteenth century with a small factory that restored old fragments of fifteenth-and sixteenth-century pottery called *majolica*, found in old wells in the medieval hill town. An unscrupulous dealer by the name of Domenico Fuschini hired two technicians from the factory, the brothers Pio and Alfonso Riccardi, to carry out the process of cobbling up the ceramics, and they soon established a workshop in Rome that eventually made tens of thousands of overly restored Orvieto majolicas for sale at modest prices. The world is littered with them. Not a month passes in the life of a dealer in decorative arts or a museum curator when a collector or a lawyer for some estate doesn't present for appraisal or sale one of these Orvieto monstrosities.

Pio Riccardi had four sons; Alfonso had two. In their early teens, one of Pio's sons, Riccardo, and both of Alfonso's, Teodoro and Virgilio, became able paster-uppers and filler-inners of the Orvieto material. At age twelve Riccardo became friendly with Alfredo Fioravanti, who was hoping to become a tailor but proved that his hands were more gifted at ceramics—both the made-up Orvieto majolicas and "new" ancient pieces as well. The boys formed a team at a startlingly young age and with the help of a crooked Roman dealer named Pietro Stettiner began to plot how to create the most dramatic, expensive, truly singular ancient forgeries since the golden days of the Roman Empire in the first century A.D.

They knew from the elder Riccardis that in 1871 the British Museum had bought a huge terra-cotta Etruscan sarcophagus in the form of a banquet couch, decorated with low reliefs and on the top, a life-size loving couple wining and dining into eternity. These revelers had curious proportions, wraithlike with knobby limbs. When it surfaced on the art market, this sarcophagus had caused a sensation. Scholars were convinced that it was an example of an as-yet-undiscovered ancient Etruscan workshop. So the boys cannily decided, while the flower was still in bloom, to fashion a standing "Etruscan" warrior to look as if it had been produced in that same fourth-century-B.C. studio. His proportions were to be anorexic and knobby like the revelers on the sarcophagus. The sarcophagus was a fake.

The work started just before the First World War. The boys' technique of manufacture was virtually dysfunctional—they had no idea how an ancient Etruscan terra-cotta figure might have been made and didn't even

bother to check out the rudiments at any of the museums where some fairly large, genuine figures were on display. Instead of beating the clay until it was delicate enough to be rolled up in a single ball, which would have been the technique in antiquity, they made up several heavy slabs of clay about three inches thick and lumped them together haphazardly. Their clay was three to four times thicker than that of any real monumental Etruscan statue.

That "old" warrior, a sort of proto-Giacometti, was intended to be striding, carrying a shield in one hand, and some sort of weapon, never supplied, in the other. His legs were chunks of clay from the feet to the knees, and from there up, huge rolls of clay. The elongated proportions were bizarre and exceptionally ugly. When it came to fashioning a shield, nothing worked because of the weight of the clay, so the boys simply discarded one arm and thereby committed one blunder usually avoided by the better sculpture forgers: making an incomplete object from the beginning. This travesty would soon be offered to the Metropolitan by a special agent and bought for an astronomical price.

From the turn of the twentieth century until the early forties it was not uncommon for certain of the most distinguished art museums that collected Italian old masters and particularly ancient sculptures to retain their own art agents stationed abroad. These individuals were a mixed lot. Some were honest—real *marchands-amateurs*. Others were independently wealthy and boasted of yachts, villas, stately homes in England. Many, despite little or no formal training, were confident they knew much more than drudge scholars who, unlike them, were not blessed with a natural "eye" which they treasured beyond any other capability. Their "eye," that ineffable sense of connoisseurship, would enable them to see true beauty, true ancientness, and true deals. Because of this myopic and arrogant attitude, they were often gulled by fakers and con men and consequently passed along to their institutions costly and embarrassing phonies.

There were also those who were crooked and masked their crookedness brilliantly. We believe today that the crooked agents were greater in numbers than anyone ever suspected.

Of the *marchands-amateurs*, Edward Perry Warren and his colleague John Marshall worked for the Museum of Fine Arts, Boston. Harold Woodbury Parsons acted as agent for the Nelson-Atkins Museum in Kansas City and the Cleveland Museum, somehow handling his affairs so as to avoid conflict of interest. Wolfgang Helbig, a sometime member of the prestigious German Institute in Rome, advised and bought for Boston but primarily he acted on behalf of that splendid repository for antiquities in Copenhagen

founded by Carlsberg beer owner Carl Jacobsen, the Ny Carlsberg Glypto-thek.

Helbig was an astonishingly clever secret forger, a crooked archaeolo-gist, and a brilliant flimflam man. Marshall is suspected of shenanigans, though unproved, because of his tendency to be involved in obvious fakes. Only Harold Parsons seems to have been pure and tried to unmask forgers and inform the institutions that bought their works that they had been had. Typical of whistle-blowers, Parsons was often spurned and condemned, including by the Met when he blew his whistle at several "Etruscan" terra-cottas.

These were, of course, the phonies produced by the boys Riccardo Riccardi and Alfredo Fioravanti. It was John Marshall who became the "mark" for the "old warrior." Pietro Stettiner, that crooked dealer who early on approached them, presented the knobby Etruscan to Marshall and he instantly dashed off a letter to Gisela Richter, the curator of Greek and Roman art at the Metropolitan, a renowned author of scholarly books on early Greek art.

The letter was dated November 15, 1915, a day still within the age of innocence. It proclaimed, "One thing I have arranged for, if permission for it can be obtained. It will make you groan to hear of it: the biggest T.C. [terra-cotta] you or any reasonable human being ever saw. Milani's 'Atlante' Tav. XXX will give you an idea of it, but you must multiply the height by 7 (seven!)."

Milani was the author of a book on Etruscan art and *Tav.*, or plate, was an illustration of a diminutive figure something like the anorexic warrior but one-seventh as small. Which should have been the tip-off. One standard rule when it comes to fakes of antiquities, forgers almost always expand, never diminish. Where's the money in transforming something large into something small? But Richter believed in the sham.

Naturally, governmental permission to export the piece never proved to be a problem. The warrior was simply smuggled out of Italy and arrived in New York ten weeks after Marshall's breathless letter, at which time the boys embarked upon the second of what would eventually be four Etruscan capers.

The second fake was a helmeted head of a warrior almost three feet tall. The boys had apparently gotten the idea from a reference by the ancient historian Pliny to a pair of legendary terra-cotta sculptures fully twenty-five feet tall depicting Jupiter and Hercules, made by the Etruscan sculptor Vulca for the temple on the Capitoline. The model for this Hollywood extrava-

ganza was mouse-size, a two-inch vase in the shape of a helmeted soldier—
a type called an *aryballos*—on display in the Orvieto museum. This huge
head, was also sold through Pietro Stettiner—in fragments, 178 pieces of
pure fantasy, shipped to New York in July of 1916 during the time German
submarines were stalking the American coastline.

One supposes that John Marshall thought the treasure was safer on the
high seas than in Rome if a devastating land war broke out. Or, maybe it
was that he simply didn't care, knowing that it could not possibly be real.

Curator Gisela Richter certainly believed it was ancient. She was even
more ecstatic about the giant head than she had been about the old warrior
and wrote Marshall, "The broken edges at the bottom of the neck and of
the crest indicate that the head formed part of a colossal statue of a warrior."
She calculated that the original figure, if standing rather than sitting, would
have been twenty-three feet tall. She observed, "No wonder that centuries
later there were still stories current of Etruscan sculptures which had ex-
panded to a huge size in the kiln." She cited the same awesome work
mentioned by Pliny which he claimed measured some fifty feet from the toes
to the top. Neither this nor any other giant Etruscan statue or fragment has
ever been found.

Marshall, who took pride in being an "addict of Etruscan art," was an
ace when it came to identifying and analyzing their materials, and he fasci-
nated friends with his swift ability to date Etruscan works. He talked often
about how he had visited more than once every museum in Italy and else-
where that possessed Etruscan works of art. Tens of thousands of objects
which had been dug up since the middle of the nineteenth century were on
view in Rome and throughout Tuscany. It's inconceivable that he didn't
suspect what was going on. The figures cost in today's equivalents millions
of dollars, and his commission was hefty.

Richter was at the height of her scholarly career and knew every im-
portant Etruscan piece in Italy. One presumes that she was taken in by the
suave John Marshall and then allowed curatorial greed to take over. Pride
no doubt had something to do with her eagerness to acquire these largest-
ever-discovered Etruscan sculptures. Gisela Richter did act properly and
professionally, it must be said, and before asking the Met's trustees for the
money, had the pieces studied by a number of technical experts.

One was a clay specialist by the name of Charles Binns. He calculated
that both the old warrior and the stupendous fragmentary head had been
fired in one piece at a temperature of nine hundred and sixty degrees centi-
grade and that the difference in temperatures between the top and the

bottom of the huge, primitive Etruscan kiln had been an astonishingly small twenty degrees. That indicated that those Etruscans were incredibly sophisticated. The firing, Binns postulated, had to have been maintained at a continuously diminishing heat for a matter of months, not days, so that the clay mass could cool gradually in order not to rupture in a thousand places.

Why Binns didn't ever ask himself the question: Instead of two enormous kilns—one something like twelve feet tall for the old warrior and the other thirty feet tall for the twenty-three-foot figure that must have accompanied the head—why not one six-foot kiln in which a bunch of clay shards had been fired? After all, his findings proved that both terra-cottas had been fired and then assembled, which alone suggested they might be fake.

After the successes of the first two Etruscans, Alfredo Fioravanti produced a beautiful full-length standing young woman called a *kore* in the same technique, making her full-size in clay, breaking her up for the firing, and ultimately mutilating her to re-create the passage of centuries. This statue was hawked through Pietro Stettiner to Wolfgang Helbig who passed it off to the Ny Carlsberg Glyptothek.

To make successful forgeries, not only must the technique be convincing with all the marks of age settling in as perfectly logical but there must also be a provenance that makes sense, at least to the victim of the scam. For all these Etruscan terra-cottas suddenly to appear—good pieces of Etruscan art don't show up all that often, perhaps every thirty-five years or so—there had to be a find spot that sounded plausible, seemed specific, but could be kept vague and all but inaccessible.

Five miles from the boys' hometown of Orvieto there's a hamlet supposedly called Boccaporco (literally "foul-mouth"), which cannot be found on any map. The boys spread the word that farmers there had uncovered the remains of a vast Etruscan temple site in which the two statues bought by the Met were found along with the *kore* and a host of Attic vases dating to 500 B.C. The solid terra-cotta pedestal for the "old warrior" even existed in situ, they said. But there were problems visiting the secret site, dealer Stettiner told John Marshall. The village was well off the track in rugged countryside, and the farmers had, unfortunately, covered over the site and planted wheat. As John Marshall wrote Gisela Richter in 1916: "Nothing can be done until the harvest here is over, but I expect news of some sort when I go back to Italy." The news never came.

There was one egregious error in the provenance story and it is a

wonder why Gisela Richter didn't spot it. Much was made of the pedestal for the "old warrior," but a pedestal would have been inconceivable in ancient Etruscan times. These statues were not made to be displayed for aesthetic purposes as if for a room in a collector's mansion or the gallery of a museum. They were invariably attached physically to architecture and served as decorations on the roof or in tympana. Once again Richter's fine sense of scholarly observation had been dulled by her greed.

The boys were drafted at the start of the First World War, inducted into the same regiment of the Italian army. There they wiled away the time plotting their next phony, which they wanted to be the most dramatic of all time: a terra-cotta image of Mars fighting with his right hand holding a javelin which he is about to throw, just over life-size. Once again the model was a small figure about five inches tall, a bronze Mars found near Dodona and on display in the Berlin Museum. The piece had been published extensively.

Within months after the armistice the brothers Riccardi and Alfredo Fioravanti started work. They rented a house in Orvieto, set up a studio large enough to contain a kiln to fire the Mars in pieces, and began working the clay. This fighter was constructed just like the "old warrior" with solid clay lower legs, and upper legs and torso made out of rolls. Yet this one was furnished with many more strengthening devices. It was also subjected to the copious smearing of the insides of its rolls with clay and furnished with thick buttressing for the head and at the crotch.

The arms were made separately and reinforced with metal rods which were removed when the clay hardened. The torso was fashioned with a cone-shaped hollow where the head would later be attached and the head was made with an oval neck to fit. At the top of the figure a large peg, inserted in the clay and molded into a lump, was later removed, leaving a hole. Gisela Richter later on mistook this aperture as a vent left by the Etruscans to allow excess heat to escape in the firing of the whole figure.

One of the features about the "Etruscan" Mars that initially bothered Richter and many others was that the proportions of the statue were bizarre. From the feet to the waist everything was "Etruscan," but from the waist to the shoulders the anatomy seemed stunted and squashed.

Richter would eventually explain away Mars's curious physique as another stylistic aberration of the particular school of Etruscan artists who had crafted the sculpture. The real reason was that the room in the humble dwelling used by the boys had too low a ceiling for a figure of the tall and elegant proportions of the Dodona bronze they had used as a model.

The Etruscan Mars has a striking black glaze, something similar to that on Attic vases of the sixth century. But of course it is not the true shiny, impenetrable, ancient glaze, but a manganese dioxide containing various traces of properties that were unknown in the sixth century B.C. The boys didn't care. By this time they knew that museum curators and directors preferred image to substance and seemed to disregard technical matters.

They painted the glaze and various colors of the body armor and skirt, or kilt, which stopped just above Mars's genitals. They waited for days as the clay of the hefty figure dried out and developed cracks. When it was dry enough they threw it to the ground and put the random pieces into a small kiln. This time they made sure that the plinth of the statue bore the marks of sand, for by this time they had learned that an ancient kiln would have had a sand floor. This tiny, canny detail probably made it possible for the forgery to succeed, for the defenders of the Mars went back time and again to the argument that no modern forger would have known about the sand floors in ancient kilns.

Fired piece by piece the process took two nights and a day. There were some anxious moments. The boys feared that there might be excessive shrinkage. If so, then they were lost, since the hardened fragments had to be glued back together perfectly to work. But it couldn't have turned out better; there was almost no shrinkage.

Then came the single most important moment in all art fakery, the setting up of the "sucker." One story goes that Alfredo Fioravanti and his sidekicks followed John Marshall and found out which of the Rome restaurants he frequented. Several times they stationed themselves at tables close to his and started whispering about an astounding discovery of theirs in an illegal excavation. They were said to whisper about the hundreds of pieces of an ancient clay statue of Mars.

In time Marshall is supposed to have become conscious of their private conversation, but every time he tried to approach the conspirators they looked at him anxiously and fled. Finally, it is said, he got close enough to ask what they'd found and they took him to a farmhouse near Orvieto and showed him the hundreds of fired pieces laid out in the sun.

Marshall, according to the tale, personally smuggled the fragments out in suitcases, making half a dozen trips over the border before they were all in Switzerland.

Another story relates that it was not John Marshall but Gisela Richter who was followed by the boys when she was working at the American Academy in Rome on the Janiculum. Richter, according to this version, was

shown the fragments by Fioravanti and acted as the smuggler herself, risking her academic reputation by carrying suitcase after suitcase full of bogus fragments.

The second version is most surely phony, since Richter said she never met Fioravanti and she would never have taken the risk of smuggling an ancient work herself. That's why one retained experts abroad. Besides, had she seen the fragments of terra-cotta strewn out on the ground, she would undoubtedly have grown suspicious.

More likely Marshall was a part of the confidence game and helped set it up, for three reasons.

First, the dealer Pietro Stettiner, who handled the Mars, further whetted Marshall's appetite by telling an unnamed official at the American Academy that a large head of an Etruscan figure had been found, was part of a treasure that included the large figure, and was for sale. That official then told Marshall. When Marshall visited Stettiner to learn what was going on, he was shown a foot-high bronze warrior that possessed some of the more telling stylistic characteristics of the fake Mars and which Stettiner used to prove the authenticity of the large piece.

Yet this bronze, a pastiche of old and new elements, was itself a fake. The upper part was a fragmentary, reworked female statue—authentic, but wrecked—and the lower part was a male. The piece had been elongated falsely with a bronze midsection inserted and attached with a copper rivet, a detail of construction that the Etruscans did not know. The head had been extensively etched and rechased and the bare shins recut to look like armor. Other add-ons included a new bronze crest and cheek pieces for the helmet and, finally, a modern beard. The mess had been blanketed by a thick patina of plaster, paint, and wax. It is inconceivable that an experienced Etruscologist like John Marshall would ever have been fooled by such a ridiculous paste-up.

Second, Marshall kept insisting that Richter not publish the first two Etruscan acquisitions until he had pinned down the Mars and even after the transaction had been completed not to publish any of them for some years to avoid the wrath of the Italian authorities in charge of the national artistic patrimony.

Third, Marshall knew that the British Museum's Etruscan sarcophagus was fake. It had been the one that Fioravanti used as a model in part for his "old, skinny warrior."

In August of 1919 Marshall cabled the director of the Metropolitan that he had finally seen the new find, "Mars fighting, 260–270 centimeters

high. Wonderful preservation. Same artist as big head. Most important thing ever offered us. Cannot get photograph. Price asked quite fantastic."

Since the Metropolitan never divulges prices, that price is not known. Rumor states that it was a hundred and fifty thousand dollars or something like five million in today's purchasing power. Stettiner rebuffed Marshall's attempts to bargain by telling him that the Mars was sought-after by another institution. Frantic that this "great prize" might elude him, Marshall remained in Rome for over a year after Christmas of 1919. It was only after he left, in early February of 1921, that he took possession of the figure and the Metropolitan purchased it at the end of the month. The boys were ecstatic. While Stettiner had paid them only a few hundred dollars for the "old warrior" and the colossal head, they received a bountiful forty thousand dollars for the Mars.

Fioravanti and his colleagues then embarked upon their fourth Etruscan forgery, this time a huge terra-cotta relief six and a half feet high by twenty feet long on which twenty figures were depicted in mortal combat. This ambitious piece, offered to Marshall, who never moved on the proposal, has never turned up and one wonders if it was destroyed or still lies quietly in some Italian storeroom awaiting the beginning of the next scam. The chances are that it will turn up eventually, but it is doubtful that this time anyone will be fooled.

Once the Mars arrived in New York, the clay expert Binns again examined it and pronounced it good. Richter refrained from publishing the treasures, still hoping that Marshall might be able to find other grandiose objects from the same dig at "Boccaporco." It was only in early 1933 that the three pieces were published in the Met's monthly *Bulletin*.

The reaction from the fakebusters was immediate. Piero Tozzi, a jolly, roly-poly art dealer of Italian decorative arts in New York, and a highly decorated hero of the First World War, immediately sent a note to Gisela Richter about the acquisitions, stating flatly that the statues were modern and had been created by the "Fioravanti-Riccardi brothers." Although Richter seems to have spurned Tozzi—he was an eccentric, a nonstop talker, and rather bothersome—she did track down Fioravanti through Marshall's former secretary in Rome and was told that he was a tailor and part-time chauffeur for an art dealer. Never a forger of antiquities! With that her momentary concerns subsided.

She published the Etruscans again in a major book in 1937, fully twenty years after she had wanted to. Marshall's warnings to her about publishing too soon—before the heat had subsided on the question of how these great

masterpieces had left Italy—had proven to be most effective. The publica-
tion was received with accolades as is so often the case when an especially
bombastic series of fakes are hoisted into the scene. Precisely the same
thing happened when the Getty kouros, today's equivalent to the Etruscan
warriors, made front pages in the 1980s (see Chapter 18).

The few fakebusters who made negative remarks about the Met's Etrus-
can treasure were quickly attacked by other scholars. One fakebuster, Enrico
Paribeni, an Italian who would become the world's most eminent Etruscolo-
gist, remarked shortly after the war upon seeing a photograph of the Mars
that it could not be authentic. His reason was simple: To exhibit the statue,
the Met had to support the heavy terra-cotta by a large metal rod from the
floor to the middle of his crotch. Since sculptures like the Mars always
decorated the roofs of temples, if this one could not stand up on its own,
how could it be real? Paribeni's trenchant statement was not commented
upon by the Metropolitan.

The reason why the Etruscans at the Met were accepted as real for so
long in scholarly circles had less to do with the inherent genius of Alfredo
Fioravanti and the Riccardis than with the coming of the Second World
War, which made it impossible for Italian experts to study the pieces.

As soon as the Italians could get to New York, the criticism intensified.
Fakebuster supreme Giuseppe "Pico" Cellini remarked that all three had
nothing to do with either the spirit or soul of Etruscan art; the warriors
seemed to him as "stiff and proper as tin soldiers." More damning, it was
reported he said that the clay of the Mars looked bizarre and would be found
to contain ground glass from Italian beer bottles. He was criticized as being
flip and ignorant. What Cellini actually did say was not that the clay con-
tained Peroni beer-bottle glass, but that since it was as thick as a beer bottle,
it could not be ancient. He was, of course, dead right. But the Met's officials
stuck to their guns.

In 1959 the curator of Greek and Roman art Dietrich von Bothmer, a
specialist in Greek vases, took Etruscan specialist M. Cagiano de Azevedo
on a tour of the collections and suggested that the scholar might want to
look at the Etruscans. Azevedo shrugged and said no, adding, Why bother?
I know the man who made them. When pressured, Azevedo did examine
them and scoffed that the cracks in the black glaze had been made by drying
standard varnish in some special way. The Met found no standard varnish
and felt vindicated.

The Italian's remarks, however, energized the museum into making a

more thoughtful assessment of their unique treasures. The then-director of the Met, James J. Rorimer, instructed Bothmer to get to work.

About the same time, *marchand-amateur* Harold Woodbury Parsons launched his investigation of the pieces in Rome and began to dredge up rumor after rumor, all of which were, as it would turn out, completely accurate. He was wrong in only one thing: Parsons thought that his friend John Marshall had been "terribly wronged" by the fakers who, he believed, in bedeviling him, had contributed to Marshall's early demise from a heart attack. Parsons tried to let Rorimer know what he had learned, but Rorimer, who hated Parsons, ignored him.

One of the Met's staff who contributed greatly to the unmasking of the Etruscans was the operating administrator Joseph V. Noble, who had been experimenting with his own kilns at home, trying to reproduce the ancient Greek techniques of creating those hard glazes on the wonderful red-and black-figured vases. Noble actually managed to make effective, though crude, vases with the ancient Greek glazes. He also made a stunning breakthrough in figuring out how the ancient Athenians had combined red and black glazes on the same vase.

Noble took a sample of the black glazes on the three Etruscan pieces to a commercial lab where specialists found that the substances contained the manganese dioxide that Fioravanti and Riccardi had painted on the figures. This substance was not known in Etruscan times.

Following that discovery, Noble and curator Bothmer did what Richter and her colleagues should have done in the beginning—they studied every Etruscan terra-cotta and learned the basics of how they were made. The most basic of the basics was that in every undoubted Etruscan terra-cotta statue of any size, there were, and had to be, a number of large holes in the finished piece, holes that allowed sufficient air to get in during firing and drying. The Met's pieces had only one hole each, not for drying but for the fitting-together of the various fragments.

Faced with the second basic—that all three pieces of New York's Etrus-cans had to have been sculpted, then broken, then placed in a kiln—still the Met hung on to its hopes that, somehow, some new evidence would turn up that would clear away all doubts. It was like a scholarly Watergate. For by this time, virtually all Etruscologists openly laughed at the idea that these "ludicrous, stupid, disgraceful abominations," as "Pico" Cellini called them, could have a shred of ancient reality in them.

I learned at the time from Rorimer that the Met was planning to

stonewall, because in 1960 I was acting as his special assistant and he often discussed the troubling issue of the Etruscans with me. He was, however, forced to act when Harold Parsons wrote a letter to *The New York Times* in December 1960 stating exactly why all the Met's Etruscans had to be fake. Parsons claimed he'd seen the missing thumb of the "old warrior" in the home of one of the forgers in Rome who had made the pieces. The *Times* alerted Rorimer and the letter's publication was put on hold.

On January 5, 1961, Parsons brought old Alfredo Fioravanti to the office of the American Consul in Rome and the forger made and signed a confession. When this news got to Rorimer, in a panic he dispatched Bothmer to Rome and there he met Fioravanti. Bothmer had brought from the Met a cast of the hand of the "old warrior" from which the thumb had always been missing. In a flash the forger fitted his thumb neatly to it.

But even then Bothmer tried to stave off certain defeat. He tried to argue that the thumb alone didn't prove that the statue wasn't ancient. It could have been found, he tried to reason, at the authentic site at "Bocca-porco" by someone and given to Fioravanti. All defenses collapsed when Fioravanti sat the curator down and told him details about how all three sculptures had been manufactured, details that could not possibly be explained away. As is so common with art fakers, nobody was charged with a crime and Fioravanti was not asked to give the museum back any part of his proceeds in the venture.

So on Valentine's Day of 1961, the world learned that the three Etruscans, so admired for so long, published hundreds of times, taught in schools as exemplars of the spirited and bellicose Etruscan civilization, were really prime examples of modern Italian sculpture of the 1910s and 1920s.

Recently a public relations official, Tanya Moone, stated, "The warriors are accessible to no one, not even scholars."

# MY EARLY EXPERIENCES

*T*o become a fakebuster, total saturation is vital. Even more vital, though rarely possible, is to meet a top-flight forger and learn some of the secrets of the trade. At a young age I had the good fortune to encounter a master forger and, in exchange for my keeping quiet about his "business," I was shown his startling inventory of fakes, much of which is still alive and healthy today, and for the most part completely undetected.

It was the summer of 1951 and I was an undergraduate at Princeton University majoring in art history. I had been offered a summer job in interior decorating by my father, Walter, who had gained the controlling ownership stake of Bonwit Teller's in the late 1940s and was struggling successfully to make Bonwit's the most elegant and fashionable woman's clothing store in America.

He'd opened a branch in Boston and with the aid of his old friend and interior designer William Pahlman, had decorated the store with a combination of eighteenth-century French antiques and contemporary furniture. The establishment had created a sensation in the field of interior design and in retailing. Sales had soared. Wanting to capitalize on that success, my father decided to establish a similar Bonwit's in downtown Cleveland in a shabby Victorian building. I was to be the manager of the New York warehousing operation, making sure that the hundreds of antiques were repaired, stored, and shipped on time to Cleveland for the installation. I began the

moment I got out of Princeton in the spring and worked until the grand opening just after Labor Day.

The work was lonely and exceptionally boring. I found myself sequestered in a vast, dark chamber in Cirker's Gramercy Warehouse in Midtown Manhattan on the far East Side rummaging through stacks of furniture and paintings, entering them all into inventory books. I had to make record drawings and write a brief description of each chair, table, sofa, sconce, and chandelier that Pahlman and his troops had purchased in antique shops on First and Second Avenues that catered only "to the trade," places like Sheba Taylor. You could buy anything, from Italian sixteenth-century chairs to seventeenth-century choir stalls to eighteenth-century desks to nineteenth-century beds in seemingly inexhaustible quantities, at high levels of quality and at delightfully low prices. I remember a series of twelve mid-eighteenth-century gilded French chairs, beaten up a bit but all authentic—going at wholesale for two hundred dollars apiece.

Stuck in the gloomy confines of a warehouse five days a week, most of the time so far ahead of my cataloguing that I just sat there, unable to read because of the lack of light, not really wanting to because of the general torpor of the situation, I was tempted many times to call Pahlman and quit. Until I met Frank X. Kelly.

Kelly was a paintings restorer. He was a tall, stooped man in his midfifties with an exceedingly pale face and a constant cough who smoked all the time and played the horses avidly. He had a ramshackle studio on "art row" —57th Street between Lexington and Third. As the day approached when the restored and reupholstered furniture and the paintings had to be shipped out to the store in Cleveland, I visited Kelly more and more frequently to see how he was doing on the pictures. They were pleasant still lifes, landscapes, a portrait or two—dozens of eighteenth- and early-nineteenth-century paintings which today would cost in the ten-thousand-dollar range but back then when art was used legitimately and frankly as pure decoration cost only a couple of hundred apiece.

The condition of these decorative paintings was wretched. They'd been hammered, stabbed, and poniarded. A few had obviously been used as dartboards. Most had been repainted, slathered with copious coats of varnish the color of brown gravy, cut, cropped, relined, and dismembered. The frames in many cases were more attractive than the works. But in almost every instance there was something beneath the mucking around, something that the gifted fingers of Frank X. Kelly could resurrect.

Pahlman was more attracted by the shape of paintings, especially the

upright oval, than the subject matter. He was a genius when it came to shapes, especially of interior spaces. He had an uncanny ability to scan a blueprint and virtually convert the drawing into three dimensions in his mind and tell us where he wanted to place every sconce, sideboard, wicker couch, and painting. He seldom made notes and only occasionally made sketches, but the ensemble always worked out just the way he had envisioned it.

The decorator's instructions to Kelly were, "Make these daubs come to life." Kelly faithfully restored those paintings that were in better condition and used the shadowy remains of the more damaged pictures to invent artistic nostalgia pieces "of the period." Those were the ones, he told me, that he adored. His working hours were erratic. He never entered the grubby studio, which was on the fourth floor and reached by a creaking elevator that was broken down a great deal of the time, before eleven in the morning. He was in and out all day, shambling to the corner newsstand, which was in fact a secret bookie parlor, to place a bet on some race at Bowie or Hialeah or Gulfstream. One table in the disheveled studio was clean, perfectly organized, this was where the *Racing Form*, the *Mirror*, and the *Daily News* were carefully arranged, open to the race sheets and the predictions of various racing columnists.

I was entranced by the odd combination of true talent, for he was a startlingly adept craftsman and painter, and the raffish horse bettor. He was a born enthusiast, was obsessed with baseball as I was, and above all, was a natural teacher and storyteller. Once I had worked my way into his confidence, he opened up his heart and his storybook to me and we made a team.

The teachings of Frank X. Kelly ranged from the track, which slowed down to a trickle when he saw how bored I was, to the foibles of the players on the three local baseball teams, to painting, art history, art philosophy, and the art market. He was acidulous about the latter, believing that every art dealer was a thief. "Ever notice that the paintings you guys buy that're in the worst condition come with the best frames and those that look decent have frames in a mess?" He demonstrated how the inexpensive damaged works had been cut or enlarged to fit into the good and costly frames and the more expensive pictures in better condition had been stuck in badly preserved frames. It was what Frank called the "balance of the marketplace."

In the final month before the big series of shipments to Cleveland, I would drop in at Frank's every day, including weekends, and check up on how many pictures were ready to go back to our warehouse. The door to the studio was never locked, despite a quantity of exceptional pictures Frank was

working on for other clients, and half the time he'd be around the corner placing a bet.

One late afternoon I entered, and seeing no Frank, went through the Pahlman work, making notes on what could be picked up the next day. I waited to say hello, but Frank didn't return for almost an hour. Having nothing better to do, I started to go through the many bins in the three-room shop where dozens of paintings for his other clients of all sizes were stored.

My first revelation was that some of his clients were art big-timers. I spotted some spectacular American paintings of the nineteenth century: Thomas Cole, Thomas Eakins, several Grant Woods, and a Charles Willson Peale. Each painting had a sheet attached to the back describing it and the hours Frank had worked on it, noted by the day, the name of the owner, and a bibliography. But I already knew pretty much what I was looking at. At the time, I was between my sophomore and junior years at Princeton, and having been inspired by a professor of medieval art because of his fascinating lectures, had decided to dedicate my life to art, either as an art historian, an architect, or a painter. I was waiting for the muses to tell me which activity to pursue.

My second revelation, or shock, came about half an hour into my brash investigation of the full contents of Frank Kelly's studio. I encountered a series of painting bins that spread along a twelve-foot wall on two tiers in the back room where Frank kept his paints and brushes, the room that had the best natural light coming in from a large, tar-specked window facing north. The pictures in the first bin were all by Claude Monet: haystacks, poplars, still lifes, the rocks at Etretat. They were impressive. I was struck by the fact that there were no sheets with names of clients, the histories of the works, or his work schedule.

When I came to the fifth canvas or so in the stack, a still life of flowers from about 1875, I saw that the Monet, signed, was unfinished. The next Monet was a sketch in oil, merely a bunch of brushstrokes in beige washes with a quarter of the sunny landscape filled in with oils. The next three were the same—incomplete Monets.

Bin after bin, I found the same astonishing thing. Edouard Manets finished and barely begun. Works by Paul Cézanne, both oil and watercolor, complete or just started. Fully and partially painted Renoir's—there must have been twenty of them of all types from flowers to nudes, landscapes, and portraits of young girls. I was astounded to come across three tiny canvases by Georges Seurat, one just started.

I was digging around, entranced, when Frank stepped into the room,

cleared his throat and said, "Friend, maybe we'd better keep all this a big secret, don't you agree?"

I agreed, but I exacted a proviso. I would never mention that I had found Frank X. Kelly's stash of forged Impressionists and Post-Impressionists until he was dead, in exchange for his showing me the tricks of the forger's game. He would have anyway. By this time I was Kelly's closest confidant and he was intrigued by my temerity.

Over the next three or four weeks, for sometimes up to three hours at a time while he was finishing up one of the Pahlman paintings or one owned by another of his clients, he'd tell me tales about the fake business. He never actually worked on one of his fakes in front of me, though he did once show me how he obtained old canvases—in the same antiques shops Pahlman visited on First and Second Avenues—and how he'd scrape them clean to paint his fakes. But he did that for only half of his products, he told me. Scraping was too time-consuming and the people who bought his Impressionists, both dealers and private collectors, didn't seem to note that in many cases the canvas was far too fresh. The dealers who patronized him, he snorted, didn't care, since they knew exactly what they were buying.

A Renoir landscape took him two hours. A Cézanne still life, three or four. A Manet, about the same. A Seurat took longer because of the pointillist technique, though Frank never painted a dense Seurat, preferring the stronger, more captivating sketches over finished paintings. Claude Monet was the hardest Impressionist to forge; the man was "a genius" and, when it came to subtle colors and lights, far surpassed his colleagues.

The volume of Frank's work was prodigious, approximately five to ten a month. He'd been working "seriously" for almost five years. Whom he forged depended on the marketplace. He had a dealer whom he never mentioned and I never identified who commissioned three-quarters of his Impressionist pieces. He earned between a thousand to fifteen hundred for each, which would have been a huge amount of money for anyone but a racetrack addict. I doubt if Frank Kelly ever saved a dollar.

He gave the impression that beyond this one New York picture dealer, who would at times order up three Impressionists or so to seed into the rather modest auction action, there was an international network of runners and dealers who would take his fakes. The South American market was fecund. But America was where the demand seemed never to fade.

Frank told me, always in rather vague terms, that there was a loose confederation of forgers and forgers' agents that existed to inform "members" of the presence of fakebusters who were all too willing to destroy forgers'

careers. The confederation also informed "members" about any scientific advance that might aid in spotting fakes.

On his own and without any placement or marketing organization Frank would paint the Seurats, small-scale Daumiers, and his favorites, "the early, unknown paintings by Manet, Monet, and Puvis de Chevannes." He would occasionally do an Edgar Degas sketchy oil and deliberately fragmentary pastels. And when he felt up to it, he'd paint a half dozen Raoul Dufys in one sitting.

Where did the pictures end up? All over the world, in private collections for the most part. Museums seemed to be suspicious; there were, at that time at least, only a few Kellys on view at the better museums. He never wanted to hang in museums, for he felt that sooner or later museum curators and restorers whom he respected for their skepticism and knowledge would "finger" his masterworks. I don't recall any ever doing it, however.

The models for his Impressionists came purely from Skira books. He must have had every publication Skira had ever turned out on the Impressionist and Post-Impressionist artists. His colors were Skira-esque, those unforgettably exaggerated tones, more glowing than the real Impressionist paintings. He was proud of being able to capture the Skira colors precisely. He preferred them to the genuine colors, saying that his Skira hues would fade into just the right harmonies in time. And they did.

Kelly would never copy a work in toto. He was a master *pasticheur*, who would pore through the illustrations in his Skira volumes and with tracing paper sketch out all the elements from five or more, say, Renoirs that he wanted to bring together into a convincing "new" floral study. He took elements of varying sizes and proportions and simmered them together like the multifarious ingredients in a thick "everything-leftover" soup and have the finished product taste superb, with an emphasis on the prettiest elements.

It sounded, and looked, very easy. But it wasn't. It was difficult to achieve what Kelly kept referring to as the "right tempo." That was the ease, the casualness with which the authentic artist unconsciously painted. Kelly had to practice tempo and speed of execution. Forgers invariably had to work slower than the originators, and he felt the faster he could paint a fake the better, even if at times he got sloppy. No one would accuse Renoir or Monet of painting too fast. Every master was expected to be loose. But if the work exhibited signs of being stiff, that was curtains for the faker.

He talked to me for hours about how to detect fakes. Four prime rules stuck firmly in my memory. One, a fake must look juicier, more appealing, more energetic than the original and slightly older. Two, the surface image

was all that mattered, for scientific analysis of the foundations almost always produced conflicting evidence. Three, the less contrived a fake's provenance, the longer it would last without being detected, so don't waste motion struggling to invent a convincing history of the fake. If, incongruously, nothing was known about a painting, it would be taken more seriously, since mankind seems to have embedded in its brain the notion that every day something miraculous will be found in an unlikely spot. Four, if enough fakes were made by a particular forger and if sufficient time passed before they were exposed, then they would be used as models for other fakes and once that happened, few would ever be detected.

Kelly was something of a fakebuster, too. All forgers are. He pointed to fakes of Impressionists in local collections and was of the opinion that he had never seen a real Amadeo Modigliani except for a handful in the Museum of Modern Art and in the Barnes Collection. He was also convinced that the Henri "Le Douanier" Rousseau had been as prolifically forged as the painter of Parisian scenes, Maurice Utrillo. Both remained virtually undetectable because their techniques were so awkward and slap-dash.

All too soon the time came to send everything out to Cleveland, and my relationship with Frank X. Kelly came to an end in the fall. I never saw him again.

But I have seen his works. Last year in two distinguished Madison Avenue galleries I saw a Renoir and a Dufy. And when I was in my first year as director of the Metropolitan Museum in 1968, I attended a gala reception and buffet dinner at a Fifth Avenue duplex apartment after a concert performance of La Sonnambula sung by Joan Sutherland and was escorted through the halls and chambers by my hostess to see her collection of Impressionists. Out of the twenty-five paintings or so, five were by my former acquaintance Frank X. Kelly. I think I had even seen two of them when they were as yet unfinished. They all looked more "Skira" than I had remembered, which is the tip-off in Kelly's works.

When my hostess asked what I thought, I resorted to "museum" talk, which is to indicate to the person listening that there are radical things wrong without actually spelling it out directly—one never uses the word fake. So I remarked, I thought pointedly, on the unusual nature of this or the odd colors of that and the strange style of that. But my hostess didn't notice. I imagine the Kellys are all or almost all still out there making their gradual way into catalogues raisonnés and the marketplace.

Frank Kelly was one of the people who heightened my suspicion about

what everybody else says about the originality or condition of most works of art. During my undergraduate studies, I prayed for the moment when a slide or photograph of one of Frank's works would appear in a seminar or on an exam and I could expose it as what it was—keeping his name quiet, of course. It never did.

In undergraduate education, as is to be expected, not a word in any of the art-history classes was mentioned about either fakes or drastically re-painted or refurbished works of art. Only once in all of my graduate work were fakes or overrestored or nonartistic works passing as real works of art discussed. When I was still an undergraduate I was once permitted to join the graduate students in an advanced seminar on modern sculpture, with a heavy accent on Henry Moore and Jacques Lipchitz. The professor, A. M. Friend Jr., was something of a legend in crypticism when it came to art—a man who could offer up a one-sentence question for the examination for an entire semester's course.

One day he shoved into the middle of the table a foot-long silvery abstract sculpture set into an elegant mahogany base. He asked each gradu-ate student in turn to comment on what forces the piece seemed to exem-plify. The remarks were things like "sweeping vanes of strength in the upturned ends," the real "strength exists in the silver itself," or "it's like the Phoenix being resurrected." Others saw a human figure reclining. And protoforces of amoebas and atomic chains.

I was the last in the circle. And as it came to me to say something, I was in a sweat. The silvery sculpture didn't look to me like a work of art. It had what I thought was a handle and at the other end some kind of curious spoonlike shape. The soft, quizzical eyes of Professor Friend alighted on my face and he slowly pushed the pedestal and sculpture toward me and said, "And what does our undergraduate colleague think?"

"It's not a work of art," I blurted out.

"You mean it's a fake?" the professor asked.

"No. It's some kind of tool. I see no strength in it, no particular poetry, something rather workmanlike, matter-of-fact."

Friend gave a short braying laugh and said, "Tom's right. It's a vaginal spatula. For delivery of babies. Our undergraduate has the 'gift.'"

About halfway through graduate school, my wife and I decided to suspend formal education, which was boringly shackled to the study of books, articles, theories, and the scrutiny of colored slides and black-and-white photographs, and go to Europe for a year and a half. We spent most of our time in Italy, visiting scores of museums and churches, but we traveled to

every country in Europe, missing only Spain and Greece. I don't think there was a site or gallery or museum or church treasury we didn't worm our way into.

That was the time I spent four months in Sicily, in ancient Morgantina, today's Aidone, and found the subterranean room with the real Tanagra figurines. We were there on a dig. The staff of the Princeton-sponsored Morgantina excavation had a director, Erik Sjoquist, a Swede who taught Greek and Roman art, and a professor from Bryn Mawr College, a classicist, Lucy T. Shoe. The rest of us were students.

Professor Shoe was renowned for having published a landmark series of template drawings of the profiles of Greek architectural details. She could whip out her steel template, lay a fragmentary stone or stucco piece on it, and correctly date it almost to the decade. Sculptural and architectural styles moved with a determined rhythm in classical times. She was stiff-backed and unsmiling, barely tolerant of our sometimes outrageous talk at the dinner table and our high-jinks, which included going on rat shoots with our trench workers around the villa in which we were living, and dancing with our male Sicilian coworkers in the local bar.

One night we—I—decided to pull an archaeological practical joke on the proper Ms. Shoe. Some months earlier, my wife and I had liberated some Etruscan tufa phallic symbols, about six inches long and four in diameter, which we'd found by the score lying on the sides of age-old paths leading to the necropolises in Cerveteri, not far from Rome. My idea was to seed three of the best phalluses in the area where Lucy Shoe and her trench workers were digging and watch her identify the alien stones with her template and perhaps believe that the Etruscans had ventured to Sicily, miraculously far south into the Greek colonists' territories. A landmark historical discovery.

Late at night with some of our rat-shooter colleagues, all of us invigorated by fresh, still-fermenting local wine, we packed our Etruscan artifacts into the proper level of Shoe's trench. She found them at noon the next day. She showed no emotion, according to our Aidonese digger colleagues who had actually dug them up. The template came out of its bag. The points of the thin steel bands were placed on phalluses and drawings were made. Still no comment, no outcry over this most exceptional find. Lucy Shoe wrote down descriptions, wrapped the objects carefully into old blankets, set them into the wooden trays used for finds, and had them brought down to the storeroom.

No comment. We were going nuts.

At the end of dinner, in the candlelight, the prim, white-haired Lucy

Shoe straightened her already well-postured back and said, "Erik, I found three of the most unexpected stone objects today."

This was it!

"But the next time one of our interns—I imagine one who was living in Rome or near the Etruscan sites and I think I could identify him—wastes a good deal of luggage space by bringing unauthorized Etruscan antiquities, common phallic symbols, down to a Greek colony—at the very least he ought to select phalluses of the right date. Really!"

In time we got to be very friendly with fakebuster Lucy T. Shoe. It was she who told us that when we made our weekend rounds of ancient sites we ought to be on guard for local purveyors of antiquities. Everything they offered would be fake. A few weeks later in Segesta or Agrigento a short man suddenly darted out from behind one of the weed-overgrown toppled columns drums. "Want to buy something old, rare, and important?" he said in Sicilian. "What do you have?" I asked. He drew out from behind his back a statuette about six inches high, one that depicted a seated goddess. Very powerful, very rare—dating clearly to the beginning of the sixth century and maybe earlier, a terra-cotta or so it seemed. I wanted it, if the price was right. I smiled greedily and the ad hoc antiquities dealer thrust the statuette toward me.

I was expecting to take hold of a light, fragile terra-cotta and almost fell on my face when the "terra-cotta" weighed something like ten pounds. It was solid metal. I could see that the thing had been cast from an authentic ancient mold, an object of considerable rarity. I handed back the dead weight and asked the man if I could dicker for the mold. He laughed, launched a standard Sicilian curse into the air, and told me I must be crazy to ask him to give up the goose that would lay all his golden eggs.

During the years we lived abroad, 1956 and 1957, the uprising against the Communist regime in Hungary was taking place and we traveled to Vienna laden with clothing and various gear which we deposited in one of the Liechtenstein palaces for the refugees who were pouring across the Austrian border. It was during that month-long sojourn that I learned how clever the Viennese fakers were at making their goods and at setting up the potential sucker.

In Vienna I discovered the startling works of the Secession innovator Gustav Klimt (1862–1918) and the Expressionist Egon Schiele (1890–1918), the latter the creator of the well-known steamy naked ladies. We asked in every gallery around town if they had any works by the artists and

to our delight found and bought several drawings and gouache studies by Klimt and a delicate example of Schiele's "pornography."

We got rather friendly with the proprietor of the gallery who was pleased at the sale. So were we—the Klimts cost under fifty dollars and the Schiele less than twenty-five. For some reason he confided to me that although we'd bought an original Schiele pencil drawing, the proprietor had perfected a technique of making prints of his drawings that were indistinguishable from the real thing, which he possessed in abundance. These prints on old, browned-out paper looked just like the real drawings. Most extraordinarily, they could actually be erased. He proceeded to demonstrate how the lines could be erased, although they definitely were prints. He never told me how it was done. I've seen them all over the place since then. I'd say easily 50 percent of those famous Egon Schiele pencil drawings on fragile, thin, browned-out paper are reproductions. They fetch thousands of dollars each.

The same dealer asked me if I might be interested in an oil painting with a fascinating provenance. It was a sketch of an old man sharpening a knife on a grindstone, clearly related to Francisco de Goya (1746–1828) in style. It wasn't the large canvas of the same subject in the National Museum of Budapest, the dealer explained, but wasn't it interesting that a large number of works of art privately owned in Hungary had poured out of the country with the refugees? This work was surely one of them. And if the larger, finished Goya was in the museum, well, that virtually proved its authenticity, for no doubt the same family who had given the finished (but not as vibrant) version to the state museum decades ago kept the scintillating sketch and had spirited it out? The implication was that the small picture had arrived since the borders had briefly opened.

That is how I lunged greedily for my first fake. I spent more money than I needed to spend, about seven hundred and fifty dollars—which was several months of our meager stipend. The more I gazed lovingly at my oil, the more I recognized not the genius of Goya but a thinly and perfunctorily cooked-up picture with muddled details just where one would expect the postcard of the original would be fuzzy—and was. I had bought it out of classic greed and speed.

◆ ◆ ◆

A graduate-school education in art history at Princeton University in the 1950s was eccentric. The M.A. degree, normally a one-year travail in every

other school in America, was a lengthy three to three and a half years in the making. The Ph.D., instead of the long grind of virtually every other university in the nation, was, at Princeton, a requirement that the student was permitted to dispatch as quickly as he could, often in just six months. The M.A., archly called the M.F.A., Master of Fine Arts, encompassed the entire range of art history from the caves of Lascaux to Jackson Pollock and beyond, despite the fact that nineteenth-century American art and architecture was the most contemporary course offered. There was also no formal instruction on European art after the eighteenth century; it ended with the French painter Antoine Watteau. To prepare for the hideous five-day written and oral examinations, Ph.D. candidates were expected to read on their own what was not divulged by the professors in seminars—and that was fully 75 percent of art history.

All works of art and architecture were presented through black-and-white glossy photographs or faded and battered colored slides. The school's art museum was a fusty, dank, and cramped building—leagues from the spanking, modern plant of today—and the works were exhibited lackadaisically. Graduate students were seldom encouraged to look at works of art, and were never encouraged to handle them.

The typical Princeton story goes that the renowned and cosmically erudite professor of art history at the Institute for Advanced Studies, Erwin Panofsky, a theorist to the marrow, once exploded, "Damn the originals! They hold me back from my theories." Most certainly "Pan," as he was known, would never have been responsible for such a philistine outburst, but it is equally certain that he far preferred black-and-white glossies to real works of art when concocting his labyrinthine theories on iconography and iconology. In that arcane discipline, silhouettes were the alchemist's touchstone.

My mentor through the Ph.D. thesis was a most exceptional professor who was responsible for the single time fakes entered my formal education. His name was Kurt Weitzmann and his field was medieval art in general and Byzantine art in particular, with a strong emphasis on the earliest icons and on groups and recensions of early illuminated manuscripts. But Kurt, a beetle-browed German, who, after decades of living in America, maintained an impenetrable Teutonic accent, was also an enthusiast of contemporary painting and sculpture and knew more about the German Expressionists than most specialists in the field.

Weitzmann insisted that his seminar students gain the rudiments of hands-on knowledge and "special sensitivity" about works of art, and was

the only professor in the art department who brought actual pieces into his seminar room in order to teach basic connoisseurship. He had studied and collaborated with a great German art historian by the name of Adolph Goldschmidt who had compiled the landmark multivolumed corpus of early medieval ivory carvings. Later Weitzmann would collaborate with his professor on the series about Byzantine ivories of the tenth through the twelfth century.

For my doctoral thesis I chose to penetrate the secrets of the antique models used to fashion a small group of the earliest, and most creative, ivories of the eighth and ninth centuries, those produced in the court workshop of emperor Charlemagne, whose advisors were actively trying to evoke the artistic styles current during the glory days of Constantine the Great in the first half of the fourth century.

The work was appropriately theory driven and plodding, as befitted the Ph.D. exercise. The true excitement came when I was allowed access to the photograph files Goldschmidt had gathered and to which Weitzmann had contributed, of medieval forgeries—that is, pre-Gothic—ivory carvings. There were hundreds of them. Weitzmann was on call by museums around America and Europe and by dealers to vet any Western or Byzantine medieval ivory that came into view, a task he carried out for no pay or commission. His only compensation was to obtain excellent photographs of the works. The file was updated monthly. I persuaded Weitzmann to show me every one of the several hundred fakes and teach me why the pieces had to be no good.

Mistakes of subject matter or iconography were the most prevalent, followed by gaffes in the Latin inscriptions, especially the complex abbreviations with which early medieval artists and scribes seemed to have been obsessed. Weitzmann was most emphatic about one "canon" of ivory forging: In the Middle Ages it was impossible to have an exact copy. He also believed and proved why using fine black-and-white photographs was perfectly acceptable for detecting fakes, but only in the field of ivory carving and only up to the dawn of the Gothic style. Another one of his credos was that a badly carved detail—be it two minuscule fingers or a single fold in the tortuous waterfalls of drapery or a miscue in carving of one bead in a bead-and-reel border—was the likely sign of a faker at work. In medieval times, good technique was next to Godliness.

Though the majority of the faked ivories were puerile, I remember being stunned by the large number of faked ivories of the tenth, eleventh, and twelfth centuries and guessed that they comprised 25–30 percent of all

existing pieces. And I was appalled to learn that something like 75 percent of the fakes were still wandering around the world of collecting and art dealing. I still see them surfacing every year by the dozen either in the possession of collectors who have no idea what they are or in the inventory of dealers who have been fooled.

It was Kurt Weitzmann who, even more than Frank X. Kelly, molded me into the art skeptic I have been during all of my professional career.

# YOUNG AT THE GAME

*A* rmed with the M.F.A. and my doctorate looming, I entered the curatorial ranks of the Metropolitan Museum of Art in the sweltering August of 1959 at the bottom rung of the ladder. The post, which doesn't exist anymore, was curatorial assistant and paid a munificent five thousand and five dollars per annum. I was assigned to two departments, the medieval which was at 82nd Street, and The Cloisters, the enchanting museum in Fort Tryon Park at the north end of Manhattan that had a vast endowment granted by John D. Rockefeller Jr., for the purpose of collecting and exhibiting art of the Middle Ages.

But for the first six months and intermittently for the next several years, I served as personal executive assistant to the Metropolitan's director, James J. Rorimer, also a medievalist and one of the creative forces behind The Cloisters where he had served until the war as chief curator. Rorimer, "Jimsie" to his former curatorial colleagues (but God help them after he became chief if they used the nickname) was a rotund, dark, nervous man with jet black, and thoroughly penetrating, eyes that never rested in one place for more than a few seconds. He was obsessed by forgeries and was sometimes rendered virtually paranoid by them. He told me once that when he entered a dealer's shop he often felt that forgeries were attacking him. He confessed that he sometimes dreamed that the "masterpiece" he had just argued through the Acquisitions Committee for hundreds of thousands of dollars would appear the next morning on the front page of *The New York Times* as

a sorry fake. Rorimer was especially queasy about drawings and confided to me that he was convinced that all drawings not known since the moment of their creation were likely to be fakes.

He hated being pressed about what he thought of a work of art, preferring to let the object simmer in his eye and mind before making a final judgment. Some works he suspected for decades without ever coming to a decision. Once, during a conference of museum directors, the host museum had mounted an exhibition of forgeries side by side with the genuine articles, most of them Picasso drawings. Rorimer had made his colleagues snicker by refusing to take part in the harmless game of quickly—for speed was the essence of the game—examining each pair of paintings, drawings, prints, or whatever and saying which was real or not. The directors were to be scored and Rorimer just couldn't abide being measured in public, even in a connoisseurs' frolic.

When it came to spotting fakes outside his field of medieval art, Rorimer was superior—when he allowed anyone to know what he really thought. This talent was odd, since his knowledge of art in general was weak. Even odder because, when it came to medieval works, Rorimer repeatedly demonstrated a febrile "eye," either missing fakes altogether or branding as fakes pieces that were obviously authentic.

The reason was that Rorimer was a scientist, not a connoisseur—though when he encountered high quality, he recognized it quickly and jumped upon it for the museum. His great forte was in having perfected the use of ultraviolet—the black lamp—to examine works for genuineness and the extent of restoration. He had written a pamphlet on the subject just before the Second World War, which had become the primer of the field.

Ultraviolet, today one of the basics, is a handy weapon to see rapidly whether or not a sculpture carved out of the lighter-hued stones (limestone, marble, alabaster) is old or has been extensively repaired or made up from old fragments. The lamp, used in a very dark room, makes these lighter-colored stones fluoresce in varying shades of buttery yellow or shocking purple, depending on when the stone was cut. The longer the sun or the atmosphere soaks into the surface of stone, the greater the penetration and the more yellowish it appears under the black light. In the most startling examples, say, a twelfth-century marble shaved down along one side and cut off along another or added to on the top with some element of decoration, the fluorescence will indicate through raw and ugly areas of deep purple where the shavings, cuts, and add-ons have occurred. With ceramics or terra-cotta, ultraviolet will reveal the cracks and repaired sections unerr-

ingly. Ivory carving is also susceptible to ultraviolet, but glass, dark stone such as basalt and porphyry and metal and enamels all but resist the light's ability to finger the fresh parts or the wholes.

Of course clever fakers learned how to neutralize the lamp. Indeed, it was Jim Rorimer's landmark pamphlet that taught them the characteristics of the lamp and how to beat its fakebusting talents. Rorimer knew that, and it made him even more paranoid about fakes.

Not long after I had left his office and joined the medieval department, I had the unfortunate experience of running afoul of that obsessive suspicion. One day in 1960 an American who said he had been living in Greece since the end of the war, when he had returned there to marry a young woman he had met as a G.I., came to the museum without an appointment. He carried a heavy cardboard box in his hands. He claimed that inside was a Christian marble he'd discovered in a well on his wife's parents' property near Corinth. Someone at the information desk referred the man to me and I came out to help carry the twenty-pound thing into my office.

The head that emerged from the box was so powerful that it almost literally threw me back against the wall. In creamy marble of the finest sort, the piece was almost sixteen inches tall and depicted a bearded, baldheaded old man with huge staring eyes. The sculptor had made rhythms with his drill, happily using the instrument for dramatic effects of heavy light and shade. Normally, the drill was employed to cut off excess stone and was seldom apparent in the finished product, until early Christian times. Instantly, I knew I was looking at a major work of the early fourth century, no doubt a prophet, indisputably of the greatest importance.

After being assured that no official in Greece knew of the piece and that it had definitely not been registered, published, or inventoried by description or photograph, and trying to look bored when the man quoted the astonishingly low price of thirty-five hundred dollars, I put the piece on a dolly and wheeled it through the museum right to the mezzanine office of Jim Rorimer.

He was at the time having a meeting with the operating administrator, Joseph Noble, the man who had been so clever in helping to debunk the Etruscan sculptures. Rorimer dropped everything to study the striking head.

After a half hour he asked me to leave the piece overnight so that during his meetings over the rest of the day and the following morning, he could just give it a glance and assure himself of its stature. At the price being sought, he was almost positive that he could spring special directorial acquisitions funds for the object. I was elated.

The next day Rorimer's secretary called me at nine o'clock to say that I could retrieve the head and that the director would talk to me when I arrived. He perfunctorily dismissed the fabulous head as "suspicious" and told me to get it out of the museum. But why? He seemed reluctant to offer any explanation, but I, enraged and showing it, insisted. At length he said that his ultraviolet lamp had shown the marble yellowish all right, but a yellow that reminded him of some of the greased stones intended to fool connoisseurs.

I practically yelled at him. How would an American ex-G.I. know how to do that and why would he bother for a mere thirty-five hundred dollars? And I expressed some doubt about the reliability of the black lamp to show anything profound. That was a mistake. Rorimer reddened and informed me crisply that Joe Noble had independently doubted it, his experience with Greek antiquities having been significant. Noble had pointed to the staring eyes as a weakness on the part of the presumed faker. To him the clincher was the fact that one side of the bearded prophet's face was not in balance with the other.

I tried to point out that staring eyes and strange proportions were indelible stylistic characteristics of the late antique and early Christian epochs.

But he had made up his mind and by this time was livid at the most junior member of the medieval department basically telling him that he didn't know a damn thing about early medieval art. I was told to leave his office, and take the stunning head with me.

In a rage I called one of my fiercest competitors, the curator of Greek and Roman art at the Museum of Fine Arts in Boston, Cornelius Vermeule, and told him about the fine work. The American ex-G.I. delightedly hopped a train that afternoon and by the next day, Boston had purchased the head. Later research by Vermeule strongly suggested that this was the cult portrait of Saint Paul in the early Christian basilica dedicated to him in Corinth.

◆ ◆ ◆

When I was finally ensconced in the medieval department and The Cloisters my daily routine consisted of arriving before the galleries opened to the public and staying an hour after closing for the blissful opportunity to hold every object in my hands—there were several thousand of them in all materials in both collections—and pore over them trying to figure out how I could prove to my own satisfaction that they were real, and, if so, where had they been damaged (they all had) and how they had been restored.

I'd wheel out the cart and with the aid of the department helper open the vitrines and the flat cases and just eat up the works. Purposefully, I didn't read the often-voluminous catalogue cards on the objects or the somewhat erratic files. It was just my feel, my eyes, my gut, and my hunches I wanted to use to gain the facts. I graded all the works for levels of quality and importance and kept a special file on what I thought were fakes or works so extensively reworked that they amounted to about the same thing.

I also spent hours in the storerooms scrutinizing the supposed fakes: several examples of silver work from the Marcy workshop; a dozen fake enamels; a half dozen or so phony Gothic ivories; and obviously wrong stone heads, mostly Gothic; and lots of woodwork, primarily phony fragmentary ecclesiastical furniture assembled by various donors to the museum.

Most of the time my "cold" assessment of the works on or off view tallied with the official attribution. When mine differed, I wrote down my objections or the reasons why I thought a supposed fake should be returned to view, and tried to convince my superiors that my will should prevail. In every instance they agreed.

It was thrilling to be granted such trust. Margaret Freeman, curator of The Cloisters who had worked her way up to the position from the department of education and was not a trained medievalist, was delighted to have a junior member of the staff who wrestled with questions of real and fake like some Baptist preacher against the Devil. A sweet, intelligent woman of grand self-confidence, sharp wit, and a natural "eye," Peg Freeman in time enjoyed jumping with me into the fray of rooting out fakes, especially when it came to a work of art that "Jimsie" was proud of having acquired.

The only time she got short-tempered about one of my "doubts" was when I kept questioning the condition, and even the authenticity, of three "secret" Romanesque Catalonian objects that the New York drawings dealer Harry Sperling had managed to have smuggled from Barcelona. They were to be the pièces de résistance of the newest grand acquisition of The Cloisters, an entire apse of a Romanesque church from Fuentidueña in Segovia, which the Spanish government had sent to New York "on indefinite loan" in exchange for a series of Spanish twelfth-century frescoes mounted on canvas for "indefinite loan" to the Prado.

They were all Catalan and painted. One was an altar cross, the second an altar frontal showing Christ enthroned, and the third a rare low chest with a curved roof, or cover, with Christ enthroned surrounded by the animal symbols of the Evangelists. My instant reaction to these treasures was "too good to be true" and "cartoonlike." They were suspiciously similar in

drawing style, despite the fact that they were supposed to be of different dates and had come from different Catalan churches. They were also suspiciously "primitive" in style. The animals looked idiotic, especially the Lion of Mark which had a tubular neck that seemed to be made out of soft rubber. Finally, all the figures were surrounded by black lines, which was correct Catalan rough style, but the black paint seemed thin, tentative, feeble.

Every time I would bring up the Catalan cross, altar, and chest, for the first time in our relationship Peg Freeman would say something about my slender experience in Spanish art and that the museum's conservators had thoroughly analyzed the paint and gesso and had given the objects their fullest blessing.

My boss downtown, a pale and nervous curator, William Forsyth, was interested in the issues of real and fake, but he was immersed in trying to complete a major study of French tomb sculpture of the fifteenth century and gave me primary responsibility to update and change the files and to take pieces off exhibition or install them from the storeroom's valley of the damned.

In 1959 and 1960 my job downtown in the medieval department was really to learn the collections and keep relatively quiet and out of trouble. Occasionally, I was allowed to write letters of refusal to dealers who had sent in unsolicited photographs of objects for sale. One of these photographs had come to James Rorimer from Harry Sperling, the dealer who had seen to the smuggling of the Catalonian paintings. Rorimer had sent the black-and-white photo down to Bill Forsyth, who had turned it over to me for polite dismissal. It showed a white-stone, almost-square carving representing the *Annunciation*, with the Virgin and angel standing under an elaborate arcade below a crenelated battlement. The piece seemed twelfth century and the style was distinctive—dwarflike figures with exaggerated, navy-bean-shaped faces in near profile with draperies that were exceptionally abstract even for Romanesque times. Mr. Sperling's letter was casual: "This relief is, I am told, Italian and Romanesque and can be obtained for $50,000. Not being acquainted with medieval art I really cannot assure you if it is as purported or if it is any good at all."

Rorimer had noted "?" and Bill Forsyth commented only that it looked strange to him, principally because it appeared to be in marble what an ivory carving normally looked like: smooth, white, diminutive rather than monumental. I was instructed to "practice" the writing of a typical turndown letter.

And I did. The letter was approved and duly sent. But I retained the

photograph, which had none of the standard information on the back such as measurements or even the material.

Over the next few days I could not get that picture out of my mind. I even had a dream about finding it along a roadside in Italy, a reminder of my sunny days as a graduate student. The thing became something like a stupid ditty that I couldn't erase from my mind, so I decided I had to find out what the curious stone was or I would go nuts.

I went to the museum reference library to skim, first through the most general books on Romanesque sculpture in Italy, hoping to see a few of the stylistic hallmarks of the *Annunciation* somewhere. I must have gone through a thousand photographs. There were vague similarities to sculptures of the twelfth and thirteenth centuries in such towns as Pisa, Prato, and Florence. I spotted things with a comparable faint classicizing in the figure style and the egg-and-dart border motif which seemed to hark back to ancient Roman times. But there was nothing that zapped me as a match.

Because of these faint echoes of Tuscany, I narrowed the search down to that region of Italy and became intrigued when I found similar decoration in a grand marble pulpit with seven square decorative reliefs set up in the Romanesque church of San Miniato al Monte in Florence. There was only one figure carved on the San Miniato pulpit, a Saint John the Evangelist who looked like a stiff figurehead from some whaling vessel. He was less accomplished than the Virgin and angel on the photograph of the marble Sperling had sent, but the decorative elements were superior. How frustrating.

I was about to give up when I noticed a footnote mention of another pulpit of about the same date published in the journal *L'Arte* in 1906. I sent up a prayer that the library possessed it. It did, and in an article by the scholar Odoardo Giglioli, I struck gold.

It was in the form of a small, slightly out-of-focus illustration showing a pulpit embedded in the wall of a church named San Leonardo in the hills of the hamlet of Arcetri above Florence. The pulpit's six reliefs were published—*Tree of Jesse, Nativity, Three Magi, Presentation in the Temple, Baptism,* and *Deposition*—but no *Annunciation*. The style of these reliefs and Sperling's photographs fit perfectly. There were the same harsh draperies, stocky figures, egg-and-dart borders; the twin arcades and battlements over almost each panel; the bulbous navy-bean faces; even the black inlays for eyes.

Giglioli had discovered that the impressive pulpit had once been in a church in the center of Florence which had been destroyed to make room

for Giorgio Vasari's Uffizi. In the late eighteenth century the six reliefs had been taken to San Leonardo. The first church had been called San Piero in Scheraggio.

The next day without asking Rorimer or Forsyth I cabled Sperling, telling him to hold the piece for us—we were extremely interested. As an aside I asked if he knew the precise measurements of the marble. In a few days he assured me that he'd put it on hold and that the marble measured a little over twenty-six by twenty-four inches. Imagine my delight when Giglioli's article mentioned that the six stones in Florence measured almost exactly the same.

We were to buy the *Annunciation* for The Cloisters at the inexpensive price of fifty thousand dollars, but only after Jim Rorimer had examined the stone in a garage in Genoa where it was stashed awaiting our approval as to its authenticity, whereupon a professional smuggler would get it out of Italy. Rorimer, to my amusement, insisted that we go see it with French newspapers under our arms, one of which he deliberately "forgot," and to speak French. A few days later he accompanied me to San Leonardo and examined the pulpit.

I found the proof for where the *Annunciation* fitted into the reworked and reassembled pulpit and the precise position where it originally belonged in a series of inscriptions in Latin carved into thin strips of marble, some three feet long, others, more fragmentary, a foot or so in length. At first, I found the cobbled-together inscription under the *Deposition* impossible to figure out until I realized that the first word, *Angeli* didn't belong. So, early the next morning, without Rorimer present, I snuck into the church and cut away some plaster half covering the letter *i* in *Angeli* and found, not entirely to my surprise, the letter *u*. Thus *Angelus*, or the *Angel of the Annunciation*. I was later able to buy a number of sepia postcards of the six pulpit reliefs, and with my wife's help in identifying the Latin inscription, determined just where in the original ensemble the *Annunciation* had been placed.

The powerful relief was smuggled by Sperling's henchmen into Zurich and from there it came openly to New York and can be viewed today in the cloister of Saint-Guilhem-le-Desert at The Cloisters in Fort Tryon Park.

◆   ◆   ◆

It was largely because of my luck in pairing Sperling's photograph with the pulpit in San Leonardo that Jim Rorimer decided to introduce me to the real world of art—art dealing in Europe—in June of 1960.

My wife, Nancy, and I and Jim and Kay Rorimer and their two teenage

children swept out of Paris in a Chevrolet station wagon which had been shipped over from the Rorimers' home. We raced through the Loire Valley, laughing our heads off identifying all the rubbish in the tarted-up chateaux, into Spain, along the pilgrimage route to Santiago de Compostela, then back through Barcelona.

The game of choice was: Is it real? Rorimer and I jousted over each work we encountered. It could be athletic on occasion. We spotted a three-foot-high bronze-and-enameled seated *Virgin and Child* on one of the more important altars of the majestic cathedral of Salamanca and I pronounced it "superb" from afar. To Jim Rorimer the statuette was either a copy or a drastically restored clunker.

"Fake!" he cried.

"Genuine!" I shouted.

Not many minutes after our exchange, a priest grew slightly pale to see us both in stocking feet squatting on top of the altar examining the bronze-and-enameled figure with our pocket magnifying glasses.

"Genuine," Rorimer proclaimed, laughing as we climbed down. "Just as I said in the beginning."

Our incessant bickering about what was real or fake, restored or pristine, drove our families up the wall at times, but we never stopped. I'm sure we sharpened our eyes because of the exercise and from that time became more astute connoisseurs.

The last stop in Spain was Barcelona from where, after a few days of beaching and racing through the fascinating old city, our families would return to America, and Rorimer and I would continue on to Italy and eventually back to Paris. Jim Rorimer was in love with the Catalan capital and introduced me to what seemed like a dozen art dealers, hosts of hearty restaurants, and a killer of an aperitif named Anis del Mono that gave me a horrible pain in the middle of my skull the next morning.

We spent a week visiting every worthwhile monument from Roman times to contemporary, from the small Catalan churches on the periphery of town to Antonio Gaudi's Parque Guell and his incomplete Art Nouveau church of Sagrada Familia. We drove that beaten-up station wagon from the beaches up to the dazzling overlook on the great hill dominating the port town christened Tibidabo—"To Thee I Will Give"—signifying the words the Devil used to try to entice Christ with the wealth of the world.

Rorimer loved acting like an undercover agent and he was at his conspiratorial best when we paid a "secret" visit to the discreetly luxurious home of the brothers Junyer, high in the hills overlooking Barcelona. This was a

private collection of astounding medieval paintings and objects owned by two ancient and doddering brothers who had assembled their goods during the glory days at the turn of the century when the local churches regularly sold anything of value to anyone who wanted to pay the price. It was also the collection where Rorimer and art dealer Harry Sperling had found the twelfth-century Catalan altar frontal, cross, and chest for The Cloisters that I had questioned so many times.

We had to slip in and out of the house unobserved by any Spanish museum officials who might have been lurking around, for Rorimer was genuinely nervous that when the triumphant medieval objects were published—the altar frontal was to be the frontispiece in the forthcoming Metropolitan *Bulletin* on the Fuentidueña chapel—the Catalan authorities would bring a court action against him for having illicitly purchased smuggled artistic patrimony. I participated in the charade with great amusement.

There must have been twenty rooms in the sprawling, darkly lit house. We followed one of the brothers' keepers patiently through chamber after chamber making polite comments about the Spanish paintings, the painted wooden statues, the enamel crosiers and plaques.

Rorimer had wanted to have one final inspection of the items to see if there wasn't something he could snag before the grand opening of the Apse. The elderly brothers padded along behind us like stray dogs hoping for a handout. One talked on incessantly in Catalan, a dialect of which I knew not a single word. The silent brother would halt from time to time to urinate in his pants, his face taking on a look of sheer rapture.

After several hours Rorimer sighed and muttered to me that although there were treasures he'd love to possess, there was nothing left that was up to the quality of The Cloisters, or that he dared try to sneak out of the country. The brothers' handler kept pulling out old pamphlets, books, and exhibition catalogues to show us that the majority of the pieces were so exceptional that they'd been published. It was not what Rorimer wanted to hear. He whispered to me that "our" three pieces had never been published or registered by the state.

After that bizarre experience the two of us went to the mammoth Catalan Museum, housed in a grand monster of a structure that had been part of a nineteenth-century world exposition. We spent hours going through the medieval items. Most unusual and striking were several dozen frescoes pulled away from the apses and domes of small Catalan churches and mounted on plaster replicas. There were also dozens of crisp, powerful, altar frontals all having distinctive heavy black silhouettes around the figures

of Christ and the saints. I spent much time studying the paint, so thickly applied that it looked like tar, and I began to have further doubts about the insubstantial paintings that in two months were going to make such a splash. But, I didn't dare get into the issue again with my volatile boss. As it turned out, the issue would soon hit us squarely in the face.

At the end of our stay, Rorimer put in a call to the director of the Catalan Museum, José Gudiol, a relaxed, affable man who drove my boss to distraction because of his predilection to put off everything until another day, or year. Gudiol said to meet him in the largest central gallery where he was supervising the hanging of some tapestries. On the way up, Rorimer told me to be careful not to allude to the Junyers or the three Catalan treasures.

Gudiol, a tall, lanky man in his fifties, greeted his friend with something like, "What are you up to in town, Jim, wresting art treasures away from us?" Rorimer reddened and told his colleague that he'd combed every art dealer in town and was appalled at the lack of decent material of any date. Gudiol shrugged, commented that the best things never got to the dealers because the restrictions against importation were too strict and, to our complete surprise, inquired if Rorimer knew of or had seen the astonishing collection of the Junyer family.

Rorimer's black eyes bulged. I tried to look cool, though it didn't much matter since José Gudiol was not looking all that closely at the reactions of an assistant curator. Gudiol chattered on about how he'd recently found the most entertaining series of forgeries that seemed to emanate from the Junyer collection—"especially Catalan painted objects supposed to be from the late Romanesque period." Gudiol, excited about his discoveries, raced on while we just stood there, as if stunned by darts tipped in curare. The Junyer family, Gudiol explained, was forming its exceptional group of Catalan pictures and sculptures around the turn of the century, which made them vulnerable to fakes. The reason is that around 1900, Catalonia tried to secede from the rest of Spain. The feelings for nationalism were intense. Every wealthy patriot in Barcelona had to have an example of Catalan art of the Romanesque period for pure patriotism. Supply couldn't keep up with the demand. Two gifted forgers by the name of Ozo and Ruiz made excellent fakes, usually by repainting badly damaged originals.

Rorimer by this time was almost choking but managed to ask Gudiol what kinds of fakes.

"Altar frontals, church chests, statues, crosses. I have a marvelous example of one of the Ozo-Ruiz fakes in the laboratory. Would you like to see it?"

Rorimer nodded.

Gudiol motioned for a technician to retrieve the piece from the store-room and shortly a pair of attendants opened a door at the end of the long gallery. They were carrying a three-or four-foot-high painted wooden statue of the Virgin enthroned. In the flash of a second, Rorimer and I could see—we turned at once to look at each other aghast—that the saints embellishing the sides of the wooden throne were identical in style to the figures painted on The Cloister's altar frontal, chest, and cross.

A closer look brought out all the common weaknesses—all the details I had found objectionable: the weak black lines, the putty-soft bodies, the all-too-regular drapery folds, the stupid grins on the faces, the flashy colors, the cramped hands, the cartoonish bull, eagle, lion, and angel symbols of the evangelists.

We thanked Gudiol for his courtesy and congratulated him on his "find." He promised to send Rorimer his forthcoming article on the works of the master fakers, Ozo and Ruiz. Nothing was said about our treasure trove of Ozo-Ruiz.

As soon as we were back in our hotel, Rorimer cabled the museum's conservators, who had, he insisted, convinced him all three objects could never have been made in modern times and asked them to restudy the paint structure, to analyze the physical properties of the paint, and to examine the wood core.

In two days we received news that they could find nothing awry.

This time Rorimer got on the phone with them and shortly thereafter, the conservators sent a communication stating that on re-reexamination they had discovered a sufficient number of physical properties that indicated beyond doubt that all three items dated to about 1910.

James Rorimer demonstrated considerable courage when he received the confirmation of our suspicions. "It was my fault," he said. "I personally insisted we buy them, never really looked at them, except in photographs—the dumbest thing one can do—and I had them smuggled out of Spain. Do you think Gudiol knew and was having fun with us?"

I said no. The thought had occurred to me, but I didn't think so, for Gudiol was too pompous.

"Learn three lessons from my laxness," Rorimer told me. "When you buy, take your time. Never buy from photographs. Never, never rely on what conservators tell you."

Rorimer thereupon telephoned the chairman of the board of trustees, explained that he was responsible for three Catalan forgeries costing three

hundred and fifty thousand dollars, and that the offending pieces would be placed in the deepest storage possible.

They have been there ever since, unannounced, and never shown—total artistic pariahs.

# 9

# A REAL PRO

$T$ he way I really learned how full the universe of fakes really is was by another chance encounter. In 1960, during my second year in the curatorial trenches at the Metropolitan, a young German scholar by the name of Erich Steingräber was contracted by Jim Rorimer to give him an independent opinion about every object in the medieval department and The Cloisters.

The other staff members in our department were resentful of the foreign intrusion but from the moment I watched Steingräber examining a work of art, I knew he had startling perceptions. A nervous, wiry, balding, intense man in his late forties with eyes that seemed never to stop flickering, he was the associate keeper at the Bayerisches National Museum. His smile was incandescent. He spoke rapidly in not altogether perfect English. With a pulsing wrinkling of his brow he would occasionally signal the fact that he had understood perhaps only half of what was being said. His remarks were punctuated by a nervous, explosive *"Nicht wahr?"* "Is it not so?"

For six months, in the evening or the early morning, or sometimes both, we'd take objects out of the cases in the Treasury and the early Christian and Byzantine galleries and, as he described it, "tear them apart." During public hours we worked on the sculptures and paintings that were not in cases. And we pored over the material in the storeroom.

After the medieval department had been scoured, we attacked the thousands of objects in The Cloisters. There was virtually nothing we didn't lay our hands on—from great treasures to huge architectural elements, frag-

ments of choir stalls hidden away in the darkness, iron utensils or trappings for doors and fragments of stained-glass windows.

To watch Erich approach a work for study was like seeing some animal engaging in a mating dance. He would circle the object at first stiff-legged, back arched, and then would dart in to examine it very closely. Totally immobile, he would scrutinize it for a minute or two looking for repairs or weaknesses. He explained that he didn't want to take it into his hands until he was sure that nothing would break.

His eyes would dart over all the surfaces. Once he was assured that when he picked the thing up it wouldn't fall apart, he'd seize it quickly and surely. He'd hold it at various lengths, squinting at it, turning it around, upending it, spending a great deal of time on the bottom and the back. All the while he'd carry on a conversation with the object or with a colleague, punctuated by "Nicht whar?"

He'd mutter that it was, say, an excellent example of "brown enamel," a material that I had never heard about, and that the piece was in better condition than those in Dresden, Berlin, Cleveland—he had all the comparisons on the tip of his tongue. Then he might launch into a learned description of how they made "brown enamel" in the Middle Ages, complete with statistics on the temperatures required to fire and produce the singular decoration and citations of books and articles on the technique.

How thrilling it was to pick up fundamental knowledge from the experiences of an expert, information that a neophyte could never hope to gather from a seminar or through books. These kinds of facts were seldom written down and, more likely than not, were held close to the connoisseur's chest.

Steingräber persuaded me that the chief element to look at was the combination of wear, usage, and age. "Find and make yourself a drawing of every bit of wear, each scratch, each bump. Then try to explain when the damage had been done, how, and when." He advised literally making a map of the wear. What might be an abrasion of the thirteenth century or a dent of the fifteenth? Were there any repairs or additions? If so, date them. Were they old or modern? Often a forger added an "ancient" repair to lull the connoisseur.

It was also vital to categorize the basic types and levels of corrosion. This was to be done in the field before one had gotten the object back to the museum where sophisticated scientific tests could be carried out. Every metal but gold corrodes, and even gold corrodes if it contains the slightest mix of another metal. And gold ages, becoming as the goldsmiths say, "sour" or brittle. You had to see if the corrosion was stacked in the right "sand-

wich." Ancient bronze had to set up in regular layers of cupric chloride, a brown patina, underneath a cupric oxide surface, which was green and crystalline. Old silver normally turned a dark grainy purple. Yet if these normal patterns of corrosion didn't appear, that didn't necessarily mean the object was a fake. Many times, illegal excavators would overclean an ancient bronze or object made in silver to see what it was and then had to repatinate in a phony way in order to sell it.

Steingräber drove hard on the point that the wear on objects, and even sometimes paintings, always proved what the piece had been made for. And if the wear was inconsistent with a specific usage, then the thing was proba-bly a fake. One extreme example he cited was a medieval object called a *pax*. This was a peculiar devotional image made to be kissed by the faithful. One could tell, Erich insisted, the difference between aging brought about by the natural caressing of thousands of lips over the surface or that induced by gentle artificial abrasives.

Highly reliable for the unmasking of a forgery, he also believed, was the analysis of style. Forgers seldom understood the subtleties of style; most curators didn't either, and one had to look for silliness, ridiculousness, mis-takes, and what he called the "buffoonery inherent in fakes."

It was from Erich that I learned that haste was the enemy of proper, scholarly scrutiny and those dealers who purveyed fakes would invent all sorts of reasons why the purchaser had to buy it now before a competitor made an appearance and seized the prize.

The best weapon in the struggle against art fakery is common sense. How could anyone believe in the abrupt appearance of some item you'd always been dreaming of? How could the rational connoisseur have faith in something that surfaced out of nowhere to become the rage of the art world? The history of collecting, Steingräber pointed out, was filled with tales about incomparable treasures that were at first ignored. The appearance of a genuine treasure was usually mundane. The prices were often ridicu-lously low.

Steingräber seemed as capable of exposing fakes in the early medieval periods as he was in his special field of the Renaissance and Baroque. We decided that two prized pieces of supposedly early Christian gold glass had to have been made in Italy by brilliant miniaturists in the early nineteenth century. One was a delicate head made of stippled gold on a green glass ground of a matinee idol in three-quarters view with a Greek inscription that translates, "Gennadios, most accomplished in the musical arts." It was dated to the second half of the third century. Its exceptional technique

looked suspiciously similar to that of another glass depicting a mother and child, called early fourth century, from Alexandria. This one was said to have been found at Tivoli near Hadrian's villa. To us they both seemed to have been made by the same artist, despite the disparity in date. The stippling technique was closer to the Renaissance than to early Christianity. The mother's hairdo is a flattened and misunderstood adaptation from stone portraits. The baby, not a Christ child, inexplicably wears a pilgrim's oil vial. The glass exhibits an overall grace and sensitivity that is at odds with early Christian art. In the first decade of this century it was fashionable to call any early Christian object that was soft and graceful in style *Alexandrine*, but recent studies indicate that there was no such Alexandrian workshop and no such style.

I came to the conclusion that the models for these gold glasses were probably several in the Vatican Museums. One, inscribed to someone named *Grego*, had been found attached to a tile in the cemetery of Panfilo outside the old gates of the city. The style was the finest ever found in gold glass, using the brushed technique very delicately, and giving a characterization to the faces equal to Egyptian painted mummy portraits. The second in the Vatican is a blue glass medallion inscribed to *Eusebius* which came from the catacomb of San Callisto. The lettering of the inscription was very close to that in the Met's *Gennadios*, which, however, dated much earlier. I found it very odd that on such a luxurious gold glass as the Met's, there was no inscription. I guessed that the forger thought he might make a mistake with his uncial.

We wrestled with the intriguing silver *Antioch Chalice* bought in the thirties by John D. Rockefeller Jr. and hyped by some as the chalice used at the last supper. We found nothing that indicated that the *Antioch Chalice* is anything other than a properly primitive and technically awkward, totally genuine Syrian silversmith's work of the mid fifth century which copied the technique normally employed in making glass cups. It looks suspicious because of its heavy-handed restorations.

In the case of several works, we were never able to get rid of our doubts. Normally, a persistence of doubts means that the chances are excellent that the piece is phony. One of these is one of the most famous works in the Met's medieval department, a painted oak *Virgin and Child* a little less than a foot tall and traditionally dated French, 1270–80. The paint is nineteenth century. We vacillated back and forth and finally concluded that despite our qualms it had to be okay, since the eyes of the child and the Virgin were so Chinese-looking. A forger would not have Orientalized high Gothic, but

would have emphasized the Caucasian nature of the Madonna and child. Our lingering suspicions came from that all-too-obvious later paint. We wondered if the clearly added-on polychromy had been slathered there as part of an ingenious obfuscation process. The statuette is on view today, and viewers can make up their own minds.

A piece we figured had no chance at all is a large fragmentary enamel depicting the crucified Christ. It's in the medieval department treasury and is said to be from a processional cross from Limoges. The date is claimed to be about 1185–90. The thing looks like a manufactured fragment. And there is the enamel cross in the Cleveland Museum that looks like it was made by the same artist. In this special case, finding a near replica of the period is not proof that one of the two is a fake. Limoges was factory mass-producing enamels in the twelfth and thirteenth centuries. But the Metropolitan's cross is a markedly inferior work of art compared to the Cleveland piece. Christ's face is too purple. The drawing of the figure is bland, too clean, too proper, too careful. The Savior seems geriatric, weak, febrile, lacking in character when compared to Cleveland's Christ, which possesses the kind of power that could convert a stone to the faith.

Erich and I had great fun arguing over which French Gothic ivory carvings are unassailable. When you cast aside the obvious clunkers, there is still a perplexing abundance of fourteenth-century ivory carving, mostly diptychs that were apparently used as private altars. How can it be that Gothic ivories have survived in large number despite ivory's fragility? The answer is that many are extremely clever fakes created for the most part in the late nineteenth century during the Romantic period—and by that acquaintance of mine who had confessed to the creation of so many ivories of the "fourteenth" century.

In the treasury of the medieval department, there are displayed side by side, a fine original Gothic ivory and what I believe is about as clear an example of the forger's craft as one can encounter. The latter is still considered an authentic Gothic ivory by the museum.

The authentic one is a diptych once in the collections of Georges Hoentschel and then J. P. Morgan, and the bad one once graced the Frédéric Spitzer collection and that belonging to Emile Baboin of Lyons. The fake came to the Met in 1950. The glistening white pair of plaques are both delicately carved with a host of scenes from Christ's Passion: the Entry of Christ into Jerusalem; Last Supper; Betrayal; and the Crucifixion.

The Spitzer ivory is prissy, awkward, and cautious. The decoration throughout is misunderstood. The anatomy has a "modern" feeling to it.

The smoking gun is a figure who lays down his cloak in front of the ass carrying Christ toward the city of Jerusalem. The odd fourteenth-century posture has been completely misunderstood. The man squats instead of elegantly "curtseying" as he spreads the garment forth. The garment itself is a bulky, rough cloth and not, as in the other ivory, a splendidly tailored cloak. Once one has spotted the awkwardnesses and the silliness—the buffoonery of the faker here and throughout all the figures in the bogus ivory—one has to laugh.

Late one afternoon in the upper office of the tower in The Cloisters Steingräber and I were poring over one of the more valuable reliquaries in the collections, one of beaten silver in the shape of an index finger. It came from George Blumenthal, the astute collector and once president of the museum. This finger reliquary, considered by most experts to date in the early thirteenth century, was noteworthy because it was decorated with a ring—an integral part of the silver of the finger itself—with a large uncut emerald set in its center. The piece stands up proudly on three tall, skinny legs and because of its height and slender majesty was praised as the epitome of the soaring Gothic style in one small object. Finger reliquaries are few and far between; there are perhaps only half a dozen in anywhere near intact condition, and this one is in the best condition of any. There's an inscription, which no one had ever been able to decipher, circling the round base on top of the storklike legs made out of a special shiny hard substance called *niello*, used in the Middle Ages for very precious objects.

Steingräber went through his stalking of the piece and his voracious examination, barked a laugh, and cried out that the thing had to be a fake.

The piece was thought to be one of the most precious items in the entire collection of the medieval department. George Blumenthal had bought it for his world-famous collection of medieval works and he had always received the best advice. What condemned it?

"Points one, two, and three."

One, the three almost invisible stamps on one of the legs. I thought they looked legitimate, but Erich said they could not be thirteenth century. The type of mark, Erich observed, only appeared on French goldsmiths' work of the late eighteenth century and afterward.

Could they have been added later?

I was advised to look carefully with my glass and describe what I saw.

Indeed, the marks were not stamped, but seemed to have been cast into the legs. And there was more. The inscription was gibberish. Plus, what everyone had assumed was *niello*, used to make the letters black, was actually

mere tar—soft, ugly tar. We actually plucked some out and tasted it. The forger either didn't know how to make real *niello*, which is silver sulfide, or didn't bother. It was the overall image that probably counted for him.

Most telling of all was the stunning emerald in the ludicrous ring. Steingräber asked me to remove it. I couldn't.

"One cannot remove it, *nicht wahr?* That is a problem. In every other genuine finger reliquary in existence, the ring can be removed, because these rings were not part of the decoration but gifts to the relic itself." In other words, they were always placed on the saint's finger reliquary later on by a person especially moved by seeing the reliquary. Perhaps he had been cured and in thanks took off his own ring and placed it on the saint's finger.

What about the emerald? Was it good?

Definitely. Steingräber figured it had been put there to increase the price of the object. He stressed the fact that all rings on genuine finger reliquaries were rather modest—none had flamboyant stones.

The emerald turned out to be the likely trap. It seems George Blumenthal was not only a collector of reliquaries, his most desired type being finger reliquaries, but a gemstone fancier as well. The word must have gone out among the better forgers of medieval goods that a fine, rich mark was in sight.

The more I looked at the finger, the more I realized that its true nature was easily detectable from its style alone. It was insubstantial. It possessed no weight or heft or, indeed, character. It was only a thin shade, an image of something grand and deeply religious.

◆ ◆ ◆

After the Steingräber lessons, I thought I had become an ace and indeed had gained the confidence to go out and buy millions of dollars' worth of medieval works of art. For Jim Rorimer had handed me the responsibility of riding herd on all purchases for The Cloisters and the medieval department. I concentrated on acquiring for The Cloisters, since the institution was blessed with a large endowment that yielded nearly eight hundred and fifty thousand dollars a year for obtaining works of art. Back in the early 1960s that was a fortune, easily worth ten times the figure today.

For the study of a special English work of the mid twelfth century I had become saturated with the English so-called damp-fold style, christened thus because the draperies seemed almost like swirls and eddies of a stream racing over submerged rocks. During this time I happened to stop on my rounds of New York galleries at an eccentric Italian dealer who devoted himself to

obtaining decorative arts of the High Renaissance. He was a war hero by the name of Piero Tozzi and he was a peppery, diminutive ball of fire who occasionally bought the rare and exceptional. As mentioned earlier, he had been one of the people who first fingered the "Orvieto boys" responsible for the Etruscan warriors.

But he could also be so wrong in his opinions of authenticity that one had to wonder if the fine pieces he managed to get weren't pure luck. Prominently displayed in his shop on Lexington Avenue and 57th Street was a large bronze doorway that Tozzi insisted was sixteenth century. Everybody who knew anything about Renaissance style realized that the door was late nineteenth century, perhaps designed by the American Italophile architect Stanford White, but no one could convince Piero Tozzi. I didn't want to, because I didn't want to hurt his feelings.

One morning I strolled in to listen to a few jokes and hear some entertaining anecdotes about the art community when Tozzi informed me that he'd just bought a gold "something" from a runner that I might someday be interested in for The Cloisters. But he wouldn't let me see it, since he was still studying the work. I pleaded with him to give me a quick glance. Reluctantly, he reached into the top drawer of a massive old black safe and brought out a tray lined in velvet. From ten feet away I could see a tiny figure engraved on the gold surface of something—it was about the size of a postage stamp. The drapery folds were doubtless English, dating about 1175, I thought. I was so filled with my English researches that I was positive. Once I had the thing, a solid gold locket, in my hands, I saw that there were two figures: a bishop reverently handing over something to a queen. The locket had a series of Latin inscriptions along four sides, inscriptions that I recognized were definitely English in style. The style and the engraving were excellent.

I asked Tozzi the price. He didn't know yet, he said. He became very nervous about my clutching the locket. I insisted, very rudely, that he establish a price at once. Despite his consternation, eventually he stammered that it would be in the range of two thousand or so. I clasped the locket in my fist and told the distraught Tozzi that I'd pay two thousand that very same day, which happened to be the limit I could spend without presenting a work before the director and the board of trustees, and walked out as fast as I could.

Tozzi bellowed after me, "But I don't want to sell it until I know what it is!"

I said that I'd tell him what it was.

The gold locket turned out to be English all right, and dated to 1173. It turned out to be a reliquary—the only one to have survived—made to contain the relics of Thomas à Becket and had been taken on a pilgrimage by his successor as archbishop of Canterbury to one of his strongest support-ers, Queen Margaret of Sicily, who was depicted on the locket.

After this delicious little coup I felt invincible.

One morning in 1962 I decided to drop in on Rosenberg and Stiebel, the distinguished gallery on 57th Street. Saemy Rosenberg, one of the pro-prietors, had a habit of grabbing the best medieval works available in the world. He would always call me when he thought he had something worthy of The Cloisters or the Metropolitan, but I found I slept better just stopping by unannounced from time to time.

Rosenberg had a special late-Gothic cupboard in which he kept his special small treasures, and it was there that I found a miracle on this visit. It was a painted wooden Madonna and Child about eight inches tall—a total beauty—standing on a pedestal with three captivating kneeling, winged angels holding the pair up. Enchanting. Poetic. I thought it was curious that he hadn't called me right away. I felt as if my suspicion that I wasn't always the first to see his newest things was correct.

I dated the diminutive sculpture to about 1475 and thought it to be German, perhaps from the middle Rhine region, made by an artisan who had managed to combine religious piety with the tenderness of motherhood, dogma, and reality. It was an image of such elegant sinuosity that I fell in love at once.

I was a seasoned professional by this time, I figured. Even more, I was a pro on a roll. I'd just come back from a month's trip to Germany and had crawled over dozens of German late-Gothic painted, wooden sculptures. I was saturated with them, and therefore my senses were especially keen. I pointed my brain at that *Virgin and Child* and ticked off like some computer the special characteristics of style and color and demeanor that guaranteed it to be genuine.

Actually, I was so entranced with the sweetness of the image, the delightful interplay between Virgin and her son and between them and the playful angels that the issue of genuine or fake never entered my mind. My emotions had completely taken hold. Besides, I was in the august house of Rosenberg and Stiebel, the greatest decorative arts dealers in the world.

I cannot recall what the history of the piece was or what famous collections or exhibitions it had been in, but its history sounded glowing.

The price was something around thirty-five thousand dollars or so, I recall. I didn't think it was high, nor was it a bargain.

Impulsively, I said we'd buy it. By that time I had the power to commit such an amount of money without bothering my superiors.

The piece was sent up to the Metropolitan the same day. I put it on my desk, just for me, for the delicious weeks I would study it, measure it, make a description for the medieval department's catalogue cards and files.

It must have been only a week later when Jean Feray, a French colleague in the Monument Historique, the French government entity that protects the nation's architectural and artistic landmarks, happened to come to town and stopped by. He gazed at the new acquisition raptly, adjusting his glasses rather excitedly as he put his face centimeters away from the lovely statuette. Then he leaned way back in the chair and exclaimed in French, "Marvelous! You know, this is the first German Gothic sculpture I have ever liked! The rest are so twisted and brutal and primitive even when they're done by the best artists. Congratulations."

In an instant I knew the seductive sculpture couldn't be genuine. A Chauvinist like Jean Feray could never like a true German Gothic sculpture. In a flash I realized that this was far from stolid German late-Gothic style which is, and should be, a little awkward, steely, quirky, shadowed with a bit of angst. This was elegant and sweet, human and polite.

Why didn't I or the Metropolitan's administration try to get the money back or at least a credit with Rosenberg and Stiebel? Two reasons: First, the firm had been fooled just as I had been; second—and more important— the firm had such a lock on the best of the best that I didn't want to annoy the principals.

The acquisition was my responsibility. I had violated my own strict rules about how to examine a work of art and I had tossed my precious fake-inhibiting checklist to the winds. The lovely *Virgin and Child* went into The Cloisters' storage where it is today available to students of medieval art, who will, perhaps as a result of seeing it, become less impetuous collectors of late-Gothic German sculpture than I was.

◆ ◆ ◆

Another New York dealer who is legendary for the excellence of her medieval and Renaissance objects is Elisabeth Drey. She has an elegant shop also on 57th Street which I visited like clockwork every two months and always the day after she returned from a European buying trip.

I always walked into her place with a sense of high anticipation, almost shivering with the knowledge that I'd soon be confronting a thrilling work of art and one that would be, likely as not, a surprise. Elisabeth Drey's tastes are courageous and she takes a chance occasionally on the offbeat.

I was not to be disappointed one fall morning of 1964 or 1965. She smiled conspiratorially, as she liked to do, and guided me into her inner sanctum. There she showed me a large transparency of a startling bronze-gilt enamel about eight high inches by six in width. I knew in a hundredth of a second what it was or seemed to be. It was something of a puzzle, a variation of a renowned, and much-published, enamel representing the *Annunciation* created by that genius of the late twelfth century, Nicholas of Verdun, for his world-renowned pulpit in that ancient monastery outside of Vienna, Klosterneuberg.

Nicholas of Verdun, master metalworker and enamelist had signed and dated his enormous undertaking in the year 1181. The thing is a majesty: fifty-two bronze plaques with champleve enamels illustrating the Old and New Testaments. It was originally a choir screen, which in the twelfth century was perhaps the most important part of the church, and was changed into a retable in 1374 owing to transformations in the liturgy, and then a few enamels were added to fill out the story and give greater size. The retable is one of the most breathtaking objects in Christendom.

Could it be a duplicate of the twelfth-century *Annunciation?* In another fraction of a second, I realized that it couldn't be. The style was wrong. Instead of the thin, acrobatic angel in Nicholas's plaque and his balletic Virgin, shyly pulling back from the messenger from God, this angel and the Virgin were overweight behemoths. Over each figure raced a worried, churning waterfall of draperies. White-water raft stuff, not the delicate harmony of fabrics falling almost silently to the ground as in Nicholas's creation. But, I asked myself, could it be one of the enamels made as some sort of a test by one of the craftsmen of the late fourteenth century?

I took the transparency back to the museum and into the library where I got out the publications describing the alterations. The enamels added later looked nothing like this Annunciation, being rather more stick figures than inflated giants. I vacillated about whether to purchase the enamel for some weeks and finally informed Elisabeth Drey that she should have it shipped over.

The price was, I remember, in the fifty-thousand-dollar range. High, but if this piece was linked to the great Klosterneuberg altar, then it would be a worthy historical document; if not one of the most captivating pieces

in the collections. My interest was buoyed when Mrs. Drey told me that the monastery had owned the enamel for years, no one knew exactly how long, and that the Austrian government had given special permission for the piece to be sold and exported. After all, they already had the magnificent twelfth-century piece by Nicholas.

When the piece came I was elated. The style was even more brutal than the slide had demonstrated. The figures were two grotesque human beings gesticulating like actors in a silent movie. The enamel itself was juicy and thick like some blue icing on an exotic cake. Between the angel and the Virgin was a lectern with an open book fashioned in a rare technique called granite-enamel.

I came to the conclusion that the figure style was too harsh to be nineteenth century. Virtually all nineteenth-century fakers of Romanesque and Gothic things clean them up, make them romantic and saccharine. To me the provenance of Klosterneuberg was the best sign of all. So, I bought the enamel convinced that it had to be a plaque made by the team of fourteenth-century craftsmen as a demonstration to the Abbot that they could mimic the dynamic style of Nicholas of Verdun, after which they were hired and instructed to make the new enamels in the fourteenth-century style.

I defended my thesis with passion for the next ten years, and watched it slowly collapse like a balloon with a tiny hole in it. Every time I looked at it it seemed to get more and more flabby in style, the treatments of the garments and the handling of the spaces increasingly nonmedieval. The end to my self-delusion, the climax to my absurd rationalization, was a publication I championed at the Metropolitan issued in 1975 about all the greatest acquisitions made in the decade before. The curator in charge of The Cloisters, Jack Shrader, wrote the following.

Austrian (Klosterneuberg), 15th c. (?)

Under the impact of his model, the Annunciation plaque on the Altar of Klosterneuberg, the artist has so cleverly concealed the stylistic tendencies of his own generation that the precise date of the plaque has eluded all who have studied it. This imitator—or early "forger"—maintains artistic independence and late-Gothic character while translating the late-twelfth-century style and composition . . .

In others words, this is a hopeless fake. Now, I completely agree.

# BUSTING WOLFGANG

*D*uring my early curatorial years one of my best friends in the profession was an art dealer, my age, an Austrian by the name of Wolfgang Hofstatter. I took to "Wolfie" because he was bright, eager, and mischievous. He was stocky, strong, athletic, and was in love with hunting, as I was. He and his wife had two sunny young daughters. My wife and I had one. We also shared a mutual contempt for the pomposities of the art profession and a passion to gather up as many masterpieces of art as we could—he for his gallery and me for my museum. We both thought we were more talented and perceptive than anyone else in our respective fields.

Wolfgang was a brilliant art dealer with a beautiful gallery in a choice location in Vienna. His wife was a full partner in the enterprise and was the brains behind the decoration of the establishment in a style that combined the "old world" and the contemporary.

He specialized in seventeenth–eighteenth-century Austrian decorative arts, and from time to time came up with the occasional medieval piece. His philosophy was that a worthy work of art had to be not only beautiful and historically important but also in highest taste, in the most exalted sense of the word. The works he chose to handle had to be all of that, plus they had to be things you could live with. Wolfgang often told me that although he admired museums, he wished that great works "don't go to those prisons too soon." I agreed.

From 1961 until 1965 I would see him three or four times a year in

New York or Vienna or at his country hunting chalet in the small town of Ibs. In Vienna, we'd often go together to the series of splendid museums that make the Hapsburg town the single finest place in the world for Western art. He had been advising the spectacular imperial treasury, the Schatzkammer, on how to design their new vitrines and light their dazzling objects. We haunted the early medieval sections of the treasury and the great Kunsthistorisches Museum. His eye was fabulous and his remarks about the pieces always opened up new insights into the works.

Wolfgang was determined to become a dealer of the same renown as the best who had ever been: Joseph Brummer in New York, Julius Boehler in Munich, George Wildenstein in Paris. On every trip I'd see some lovely, tantalizing things—admittedly minor, yet worthy of The Cloisters—and would try to buy them. But Hofstatter would laugh and tell me that they were okay but not quite good enough either for me or The Cloisters. He wanted his dear friend to have only the *"beste am besten."*

I confided to him that I was seeking the rarest work of medieval art imaginable, something that had survived in only two dozen examples. That was a piece that exemplified that magical artistic international style born in the Burgundian court and had burgeoned in such court workshops as Prague and Vienna from 1400 to about 1420 when the hyperrefined style abruptly disappeared. The period is known to art historians as both the *Weiches Stil* and the "Beautiful Style." The movement was at the same time the end of the grandeur of the chivalric Middle Ages and the birth of the earthy Renaissance. I demanded not some fragment of trumpet-fold draperies—the hallmark of the style, or a piece of the sweet face of some saint, but a full statue or painting.

"Wolfie" laughed. The chances were minuscule to impossible. Yet he said he'd keep looking and asking around. Aim high and the great hunt will usually be successful.

Wolfgang's passion for art was really only a secondary one. He lived his life for the hunt. He was obsessed about hunting the *reh*, the small deer of Austria and the larger variety, the fallow or *sicher* deer. His country place and shooting preserve near Ibs was grandiose. You couldn't hunt in Austria unless you were a landowner and had passed a rigorous course on the handling of guns. His property was extensive with forests and verdant fields. The two of us, garbed in our Austrian hunting clothes, which he graciously lent me, dashed about in a special type of four-wheel-drive vehicle made for the army.

We would go out in the late afternoon looking in the herds of *reh* for

specimens that were best of all, ill—say, a beast with one of his antlers growing in on his skull. Wolfgang supplied me with one of his best rifles with a scope and advised me to watch through my binoculars for the specimens with the grayest muzzles.

After hours of watching the herds peacefully grazing and conducting a spirited conversation about fake and genuine Lucas Cranachs, the early-Renaissance painter of Germany who had painted so many deer hunts, I spotted what I thought was a suitable candidate for euthanasia. Wolfgang agreed. I drilled the *reh* and he fell dead. In Austria there's a ritual after the kill. A sprig of evergreen is placed in the animal's mouth and the hunter's companion yells out, *"Weitmanns Heil,"* and the hunter cries back, *"Weitmanns Dank!"* Then the creature is gutted and we drive back to the house and within minutes cook and devour the liver washed down with copious amounts of red wine.

A second hunt was even more enchanting. We went out in the middle of the night, climbed up a tree into a blind, and in midsummer at full moon watched silently as a herd of fifty huge *sicher* deer wandered below us. We spent five or six hours up there not moving except to swig on a flask of slivovitz and saw nothing that we, as superior hunters of deer and art, could satisfy ourselves was the proper target.

I kept badgering him every month or so. Anything?

Not yet.

Finally, three years later, I got the word. Wolfgang had spotted a worthy prize. I recall him coming to New York, staying at the Carlyle Hotel. He showed me a set of black-and-white photographs of a *Madonna and Child* statue that seemed to me to be the epitome of the high classic "Beautiful Style." Both the Virgin and child had characteristically sweet visages. Elegant, coursing trumpet folds cascaded down each side of the standing pair. Where was it? Had it been published? How much were they asking?

All he would tell me was that he had, at last, succeeded in convincing the Austrian authorities—he'd been working for years behind the scenes—for official permission for it to leave the country. He'd tell me more when we were at its side. It was exactly what I had dreamed of. As far as I could see there was nothing in America like it, and even the pieces in the Kunsthistorisches Museum were not that much better.

The price was a "bargain," a flat three hundred and fifty thousand dollars. The piece was still in the place for which it had originally been commissioned, that was none other than one of Austria's most important religious sites, the monastery of Klosterneuberg north of the city on the

Leopoldsberg mountain overlooking the Danube. I knew the sanctuary, for that spectacular late-twelfth-century bronze-gilt-and-enameled altar by Nicholas of Verdun. The moment was when I had just seen the enamel of Mrs. Drey's.

I told Rorimer and showed him the photographs, but no one else, not even my colleagues in the medieval department, not even William Forsyth, the associate curator who was an expert in fifteenth-century sculpture. The reason was silly pride. This was mine and I wasn't going to share it with anyone else. As luck had it, Rorimer was going to be in France for a conference. He suggested that I scout out the situation in Vienna and call him if the *Madonna and Child* was as good as it looked in the pictures.

I joined Hofstatter in a week's time in Vienna and together we drove the eight miles or so out to the monastery of Klosterneuberg. He chattered on about its history. It had been founded in 1106 by the margrave Leopold, who was later canonized. The legend had it that when the margrave and his wife were hunting, they lost a cherished scarf, which his dogs found at a splendid overlook above the Danube. He pledged to build a monastery on the site.

The place had a noble history; it had even resisted the Turks in the seventeenth century. Charles VI, in the early eighteenth, transformed it into an Escorial-like foundation, half his palace and half a monastic order. The striking architecture is punctuated by two lofty cupolas, the only ones of the nine Charles had planned to build that were ever finished.

The earliest church had been consecrated in 1136 but there was little Romanesque work evident. The Baroque works obscured the vestiges. The enchanting cloister dates from the end of the thirteenth century. The interior of the church has a plethora of mediocre stuccos, paintings, marbles, and painted retables. The style is an undisciplined and entertaining Baroque.

The imperial apartments are worth seeing, Wolfgang told me and laughed when I retorted that I hadn't come to graze through back rooms. But the world-famous tapestries commissioned by Charles VI depicting the myth of Dido and Aeneas were there, he protested. Forget it, I said.

Why, he pleaded, Napoleon had stayed in the apartments and had planned some of his most important battles from the heights of Mount Leopold. The library was exceptional, some hundred and twenty thousand volumes, and the church fathers were going to use some of the money from the sale of the *Madonna and Child* to put the library in shape. I groaned and saw some of these treasures, champing at the bit to see the sculpture I had come to adore.

Before we saw the *Madonna and Child* we also had to go to the church treasury. It was not open to the public, but in the hands of Wolfgang, we gained entry and I reveled in some superb Romanesque reliquaries.

Then it was off to the crypt alight with the presence of the glorious retable of Nicholas of Verdun.

In that sacred crypt, standing near Nicholas's great shrine, sat Hofstatter's treasure. The moment I saw it, I was transfixed. The statue, just a little under life-size, was set against a pillar. The Virgin was holding the Christ child and looking tenderly down into his face. It seemed to me to be the quintessence of the "Beautiful Style," dating in all likelihood in the year 1400. I was struck by the grace and delicacy of the work and the sanctity of the location.

My only concern was how we were really going to snatch such a treasure from the middle of such an important religious foundation. And I did worry a bit that my mischievous friend was playing a practical joke on me. But he insisted that he had obtained all the legal permits, so I believed him. If Mrs. Drey had gotten a permit, why not Wolfgang?

I called Rorimer and he came the next day. My boss was as impressed as I had been. He told me later that he was overwhelmed by the cascading trumpet folds and the human way the Virgin's head lovingly looked down to catch the child's face. It was classic and humanistic.

A day before Rorimer had to depart, we dashed around Vienna searching and finding other sculptures of the "Beautiful Style" and trying to get our hands on books and catalogues that illustrated such pieces. From these studies we were both persuaded that "our" piece was at least comparable with the very best.

But Rorimer wasn't ready to decide. He wanted to find an ultraviolet lamp somewhere in Vienna and bathe the statue in its black light. We finally found one and we bought the instrument. I'm sure Wolfgang had one, but Rorimer insisted he wanted to see the look on Wolfgang's face when he pulled out his.

My friend laughed heartily when Jim dragged out the machine and asked—begged—Wolfgang to get us permission from the church fathers to use it. Done in an instant. Jim whispered to me that Wolfgang's easy acceptance of what could be a damning scientific piece of equipment was reassuring.

The examination by black light showed the surface of the stone to be a classic one of divine ancientness. The *Madonna and Child* looked like it was made of the purest, most satisfyingly yellow creamery butter, about as perfect

as one could get. We examined at considerable length those cascading folds which were the epitome of the style and they, too, fluoresced buttery yellow.

Rorimer proclaimed that he had no doubts at all about the authenticity of the fabulous treasure, but he was puzzled and anxious about the legalities. We retired to a café in the district and interrogated Wolfgang.

Wolfgang patiently told us again that the monastery had received official governmental approval to sell the stunning work outside Austria as part compensation for the lands the Russians had seized from the religious foundation. The export permission was a special one-time thing. The brothers had been allowed to choose a few treasures, though, of course, not the famous fourteenth-century French Virgin we had seen in the church or the tapestries or the material in the treasury.

He took us back to our hotel. Rorimer assured him that the *Madonna and Child* would definitely become one of the finest pieces in The Cloisters' collection, and spoke about putting the beautiful statue on the cover of the museum's *Bulletin*. We were all in high spirits.

The only dampers on the festive moment were the price and the fact that Hofstatter was playing tough about the amount of time we had to complete the deal. He told us bluntly to forget about spending "museum time" on studying the piece for months. The monastery, he said, had another agent lined up and another potential buyer, perhaps more than one. We had a week to make up our minds and obtain the funds.

Over an early dinner at the hotel after Wolfgang had left us, Rorimer and I celebrated our good luck. Rorimer praised my tenacity in having so effectively "worked" on Hofstatter over the years, and he complimented my friend, saying what a polite, energetic, and intelligent lad he was. Rorimer was particularly impressed with Hofstatter's not offering us anything but the very best.

To Rorimer, the price was "hideous." In these days when prices of artworks have soared—probably to their correct values, I believe—it's hard to imagine that three hundred and fifty thousand dollars was tremendous. Yet it was a fortune, a third of the annual acquisitions funds of the wealthy Cloisters. Rorimer's feeling was, what the hell, we had the money. His patron and close friend John D. Rockefeller Jr. had always told him The Cloisters endowment was to be spent quickly for such rare pieces.

We fell silent at dinner's end, each of us thinking rosy thoughts about the truly miraculous acquisition-to-be.

Then the strangest thing happened. We both looked up at the same moment and asked each other. "Don't you sense that there's something

wrong with this deal?" The mutual paranoid society of James J. Rorimer and Thomas Hoving was called into full session.

Something was fishy. The deal was too good, too pat. At length our anxieties boiled down to four points. Why hadn't we heard of or seen this spectacular Madonna before? Why hadn't it been published by anyone? Why hadn't it been a choice part of the "Year 1400" show mounted in Vienna only three or four years earlier? Why hadn't the Austrian government bought it—there weren't all that many "Beautiful Style" sculptures in the world and the ones that had survived were always appearing on tourist posters.

Didn't this smack of the classic setup?

But what about the perfect ultraviolet evidence, I wanted to know? Wasn't the lamp all but infallible? Rorimer then admitted ruefully that he had heard of forger's fixes that some claimed could overcome the lamp and make new stone sculptures look ancient.

After the burst of suspicion and gloom we backed off somewhat and agreed that although we were probably overreacting, it was prudent to gain some time. Rorimer had a plan. He had to return to New York, but I should stay in Vienna for a few days, have another look at the piece, and stall. Meanwhile, Rorimer would take the photographs and show them to Bill Forsyth, the "Virgin-expert," as Rorimer put it. Forsyth had gathered together a vast photographic archive of fifteenth-century stone Virgins for his continuing study of French sepulchral sculpture. If Forsyth found anything disturbing, he could alert me.

Rorimer was adamant that I dissimulate with my friend and swear that we were going to buy the piece. I was to say that it was only that my nervous boss needed a few days to get the approval from the board of trustees. When he got it he'd send the money to me by registered check.

I remained an extra three days. Then I got the most surprising communication from Bill Forsyth, who had pulled off a magnificent coup of investigative work. He told me on the phone that at first he'd been thrilled with the photographs of the fabulous sculpture. Then, by the end of the day, he'd begun to worry about it. An image of something he'd seen years ago that was vaguely similar kept coming into his mind. He had pored through his extensive archive of photos and had encountered something striking, a Virgin and Child that had been for years on sale at the Madison Avenue dealer French and Company. The piece had been owned by J. P. Morgan's brother, Junius.

I wanted to know if it was the Klosterneuberg piece.

No.

But Forsyth thought it might be what the Klosterneuberg piece looked like before it had been extensively recut. From the photographs of the Morgan statue, he could see that instead of sinuous trumpet folds falling down on each side of the Virgin, there were hard, zigzag draperies that looked like a series of rugged switchback roads. Moreover, in the Morgan statue, the Virgin didn't look lovingly down at the face of the Christ Child but stared straight ahead.

Bill Forsyth's gut feeling that the Klosterneuberg sculpture had to be the Morgan one recut was backed up by a number of details common to both. One was the distinctive nose of the Virgin which seemed identical in both. According to Forsyth, the Morgan piece had to date to around 1510, long after the late-Gothic majesty of the "Beautiful Style" had vanished. Forsyth was convinced the Morgan sculpture was a rather rude example of the late Rheims style.

The clincher had come when Forsyth had gone to French and Company and had shown an official his photos of the Morgan work and inquired if it was still around.

No. The piece had been sold.

To whom?

For just under a thousand dollars to a young German collector. It was about three years before. Forsyth had met Wolfgang several times in New York and asked if the buyer was by any chance a man who matched his description. Sure was. Plus his name was Hofstatter.

I asked my colleague to airmail both sets of photos to me in Paris. I wanted to check on something with my colleague Jean Feray of the Monuments Historiques. I met Feray and handed him the photo of the Morgan *Madonna*, described it as probably of the Rheims style, and asked if he knew anything about it.

Feray snapped his fingers. Strange coincidence, he knew the piece well. He had seen it just weeks before on one of his regular tours of the Rheims district. He specified a small church in a tiny town some nine or ten miles from Rheims. The piece was on an altar in the chapel to the left of the apse.

He searched for and found a file on the statue and pulled out a picture of what appeared to be identical to the statue that had been in the Junius Morgan collection and subsequently at French and Company for years. I knew from my investigations of the silver reliquary head from Saint Yrieix that J. P. Morgan had made a practice of hiring henchmen to make copies of medieval objects his heart desired, so I asked Feray if the sculpture he'd just seen could possibly be a fake.

He scoffed and suggested that I was having visions and advised me not to be too suspicious. Go take a look for yourself. That's when I laughed.

The next morning I rented a car and drove out in pelting rain to the church. It was deserted and appeared to be locked. But soon I saw that only a rusty wire held the door. I gained entry. There on the altar of the left chapel was the Junius Morgan *Madonna and Child*. I was nonplussed. But not for long. Within seconds after I had climbed up on the altar I saw that the *Madonna and Child* was remarkably fine, but it was a stone cast. Junius Morgan, like his brother J.P., had had a superior copy made so that the French authorities would never know the original had fled to the United States.

I left the church, wound the rusty wire back on the door, and drove to the city. I called Wolfgang Hofstatter and asked if he could come to Paris. He was overjoyed and suggested that soon I would be the most fortunate medievalist in America.

I picked a very famous restaurant, a "break-the-expense-account" kind, and our dinner was magnificent. I wasted a good deal of time chatting casually about everything but the Virgin from Klosterneuberg and cash. He fidgeted in his seat, glancing eagerly from time to time at the brown manila envelope I'd brought with me. Inside were the photos of both pieces and I entertained the fantasy that Wolfgang thought it was bulging with thousand-dollar bills. Over cognac and cigars I opened the envelope and silently lay the pictures of the Junius Morgan *Madonna and Child* on the table.

Hofstatter's youthful face shone with his usual optimism and he murmured words like, "Interesting!" "Imagine!" "Fascinating!" each time I peeled off another photo and placed it in front of him. The man was so unruffled I could barely believe it. Watching his cool response I could only think of those poker games in some forties movie in which empires are being gambled at the toss of a card without anyone displaying a shred of emotion.

We got to the last photo and Hofstatter looked up, smiled ingenuously, and remarked, "I suppose this means you don't want to buy the *Madonna and Child* in Klosterneuberg."

I nodded. I asked him, a man who had become one of my closest friends in the world, "Did you do the work?"

He smiled and shrugged. Not all of it. He'd been helped by a friend who was quite accomplished. He wouldn't say another word on how the fake was made except to comment on how his friend knew all the best techniques on how to trick any ultraviolet lamp.

I asked one more question: "How the hell did you get this thing into the crypt of Klosterneuberg?"

"My cousin is the sacristan," Wolfgang Hofstatter replied with a grin.

We parted and I never saw or talked with him again. I learned some ten years later that he had accidentally shot himself while hunting and died.

Until his death Wolfgang Hofstatter's exceptionally deft fraud was standing in that most holy spot in that splendid monastery of Klosterneuberg. Then it disappeared. I wonder where it is now.

# FAKES BY THE TON

On July 17, 1987, the city of Zagreb in old united Yugoslavia was still charming, unpitted by the scars of war; the flowers in Roosevelt Square were ablaze with color; banners of the Republic of Croatia fluttered in a welcome breeze; the temperature was uncharacteristically cool—the perfect day for the opening of what was praised as the nation's finest art museum. The ceremonies were described to me by a former Yugoslav official in the arts and humanities ministry, who attended the affair. The entire contents of the institution had been donated by a great Yugoslav patriot, Ante Topić Matutin Mimara, who had struggled for decades "to realize my lifelong ambition of creating a museum such as did not exist between Vienna and Istanbul."

The dignitaries present were the most distinguished in the city and the Socialist Republic of Croatia: There was the head of the assembly; the chief of the Academy of Arts and Sciences was in attendance as was the founding director of the new museum, Ante Sorić, who would retire the moment the celebrations ended after years of dedicated work to land the stupendous collections.

The speeches were not the usual canned museum-opening string of clichés. These dignitaries got poetic and genuinely emotional. Ante Sorić, summed it up: "This day—for which we have waited for a full hundred years —fills us with pride that we should be the ones to whom falls the honor of realizing Ante Topić Mimara's wish to endow his nation and the city of

Zagreb with an art collection of worldwide renown . . . 3,754 items finally have become a part of Zagreb, of Croatia, an artistic treasure for Yugoslavia and for the entire world."

To Dr. Mato Mikić, president of the Zagreb city council—the institution, a refurbished high school where Ante Topić Mimara's "children" had found their final resting place, was "a triumph . . . a brilliant success" embodying "the truths in life and art." Mikić went on about how the generous donor had been sustained his whole life by the conviction "that art collections in remote corners of the world still concealed undiscovered works by the great masters. . . . "The new museum," he said, "now ranks as one of the finest and best equipped museums and galleries in the world" and would make "Zagreb a focus of worldwide interest."

The incoming director, Tugomir Lukšić, said:

> Who can evoke the collector's trembling excitement as he stands before a secondhand dealer's shop and sees a rare piece of ancient glass offered at a trifling price; or when beneath the superficial grime of a picture bought at auction as a mere copy, the autograph of some classic of ancient painting begins to emerge beneath the restorer's hand? Improbable as it may seem, even nowadays some hitherto unknown work by Raphael, Velázquez, Georges de la Tour, Rubens, or Rembrandt can still make its appearance; a whole series of works by Corot, Manet, Pissarro, Renoir, and Degas can still come to light. . . ."

The only hint in the opening-day speeches that something might be odd about those thousands of treasures came from the lips of Professor Doctor Cvito Fisković, the head of the prestigious Academy of Arts and Sciences:

> To experts the collections offer the possibility of continuous research, the authentication of origins by the detailed study of stylistic features, and the identification of artistic circles as yet imperfectly known. . . . In this way the Topić Collection will constantly live and undergo changes, in keeping with and depending on the development of new knowledge in art history, as is the case with every renowned gallery in the world.
>
> What can we say of the Egyptian or Mesopotamian sculptures, of these small Cretan, Greek, and Etruscan bronzes, of the Coptic candelabra or fabrics, or of the collection of several hundred crafted

objects deriving from various European countries' reliquaries, crosses, candlesticks, ciboria, monstrances, goblets, jewelry caskets, mortars, and other objects of silver, bronze, enamel, frequently gilded or encrusted with gold, rock crystal, and precious stones?

In truth, the entire collection was, and still is, one of the biggest art frauds ever perpetrated. With the exception of several dozen pieces out of the collection of 3,754 items spanning the full spectrum of world art— European painting from the Byzantine Age to the Impressionists, antiquities, medieval sculptures and goldsmith's works, Persian carpets, Chinese bronzes, Islamic works—the entire Ante Topić Matutin Mimara Collection consisted either of hopeless forgeries or of pieces so badly and deliberately misattributed they were tantamount to fakes.

Yes, the old con man had done it, and his victim, the government of old Yugoslavia, had bought his whole story without any checking or fake-busting in the slightest. I loved it.

The first time I met Ante Topić Matutin Mimara was a clear and chilly October morning in 1961 at the entrance to the Union Banque Suisse on the Bahnhofstrasse in Zurich. Topić Mimara was a squat, powerful man in his early sixties with a round face hidden by a wispy gray beard and mustache. He seemed to hunch over in pain and he kept his arms tightly at his sides as if holding himself together. We communicated in halting Italian since he knew only a few words of English. It was the first meeting of dozens I would have with him over the next decade and a half and I would get to know the mysterious man better than anyone else in the art world.

He turned out to be the most entertaining charlatan and confidence man I've ever met, someone on a par with the greatest scam artists of history. His particular genius was partly as a forger but mostly in making people believe he was a self-deluded fool who had collected works that everybody else had no faith in but which turned out to be incomparable treasures. He was a blunderer, a stumbler, a consummate practitioner of serendipity—who turned out to be right 90 percent of the time. Or so he claimed.

I had heard of him as a collector and the owner of the now-famous *Bury Saint Edmunds*, called now *The Cloisters Cross*, the English Romanesque ivory that has been hailed as the single most beautiful survivor of its epoch.

The object was my first plunge into the big time of art collecting and I have chronicled it in my book *King of the Confessors*. The situation involved my taking a chance on purchasing this spectacular twelfth-century English

ivory cross covered with biblical scenes and inscriptions in Latin, Greek, and pseudo-Aramaic which some experts in 1961 dismissed as a fake. The scholar who alerted me to its existence deemed it bogus and described Topić Mimara as "a Yugoslavian with an Austrian passport who lives in the free port of Tangiers and who keeps his collections of thousands of pieces in a bank vault in Zurich."

Mimara seemed especially proud that his wife, a medieval scholar, had been able to pinpoint the date of the cross and the king who had commissioned it, who she claimed was Edward the Confessor of the eleventh century. But her theory was at odds with the stylistic evidence, which showed the piece to be mid twelfth century. Why had she come to that conclusion? Because several inscriptions on the placard suspended over the head of a fake bronze "twelfth-century" Christ affixed to the cross (the true figure of Christ, most specialists with any eye for stylistic comparisons agree, is in the National Museum of Oslo) stated in Latin and Greek not "Jesus of Nazareth, King of the Jews," as the Scriptures detail, but "Jesus of Nazareth, King of the Confessors." The curator of The Cloisters who had preceded me confided that his initial doubts about the cross were thoroughly confirmed by the stupid inscriptions about "confessors."

I believed otherwise. No forger would have risked being at odds with the biblical texts. Most fakers are cautious souls who want their products to stand out, but not too much.

In time I was able to determine from style, similar inscriptions, and historical data that in all probability the magnificent cross had been created in about the middle of the twelfth century at the Abbey of Bury St. Edmunds in Sussex by a gifted artist named Hugo.

A recent publication emerging from the Metropolitan Museum about the cross, although debunking some of my wilder speculations about the reasons for its manufacture, firmly states that the links to Bury St. Edmunds appear to be even stronger than I supposed. The cross is described:

> Virtually unknown when it was acquired for the Cloisters Collection of the Metropolitan Museum in 1963, the cross has been widely recognized as a masterpiece of Romanesque art. No other cross from the Middle Ages, or from a later period, can equal it for richness of subject matter, complexity of form, and intellectual content. A never-ending visual delight and source of continuous discovery, the cross now forms the centerpiece of the Cloisters treasury.

Not bad for what was once "a ludicrous fake."

From the moment I saw that golden walrus ivory cross deep in the confines of the walk-in vault room in the bank, which Topić had rented for the cream of what he described as a vast collection, I knew it had to be genuine. His price back in 1961 in the Dark Ages of the art market when prices were roughly a seventh of what they have become, was six hundred thousand dollars.

That fall when I fell in love with the Bury cross and became convinced it was good as gold, there was attached to it a disgusting bronze crucifix in a lumpy wax approximation of twelfth-century style. The object was so repellent that I complained to Topić who reluctantly removed it and said that perhaps it wasn't the original figure of Christ but was, nonetheless, a "beauty, unique in the world."

"Unique in the world" would, over the years, become Topić's single most-uttered refrain. And in time I came to agree with him, but not for the reasons he seemed to believe.

Before my colleague Carmen Gomez-Moreno and I were allowed to view the stupendous ivory cross in 1961 we were subjected to a parade of works of the most distasteful variety. Some of the most graceless frauds I'd seen in my life were laid out in front of me with a gesture from Topić Mimara that said that each was a treasure beyond compare.

He dragged out of the enormous vault a chalk-white puckered and pockmarked wooden replica of the striking *Lupa Romana*, the gorgeous seventh-century-B.C. bronze Etruscan statue in the Capitoline Museum. What a travesty! You could find better examples in airport souvenir shops. But to Topić it was "unique," the only sculptor's wooden model found from the Etruscan civilization and unearthed in a secret excavation on the Palatine Hill in the 1920s when he had first come to the city to study the profession of paintings restoration. He became lyrical about how much finer his model of the wolf was in quality compared with the original, which happens to be one of the most compelling sculptures in the world. He belittled the archaeologists who had examined his wolf and had "disbelieved." He knew it was original because his heart told him as did his inner consciousness, which every true connoisseur possessed.

One after another he hauled out the lame, the impossible, the wretched, the ludicrous, and the dedicatedly phony pieces. Over the years I must have scrutinized thousands of his pieces. To my horror that first day in the bank I must have seen several-dozen deplorable phonies, which soon ringed the genuine ivory cross and seemed to strangle its credibility. The

man became ever more enthusiastic about his miserable holdings, calling them equal to or better than the entire collections of the Metropolitan Museum.

Didn't I want to buy them all? The museum would instantly become doubly enriched.

I was there for the cross alone but I recognized that I had to play it craftily, for there was the implicit hint from this wild man that if I didn't at least seriously think about the purchase of a half dozen pieces along with the cross, he'd offer it and their companions to another institution.

I groaned inwardly but acted from then on as if he were offering me the contents of the Louvre. Besides, it was possible that the ignorant man who had so serendipitously seized upon the magnificent cross might have stumbled upon something else as grand, something that he hadn't yet shown me, perhaps finding some medieval treasure that might change our perceptions of earlier times.

In the years I knew Topić Mimara I found nothing but phonies or fifth-rate pieces which he had tried to manipulate into the first rank of quality by judicious restoration and a spate of wonderful stories. Sometimes in his zeal he'd forget what he'd once told me and would change his story. On this first visit he showed me a gold-glass chalice with a representation of the Good Shepherd which he called third century A.D. and which the gullible and faulty Berlin Museum specialist active in the thirties, Otto von Falke, had actually published as genuine. When Topić pulled it out of its threadbare leather case (to me the case looked older than the glass) he explained that he had found the treasure in a small gallery in Rome just after he was demobilized as an infantryman in the Austro-Hungarian army in 1918. He had given a curatorial acquaintance of mine a different, more colorful account of how he had been sketching in the field near Hadrian's Villa at Tivoli, listening to a group of peasants singing cheerfully as they labored in the fields. Suddenly, their voices changed and they seemed to Topić to be singing in a way that suggested to his uncanny senses that they had just discovered something. He moved quickly to their side and surprised them in the act of removing a mud-caked bowl from the ground. He bargained with them and bought the superb object, a remarkable example of Alexandrian glass of the third or fourth century.

It was, in fact, a paltry reconstruction of a fragmentary early Christian glass in the Vatican Museums. His was made out of milky green glass and had a blue curlicue decoration at its flaring foot. Inside the bowl was an image in gold glass of the Good Shepherd. The figure holds a ram whose tail

coils over his shoulders like a snake. The shepherd's right hand doesn't even grasp the ram's forelegs. His face is in stark profile, looking left. Cover the head and feet and you wouldn't know what direction the young man is facing. Two flabby trees flank him. None of the gold leaf is in the least cracked or blemished, which is always the case with authentic pieces of the sort. I had the impression that it was made out of gold dough. When I lifted the thing I felt the unmistakable prick of a twist-off curl on the bottom, just what you find in fairly modern blown glass from Murano. Early Christian gold glass was not blown.

In time Topić would gradually show me his entire glass collection, not all of it fake. One of his cleverest tricks was to recruit a number of real objects, minor pieces of glass ranging from ancient Egyptian times to the Art Deco period, to stand among the phonies in hopes they might lull the observer into thinking that his suspicions were overblown. But the "master-works," all described as "unique in the world," were incomparable parodies of something that might have been—theatrical stage sets and fantasies. And as such, not bad.

Among these was a fake that was mindboggling in its audacity. It was a foot-and-a-half-tall jar in purplish brown glass with "cold enamel" painted decoration taken from English tenth-century manuscript illuminations of the Winchester school. He claimed that these decorations were identical to those on one of the most extravagantly beautiful manuscripts of the tenth century, the *Benedictional of Saint Aethelwold* in the British Museum. It seemed to me that Topić himself had copied the interlace and floral motifs from some poor color reproduction of one of the Winchester Bibles in which the hues were either faded or hideously out of balance, with mustard yellows, garish oranges, and strange floral decorations that looked like dried-out husks of oranges.

Of course he insisted that the manuscript and glass had been illumi-nated by the same artist. He had found the glass in a church on the Conti-nent—he refused to name it—which had many English contacts. The priest who had sold the glass confided to him that it had always been thought of as coming from Winchester Cathedral. This, Topić claimed, was the single most glorious reliquary jar in all of history. He was asking a mere two and a half million dollars for it.

For a few minutes I was willing to give him the benefit of the doubt until my fingers found that telltale twist-off on the bottom that could only mean the glass had been blown and thus definitely not of the eleventh century.

After several years of peeking at the full glass collection, which had Islamic and Oriental examples in addition to European material, I came to the conclusion that Topić himself must have created all the "cold enamel" decorative and figural motifs, with a glass blower fashioning the receptacles.

He was proud of what he called a holy-water vessel from the Rhine. It was, of course, from the most exalted period of the Middle Ages, the time of Charlemagne. A clear purple glass cup (something like the shape of old shaving mugs), it was painted with "cold" white enamel depicting an atrocious angel pouring water on the ground from a chalice copied incompetently from a much-reproduced psalter. It included several personifications of rivers, one of which was labeled *EUPratez*, a ridiculous error for the Euphrates.

The drawing style typified Topić on one of his off days. The figures wore costumes that were parodies of medieval garb. He had painted the bowl with his white enamel—a horrid shade of bone white—then had broken it and "repaired it in antiquity." Cute.

He had a Venetian "marriage cup" of the fifteenth century showing revelers hopping about in celebration of an engagement or wedding, made out of the same purple glass with white "cold enamel" of precisely the same color. Ninth century, fifteenth century, the style was all the same. The celebrants on this wretched hunk of glass had the same stylistic characteristics as the figures in the "Carolingian" piece. Their eyes were rendered in what I eventually saw from the inspection of hundreds of items was Topić's signature—little black piggy dots. This ugly anatomical feature appeared on countless objects, all of differing date and place of origin.

The black piggy eyes, the heavy outlines, the brooding brows, the clawlike fingers appeared in the figures of his "medieval" stained glass, as well, which he owned in distressing abundance. The stained glass must have emerged, I was convinced, from the same glass factory that had fashioned the glass bowls, cups, and reliquaries.

The stained glass led me to his paintings collection, from Byzantine icons of the eighth century A.D. to Post-Impressionists. Some of the paintings, which are today hanging in the primary galleries of the Zagreb Museum, are downright comical. There's a fake Berlinghieri Madonna and Child of the early fourteenth century that's so horrid, the Virgin's fingers look like Edward Scissorhands'. There's a Saint Lawrence by "Simone Martini" that makes the martyr who was roasted on an open grill look like he was crunched under a tank. The martyr's exaggeratedly slanted eyes are straight out of Fu Manchu.

I wasn't about to buy any of this junk, but I finally made him the offer of six hundred thousand dollars for the cross alone. I had to hang around Zurich for two weeks while the British Museum, to whom Topić had given first refusal, decided what to do. I had dinner with him every night in the same restaurant, where he ordered the same Entrecote im Topf and I smiled and cooed and praised him about the artistic magnificence he had managed to assemble over forty years.

While I was hanging on before finally closing the deal and purchasing the grand cross in 1963 for six hundred thousand dollars, he told me some of the most bizarre tales I had ever heard. When he talked about himself he would adopt a conspiratorial manner—all slinking about, eyes furtive, head craning around on his hunched shoulders, looking about for the stray eavesdropper.

He told me he had made his home in the thirties in Berlin and had met Hitler, who had ranted to him about his "thousand-year Reich." Topić had listened and advised the madman that his reign wouldn't last five years. He had been incarcerated in Berlin during the war for a year because he was an alien, then went to live in Lörrach, right on the border across from Basel, after his release. There he had stashed his collection. The Nazis had heard about it and coveted it, he said, but never found it. I can imagine Hermann Göring's agents examining it and running away—for once not loading up on spurious things, for Göring was notorious for picking up fakes.

After the war he was back in Berlin with part of his mammoth collection there. The Russians worried him, and with the aid of an unnamed American colonel, he shipped his stuff out of the Red Zone in three boxcars to Lörrach. He engaged in work with the Red Cross to repatriate refugees to Yugoslavia, cemented his long friendship with Tito, and aroused the wrath of the dread chief of Tito's internal security, Alexander Rankovich. The latter tried to assassinate him in order to gain his collection. He spoke continually to me of giving to the people of Yugoslavia all twenty-five hundred of his works, the number he admitted to in those years.

I asked him, if he was to be his country's grandest art donor, why was he about to sell me the cross? He needed cash to buy more treasures that he claimed were in the hands of "stupid" dealers who had no idea what they had. He'd get them for cheap. And if he did, he'd give a bigger collection to his beloved country. If only he could alert Tito, his old friend, to Rankovich's evil deeds, then he could proceed with his gift.

Later I was to learn on my own that Topić, who had many times tightened his belt and starved in order to buy a treasure, had shown up in 1945 in a colonel's uniform sporting a marshal's baton at the collecting point established by the Allies in Munich to sort out the hundreds of thousands of works of art stolen by the Nazis. There with the aid of a secretary, the German art historian whom he would marry and would enlist as his in-house art historian—the same Wiltrud Mersmann to whom the Zagreb Museum would be dedicated—he dispatched to Yugoslavia a number of works of art, albeit mediocre ones, that had never been in Yugoslavia in its history.

Although he didn't tell me, I also learned that Topić had been arrested by the French for currency violations in the immediate post-war years and was identified as a spy for Communist Yugoslavia by NATO's spy catchers.

After he sold his cross to me for a fortune, Topić used part of the cash to acquire a castle on the outskirts of Salzburg, the Schloss Neuhaus. It looked dreadfully ancient with its huge gate and walls crenelated for archers and crossbowmen. I must have visited the odd place three times. Each time Topić would guide me through at a snail's pace, having forgotten that he'd given me the full tour before.

Each time its history differed. It started off in his mind as Merovingian, was updated two hundred years to Ottonian, and ended up in the twelfth century. The oldest part of the castle was the keep where the walls were ten feet thick. He told me he had labored heroically and spent a fortune to cut through the massive structure to construct an elevator.

I inquired around Salzburg about Neuhaus and learned, not to my surprise, that it was a fanciful, romantic structure, partly of the sixteenth and mostly of the nineteenth century—the perfect aerie for such a faker and self-deluder.

Every time I'd visit him, the graying mountebank would show me something newly acquired and doubly suspicious. But from time to time on one of these visits I stumbled upon some genuine works or those he'd not grossly inflated either by his restorer's brush or by his fanciful imagination. One piece, rightly given the prime spot in his Zagreb museum, is a so-called Raphael, Saint Luke. It's a nice contemporary version of the one presented by the painter to the Academy of Saint Luke when he was elected a member. To Topić it was the original—of course. The proof was that several classical ruins are to be seen in the background including, incongruously, the medieval Torre dei Milizie. Raphael had been the first inspector of classical

antiquities in Italy. The painting is pleasing—about the only one in all Topić's holdings, but, as for being a genuine Raphael, it's an overly saccharine exercise that falls far short of the master's genuine lyric sensibility.

The last time I was a visitor at the Schloss, Topić told me in his most conspiratorial manner, whispering so low that I could barely hear him, that he had managed to seize from a great—unnamed—Spanish collection twelve superb drawings in red chalk by Goya.

It was the spring of 1973. The old faker looked ragged, the beard now wispy and bedraggled, the body hunched over severely. Yet the smile was still mischievous and I knew he relished showing me some more phonies. He knew what I thought of his goods and didn't care in the least. Something had happened, I didn't know what it was, to make him supremely confident. He said over and over that he realized I thought little of his "children" but that he believed in them like any good, faithful father and, anyway, he had found a new place for them.

He directed me to one of his many inner sanctums. He solemnly laid out the twelve Goya drawings—bullfights, one of the master's typical nightmare scenes, the "original concept" of the stupendous *Third of May*, two girls on a balcony, a portrait of a young lady with a fan, and the single most ludicrous drawing I had ever seen in my life.

This was an eleven-by-fifteen-inch red chalk drawing depicting Spain's King Carlos IV and Queen María Luisa out walking unattended with their child Francisco de Paula on some street of either the Pardo in Madrid or, as Topić suggested, the city of Aranjuez. They are standing on a broad sidewalk in front of a wall, looking as if they are having their photograph taken. A trio of strollers are ambling down the sidewalk behind the royal group, but take no notice of the illustrious personages. The king and the boy are dressed in flamboyant military garb. Carlos is wearing all his decorations, just the thing for an afternoon stroll in the streets.

The drawing style is dense, murky, and indescribably inept. All three figures have those distinctive Topić Mimara stylistic signatures. What amazed me was not that he had concocted the loathsome thing, but that he hadn't even bothered to disguise these mannerisms—the distinctive brooding faces with the dark eyes, the heavy hit of chalk around the lids, the piggy dots for pupils, or the clawlike hands.

He carried on at length about how having gained them he considered his collection complete. Now it was time for him to sign a concordat with the government of Yugoslavia and the Republic of Croatia to give, without strings, his three-thousand-strong collection to the people. The agreement

in principal was that the city of Zagreb would build him a museum and he and his wife would serve as artistic advisers. The Topić Mimara family would also be supplied—free—with the most expensive suite in the fanciest hotel in town to live in.

The thought of his being able to palm off his thousands of pieces of junk and forgeries on any government or group of professional museum curators seemed completely antic. I had to work hard not to burst into hysterics but did manage to make it out of the chamber, away from the ludicrous Goyas, out of the Schloss Neuhaus and away, never to see Topić Mimara again.

Over the next ten years I corresponded with him a few times, reminding him of his promise to tell me the provenance of the Bury cross. He ducked and dodged and never came clean.

But old Ante Topić Matutin Mimara emerged victorious after all. Although he died at the age of eighty-eight in 1986, the work continued on his museum and opened to the public in the summer of 1987.

Why were so many professionals and trained art historians and curators bilked by this almost pathetic confidence man and by the thousands of pieces of art garbage, in which even the genuine ones were of sorry quality? One state official of the old regime who was a junior aide in the negotiations told me that as a friend of Tito's, Topić was powerful. He was also considered a hero because of his espionage career and his courageous recovery of works of art from the collecting point that while perhaps not true possessions of the state at least did increase the meager art holdings of the republic. Besides, all Croatians, he explained, especially the intellectuals, suffer from inferiority complexes.

All true, I suppose. But there were other factors. The Croatian officials were hopelessly greedy as well as inept. They wanted a star art collection, as good as the ones the Hapsburgs had assembled in Vienna, equal to the treasures of fabled Istanbul. The perception was that the Yugoslav nation had lost thousands of treasures before the Nazi invasion and during it— something which, in fact, had not really happened—and they yearned to have the missing pieces replaced.

Finally, the art officials of Zagreb and Croatia simply didn't want to know. And apparently, still don't want to know. It's hard enough to acknowledge that you've collected one or two fakes. Admitting to hundreds— even thousands—is intolerable. To look the gift horse in the mouth and to shatter that dream of founding an art museum as beautiful and enduring as the great museums of Vienna is impossible. So the Topić Mimara Museum

in Zagreb is there, untouched by the conflicts, visited by whatever tourists dare to come to the shattered country and, as yet, none of the labels or publications have been updated, though there seems to be some discussion as to whether the "treasures" are indeed genuine.

# IF A FAKE IS SO GOOD THAT IT FOOLS ALL THE EXPERTS, THEN . . .

*A*ll the art forgers I've met tell me that they know of dozens of fakes hanging undetected on the walls or standing proudly in glass cases in the most famous art museums on earth. They get a kick out of pompous experts and theorists who boast of their ability to spot phonies. As one forger scoffed to me, "They all talk on about how a little time destroys a fake and about the five sacred 'givens' why fakers and fakes can never win. But most museum experts are idiots who don't know fakes or don't want to admit that they exist for some internal political reason."

Like any field, art history has its old saws, yet like most old saws they aren't very reliable. Most art historians swear by these tenets:

- The forger will always betray himself by some silly personal mannerism of style.
- A fake will always lack freedom of execution and originality.
- The phony is always lower in quality than the original.
- Where gut reaction and intense scrutiny by the naked eye fails to detect a fake, "science"—the computer, the laser—will always unmask the bogus.
- Fakes eventually reveal the taste of the time in which they are created and never stand up more than a generation or so before they crash.

To this the forgers reply:

- Serious fakers work assiduously to eliminate personal mannerisms and stylistic "signatures." They analyze their own styles coldly and root out any trace.
- Fakers can replicate what seems to be the burst of creativity in the original execution in a variety of ways. One is by deliberately choosing a rather plodding contemporary copy and then copy it as quickly as possible. The result looks tantalizingly glib—just what an original should look like. Another is by carefully analyzing the exact process by which painting or drawing was created, step by step, and then practice and follow the same path. I believe both techniques are practiced and can be dangerously misleading.
- As for quality, the best forgers try to make their fakes look better than the originals.
- Scientific methods used for examining works of art are disorganized, mostly undocumented with little or no indices of their effectiveness. Science is only truly useful for determining a fake after it has been unmasked conventionally by means of the eye and the gut. Science can prove only that something is right, seldom that it is wrong.
- Fakers, knowing the old saw that the taste of the times lies hidden in every phony, eliminate all traces just as they do their personal stylistic "signatures." Probably true. Besides, sometimes it's not hard to figure out in what period a forgery was created. Fakers say the ultimate proof that some forgeries last forever lies in those that fooled everybody in their day and would still be fooling people had they not been unmasked by chance or because the faker stepped forward and confessed. These are the works that crashed not because of any inherent weakness within the piece.

If there's a pop-culture "hero" of art forgery whose works are believed to have bilked every expert on earth and who has, for that, been hailed as a genius because his works must be as good as the masters he forged, it has to be Han van Meegeren (1889–1947), the "Vermeer Man." The story goes that Van Meegeren, an amusing bon vivant and a highly talented Dutch painter whose own works were sadly misjudged by the stuffy critics of his day —the 1930s and 1940s—faked paintings by the Dutch master Jan Vermeer in order to prove the critics were idiots. He never copied anything Vermeer had created, but invented new ones in Vermeer's style. He made the pictures

out of hand-ground paints that were identical to the material of the seventeenth century, utilizing ancient canvasses, aging his works brilliantly by a secret method, passing his creations deliberately to the most skeptical experts of his day, selling them for millions of dollars to a host of collectors and museum curators. He only confessed because as he said he had been wrongly accused of being a Nazi collaborator owing to the flimsy charge that he had been an art dealer who had sold Dutch national treasures to the Germans. The facts are that he was a truly second-rate faker. He did bamboozle a few art historians, critics, and museum curators. And his works did sell for millions. But he fooled none of the qualified experts. His talents lay in setting up the scam and hooking the sucker rather than in the making of his fakes. It's fair to say that his most creative piece of fakery was himself.

Henricus "Han" Antonius van Meegeren's life was unfulfilled and tawdry. From early on he was a cheat and a thief. He became an alcoholic and morphine addict, not unlike Hermann Göring, a man he admired. There's abundant evidence to link him to both the Dutch and German Nazi parties. After the war, in the ruins of the burned-out chancellery, the *Reichskanzlei*, Allied souvenir hunters found a reproduction of one of his paintings published in a Nazi magazine dedicated to exposing all "modern" art as decadent. The reproduction carried his signature.

Admittedly, Van Meegeren had some knack for art early in his life. He was a passionate doodler from childhood and by ten years of age was so obsessed with drawing that his schoolwork suffered. His earliest art teacher was a stylistic conservative who had a passion for the Golden Age of Dutch painting and the Romantic-Realists of the nineteenth century. He was the type of teacher who insisted his pupils grind their own colors in the manner of the old masters. The practice would come in handy later in Van Meegeren's career.

In the beginning Van Meegeren excelled because his drawing style had an eye-popping photographic realism. After a while it became clear that his only talent was copying; he had no creative energy at all, something that was evident in his annoying tendency to crib from the works of his classmates. He didn't exactly plagiarize, but he came close to the edge.

Van Meegeren's father scoffed at his artistic attempts and forced his son to enroll in the architecture department at the Delft Institute of Technology. Clandestinely, the son pursued his drawing and painting career. He seduced a girl, made her pregnant, and married her, all the while pretending to be studying architecture.

His father learned that he had never attended an architecture class

when he won a gold medal from the institute for a wash drawing of the interior of the church of St. Laurens in Rotterdam. (Why he got the prize is puzzling, for the drawing is depressingly similar to a work by a nineteenth-century romantic. No one on the jury seems to have noted the many similarities.) Van Meegeren sold his piece for about three hundred dollars, a small fortune at the time. He immediately made an exact copy of his drawing, and was about to sell it to a foreigner as the original when his wife, who was an honest woman, found out and stopped him. To extract himself from the embarrassing situation, Van Meegeren had to tell the prospective buyer that he would sell him the perfect copy because he couldn't stand letting go of the original.

With his newfound riches Van Meegeren had the courage to tell his father that he had never intended to become an architect and was going to become a painter. He moved to The Hague, entered the academy of art, and received his degree in the summer of 1914. He became a minor legend for his performance in his final exams. He'd received a failing mark in portraiture which annoyed him immensely. During the exam for still life he got his revenge.

The custom back then—an odd one—was that the students had to paint a still life of fruit or flowers with the examiners sitting at a table looking on. Van Meegeren made a tour de force out of the occasion. He painted the still life on the table in front, plus all of his examiners, and even the interior of the room beyond. He not only passed but got a prize for his flamboyant act, and the work was publicly displayed.

As soon as he had graduated he had two sellout shows; in 1916 and 1922. Reviews were favorable; one critic praised his "admirable exact and conservative style." Van Meegeren soon seduced that critic's wife, dumped his own, and married his mistress. After starting up a drawing class for young women, he had another artistic windfall with one special drawing he used over and over in his classes.

This was a slick rendering of a young deer so smooth it looked almost as though it had been drawn with an airbrush. It was something he could do from memory in several seconds and apparently he dazzled his students with the stunt. Van Meegeren took it to an art publisher who had rejected it as being too superficial. But Van Meegeren happened to mention that the deer belonged to Queen Juliana. Which it did, in fact, being one in the Royal Zoo. The publisher immediately bought the drawing and cut a deal with Van Meegeren for royalties.

The cutesy image with big, sentimental eyes appears today in Holland

on greeting cards and postcards. It's still one of the most popular contemporary prints. Amusingly, a number of its stylistic characteristics show up in Van Meegeren's later forgeries of Vermeers—in the faces of Christ and the Apostles.

Van Meegeren's career began to collapse in the thirties. As an artist he'd stopped dead in his tracks. Abstract art was firmly taking hold. The daring experiments by Piet Mondrian made works by dull, academic artists like Van Meegeren downright comical. To make matters worse, Van Meegeren had begun to concentrate on producing sticky-sweet religious pictures or symbolic tripe like *Work*, a composition with a multitude of stereotyped laborers somewhat like WPA art in style. The art critics, who had admittedly begun dumping on the traditional style rather abruptly, attacked him as a symbol of the old, dead ways. One critic wrote, "His Christ figures are often insipid and sweet, sometimes miserably forsaken, always weak and powerless."

The critic was being kind. Van Meegeren's works were awful. By now his pieces were a soggy mishmash of styles from the seventeenth century, the nineteenth century Symbolist movement, with a dash of Art Nouveau. His paintings were populated by wraithlike figures with long gloomy faces or by Theda Bara-type femmes fatales painted in garish colors. Van Meegeren's works were not just hopelessly out of date, they were rotten.

The realization that he was fading away only spurred the talentless Van Meegeren to defend his style of painting more stridently. He joined a right-wing art club and contributed a series of vicious, racist articles to its journal. The articles go after the supporters of modern art—his mortal enemies—sometimes in language that is difficult to comprehend. One quote sums up his frame of mind:

> With their masquerading they have created a unique type with a strong, persistent look; ditto handclasp, and peculiar gait. In spite of their independent manner, they most humbly greet certain snobs and nouveau riches encountered among the citizens and plebes. They are surrounded by satellites, parasites, and proselytes; writers of introductions, deputy directors of institutions for the insane, prophets of the art of painting, necromancers, imitation philosophers, and hypocrites. They are protected from the obtrusive public by the well-known ass-drivers, profiteers, impresarios, and speculators. . . . The slimy little group of woman-haters and Negro-lovers (pan-European style changers) is a little too immoral to be discussed here.

This garbage was straight out of the developing Nazi party line.

With his artistic career fading, Van Meegeren turned to forgery—but not, as so many writers have romanticized, because he was fighting back against insensitive art critics. He went into the game for cash. And he happened to meet a forger whom he respected because he held similar Nazi political views. This man was Theo van Wijngaarden, an art restorer and forger who didn't take long to convince Van Meegeren to become a partner in crime. Their first attempt was to create a Frans Hals *Laughing Cavalier*.

Van Wijngaarden's artistic talents were even less than his partner's, who was, at least, a gifted copyist. His major contribution to the effort was that he had stumbled upon a way of using gum instead of oil in his paints. For forgery this seemed to be an astonishing breakthrough because in the early decades of the twentieth century the standard test for the authenticity of an old master was to rub a small amount of alcohol over a small section and see if the paint surface softened. If it did, the painting was judged to be old. Only ancient oil paintings softened; the modern fakes with oil paint didn't. Except for those painted with Van Wijngaarden's hardened gum.

While his colleague cooked up the gum and spirits, Van Meegeren cooked up the standard forger's pastiche for his *Laughing Cavalier*, combining a mixture of Hals's famous original in the Wallace Collection in London and several other Halsian bawdy types by followers of Hals.

The work the team produced is unmemorable in the ranks of Hals fakes. Van Meegeren's more important contribution was to single out the sucker: an elderly respected collector and art historian by the name of Hofstede de Groot.

Van Meegeren had carefully researched de Groot's opinions on Hals and painted the *Laughing Cavalier* in just the way he knew would appeal to the expert, emphasizing the roughness, the swaggering painterly characteristics. The partners in crime arranged for a third party, a dealer who was not in on the fraud, to approach de Groot with the canvas. De Groot fell for it. He gave the picture the tried-and-true alcohol test. The paint (or rather the gum) softened and de Groot pronounced the painting to be an "exceptionally fine Frans Hals." His expertise sounds sloppy, but is not unlike what goes on today.

Based on this rave, the middleman took the picture to an eminent auction firm which bought it because of de Groot's opinion. The price was fifty thousand florins, equivalent today to about a hundred and fifty thousand dollars. It's presumed that after paying de Groot a commission for his expertise, the partners split the rest evenly. Even half the selling price was an

enormous sum in the twenties, especially for Han van Meegeren, down on his painterly luck.

The duo knocked off a second Hals and after that pictures by other seventeenth-century Dutch masters such as Gerard Terborch, Pieter de Hooch, and the relatively obscure painter Dirck van Baburen. Van Meegeren seems to have chosen Van Baburen because of his closeness to Caravaggio. Van Baburen had been obsessed by the striking light-and-dark style of the Italian sixteenth-century painter.

The money flowed in. Only one expert spotted the phonies and he challenged every fake the duo made. But then it was almost too late, for the pictures, not being very expensive, were eagerly consumed by the hungry art market. Then, just before being sold at auction, the *Laughing Cavalier* was exposed for what it was, by the star connoisseur of Holland, Abraham Bredius.

Despite his advanced age—he was seventy-eight years old—the minute Bredius caught sight of the spurious *Laughing Cavalier* he fell into hysterics and pointed out numerous stylistic errors. He even named precisely which pictures the unknown forger had used as models. Once the auction house heard the bad news it asked de Groot to refund its money. He refused and stuck by his opinion. A committee of scholars was gathered to examine the "Hals." They demolished it, exposing its many stylistic mistakes as had Bredius. Moreover, they discovered the gum used to artificially harden the modern paint surfaces. The group also revealed that the faker had used two paints—cobalt blue and a certain artificial ultramarine—that hadn't been invented until the late nineteenth century. They analyzed the whites and found that they were all zinc-based, a paint that was not in common usage until 1780. Most damaging of all, however, was the revelation that the nails used on the stretcher were clearly nineteenth century. They found these nails underneath the "original" seventeenth-century paint.

Poor de Groot quietly bought back the *Laughing Cavalier*. The news of the fake and exactly why it was a fake never became public nor was it even spread throughout the scholarly community. Neither Van Meegeren's nor his partner's name ever surfaced. Van Meegeren, concerned by the swift judgment of the committee, split with his coworker and went off on his own, determined to make fakes that would be vastly more sophisticated. No more stupid mistakes about gum and nineteenth-century paints!

Forgers will tell you that one of the distinct differences between them and genuine artists is that they have to practice in order to excel. Whereas genuine artists fare better if not tied down by repeating the same stuff, the

faker has to repeat over and over how to "throw" a work almost casually so that the effort looks natural, broad, and void of details that do not stand out over the whole. So Van Meegeren went to work and practiced making the works of Jan Vermeer.

His selection of Vermeer, the genius who produced a small body of work—landscapes and figures in luminous interiors—over all other seventeenth-century Dutch masters was a masterstroke. Rediscovered in the mid nineteenth century, by the twenties Vermeer had become the most discussed and published old master of them all.

He had become something of a national hero, too, a man who was thought to have truly captured the Dutch inner spirit. His characters were described by writers of the time as being the ideal of the Dutch ethos, handsome and pure, much more than those of Rembrandt, who was thought to be murky, dirty, eccentric. In the twenties, in Europe anyway, cleanliness and purity were cherished even by non-Fascists.

Another reason why Van Meegeren turned to Vermeer as his target was that between Vermeer's earliest pictures and the beginning of his mature style there was a convenient gap of about a decade during which nothing was known about his whereabouts or his paintings. It became fashionable in art historical circles to assume that Vermeer had spent part of the gap in Italy, soaking up the dramatic light-and-dark manner of Caravaggio. Bredius, in fact, had stated that it was simply a matter of time when early, Italianate Vermeers would come to light. Bredius had been the "discoverer" of one of Vermeer's early religious works, now in the National Gallery of Scotland. It is *Christ in the House of Mary and Martha*, a remarkably tender and confident painting that is not only unusually large for Vermeer but is painted in broader strokes than he generally employed. Now Bredius was speculating that a host of religious pictures by Vermeer would soon emerge. He and other scholars entertained the curious idea that during the seventeenth century there had been a secret society that had collected Vermeers and hidden them away, although there are no supporting facts for the idea.

Knowing Van Meegeren's cunning in having set up the hapless Hofstede de Groot so perfectly for his "Hals," one can be sure that he deliberately selected Bredius as his one and only best mark. Van Meegeren would have carefully studied the field of Holland's art historians and museum professionals before deciding upon a Vermeer for Bredius. The country is small and its art world chatters incessantly. He had heard about the books and articles in progress, for they were discussed all over the place. New Vermeer discoveries, such as Bredius's, were topics of everyday conversation.

And Van Meegeren had learned that to foist a forgery on the world one had only to fool a single expert. Once he had been taken in, the mark would do all the work to convince the rest of the world that an unknown masterwork had been found—by his one and only impeccable eye.

Bredius was a proud man, passionate about making his own discoveries. He boasted incessantly about his art historical "scoops," especially when it came to Vermeer. Fiercely independent, he delighted in debunking the opinions of other scholars. As we know, he ignored science and believed in making attributions based on his gut reactions. Best of all he was approaching eighty.

It's likely that Van Meegeren went after Bredius, too, because of the pleasure he would gain in bilking the man who had so sarcastically exposed the *Laughing Cavalier*.

Van Meegeren's first Vermeer is a crabbed, tasteless stew of a number of the artist's later works. It depicts a young whore—whose expression is simpering, frozen, and downright silly—seated at a spinet with a cavalier looking gaga at her. She seems to have read a letter given by him (although her gesture is ambiguous) and holds it in one hand with the other resting on a keyboard that is so stunted, it could not be played in real life. Vermeer would never have allowed such a messy detail, since he was in love with musical instruments.

Bredius, told he was getting the "first" look at the painting and eager to make the important "discovery" before anyone else, gobbled the rancid bait whole. He rushed an article into print in the prestigious art magazine *The Burlington* in October 1932.

He lyrically described its vivid colors and took pains to count the comparisons with a profuse number of details in other Vermeers (which is, of course, the surest sign of a pastiche). He rhapsodized over the girl's expression, calling her timid yet "inwardly well-pleased with herself." He added, "It is not often that we find such a delicacy of sentiment on a Vermeer face." Had Bredius owned a copy of Van Meegeren's *Deer* he might have wondered why the animal had a similar expression.

Because of Bredius's panegyric, the picture was eventually sold, but it is not known to whom or for how much. It's likely that it was in the range of the "Hals," around a hundred and fifty thousand dollars. This time Van Meegeren didn't have to share the proceeds. He and his wife moved to Roquebrune on the Côte d'Azur and there he set up shop to paint the portraits of the social set (all of which were highly flattering) and, even more important, to make lots more forgeries of Jan Vermeer.

He packed the tools of his new trade: two new technical books on artistic matters. One was C. F. L. Wild's *Vermeer's Techniques*. The other was an advanced study of the physical properties of oil paints. Soon he would also obtain the newly published analysis of Dutch painters of the seventeenth century compiled by Dutch scholars of the Golden Age of Netherlandish painting, Dirck Hannema and Arthur van Schendel, in which the authors spelled out the latest information on Vermeer's production and interpreted what they believed his stylistic evolution to be.

Hannema, like Bredius, spent a lot of time discussing and defending that theoretical "missing period," the "Italian sojourn" which, he argued, had to have come sometime between the large early paintings with their derivative Caravaggesque stylistic elements and the mature, smaller works where, he said, the intimate flavor of Caravaggio had been incorporated. The theory was nonsense, but it sounded convincing and every gullible art historian seems to have espoused it.

Van Meegeren also assembled some key forger's materials. One was a genuine seventeenth-century canvas measuring four by six feet with a scene of the *Raising of Lazarus* painted by the Dutch artist Hendrik H. Hondius. The other was a bunch of badger shaving brushes. He had read that Vermeer had used badger bristles to make his brushes. Finally, for background, he packed some seventeenth-century goblets, glasses, and pitchers.

The grandiose fake he had in mind didn't come easily. It took nearly four years of trial and error to invent the successor to the gum-base paint. He needed a substance that was chemically ambivalent, soft enough to pass the alcohol test, yet hardy enough to withstand the heat of the artificial aging process without becoming dark or dull. For a landmark Vermeer fake, Van Meegeren had to replicate the master's glowing yet subtle colors, especially the "frosting" highlights for which Vermeer is so renowned, and at the same time make his new paints look centuries old.

First he tried lilac oil, which was abundant on the Côte d'Azur. At first this property seemed ideal, since once it evaporated, all traces of it vanished. But unfortunately, it was no good alone, being too sensitive to heat. It broke down even when subjected to temperatures significantly below those Van Meegeren had to use to baste his painting.

In desperation he turned to substances that were, at the time, very little known: synthetics. The one that survived all his experiments was Bakelite, composed of formaldehyde and phenol. Bakelite could capture and maintain brilliant colors and could be heated to extreme temperatures without becoming dull. Best of all, it passed the alcohol test and softened at the touch.

So Van Meegeren slathered up a mixture of hand-ground pigments, tossed in some lilac oil to make them shine, added the appropriate amount of Bakelite for substance, painted it onto a canvas, and baked it in a specially constructed oven at 105 degrees centigrade. His test passed all his expectations.

This was in 1936. Before he attempted his masterwork Van Meegeren went to Germany to see the Olympics and bask in the spirit of Nazism, returned to Roquebrune, and spent most of a year forging the Vermeer of his dreams. He had decided that his subject would be *The Supper at Emmaus*, calculated to appeal to his mark, Bredius. The scene was religious, dramatic, emotional, and was one of Caravaggio's most famous works, thus a perfect example of the Italianate missing period.

He had decided not to go the easy route of creating a pastiche of existing Vermeers, as he done with his "Hals." For this forgery, the epitome of the Italian period, he would have to do the most daring thing a forger can do—be innovative.

The stakes were high. Pure invention could open him up to instant suspicion. But if it fooled Bredius, it might become the model for other forgeries in the same style. Van Meegeren was gambling on a success that would then allow him to forge the entire contents of the "lost period." Once a faker achieves a nest of pieces all in the same style, then scholars usually defend each new one by pointing to the large body of others.

How he tricked anybody with the picture today seems unthinkable. Its style is identical to his own lifeless Symbolist efforts. The faces—long with hollow cheeks and deep-set eyes—are the same as those belonging to characters in his not totally unknown works such as his religious subjects, the Symbolist tripe such as *Work*, the sticky-sweet religious pieces, even the face of *Queen Juliana's Deer*.

The "gloomy Gus" Christ he produced for the *Supper at Emmaus* looks a lot like Van Meegeren himself with his exaggeratedly high forehead and heavy-lidded, brooding eyes. There are few traces of the seventeenth century in any of it except for the still life, for which he had acquired real objects dating to that time.

Painting the piece itself was not difficult. Preparing the old canvas for the phony was. He meticulously scraped away the entire seventeenth-century *Raising of Lazarus*, a far more onerous task than it seems. He reached the original ground with its thin layer of beige wash and gesso and preserved it. The ground was crucial, for it was full of ancient cracks, something that all paintings forgers have a tough time reproducing, even in Bakelite. Van

Meegeren was counting on having the ancient cracks act as a template for the new cracks when he rolled his finished canvas countless times gently over a large cylinder.

And it worked.

He removed all the old paint except for an area of seventeenth-century white which he cleverly incorporated into the new subject. Before he painted his *Supper at Emmaus,* he cut down the canvas to conform to roughly the size of the early Vermeer Bredius had "discovered," the *Christ in the House of Mary and Martha.* He signed his picture with the standard Vermeer monogram, *I.V.M.* (I. V. Meer).

He then roasted his novel combination of hand-ground colors, lilac oil, and Bakelite in an oven at a temperature of 450 degrees Fahrenheit for a couple of hours. It emerged radiant and with a surface that responded beautifully to the alcohol test, just like an authentic old master.

Then the picture was given several light coats of varnish and rolled on the cracking cylinder. At this point, inexplicably, Van Meegeren covered the surface with India ink, which soaked into his cracks. He cleaned the picture so that traces of the ink would remain in the crevices to heighten the effect of ancient *craquelure.* Finally, he damaged the canvas just so with a number of abrasions and one small rip. For a fillip, he carried out some deliberately bumbling repairs of the damage and tacked the canvas on to the wood of the old stretcher which he had cut down to conform to the new size. He hammered the tacks into the right places. And the nails were ancient, too.

Abraham Bredius, now in his eighties and half blind, was close at hand —in Monaco—where he occasionally made a few expertises and hoped to continue writing articles. The fact is that by the time he saw the *Emmaus,* he was all but incompetent.

Van Meegeren chose as presenter a respected lawyer by the name of G. A. Boon who had served on the Dutch parliament. Van Meegeren approached Boon in Paris. His story seemed plausible, especially to someone who was not at all conversant with the standard forger tales. Van Meegeren told him that the family of his Dutch mistress lived in Italy and owned a number of unknown and unpublished old masters. The best piece was one Van Meegeren believed could be a Jan Vermeer. When a fakebuster hears a story like this, bells ring in his or her head. But it worked with the unknowing lawyer.

Van Meegeren told Boon that because of the need to protect the mistress's family name, he himself had smuggled the Vermeer out of Fascist

Italy. He convinced the lawyer that they had to fashion a cover story. It was to be that Boon was representing a French woman who had to sell her mother's pictures since her father had died. Boon was to say that he had found the Vermeer in an unnamed chateau in France. Naturally, the lawyer was urged by Van Meegeren to approach Abraham Bredius. An expertise was needed—from the very best.

It was in the late summer of 1937 when Boon took the painting to Monaco and left it for the aging expert to examine. Bredius didn't bother to examine the picture closely. He didn't consult anyone else. Of course, he applied no scientific test to it. He was overwhelmed the moment he saw the very type of painting he had predicted would surface. He wasted no time in writing an article for *The Burlington* magazine which published it—without checking or referring it to any second expert—within the month.

"It is a wonderful moment in the life of a lover of art when he finds himself suddenly confronted with a hitherto unknown painting by a great master, untouched, on the original canvas, and without any restoration, just as it left the painter's studio!" Bredius wrote. He called the colors "magnificent." He praised the harmonies of the "splendid blue" of Christ's cloak. The expressions were, he said, "wonderful." The head of Christ was "outstanding . . . serene and sad, as He thinks of all the suffering which He, the Son of God, had to pass through in His life on earth, yet full of goodness. . . ." He summed up with the words: "We have here a—I am inclined to say—the masterpiece of Johannes Vermeer of Delft."

With such a rave Boon fully expected a quick sale, and took the painting to Paris where he showed it to a number of old master dealers, including Georges Wildenstein, the patriarch of the firm of Wildenstein et Fils. The fabled connoisseur recognized instantly that the painting was fraudulent. The other sophisticated French dealers who saw the picture weren't fooled either. Everyone rejected it. The word never got out because all the French experts thought the thing was too ridiculous to mention. Not so the Dutch, who had their own agenda.

Van Meegeren instructed Boon to appeal to Bredius to lend a hand and convinced him to take it to Holland. There Bredius argued that such a Dutch treasure should never be allowed out of the country and managed to convince a group of collectors to buy the work with the Rembrandt Society as a partner. The collectors were Hannema of the Boymans Museum, R. Hoogenijk, a prominent old-master dealer, and hapless Bredius himself who was delighted to help pay for the triumphant proof for his theories about Vermeer's Italianate period.

The painting was sold for five hundred and twenty thousand florins, one of the highest prices ever paid for a Dutch seventeenth-century work and equivalent today to between five and six million dollars. Van Meegeren received two-thirds of the fortune—for his "mistress" and her family, of course.

The canvas was exhibited in a prime gallery of the Boymans Museum in Rotterdam. As soon as it was on the wall other experts condemned it. One was the art historian Dr. van Regteren Altena, who denounced it and every other Vermeer that Van Meegeren would concoct in 1939, 1940, 1941, 1943, and 1945. Two of Van Meegeren's later Vermeers, a head of Christ and *Isaac Blessing Jacob,* were also bought for the unfortunate Boymans and another, *Washing of the Feet,* went to the Rijksmuseum in Amsterdam. A huge *Last Supper* remained unsold.

Why these daubs were believed by anyone is hard to fathom. They are sentimental, badly composed, full of inconsistencies, loaded with weaknesses—as if Vermeer had experienced a series of bad days throughout his entire Italianate period. The small band of defenders kept pointing to *Supper at Emmaus* as the "proof" that Vermeer had painted in the broad, Italianate style and insisted that the naysayers simply didn't comprehend. They quieted their opponents—it was on the eve of the war—by saying that it would be an act of patriotism to buy the glorious Vermeers to prevent them from leaving the country. Germany was mentioned as the likely place they'd go if they weren't secured for the Netherlands. They were bought.

Then came the German occupation and no other connoisseur could travel to Holland to see them. Had they been able to, no doubt they would have instantly condemned them, as had some qualified Dutch experts. When the hostilities ended, one of the first individuals to spot *Supper at Emmaus* was a Belgian art conservator, P. B. Coremans, who is said to have laughed and asked, "Who is responsible for that ridiculous fake?" After the war there was hardly a defender for the pictures. Yet no one knew who had been responsible for them.

Van Meegeren might never have been caught had his rancid past not caught up with him. After the war he was arrested for Nazi collaboration. One of the charges was that a Vermeer, representing *Christ and the Adulteress,* had been acquired by Hermann Göring through a chain of dealers and that Van Meegeren had been the first person in the chain.

The picture in question was one of his truly putrid fakes, a sloppy and saccharine daub painted in 1943. The addled *Reichsmarschall* actually traded

for it about two hundred plundered Dutch paintings, although, while genuine, they were admittedly of mediocre rank.

The Netherlands Field Security Service arrested Van Meegeren in late May 1945. He could not give the satisfactory answers as to where the *Adulteress* had come from and how it had gotten to Göring. A month later in a brilliant stroke to save himself from the far more serious crime of collaboration, he confessed he was a forger, fiercely denying his Nazi links. Con man to the end, Van Meegeren proclaimed he ought to be looked upon as a patriot because he had swindled Göring and in doing so the Dutch nation had been able to regain hundreds of paintings that might otherwise have vanished.

There is no doubt that he was a Nazi and cruelly used the horrors against the Jews as a monstrously cynical means to peddle his fakes. At the end of the war the Metropolitan's curator of European paintings Theodore Rousseau Jr. was an intelligence officer who interrogated one of Göring's Dutch agents, Alois Miedel, the intermediary for the *Reichsmarschall* in purchasing a Van Meegeren. Miedel was running a small bank in Amsterdam. His wife was Jewish. Miedel claimed to Rousseau that he had supported the Resistance undercover, helping people to escape, out of loyalty to his wife. One night a middleman for Van Meegeren who Miedel knew was in the Resistance came and told him that Miedel bought paintings for Göring and that he had a Vermeer. But the man would sell to Miedel only on condition that no one ever knew where it came from; it was said to be from an old Dutch family who wanted to give their money to the Resistance to help Jews escape Germany and Holland.

Miedel promised and the picture was sent over. As Rousseau tells the tale, Heinrich Hoffmann, Hitler's photographer, art advisor, and an old friend of Miedel's, happened to be with Miedel at the time. Van Meegeren definitely knew Hoffmann was at Miedel's. Hoffmann was overwhelmed and called the painting a Vermeer masterpiece and phoned Göring on the spot. The *Reichsmarschall* sent a plane for it the next day.

The Dutch press tried to present the facts and described Van Meegeren as the "Dutch Nazi artist." But in early January 1947, the American writer Irving Wallace, swallowing Van Meegeren's story whole, wrote a whitewash article in *The Saturday Evening Post* entitled "The Man Who Cheated Hermann Goering," calling the faker an anti-Nazi hero. The bogus identity stuck.

Shortly after his arrest the beleaguered "hero" persuaded the naive

police, who didn't believe he was a forger, to allow him to paint a Vermeer in his prison cell. They could have had any of the Vermeers he identified as by his hand analyzed by the experts. Since he told them the materials he'd used, the experts could have quickly determined the truth. The forger who had swindled hated Göring and, he claimed, all the most accomplished experts in the world—a canard that seems almost never to be challenged—became even more of a folk hero, and the charges of collaboration faded away. Once again, Van Meegeren had his momentary victory.

His trial caused a sensation, probably because it was so photogenic. Most of his phonies were hanging as if in a gallery of honor. What was not reported as much as Van Meegeren's cult status were the findings of a commission assembled to analyze the works. The members discovered all the contemporary materials and gimmicks he had used. They came across some surprisingly dumb errors committed by the "genius" of forgery. One of his most egregious faux pas was a large dollop of cobalt blue—mixed in by mistake in his punctiliously hand-ground ultramarine, an ingredient common only after the late nineteenth century.

It was during the well-crafted defense by his two attorneys that much of the myth of Van Meegeren was created. They argued that their client was not guilty of the more serious charge of conspiracy to defraud, since he faked only because he was obsessed with showing the world his true genius and wanted to humble the experts only so that they would become more acute in the future. These spins appealed to the press. So, despite the fact that Van Meegeren was convicted on charges of both forgery and fraud and sentenced to a year in jail, the indelible image that emerged from the trial was that he was a roguish—but not villainous—trickster who deserved kudos for having showed up the pompous art crowd and for having "swindled" the Nazi monster.

"I didn't do it for the money," Van Meegeren insisted in a sincere-sounding way. "The money brought me nothing but trouble and unhappiness."

"There was no desire for financial gain?" the trial judge asked skeptically.

Van Meegeren replied, "No, no. I did it only from a desire to paint. I decided to carry on, not primarily from a wish to paint forgeries but to make the best use of the technique I had developed. I intend to continue using that technique. It's an excellent one. But I will never again age my paintings nor offer them as Old Masters."

His old masters have by now dulled out and look like pictures in a

Hollywood set. But the pernicious and unwarranted myth that surrounds their maker—that he fooled all the best experts in the world—is a juggernaut that may never stop. Van Meegeren didn't fool any real art experts or fakebusters, just the careless, the arrogant, and the sloppy—the very same types that get bilked today.

Van Meegeren's myth keeps on confusing people who should know better. It keeps raising the basic question about outstanding art forgeries. This is the one the witty art observer the late Aline B. Saarinen expressed better than anyone else: "The most tantalizing question of all is: If a fake is so expert that even after the most thorough and trustworthy examination its authenticity is still open to doubt, is it or is it not as satisfactory a work of art as if it were unequivocally genuine?"

Sadly, plenty of contemporary aestheticians and deconstructivist art philosophers affirm that the Van Meegeren garbage is as satisfactory as a genuine Vermeer. Which means, in a sense, to some dupes anyway, the "Vermeer man" got away with it. But never in the eyes of true fakebusters.

# HAS ANY FAKER FOOLED THEM ALL?

*A*nother so-called landmark of fakery that forgers keep bringing up to prove that the art world is populated by undiscovered, and possibly undiscoverable, fakes is truly intriguing. It's a tiara—a solid gold, openwork crown bought by the Louvre in the last years of the nineteenth century. Back then the tiara was believed to have been made in the fifth century B.C. by Greek goldsmiths and presented to the tyrant Saitaphernes by panic-stricken citizens of the Black Sea city of Olbia so that he wouldn't lay siege to the town and slaughter them.

The story the fakers tell is that the tiara might possibly still be on view in the Greek and Roman galleries of the Louvre and considered one of the finest pieces of Scythian gold ever had not its maker, the jeweler Israel Rouchomovsky, stepped forward and confessed to its manufacture. Like many fakers' tales, the story of Rouchomovsky's genius as a forger who might never have been found out had he kept silent must be looked at with a grain of salt.

The Scythians were by legend a cruel, Iranian-speaking nomadic people who inhabited the Eurasian steppes just north of the Black Sea in the first millennium B.C. and traversed lands that the Greek chronicler Herodotus described as "level, well-watered, and abounding in pasture." These nomadic horsemen might have been vicious warriors, as Herodotus amply describes, but they were also lovers of fine art. Their art was breathtaking, perhaps the most beautiful, poetic, sensitive, expressive—yet rugged—goldsmith works

ever created in Western civilization. This was primarily because they hired Greek artisans to make the jewelry. But the subject matter was far more vivid and powerful than anything the Greeks of the sixth and fifth century B.C. ever made for themselves. The Scythian works of art were all precious small objects. Because they were nomadic, these peoples didn't build buildings or erect commemorative statues. Their monuments, their treasuries, and their "investment portfolios" had to be portable—things that could adorn their bodies and could be placed in their kurgans, or round tombs, after they died.

The first Scythian works of note were excavated by chance during the time of Peter the Great in the early eighteenth century. The monarch became so enamored with them that he promulgated the first antiquities antiexportation law known to mankind. A very few examples of Scythian gold and leatherwork had slipped out to Europe in the nineteenth century, where they whetted the appetites of private collectors and museums eager to gather up exotic treasures from such a fierce, primitive peoples. The Scythians were a romantic's aesthetic dream come true.

In the 1870s and 1880s a sensational series of discoveries were made in the Crimea and the Ukraine in hidden, underground kurgans. Skeletons covered with chips of solid gold and surrounded by golden implements and jewelry were found, the kind of treasure King Croesus would have envied. These were finds from excavations of the great Bliznitsa kurgan and, in 1875, from the kurgan of the "Seven-Brothers" near the mouth of the Kuban River, unearthed by the flamboyant archaeologist Viktor Tiesenhausen. The discoveries easily outstripped King Tut years later.

Although none of the objects were ever exhibited in Europe, connoisseurs from Paris, Vienna, and London came to ogle them in Odessa, Rostov, and St. Petersburg. There were golden ceremonial helmets, tall conical extravaganzas made in openwork decorated with feather and acanthus patterns. There were solid gold scabbards with powerful and graceful representations of Scythians fighting and defeating the Persians. The figures compared favorably, some said, to the sculptures of the Parthenon. There was a gold bowl found in the Crimea in 1830 with Scythians lolling back on the ground. And there were many scenes of the famed horsemen capturing their horses, breaking them, training them, caring for them, and adoring them.

In the 1880s and 1890s many lavish publications were prepared with dozens of engravings and line drawings—collectors' books such as L. Weisser's *Bilderatlas* of 1884 and the super coffee-table volume of 1891 *Antiquités de la Russie Meridionale*, by Kondakof, Tolstoi, and Reinach. There wasn't a

private collector or major museum on the Continent or in England who didn't covet something Scythian.

Then, in 1895 and 1896, rumors began to float in the major art centers that something truly earthshaking in Scythian gold had been unearthed at Olbia, a Miletan colony on the Black Sea during Greek classical days, and might be exported.

Soon Heron de Villefosse, the curator of the department of Greek and Roman art at the Louvre and M. A. Kaempfen, the director of National Museums were approached by three agents, Schaschelle Hochmann who was Russian, and K. M. Szymanski and Anton Vogel from Vienna. What they had was a magnificent solid gold tiara, which anyone could see was one of the grandest antiquities ever discovered: a crown nearly seven inches tall weighing 16 ounces of pure gold. The crown of subtle conical shape was crafted with incomparable skill out of three distinct pieces, soldered together in ancient times. The shape of the crown was that favored by the ancient Persians and would eventually be transformed in late medieval times into the tiara worn by the popes.

The top section was embellished with delicate openwork that featured feather motifs, scrolls, and acanthus decoration. The bottom section was a frieze with a host of splendid wild animals in a grove of trees beneath a spray of vines, all typical Greek. The low, delicate reliefs in both zones were marvelous, but it was the middle zone that was triumphant. It depicted dynamic Scythian horsemen with their spirited steeds and a group of female acolytes making an offering of a tiara of almost exactly the same type— indeed it was the very same headdress—to a known historical ruler. A Greek inscription in high relief adorned a prominent turreted wall beneath the horsemen and priests: "The Senate and the people of Olbia to the Great invincible Saitaphernes." The curator knew instantly that the inscription in virtually identical form had been found during excavations on several stones of the ancient walls surrounding Olbia.

Villefosse and his director were stunned. They dared to hope that the impressive object was genuine. But Villefosse wanted time to scrutinize it carefully. He was disturbed that the agents kept hurrying him. They told him that there were other great institutions that had expressed avid interest in seeing the golden object. So his study was just a bit hasty.

There were a number of questions that had to be answered. Why, for example, had the tiara been made in three pieces soldered together? Eventually, Villefosse seems to have become convinced that the top portion, shaped like a drinking bowl, might have actually been one, despite the fact that it

was fashioned in openwork. It could have been a ceremonial cup of some kind, deliberately worked into the tiara made for the tyrant. A kind of extra homage.

Several assistant curators asked why some of the figures, especially the three women, looked as if they'd stepped out of a Renaissance painting, specifically one by Raphael and his assistants in the Vatican, depicting *Constantine's Victory Over Maxentius*. The figures on the tiara were grouped almost identically to those in an engraving of Raphael's picture by Giulio Romano. The curator answered that all it meant was that Raphael had been supersensitive to the spirit of classical antiquity.

There was some discussion about getting in touch with other colleagues for advice, such as Adolf Furtwangler, the crafty connoisseur of classical material in Munich.

But no. He was German, after all.

What about someone at the Hermitage? One of the Russians who had excavated Scythian objects? No again. The Russians might do something rash, perhaps even make a claim for it.

So, as it turned out, the due diligence performed on the tiara of Saitaph-ernes by the chief curator and the director of the Louvre was meager. During all of the study, the real clue about the true character of the tiara was staring them in their faces. For an experienced fakebuster it was kindergarten stuff.

Villefosse, blinded by his desire to acquire the rarest of the rare, approved the purchase. The general director supported him. The price was an astounding two hundred thousand francs—worth upward of eight million dollars today. The Louvre didn't have the money, so two friends of the museum advanced the cash with the understanding that they would be reimbursed by the chamber of deputies.

On April 1, 1896, the Louvre announced the purchase and put the tiara on exhibit. Thousands of visitors streamed into the Greek and Roman galleries, more visitors than the stuffy institution had enjoyed in decades. The officials were overjoyed.

The honeymoon was mercilessly brief. What subsequently happened can only be described as an intellectual, political, and satirical riot that kept blowing up and subsiding and blowing up again for almost six years.

The troubles began when, less than a month after the tiara went on display, a certain Professor Wesselovsky of the University of St. Petersburg slammed the object in the solar plexus with a statement to the French press that the cherished Scythian object was a fake. He called it, "Typically modern material probably crafted by a workshop of forgers now active in the

village of Ortschakov." The professor cited similar phonies having been offered to private collectors in Odessa, St. Petersburg, and Krakow.

The Louvre assumed the air of the Sphinx, saying nothing. Villefosse didn't bother to make contact with the professor or send someone to investigate. He still believed his own opinion about the tiara and thought the academic was simply jealous that a great national treasure had gotten away. It had happened many times before that a jealous art historian had condemned a genuine work for spite.

Some weeks later one of the most respected archaeologists and art historians in Europe who specialized in Greek works of the time of the Scythians, Adolf Furtwängler of Munich, criticized the golden crown of Saitaphernes anew. He pointed to the odd and inexplicable coincidence that several of its horsemen holding the reins of rearing horses looked almost exactly like those in a genuine silver Scythian object across town in the Bibliotheque Nationale known as the *Shield of Scipio*. Furtwängler minced no words. He described the tiara as "a forgery so tasteless that it could only excite disgust."

Villefosse, infuriated with the undiplomatic language, stated that the similarities were actually a most favorable sign and helped to substantiate the authenticity of the tiara. To find parallels of general style can indeed be a good sign. But to come across exact borrowings of specific passages is a mortal wound—invariably the indication that a forger has worked up a pastiche.

The French press reported gleefully on each salvo against the precious crown, and the city began to fall into two camps of tiara lovers and detractors. Satirical verses and songs were composed and sung in cabarets. Cartoons on the growing controversy enlivened the newspapers. In the cartoons the tiara gradually became lumpier and lumpier, the transformation only provoking the Louvre's officials to defend it more fervently. They had to. Their honor was at stake and, moreover, the chamber of deputies was just about to begin the debate on voting for or against the two hundred thousand francs to repay the increasingly anxious donors.

In August yet another blow struck the tiara. At a congress of archaeologists in Riga, Professor D. Stern, director of the Odessa Archaeological Museum, declared the thing to be a clever fake. He mentioned that two art-dealer brothers by the name of Hochmann were involved.

That news did alert the Louvre that perhaps all was not well, since only the curator and the director general knew that Schaschelle Hochmann was one of the three agents who had offered the prize. The keeper of the gold-

smith's works at the Hermitage was persuaded to come to Paris. After a hasty scrutiny he declared the object "good." (A few months later the same keeper reneged and condemned the work, but that news was bottled up by the Louvre.)

Based on this giddy news the then–public relations department of the Louvre issued a statement that all attacks against the grand tiara amounted to sour grapes. The Louvre rested its case. The chamber of deputies voted the staggering amount of purchase money. The officials were confident that they'd heard the last of the attacks against the beautiful tiara.

But the blows against it became more intense—to the delight of the press and the Parisian wits—and the criticisms seemed to make more and more sense all the time. In early 1897 the name of a Russian goldsmith and jeweler, Israel Rouchomovsky of Odessa, first surfaced. Someone observed that Rouchomovsky openly boasted about making jewelry that looked suspiciously like the tiara. His objects, admittedly less ambitious and in smaller scale, had almost identical openwork to that on the crown. His pieces were all in solid gold. They had soldered parts unlike authentic pieces that had been excavated under controlled circumstances, but very much like the soldered attachments of the Saitaphernes headdress. His objects also copied Scythian motifs taken slavishly from line engravings in books.

Rouchomovsky was tracked down and was asked if he had made the tiara. He flatly denied it.

And so, once again, the brouhaha calmed down. The anti-Tiaristes stilled their denunciations; the defenders smiled smugly; and for the next several years the oddly bulbous golden hat made to placate the tyrant Saitaphernes shone in the prime exhibition gallery of the Louvre's department of Greek and Roman art. Only to explode like a dormant volcano seven years later.

On March 17, 1903, a hack painter in Montmartre named Elina (his alias was "Mayence") was charged with forging paintings by the mediocre academic painter Henri Pilles (proof, if it be needed, that forgers will forge anything). Mayence proudly claimed responsibility for the tiara.

The story made world headlines. Crowds rushed back into the Louvre. On March 19 thirty thousand people streamed in, breaking all attendance records. Had any one of them looked at the tiara and noticed just one obvious flaw that the curator of the Louvre and the director general had stared at repeatedly for hours and had completely missed, then the truth of the tiara would have come out.

All doubts voiced before were hoisted anew, except for that one and

only one that would have toppled the piece instantly. Four days later the newspaper *Le Matin* published a letter sent in by a Russian jeweler named Lifschitz denying "Mayence's" allegations and revealing that his best friend and colleague Israel Rouchomovsky of Odessa had made the crown while he had looked on. The work had been exhausting, lasting a full eight months. It had been carried out between 1895 and 1896. The piece, "never intended to be a fake," had been sold for two thousand rubles.

The story was confirmed by a certain Madame Nageborg-Malkin, a Russian living in Paris, who had spoken not long before to Rouchomovsky, who had described to her his "anguish" that his perfectly "innocent" evocation of antiquity for an unnamed client—a work in honor of what might have been made in Scythian times—was on display in the greatest museum in Europe as a valuable antiquity. He simply didn't know what to do.

When this news broke the uproar between the two tiara camps was violent. The respected jewelers André Félice and René Lalique thundered that the tiara could not be wrong since it was so beautiful and perfectly made that only an artist the likes of Benvenuto Cellini himself could have fashioned it. As professional jewelers they knew. Other proponents of the tiara contemptuously dismissed Lifschitz's tale, referring to all Russians as crude, incompetent, and incapable of either making or understanding something as high in quality as the tiara of Saitaphernes.

Finally the paper *Le Figaro* dispatched a reporter to Odessa to confront Rouchomovsky in person. On March 25 the paper printed a startling telegram from the correspondent stating that Israel Rouchomovsky had admitted making the tiara and for twelve hundred francs in expense money was prepared to travel to Paris and prove it. The news spawned more headlines, bitter controversy, and a merry circus of aesthetic jokes and parodies.

Rouchomovsky sneaked into town. He registered at his hotel under a false name. His pseudonym was discovered. He was besieged by the press and autograph hunters. P. T. Barnum announced in all the French newspapers that he would purchase the tiara from the Louvre at the full price of two hundred thousand francs—but only if the object turned out to be fake. Once again the tiara became the craze of the moment with copies of all sizes —adaptations from cufflinks to drinking cups pouring onto the market. Once again the Louvre was inundated.

The French minister of education ordered an investigation and a distinguished commission was set up by the Institut de France to oversee it. C. Clermont-Ganneau, one of its members, immediately made a statement compromising his neutrality just slightly by branding Rouchomovsky so

"vulgar and ignorant of the works of antiquity that it was inconceivable he could have been responsible for the divine tiara."

Yet when asked for his proofs, Rouchomovsky provided them quickly. Where had he gotten his models? He showed the authorities his two books on Scythian art and pointed to the illustrations he had modified only a little. He referred to Giulio Romano's engraving of Raphael's painting in the Vatican and admitted that he had copied parts of the *Shield of Scipio*.

Even then the defenders refused to believe they had been duped. They insisted that Rouchomovsky was a publicity hound and the references he cited only proved the true ancient Scythian lineage of the great crown.

The jeweler described how he had made the tiara, carefully describing details of the soldering. Still the experts resisted.

Then curator Villefosse demand Rouchomovsky make a piece like the tiara. He did. More than one. (They still exist and occasionally appear on the art market as original Rouchomovskys.) Yet there were still doubts that Rouchomovsky was the creator of the golden crown. Until he patiently told the officials of the Louvre and the commission how he had damaged the object, and precisely where the damage was to be found.

At this the Louvre surrendered, though a few people in France today still claim that a part of the tiara must be ancient Scythian, perhaps the top "cup" soldered to the middle section.

Many French experts and hundreds of thousands of people who had flocked to the Louvre had seen the "ancient" damage and all had missed the painfully obvious reason why that "damage" proved the falseness of the tiara. But three people had, earlier, spotted the key point instantly and knew positively and forever that the tiara was garbage. The first two were Viennese experts—Dr. Bruno Buchner and H. G. Leisching—attached to the Kunsthistorisches Museum in Vienna. The third was a expert—no one knows who he was—at the British Museum.

Unknown to the Louvre, the Hochmann brothers had offered the tiara first to Vienna and the British Museum and both had turned it down. In Vienna the dealer had pitched to a group of titled and wealthy trustees who fell in love with the exotic crown—the crown of the bloody despot Saitaphernes who delighted in sacking cities and nations and either killing the populace or making them slaves greatly appealed to the nobility, it seems. In London it was said that powerful patrons of the arts had put tremendous pressure on the curators to seize the rare piece. In both institutions the curators studied the treasure and spotted the single fatal flaw. Both asked a similar question: "Why is it that all the damage over twenty-five

hundred years—the bumps, the pattern of knocks and bruises—all appear at unobtrusive points on the flat, lowest backgrounds of the reliefs, while none show up on the higher parts? Shouldn't one expect the bumps—some bumps at least—to appear on the highest parts?"

So much for the fake that was so brilliant all the experts were tricked and the piece considered a masterwork until the forger stepped forward. As usual the only experts fooled were the silly, arrogant, insensitive ones—those who never really looked at all.

Poor Rouchomovsky! Or so some said. He had started off as a folk hero who had "routed" all the pompous experts and was hailed as a "great artist" only to retreat to Russia denounced as a faker or imitator by both the defenders and the critics of the tiara.

At least he maintained his sense of humor. He created a series of goldsmiths' spoofs about the tiara and himself. One extravaganza of 1895 shows a pair of Saitaphernes—one seated on a sarcophagus and wearing the tiara, with a counterpart uncrowned and weeping on his tomb while children play ball with the tiara. After that humorous artistic counterstroke Roucho-movsky vanished into the steppes.

◆ ◆ ◆

Art forgery and humor are not infrequent companions. Take the late "Grand Master" of drawings, Eric Hebborn, who some say—and he boasted—is a forger whose works will never be detected unless he chooses them to be. He died in January 1996 in Rome.

The Hebborn unveiling began back in 1978 when Conrad Oberhuber was the curator of drawings at the National Gallery of Art in Washington, D.C., and was admiring two recent acquisitions he'd made from London's prestigious old-master dealer Colnaghi—a Savelli Sperandio and a Francesco del Cossa (1436–1478), both artists of the Renaissance. All of a sudden, he noticed that the style of the two drawings resembled each other and they both displayed the flowing lines of one and the same artist.

Oberhuber was alarmed and began to scrutinize the drawings with an intensity that comes with the first alarms that perhaps there's a fake or two in the house. He came to the conclusion that the paper of both sketches had been stained to simulate age and that this artificial process, plus the uncanny stylistic similarity of the works, condemned them.

The first thing a fakebuster does when he has the good fortune to compare two phonies by the same artist—after groaning and hanging his head in remorse—is to remember all other fakes by the same hand he has

seen elsewhere in the world. The sudden shock seems to bring to the eye and mind a superalertness, which would have been nicer to have had at the moment of the purchases, but better a discovery at any time than none at all.

In this case Dr. Oberhuber recalled another drawing by Francesco del Cossa, which possessed, he was convinced, all the characteristics of his fake drawings. What struck him—and dismayed him, for how could he have been so insensitive when he'd seen his drawings at the dealer?—was a startling combination of sophisticated, sinuous, flowing movement of line (soft, supple, swift) and some passages that looked muddled, awkward, and full of the tiny hesitations and misunderstandings that are never present in an original.

The mate was in New York's Morgan Library, one of the premier drawings collections on earth, and represented a page boy holding a lance in his left hand and cockily placing his right hand on his hip. It, like the Cossa in the National Gallery, was soft and sinuous, yet annoyingly vague in details—almost a too-perfect image of the Italian Renaissance. It had been purchased in the late 1960s by the Morgan curator of drawings, Felice Staemfle, a crackerjack connoisseur in her field.

Oberhuber contacted his colleague and told her to study the page boy with a doubting eye. Soon Staemfle came to the unhappy conclusion that it could not be old. The mixture of visual and stylistic faults, the curious "wash" on the paper surface and the fact that ink lines appeared to have been shaved back by a razor blade to make them seem timeworn proved the Cossa was a modern forgery.

Was it one of the best she had seen? she was asked. Not really. It was too sloppy to be the work of a master.

Yet Staemfle was not being fair, although perhaps understandably, for she was furious at having been fooled. The "Cossa" page boy had passed through three groups of drawings experts on its way into the Morgan Library. It had been auctioned by Sotheby's, who at the time had a pair of formidable drawings experts, Richard Day and Philip Pouncey. After that the drawing had gone to Colnaghi's, which had three experts also of high reputation and profound skepticism, and finally to the Morgan, where Staemfle and her assistants presumably had more than enough time to comb over the piece.

What happened next was unique in the field of art fakery. Oberhuber and Staemfle both informed Colnaghi's, since all three drawings had come from that source. Knowing that all three and dozens more had been purchased from Eric Hebborn, an English artist living in Rome, the gallery

informed all their customers who had purchased pieces that had come via Hebborn to send their drawings back.

Lined up, many of them looked terribly alike, whether Cossa or Sperandio or Augustus John or Giovanni Battista Tiepolo or Giombattista Piranesi or Rubens. They all exhibited the same flowing lines, the washed look, the plethora of sloppy parts, the mistakes, misunderstandings, and in places carefully razor-bladed ink.

Instead of covering up the grim realization, which many dealers might have been tempted to do, Colnaghi's made a statement to the press which was reported in all the London papers. The gallery didn't act right away but waited eighteen months from the time Oberhuber and Staemfle had proven their acquisitions questionable. In the statement Colnaghi's admitted that several old master drawings their experts had purchased a decade prior from one source were now doubted. "Scientific tests," *The Times* of London reported, "failed to prove that any of the drawings are forgeries, but in some cases where the owners have requested it and the consensus of expert opinion has been against their authenticity, Colnaghi's have refunded the purchase price."

The art market, reacting violently as always to rumors, began to remove from sale and make refunds for hosts of truly authentic drawings. A virus seemed to infect everything, a virus dubbed *forgeritis* by the maker of the Cossas, the Sperandio, and all the others he claimed were genuine drawings he had tracked down throughout Italy in the sixties and seventies but which in actuality he had created.

No one was more annoyed over the brouhaha than the forger Eric Hebborn. He was enraged by what he believed was the universal hypocrisy of Colnaghi's and the others. As he wrote in his "confessions," *Drawn to Trouble*, the Colnaghi statement, which never mentioned his name for fear of libel, really said, "It's all the fault of that nasty Eric Hebborn in Rome, who year after year has offered us duds without telling us what they are. Expertise is no proof against villainy. We're sorry and, as gentlemen, we have given the collectors their money back. Furthermore, we promise never to have anything to do with that scoundrel in Italy again."

In Hebborn's mind, he was not to blame. Nor was he a criminal to have forged, at his admission, five hundred old-master drawings. Nor was he a cheat for having made scads of money from his phonies. His answers are classic fakers' replies: There was nothing technically criminal "in making a drawing in any style one wishes nor is there anything criminal about asking an expert what he thinks of it." As for the money, well, "I can see no reason

why I should give my work away." And, "If I am a crook, why do they not press charges?" Finally, he asserted that after Colnaghi's had made the announcement, he was besieged by art dealers who asked him to "find" this and that and he would produce their desires, leaving his creations in brown paper envelopes addressed to their aliases on tables and chairs in the lobbies of chic hotels in Rome making twelve hundred pounds or more a shot.

Hebborn wrote exuberantly about this "moral code" that allowed him to rationalize his acts.

- Never sell but to a recognized expert.
- Never ask a higher price than what an original would bring.
- Never make an attribution unless a recognized expert has been consulted. This makes the description the fault of the expert, not the faker.
- Never hit an expert when his "acumen is down." It's not "fair play to force an expert into a hasty decision over a boozy lunch."
- Never bribe or pay an expert for his opinion.
- Never question an expert's opinion unless it conflicts with equally expert opinion.

Hebborn justified his "moral code" and his life of counterfeiting with an outburst against the intermediaries. They "earn their living on the strength of being able to tell the genuine from the spurious and thus the faker is perfectly within his rights to pit his wits against theirs." To hell with trust and to hell with the uneven playing field created when the faker fails to inform the experts that his "game" has begun.

After the unmasking, Hebborn unmasked himself—to a point. In his genuinely amusing and important book—for the field of fakery—he confessed to jigging up five hundred or more old masters in his "Golden Years" from 1963 to 1978. His admitted range was very broad, more so than any known drawings faker in history, and his spurious offerings contained works by contemporaries as well as by artists of the sixteenth and seventeenth centuries.

He boasted of starting a new career after the 1978 exposure and completely changing his sloppy, immature, mistake-ridden manner of working. He became cautious, wily, proficient, no longer using the same flowing lines for every fake, never again employing the same casual wash for aging paper, avoiding such easily detectable techniques as using a razor blade to scratch down fresh inks to make them look old.

This time, he swore, his new fakes fooled everyone because of his punctilious manner and because, too, he "laid down certain clever smoke-screens and dodges" in order to prevent anything could be traced to him. Hebborn claims that his "new" five hundred blows made from 1978 to 1988 are so superior that "it gives me some satisfaction to note that the museums are still buying them and I look forward to the recent acquisitions notices in their bulletins with the same eagerness as some people await their football results."

No doubt Hebborn did go underground and become even more adept and slippery. His revelatory stories about his knowledge of what an old master is made of and how he simulated them are stunning. He writes lyrically of his searches to discover the paper to use for his old masters in the fly leaves of old books, paper that is precisely the age of the specific artist forged. Until the end of the eighteenth century, he explains, all paper was made by hand in Rome. Nicolas-Louis Robert invented a machine to pro-duce paper in continuous sheets, it came in lengths of thirty to fifty feet. Thus Hebborn selected artists to fit with the paper he found, not the other way around—a brilliant stroke.

He speaks lovingly of the systems he used to avoid having his own style show up in his works. He is astounding when he shows how he speeded up creating a drawing to make it look naturally old. He reveals that he found an artist's paint box of the eighteenth century with all the materials of the ancient times he was faking and thus undetectable to science, which, by the way, he pooh-poohs throughout his book.

Perhaps most impressive of all Eric Hebborn's techniques was his dis-covery that routine copyists and mediocre fakers tend not to copy the lines in the same sequence as the old master made them. He observes, "The sequence in which the lines of a drawing are put down is vital. This is because of the rhythmical nature of good drawing where one movement leads naturally to another. If one changes the order in which the lines are made, one changes the rhythm. One must know which lines are construction lines, connecting lines, and which the final strokes used to strengthen or stress the essential movements."

Yet despite Hebborn's wit, his extraordinary tales, the hilarious confes-sions, even his welcome attacks on art dealers who must learn a great deal more about whether a work is a fake or not, he never really lifted his "old masters" above their base level—their plodding, sloppy, insubstantial, forced, academic essential nature.

On one double-page spread he offers up two sketches of a young boy:

*Henri Leroy,* by Jean-Baptiste-Camille Corot (1796–1875) which is in the Fogg Museum at Harvard, and Hebborn's copy of it, challenging the reader and observer to tell which is bogus and which authentic—labeled figures 48 & 49 in Hebborn's book. He warns, "Take your time, and seek the hesitant line of the copyist as opposed to the strong sure line of Corot." He gives the answer at the bottom of the page.

I, for one, instantly selected the drawing (figure 48) that combined an unmistakable heavy-handed and academician's touch (which Hebborn calls a "strong sure line") with congeries of tiny mistakes, most of them in the rendering of the child's costume. His phony seemed all too obvious, far too plodding and deliberate for the nervous and carefree genius of Corot. And when I read his footnote telling me that the drawing I'd picked—"Answer, Fig. 48"—was the real Corot, I laughed. I wasn't surprised when I later on read the sentence, "What if I should now tell you that the answer at the bottom of the page is wrong?" I had, of course, been right.

It may be because I do have an advantage over other observers of the works of Eric Hebborn. I had the luck of having one of his efforts exposed quietly and in confidence when I was running the Metropolitan Museum of Art. The curator of drawings, Jacob Bean, had come to the institution from the Louvre where, as an American, he had the rare privilege of working in the bursting collections. When it came to assessing real and fake, Bean was about as good as anyone I'd ever seen. He was also courageous and forthright in admitting when he had been had, which was not very often. It must have been early 1968, long before the Eric Hebborn explosion, when he asked to see me about the existence of a new, clever drawings faker.

He brought an extremely handsome pen-and-wash drawing with touches of blue watercolor supposedly by the Flemish master Jan Brueghel (1568–1625), depicting some Roman round tombs at Baia. Bean explained how he had bought it at Colnaghi's some five years before, but had only recently begun to study it really hard and had come to the conclusion that it was probably a fake.

His reasons were compelling. Essentially, there was no love of antiquity in its bland lines and shapes and architecture, none of the passion to record the ancient past which must certainly have gripped a Jan Brueghel, dazzled by the beauties of Italy as had been so many northern artists. The fallen brick and concrete arches showed none of the inherent strength of Roman manufacture, which Brueghel would have recorded zealously because that's why he chose the subject matter, but were instead lumps and muddled lights and darks, a romanticized series of objects. Jan Brueghel was far earlier than

the Romantic movement as Bean pointed out. It was difficult to have a Romantic style in the seventeenth century.

The final argument was the clincher—the size of the paper: Didn't it look like the shape of a page in a book? Rather.

I was convinced. What were we to do, ask for our money back? Bean suggested not. The cost had been fairly modest and it was his mistake, something responsible museums had to swallow. Besides, if the drawing went back, who was to say, for sure, that it might not show up again in the art market?

Over the next four or five years Bean showed me either the actual drawing or photographs of drawings made by the same "lazy faker," as he trenchantly put it, the faker who turned out to be Eric Hebborn, though we were never able to pin a name to him. Bean showed me a couple of Tiepolos, a Rembrandt or two, a half dozen drawings by Stefano della Bella, whom the anonymous faker seemed to like especially, Van Dyck, Luca Cambiaso, and Jacopo da Pontormo. Naturally, we avoided their purchase.

Recently, the Brueghel has been defended by the current Met drawings curator and by Hebborn's former lover who lives in California. The latter has charged that his late friend has exaggerated wildly the number and the character of the drawings he forged. He claims that the Brueghel was never faked. Moreover, the tale Hebborn recounted, that after he created the fake he was so scared he might be discovered that he flushed the original drawing down the toilet, was also a fraud.

Good as he was, even Eric Hebborn couldn't fool them all. Those most apt to be fooled were the ones who were willing to pump "product" into the expanding market, those who never gave his creations an intense scrutiny, and the would-be fakebusters.

◆ ◆ ◆

Has there ever been, then, any art forger who has tricked them all, even the most sensitive fakebusters? I know of only two. One of the nineteenth century and one of today. The former is the "incomparable" Giovanni Bastianini of Florence, who because of his anger about not receiving a fair share of the profits encouraged his own unmasking. The latter is a Mexican who over the past twenty years created a total civilization of art that never existed and who is the denouement of this book.

Giovanni Bastianini died in 1868 at the age of thirty-eight. He seems to have been trained as a copyist, not a faker—and there were in nineteenth-century Florence, as there are today, studios where one can learn the faking

game. In his early twenties Bastianini started working primarily for a Florentine dealer by the name of Giovanni Freppa, and was commissioned to make superior copies of the works of the most popular Renaissance sculptors, who from the middle of the century had become the rage of the most avid collectors. Under the eager pushing of Freppa, Bastianini fashioned evocations and stunning pastiches.

The Victoria and Albert Museum possesses a dazzling low relief by Bastianini depicting the *Virgin and Child* in which the Virgin was patterned after a plaster copy of a destroyed sculpture by Antonio Rosselino (1427–1479) and the Christ from a fragment attributed to Desiderio da Settignano (1430–1464). In 1862 the officials of the museum believed the carving to be by Rosselino because of its tenderness, sureness, and majesty of expression.

Bastianini soon became more skilled and creative. He produced a bust of Girolamo Savonarola, the Florentine fundamentalist firebrand who burned books and then was burned himself in 1498. This marble was colored and aged and seeded away in an ancient villa near Fiesole owned by a family that claimed centuries of Florentine lineage, the Inghirami. There it was "discovered" by a journeyman Florentine picture dealer, L. Capponi, who was, of course, in on the scheme.

Capponi was "allowed" to buy it for six hundred and fifty lire and promptly put it on display in his shop. The marble caused a sensation not only because of the historic import of having a bust of the man who had all but wrecked the Medici but because of its considerable beauty, for it is an admittedly powerful work. The moment it appeared happened to coincide with the growing fervor within Italy to preserve its historic past, and legislation was being considered for the first time that might restrict the free export of national artistic and historic treasures.

Once the bust went on view, two patriotic artists scraped up the asking price, which had risen to a phenomenal ten thousand lire. The patriots for aesthetics, Giovanni Costa and Cristiano Banti, arranged for the bust to be exhibited before the public.

The chief confidence man in the racket, dealer Freppa, was elated by the success of the elaborate scam. He appears to have encouraged Bastianini next to make a bust of a revered poet and philosopher of Florence, Giralomo Benivieni (1453–1542). He did so using as his model a tobacco worker by the name of Giuseppe Bonajuti, who possessed a delightfully craggy, typically "Florentine Renaissance" physiognomy. The bust is exceptionally appealing even today and looks like the very spirit of the Renaissance, in art and in poetry as well. Bastianini was paid three hundred and fifty lire.

When the piece surfaced it was looked upon as a major discovery, perhaps by Donatello or possibly Andrea del Verrocchio. One art critic had this to say: "We did not have the pleasure of knowing Benivieni, but we confidently assert that it is a striking likeness." Such naïveté was not unique.

Bastianini and Freppa next cooked up a bust of a pretty young woman of the Renaissance which became known as *La Chanteuse Florentine*. This, as the Benivieni, was slick and sentimental, not at all the gritty realism for which Florentine art of the fifteenth century is famous. That's why Bastianini's works had widespread appeal. In order to legitimize the *Chanteuse*, Freppa conjured up a letter in French from Giacomo Rossini to his friend M. Castellani in which he loses his mind for the statue, calling it an "adorable statuette" despite the fact that both the sender and writer were Italian. It was bought by an eminent French collector, Edouard André in April 1866.

In 1864 the striking portrait of Benivieni was bought by a French dealer, F. de Nolivos, for seven hundred francs with the understanding that if he could sell it for a profit, Freppa (and Bastianini, unknown to de Nolivos) would share a percentage. De Nolivos took it to the Parisian auction house Hôtel Drouot, where the Louvre bought it for a hefty thirteen thousand six hundred francs in 1866. This is equivalent to something in the high six figures these days, pretty sensational for a sculpture.

The Renaissance poet was the toast of the town, and at first Bastianini and Freppa were pleased. Then disillusion set in when it became obvious that dealer de Nolivos would not only not pay Freppa any more money but also refused to believe, when informed, that Bastianini had the talent to make such a spectacular work.

Seeing that he wasn't going to receive his percentage, Freppa, supported by Bastianini, called mortar fire onto his own positions by writing an article in the magazine *Chronique des Arts* in December 1867, which spelled out in detail just exactly how Bastianini had faked the sculpture. The Louvre and the minister of culture, the arrogant and leaden-eyed Count de Nieuwerkerke (who would later vilify the Impressionists) steadfastly defended the phony and it was only after Bastianini dropped a host of indisputable clues that the fraud was conceded.

When Bastianini's fakes came to light, they were still admired. One of those patriotic artists who had dug so deeply into his pockets to save the "Savonarola" for the nation said he was delighted to learn that so fine a sculptor as the maker of his bust was still alive. (The work is today on exhibit in the Convent of San Marco in Florence, as a Bastianini.) The man who had been bilked into forking over fifteen hundred lire for another

Bastianini masterwork, the bust of a Florentine gentlewoman, Lucretia Donati, sold it to the Victoria and Albert Museum as a Bastianini for a sum that wasn't too far below that paid for genuine Renaissance pieces.

Today, though some art historians have belittled Bastianini's achievements—the late sculpture connoisseur Sir John Pope-Hennessy described him as "diligent and uninspired"—his works stand up, eerily so. He did capture the mysterious alchemy of the Renaissance better than any forger and even better, according to some, than the lesser artists of the Renaissance themselves.

His works are infinitely superior to the sketchy, untutored, and mostly laughable Renaissance sculptures by Alceo Dossena, who has, unjustly, received enormous press attention as the best forger in history. As Mark Jones, the editor of *Fake! The Art of Deception* observed, Bastianini may still be dishing out his formidable brand of magic, a century after his untimely demise.

The particular magic comes in the form of a terra-cotta bust of a woman that the Victoria and Albert Museum has owned since 1912. When acquired it was considered to be Bastianini's precise copy—a superb one—of a work by Desiderio da Settignano in the Louvre, which was considered a genuine Renaissance piece. Now, however, doubts are beginning to cloud the Louvre piece. It seems not unlikely that the Victoria and Albert Desiderio is Bastianini's model for the Louvre sculpture—another Bastianini.

# DEEP SUSPICIONS

When I became director of the Metropolitan in 1967, I decided to participate in a series of seminars offered by our education department to certain graduate students at the nearby Institute of Fine Arts who were interested in becoming curators. My subject was the ongoing plague of art forgeries and how to detect them. I wanted to pass along some of the secrets I had learned in my years as a fakebuster. I also figured there was no better way to keep my own eyes sharp.

I talked to a number of groups over a period of three years and believe I scared most of the students into realizing the extent and the devilishness of fakery. I restricted myself to the medieval period and chose a number of authentic and bogus items on exhibition and in the storerooms. My basic theme was that one had to be extremely cautious in jumping to a set conclusion about a fake and then embracing that conclusion for the rest of one's career. I tried to show that sometimes what seems to be artistically superior can turn out to be a piece of chicanery.

To do this I selected a series of pairs or near pairs mostly of decorative-arts objects, one piece authentic and the other a faker's attempt. One of the examples was the pair of fourteenth-century French ivories that Erich Steingräber and I had discovered—one real, the other a capable adaptation of the nineteenth century. Another twosome were very similar Limoges enamels, one authentic, one spurious. Yet another was a pair of thirteenth-century bronze figures. The pièce de résistance was a pair of French silver censers dating to about 1500—supposedly.

With the first two examples, the students were quick and unerring. They were eloquent in their descriptions of how the fakes were lesser in energy, fainter in execution, sloppier at times, especially in details, often incomprehensible or even wacky, lacking the subtlety of the spirit of the age they were supposed to be. One student, I can't remember who it was, even pointed out that one of the bronze figures must have been faked from one viewpoint, a single photograph. The reason, he thought, was that the clothing and hair on the back of the figure was messy, vague, and didn't quite follow around from the front, which had been neatly handled. The photo used by the forger only showed the front.

It was a penetrating observation, especially for a student not steeped for long in matters of forgery. Many forgeries of three-dimensional objects collapse because the side or back which cannot be seen by the faker is simply filled in incorrectly. And, surprisingly, not many museum people or connoisseurs seem to understand that.

The silver censers were not so easy. These covered incense burners were fashioned like a tower with windows, turrets, crenelations, and buttresses. They appeared to be virtually identical, a perfect pair made by the same late-Gothic silversmith. Yet, I warned the students, one was real and the other a magnificent copy of the nineteenth century at a time when the Gothic style was revered and had been repeated countless times in objects ranging from church paraphernalia to jewelry. From the middle to the late nineteenth century there were restorers specialized in repairing old and battered or fragmentary Gothic church objects who often became forgers after hours, creating epic pieces for unscrupulous dealers. I told the students there was one vital clue that would allow them to figure out easily which censer was the copy. Just one clue.

Under a pocket magnifier the censers were radically different. One was beautifully fashioned with strong, sure lines and skillful forms—clean and sharp-edged with the marks of its age in numerous bumps and bruises. The second appeared to be casual in drawing and sculpture. No form was the same. Each little tower had a different dimension and shape. The buttresses looked pasted on, hardly capable of strengthening architecture. This second censer appeared to be made of soft, tossed-around silver, like melted wax which in certain areas appeared slightly out of focus under the glass.

Each censer had its champions. Half the class vouched for the authenticity of the "pure" one. The "soft" one had an almost equal number of fans. And the arguments for the authenticity of each were persuasive. In fact, my premise that one censer had to be fake was challenged by several students.

Why was I so confident that one of them had to be phony? Was I playing a trick? Couldn't they both be right? Wasn't it possible that in the sixteenth century one craftsman could have had a steady hand while the other was shaky? Couldn't one—the "pure" one—be by a master and the slightly inept one by an apprentice?

The rationalizations were entertaining and I tweaked the students by remarking that such attempts to rationalize always surrounded a good forgery when the prospective purchaser or owner desperately wanted it to be real. But, I insisted, what about the clue? The proof that one censer could not possibly be right?

Nobody spotted it. Well, it was arcane. The tip-off showed up in the "pure" censer, the one so beautifully made that it seemed almost cautious. I was able to demonstrate that the host of ancient bumps and knocks had been copied almost exactly but in slightly different positions from the more "casual" censer! Close scrutiny proved that these were not the marks by someone dropping the censer or swinging it too hard. These were small hammer marks. Instead of abrasions there was evidence of a file having been used. And so on. The basic point of the exercise was that with certain fakes, the good-looking one—the "pure" one—can be the bad one.

Perhaps it was my using the two censers in the seminars that got me thinking darkly about one of the Metropolitan's most famous objects, the so-called *Rospigliosi Cup* of the sixteenth century. When the cup was in the possession of the art collector Benjamin Altman it was said to have been made by the finest goldsmith of the Renaissance, Benvenuto Cellini (1500–1571).

The cup is in the shape of a gold scallop shell with energetic enamel inlays on the underside. The glowing receptacle stands on the back of an enameled dragon that perches on top of a grand turtle, also vividly enameled. The handle of the stunning cup is a crowned sphinx enameled all over, with wings and golden bare breasts. Hanging below the breasts is a huge, perfectly shaped pearl. The cup has always been considered the very symbol of the late sixteenth century with its reverence for playful, luxurious objects decorated all over with grotesque and lively etchings and enamels.

We all knew that the splendid piece wasn't by Cellini. One of the Met's most skilled curators, Yvonne Hackenbroch, had demolished that legend back in 1969. She found that the decorative features had to have been adapted from a series of twenty-one engravings of grotesque vessels published in Antwerp in about 1548, designed by one Cornelis Floris (1514–1575), an architect and sculptor of superior talent.

Hackenbroch showed that Floris's grotesques enjoyed a huge popularity in Florence in the late sixteenth century and were extensively used by goldsmiths working there. They were earthy, even obscene at times, anticlassical and outrageous. Just the thing to offset the ponderous staidness of the High Renaissance. She had even been able to pin the cup to the goldsmith most likely to have made it—the Delft goldsmith Jacob Bylevert, known in Italy as Jacopo Biliverti. Biliverti had fled the Lowlands to Florence in 1573 after the Spaniards sacked Antwerp. Once in Florence he was hired by Francesco de' Medici. One commission had him creating a pair of sphinxes to embellish a spectacular lapis lazuli vase carved by Bernardo Buontalenti (ca. 1536–1608). These sphinxes seemed to Hackenbroch full-blooded sisters of the creature on the *Rospigliosi Cup* and on that basis and a few other pertinent stylistic points, the scholar attributed the cup to Biliverti.

Her reevaluation was going on just before the Metropolitan's centennial in 1970 when we were planning to conclude the year-and-a-half-long celebrations with a blockbuster exhibition entitled "Masterpieces of Fifty Centuries" in which we wanted to show in chronological order what we considered the finest works of art in the entire institution. The *Rospigliosi Cup* was intended to have a prominent position in the show. I was pleased with Hackenbroch's researches and didn't care if the treasure wasn't a Cellini.

In selecting the various works of art for "Masterpieces" I had the opportunity to examine many of them in my hands. In fact, I insisted upon it and spent a number of heady hours in the various departmental storerooms studying pieces that were off exhibition for the first time in years. There might never again be such a chance.

I was enthralled with the *Rospigliosi Cup*—at first. Then, as I inspected it with my pocket magnifying glass, I was shocked. First of all, the thing was so perfect. The drawing of all the decorative areas where the enamels had been laid in was so correct, almost as if a robot had done them. There was a fussy prissiness to all the engraving. The faces of the turtle, the dragon, and the sphinx seemed to me to be stiff, vapid, though marvelously rendered. The breasts of Madamoiselle Sphinx were as if covered by two discreet veils, which was hardly what I expected to find on an object made during the raunchy epoch of Mannerism.

This was not the gorgeous Impressionistic technique of Cellini, whose magnificent saltcellar in the Kunsthistorisches Museum in Vienna I had just examined. This was a kind of mathematical perfection. Nothing seemed to be organic. There was no flow, no spirit. It was cold and unemotional, having no breathing, moving "flesh." Worst of all, the cup had few marks of

damage at all on it—no bumps, no scratches to speak of, no sign that it had come down through four hundred years or so. I could think of only one thing as I looked at it—that nineteenth-century "pure" censer. And the *Rospigliosi Cup* had even fewer marks of age!

I didn't tell a soul about my qualms that this great treasure of the Metropolitan, the subject of so many posters and postcards, one of the prides of the institution, was possibly a forgery. Was I seeing things? I was confused.

I looked into the history of the piece and became more confused. The provenance of the *Rospigliosi Cup* appeared to be indisputable. The first time it was mentioned was in an inventory of the possessions of the Rospigliosi family taken in 1722, precisely October 6, and the papers were cached in the state archives of Rome. The piece was described. A translation had been made by Hackenbroch: "A tazza of gold worked like a shell, on a foot in the form of a tortoise, and an enameled reptile, and for a handle a winged sphinx also of gold, and that sphinx has hanging at her breast an irregular pearl of about twenty grains and the whole weighing three pounds."

The cup had been published in 1852 in a forerunner to coffee-table volumes by a pair of scholars cataloguing the best decorative arts objects of medieval and Renaissance date. A very large and detailed colored illustration of it was printed, one that is extraordinarily detailed—or so I was informed. I didn't actually get the volume from the library and examine the illustration; I should have.

Finally, the cup was mentioned by Eugene Plon, a famous connoisseur of the late nineteenth century who wrote a standard work on Benvenuto Cellini. Plon described seeing the cup in the possession of Prince Rospigliosi in his ancestral home near Pistoia. Plon carefully stated that although there were no documents proving that Cellini had made the object, the prince was certain that it had belonged to one of his ancestors, a grand master at the court of the grand duke of Tuscany.

After that the record was slim. The treasure was sold in London shortly after the turn of the century by the eminent dealer Charles Wertheim to the renowned collector Benjamin Altman who gave it to the Metropolitan as a bequest in 1913.

Yet my doubts didn't disappear entirely. I was obsessed with the possibility that the grandiose piece could be a nineteenth-century concoction; there were countless examples of forgers making exceptional copies of heirlooms for families that concealed the original and sold the copy. For once I didn't raise a rumpus and the *Rospigliosi Cup* remained proudly on exhibit.

◆ ◆ ◆

My worries about the *Rospigliosi Cup* had a decided impact in how hotly I chased after supercollectors Jack and Belle Linsky for their collection of old masters, French furniture of the eighteenth century, luxurious Renaissance objets d'art, and sixteenth-century jewelry, which I started to do three years later. The two collectors had made an enormous amount of money from Jack's company, Swingline staplers, and had started acquiring with an outspoken gusto seldom seen in the rarefied and oh-so-polite circles of those who acquired French furniture and old-master paintings. Jack had become mentally incapacitated and Belle, a diamond-in-the-rough with a harsh New York accent, had taken command.

She would literally toss her head back and bray about her auction triumphs, boasting how she had outbid all the cowardly museums and private collectors in the world. I found her frank delight in having beaten all the establishment collectors refreshing. Her observations about the art she owned were, thankfully, never couched in the staid and dull language used by art historians. Belle Linsky got a bang out of her divine French furniture and had a good time telling everybody about it.

I wanted the collection for the Met. The paintings fit in decently with the museum's holdings and the furniture was perfect for a group of French period rooms we were thinking about. Belle even had a group of eighteenth-century Russian porcelains that were about the best I'd seen and we had very little of that kind of thing. Moreover, Belle told me she was interested in funding a number of curatorial positions. In museum work, the hardest money to raise is for curators' salaries.

The negotiations finally got down to Belle agreeing to give everything plus an indeterminate number of endowments for curators' pay and student fellowships. The only sticking point was that she demanded that her pieces be exhibited in special galleries separate from the rest of the museum, the Jack and Belle Linsky Galleries. The works could never be loaned out and had to be displayed all the time with the sole exception being the refurbishing of the galleries every twenty years or so.

I had agreed to some pretty pushy demands on the part of the executors of the estate of another powerful collector, Robert Lehman, so I had no qualms about displaying certain private collections in galleries separate from the rest of their department. Yet Lehman's works were far more numerous and far finer than the Linskys' treasures and with his there weren't the stark

ukases of "always-on-display and no-loaning." Yet I was of half a mind to go along with the Linskys' wishes. I decided to pay a visit to Belle's apartment for one last look before finally making up my mind and recommending the deal to the trustees.

I toured the paintings and in the cold light of day, and reevaluation, found that out of the forty-seven, there were only two that I could honestly say were equal to or better examples of the same artist already in the Met. One was by an artist we didn't have at all, the Spaniard Luis Eugenio Meléndez (1716–1780), who was a contemporary of Goya's, but the Linsky work was not representative of his intimate works. There were several-dozen Renaissance and Baroque bronzes, but nothing that cried out for salvation. The medieval works were lackluster, I had to admit. The French furniture was excellent, especially a commode by Jean-Henri Reisener (1734–1806), but the museum already owned more French eighteenth-century furniture than it could display.

I was getting more and more chilly. My decision not to pursue the Linskys all that fiercely came when I stood in front of a large glass case in the spacious Linsky salon, gazing at a number of pieces of Renaissance goldsmiths' works: jewelry, rock crystal bowls, and a diminutive house altar in wood and enamelwork. Bells began to ring in my head. These *objets de virtu* had, I thought, distinct similarities to the *Rospigliosi Cup*. So cautious, so pure. And virtually no knocks or bruises.

This was particularly true of one of the most lauded gems of the collection, the house-altar/cabinet combination, a spectacular tiny German work of the late sixteenth century. I had listened to Belle's ecstatic description of the truly stunning piece on a number of occasions. To her it was the finest on earth, more complete than even the material by Wenzel Jamnitzer (1508–1585) in the Green Vaults in Dresden. Belle had a point. Her diminutive but luxurious piece of decorative arts seemed equal in quality to at least the one in the world-famous Treasury in the Residenz in Munich.

It was only a foot high and was loaded down with enameled religious scenes, including a dramatic depiction of the Adoration of the Magi in the central portion. The Last Supper and Saint Martin and the Beggar were decorated with an abundance of gorgeously enameled scrollwork, pilasters, columns, fanciful figures, heads, busts, and even a miniature Persian carpet in enamel. It looked like a fantastic skyscraper ablaze with figural decorations. The figures were the size of a thumbnail.

The only problem with the thing was that hard as I looked, I could find

little damage. Cold enamel is exceptionally fragile material. In it there are always losses. But this cathedral-like altar had virtually none.

On the basis of those anxieties, I stalled on Belle Linsky's mandates. She became annoyed with my casual attitude and swore she'd give her collection to another museum. That was fine by me, for I was becoming increasingly edgy about the true value of the collection, thinking there was the real possibility that one of its most illustrious sections—those fancy jewels and *objets de virtu*, just the kind of thing people would love—was riddled with phonies.

I retired from the museum in 1978 and forgot about the Linsky problem. The chairman of the board, C. Douglas Dillon, one of the greats in the history of the place, responsible for raising more funds than perhaps anyone in its history and for igniting an interest in bettering the Oriental art collections, took up the task of landing the Linsky Collection as the challenge of the decade.

Doug Dillon's efforts were successful and the collections came to the museum, under some choking restrictions, and were installed in several galleries incongruously separated from the rest of the Met's similar holdings. Apparently, no one in the curatorial department involved had raised a question about the precious Renaissance objects.

Until 1978 when Charles Truman, a young assistant keeper of ceramics at the Victoria and Albert Museum in London, rediscovered a sizable cache of colored drawings and notes by a German goldsmith of the nineteenth century by the name of Rheinhold Vasters. Truman, a lively fakebuster, instantly recognized that many of the thousand or so drawings were not for modern jewelry by Vasters, but were working drawings for a whole series of fakes of Renaissance and Baroque goodies.

The year following, Truman published a four-page article in the now-defunct *Connoisseur* magazine with the amusing subhead, "A New Gorgon Arises to Turn Dealers and Collectors into Stone." The drawings Truman had bumped into had been, as he described it, first offered to the Victoria and Albert Museum in November 1912 by a famous London art dealer, Murray Marks, for study purposes only. Edward Strange, the then-keeper of the department of engraving, illustration, and design, turned them down, hoping for a gift. He noted that they were "of considerable interest, being executed with remarkable skill as designs for goldsmiths' work, many pieces of which, I understand, have been placed on the market as old work." Strange never told anyone of his doubts about the authenticity of the draw-

ings. In time 1,079 drawings by Vasters were given to the Victoria and Albert, "lost" inside the vast building and found again by Truman.

Truman mischievously wonders in his article if the keeper of metalwork was even informed of the fact. Probably not, for then the Victoria and Albert, and the British Museum as well, would have realized the precise drawings for works that up to then they had assumed were sixteenth- and seventeenth-century pieces, could not be earlier than the nineteenth century.

Truman observed that Vasters's "detailed notes leave little doubt that the items were intended to be manufactured in the workshops. In one instance as many as 32 identical links were ordered, and mention of 2, 3 or 4 pieces of the same design is not uncommon."

One note recorded a connection with the Viennese *marchand-amateur* Frédéric Spitzer, a flamboyant and powerful member of the world of antiques. Spitzer, who ceaselessly scoured Europe for pieces, eventually assembled a staggeringly large collection of antiques, from arms and armor to ivories, glass, enamels, bronzes, and especially the kinds of materials Vasters had so lovingly drawn.

The link of Vasters to Spitzer was not good—for anyone but a fakebuster. Every art forgery specialist knows that a towering percentage of the thousands of objects sold by the Spitzer estate "in the sale of the century" in Paris in 1893 were forgeries or so addled by restoration that they were tantamount to fakes. Today when one spots an ivory or a bronze or a medieval wooden casket or even an embroidery and certainly a piece of Renaissance or Baroque jewelry with the provenance *Spitzer Collection,* one can be almost certain of past chicanery.

Spitzer was a master image maker and when heavy hitters in the art-collecting world were invited to his private museum, the Musée Spitzer, in the fashionable sixteenth arrondissement, it was possible that Franz Liszt might be at the piano. At the time of his stupendous sale, certain fakebusters, among them the legendary Justus Brinckmann of Hamburg's decorative arts museum, spoke out openly about Spitzer's penchant for obfuscating or lying about provenances; his propensity for mixing old and new pieces into a form that had never existed; and his taking an old work, breaking it up, creating a new series with the pieces, essentially multiplying it.

The fact was that although Frédéric Spitzer owned a few authentic treasures, he was the kingpin of an art-faking operation that employed dozens of craftsmen. Among the principals was Vasters. As Charles Truman

was to find, twenty-one Spitzer-owned works showed up in the Victoria and Albert Museum's working drawings by Vasters.

Truman doesn't say outright that everything in the Vasters drawings were made as fakes. They were not. Yet, he did put it rather strongly:

> From Strange's comments on the drawings in 1912, we may surmise that Vasters, or his clients, were deliberately attempting to deceive collectors with some of the jewelry, silver and gold which he was manufacturing. This in itself does not condemn all the jewelry and crystals which appear in the drawings, although some of the instructions which accompany them strengthen the supposition that many are working drawings for fakes. What it does mean is that in the light of present knowledge those pieces which do occur in the Vasters collection should be treated with the utmost skepticism.

Good British understatement.

The Linsky house-altar does show up among the Vasters drawings. Other great collections of the Metropolitan are tainted by the Vasters virus —the Altman Collection, the Bache, the Morgan, and the Robert Lehman. So are collections in the Victoria and Albert and the British Museum, among others.

The Widener Collection in Washington, D.C. has six breathtaking Renaissance jewels which were found in 1994 to be fakes, not produced by Vasters but by a highly respected French nineteenth-century jeweler by the name of Alfred André. These were revealed by the canny fakebuster Rudolf Distelberger, a curator at Vienna's Kunsthistorisches Museum.

After Charles Truman's revelations Distelberger was invited by the National Gallery to scrutinize the Widener jewels. He felt uneasy about the six pieces, mostly gold pendants with enamels depicting such Vasters-like favorites as a triton, a centaur, and a sphinx. But none of the Vasters drawings showed these specific works.

Distelberger had a brainstorm. He recalled a rock crystal casket he'd examined years before in Madrid. It was authentic but had been restored massively in the 1880s. The queen of Spain was so impressed with it, she insisted the restorer, Alfred André of Paris, sign his handiwork. Through a friend, Distelberger learned that the firm of André still existed. To his delight the André descendants possessed hundreds of models and casts of pieces produced by the talented goldsmith, who does not seem to have been

a forger. So far the Viennese fakebuster has discovered at the André studio a wax model for the tail of the triton and a plaster for the sphinx. He also learned that André executed many of the Vasters designs and had worked on commission for con-man Frédéric Spitzer, apparently unaware that the dealer was going to assign false provenances to them and sell them to intermediaries as ancient pieces.

But what about the *Rospigliosi Cup?* Were working drawings for it discovered in the Vasters materials or Alfred André's models? Not the whole cup. Just a number of sphinxes that are dead ringers for the one atop the *Rospigliosi Cup* and awfully close to the Widener gem.

Truman's exceptional fakebusting impelled the Metropolitan in 1986 to take the cup apart. A number of things which were woefully wrong were observed. On January 12, 1984, *The New York Times* art reporter Leslie Bennetts filed a story stating that forty-five Metropolitan artworks had been found to be forgeries, in the largest single catch in any museum's history. She related the story of Charles Truman's astonishing find and listed the Vasters and other bogus Renaissance and Baroque jewelry, including the so-called Cellini Cup which had so disturbed me.

These and many penetrating observations on the "Cellini Cup" were published in 1986 by Yvonne Hackenbroch in the museum's *Journal.* They included the discovery that the cup had been cast in a number of small sections, unlike the sixteenth-century practice and with the use of soft solder—definitely never used in the Renaissance—and with "strange tubular reinforcements" in the legs of the turtle. And a feeling of "cold perfection." And hardly any damage at all.

It was of some satisfaction to know that my queasy feelings were right, but very sad to realize that the vaunted *Rospigliosi Cup* was not an original.

Yvonne Hackenbroch summed up her intriguing dissection of all the Vasters pieces in the Met's collections by writing: "The tantalizing thought cannot be entirely dismissed that somewhere, hidden away in a private collection, the original *Rospigliosi Cup* still survives."

Or, I might add, another, better, less pure and far more organic and stylish fake.

# THE PSEUDO-FAKEBUSTERS

One of the most revered dictums about the subject of art fakery was voiced in the 1930s by the scholar Max Friedlander: "It is indeed an error to collect a forgery, but it is a sin to stamp a genuine piece with the seal of falsehood." The sin is committed all the time, usually by brash students or amateur art historians, but also by trained professionals. The latter, surrounded by a plethora of odd and inexplicable works of art, sometimes get unreasonably paranoid and begin to see forgeries all over the art landscape.

Does it matter? Once a real work has been branded a fake, is the work irretrievably damaged? Was Friedlander right? To find out one should look at some of the more notorious times when his law was violated.

Shortly after I became director of the Metropolitan Museum, there happened to be a rash of newspaper stories about art fakes, especially about a Parisian picture dealer who'd been caught palming off dozens of phony late Impressionists. One of my staffers came up with the idea of having a week-long seminar by professionals for the public on art forgeries. I liked the idea. It would be a major step in my program to open up the museum's unreasonably hidden activities to a broad audience. Except for two directors out of seven, the official attitude about fakes had been to treat them like Pentagon secrets.

The first director of the Metropolitan, the eccentric General Luigi Palma di Cesnola, was more outgoing; he exposed at the main entrance a sculpture deemed a fake by the press. Cesnola asked the public to hack away

at it with knives or whatever to learn whether it was real or bogus. It turned out to be genuine, but a hideous example of the genre, Cypriot sculpture, which is fairly hideous in any period of antiquity.

Director Francis Henry Taylor, who ruled the Met throughout the war until the early fifties, mounted a minor exhibition of fakes, but it didn't advance the study of the field significantly.

In the spring of 1967 at a regular staff meeting I announced my intention to appoint a group to plan for a full-blown series of lectures, presentations, and round-table discussions for the public on all aspects of art forgery and how to detect them, all of which would be highly publicized. The subjects would range from stylistic analysis to scientific examination to legal questions. We had been promised the cooperation of the attorney general of New York State to support legislation making it tougher to be a faker, for up to that moment penalties were light.

At most art museums, there are secrets the curatorial staff keep to themselves and away from the executives of the administration. Knowing this, I wasn't surprised when, after I'd made the announcement, one member of the staff stayed behind to talk to me about a highly confidential matter. This was the operating administrator Joseph V. Noble, the discoverer of the crucial evidence pertaining to the *Etruscan Warrior* which proved the black glaze could not be ancient. He was a man I never liked or got along with. When I accepted the post of director, I'd made the mistake of agreeing to the demand by the president of the board to retain Noble as virtual second in command. Noble had been the head of the administrative committee during the search process and had expressed to several people that he thought he had as good a chance as anyone to become director.

It was clear from the start that Noble and I were not going to work together for long. I was always seeking a way to get rid of him. Yet his performance in the first six months I'd been there had been impeccable. He had demonstrated no outward insubordination with me, had never questioned a single one of my directives, had not whispered or gossiped or uttered a word against me. But I still felt he held me in contempt. I could see it in his eyes, the way he drawled, "Yes, Tom," when I told him to do something. I perceived a faint disdainful smile on his lips, a barely noticeable curled lip when I spoke at a meeting. His attitude toward me seemed to say, "Mister, you're just a flash in the pan. All I have to do is to wait and take my turn."

The matter Noble wanted to reveal was that he discovered that one of the most renowned works of art in the museum's ancient collections, a work that had been reproduced in thousands of plaster casts for sale over decades,

was a fake and a rather simplistic one at that. He had the proof: the piece, which purported to be 470 B.C., had been cast in bronze in a technique called sandcasting, invented in the fourteenth century A.D.

Was he sure?

Positive. There were many other damning reasons. He believed he even knew who the faker was and confided that he was still living, an American neoclassic sculptor highly renowned in the 1930s and 1940s.

Noble suggested that the public seminar would be the perfect time for him to announce his sensational findings. It would come as a fitting climax to the proceedings and would most certainly make front-page news all over the world.

That interested me.

I went to the storeroom where the object had been sequestered and studied it. I had the immediate impression that if the thing were a fake I was losing my touch. The style didn't cry out modern or Art Deco, which Noble insisted it was beneath the surface. The anatomy of the work was soft, I agreed with him on that point, but I found the softness pervasive, part of the stylistic charm and personality of the piece rather than an indication that the sculptor was a bungler or trying to be too safe. To my eye, the sculpture wasn't "weak." I voiced my doubts, but Noble dismissed them pointing to the overwhelming technical evidence that proved the piece modern.

I could see that he'd become quite passionate about his theory, so I decided to let him take center stage at the seminar and if the object turned out not to be a fake . . . well, perhaps Joe Noble would get out of my hair.

The evening seminars were conducted in late November and early December of 1967 in the museum's auditorium at a time convenient for members to attend—along with the press, who had been sent an expansive press package. It wasn't hard to assemble the journalists who always go for stories about art forgeries. Plus, this was one of the rare instances when the Metropolitan Museum allowed outsiders to glimpse the inner workings.

I gave the first talk. I started off with an explanation of why I wanted to make public our fakes and discuss the normally tabooed subject. "The game of duplicity, the fine—or unfine—art of forgery is something that involves everyone in the museum business almost daily," I said. "We think that discussions openly about fakes and their detection are a vital part of the museum's educational obligation to the public. This is a part of the daily life of people who work in museums; it's something we worry about, often after the fact."

In my remarks I also dropped a few veiled references to the hazards of calling genuine works fakes. I quoted Max Friedlander and added, purely for Joseph Noble, "During the Roman Empire, for instance, there was an extraordinary amount of copying; some of it straight forgery. . . . It must have been hair-raising to live in Rome during the time of Hadrian. You can imagine the clank of chisel upon marble as people hurried to get genuine Greek things, 'just brought over from Greece' to impress the emperor."

I gave a lightning-fast history of art forgery: the wily Venetians, the crafty Renaissance fakers, the masters of the seventeenth century who churned out hundreds of Renaissance old masters, and the perfectionists of the nineteenth century. I described the essential types of fakes: the blunt and unsophisticated copy, the pastiche, and the ambitious attempt to create something entirely new.

I took the audience through the checklist of how professionals examined works, and ended the discourse by telling the audience that when they collected, to be successful, they'd do well to describe their mood at the moment they wanted to make the plunge. This was when I talked about the three greatest dangers to art collectors: speed, need, and greed.

I was followed by the urbane chairman of the department of European paintings, Theodore, "Ted" Rousseau, who spoke on the subtleties and thrills of detecting fakes through stylistic examination. He captured the attention of his audience by stating at the outset, "First, a word of warning: We should all realize that we can only talk about the bad forgeries, the ones that have been detected; the good ones are still hanging on the walls." I heard a few nervous laughs from some of New York's most eminent collectors.

Rousseau took a group of Van Meegeren "Vermeers" and compared them, with projected slides, to real works by the master himself. He was appropriately disdainful about Van Meegeren's "crude pasteups." He spoke eloquently about what contributed to making Dutch seventeenth-century painting look the way it does: "the feeling of peace and security and prosperity, the peoples' satisfaction with themselves, the delight in material riches natural after a long period of disaster and war, and the Protestant reserve and reticence."

He described genuine Vermeers as possessing "cool serenity, the feeling of completely arrested movement and of silence." He made the penetrating observation that there was virtually nothing personal about any of Vermeer's subjects. A sleeping girl in one of the Metropolitan's pictures was "rather like the still life—she doesn't make you want to put your arm around her

waist. The delight you take in the picture is entirely a visual, aesthetic delight, not sensuous or emotional in any way."

He praised Vermeer's "incredibly lovely nuances of light and color—each form surrounded by crystal clarity" and pointed out that Vermeer didn't model his form, but created it by a "series of colored facets, evoking rather than representing it." To these graceful attributes Rousseau compared Van Meegeren's works, calling them "greasy." No better word could have been evoked for the vulgar creations of the overly lauded faker.

Ted Rousseau cautioned his audience, "For any of you who intend to buy works of art, all I can say is, don't go into it unless you're willing to give it a tremendous amount of time, to train your eye, to look and look and look."

His final words were unexpected: "And, even then, probably the best lesson you can have is to buy a forgery."

Noble's turn came at the subsequent evening session. The house was packed even though it was to be scientific and technical stuff, which might normally be considered too dry for the general public. But the word had gone out that something sensational was going to be happening.

Noble was appropriately dramatic. "At the first session Tom Hoving spoke about a museum's responsibility to set the record straight in the case of forgeries that were discovered in its collections. This is the responsible thing to do, because the truth is what we are all seeking. We have an announcement to make tonight; since we were holding this technical symposium and since the announcement concerns a technical analysis, we thought it most appropriate to tell you about it here."

As he spoke two department helpers trundled a wheeled cart to the middle of the stage. Something was hidden under a large black cloth. Noble stepped from behind the podium and swept the cloth away. There on a trim wooden pedestal was a most surprising work of art, the exceptionally beautiful, renowned, much-published and praised bronze Greek horse of the fifth century B.C. One of the triumphs of the vast classical holdings.

"It's famous, but it's a fraud," Noble proclaimed.

There was a collective gasp of shock from the seven hundred or so members of the audience. Sitting in semidarkness, the spotlights brilliantly illuminating the brownish creature, I must admit that the piece still didn't look to me all that patently a work of the 1920s.

When Noble had first told me about his suspicions he'd recounted an odd tale about confronting the faker in person in the Greek and Roman galleries. He had begun to suspect that from style, the horse had to have

been made by someone who hadn't managed to disguise his Art Deco roots. Noble suspected someone like the neoclassic American sculptor Paul Manship, who was universally popular in the 1920s and 1930s for such works as *Dawn*, the monumental gilded reclining figure in the skating rink at Rockefeller Center, and a series of captivating bronze gates for public parks and zoos.

Noble had been elated to find in the file on the horse that it had been brought to the attention of the Met's purchasing agent in Paris in 1926 by none other than Manship, who was studying art in France at the time. The coincidence all but confirmed Noble's suspicions that Manship was the faker. Then he had a chance encounter with Manship in the Met's halls. Noble had politely asked him what he could tell him about the Greek horse. According to Noble, Manship had "turned white" and cried, "I cannot!" and fled the gallery.

Even after hearing about that, I found it hard to believe the horse was neoclassic in its heart. I had singled out one detail to focus in on, which I've found effective in testing authenticity. In this case, the mane. I was struck by how soft in modeling the hair was and by how little accentuation or chiseling there was on it. It was soft, but good soft.

Whatever it was, it wasn't the French-curve rectitude of the works of Paul Manship or his contemporaries. In their pieces every detail was so overly finished that the striving for perfection was oppressive. This mane was stylized, but in a freely drawn and energetic way. Nothing was patterned or repeated or so carefully measured that it might have been someone cautiously copying a Greek model.

But I was probably wrong, just being sentimental about one of the museum's most cherished items. After all, Noble had found the ultimate proof.

He deftly described the historical importance of the horse. How it had always been dated to the grand moment of Greek art, 480–470 B.C. "The horse has been so popular," he continued, "that over the years thousands of plaster casts have been made of him and you can still buy them—up until tonight."

That got the audience laughing nervously.

He pointed out that until that night the horse, unlike the Etruscan warriors which Noble had helped to expose through a scientific analysis of the materials, had never been questioned, on any stylistic or technical basis, by anyone.

"All right, if it was never questioned, what happened?" he asked. "I've looked at it in every light and from every angle. But one time . . . as I was walking toward the horse, I saw something that I had never seen before." It was a line running from the tip of his nose up through his forelock, down the mane and back, up under the belly, and all the way around. "I recognized it as the casting fin caused by a piece mold. The sections of a mold had come together there and the metal had oozed out, forming a casting fin that had been filed off, leaving this line."

Yes, he said, it had to have been cast. But what kind of a cast? The lost-wax system? Surely, yes. For that was the technique universally used in antiquity.

Lost wax had four basic steps: first, making a wax model; second, covering the model with clay, leaving a hole in some inconspicuous place; third, heating the clay which caused the wax to run out of the hole (hence *lost* wax;) and, fourth, the bronze was poured in and the mold was broken away when the metal had cooled.

"But," Noble emphasized dramatically, "our horse's mold line is from a mold made out of sand, a process not invented until the fourteenth century."

The audience murmured in admiration.

The point was devastating, I had to admit. It was like Van Meegeren using a blue that hadn't been invented until the nineteenth century or the silly damages applied to the crown of Saitaphernes. Still, to me, the horse seemed to glow there on the lighted stage. I had to say to myself that the creature never looked more convincing.

Noble had other condemnations. There was an inexplicable hole in the center of the mane. If it were for the harness the forger had committed a grave error, for harness holes should be under the horse's ears and there weren't any. There was another puzzling hole bored deeply into the top of the forelock (which looked as if it were swept back like the horse were running, but he was standing still). Noble had found similar holes only on the archaic horses from the Acropolis, life-size ones. There the holes had a real purpose, to fix a metal stick to keep pigeons away. No horse only fifteen inches tall would need such a device.

"The forger saw the marble statues and saw the hole and thought it was for a plume or something and he added one. Ridiculous," Noble scoffed.

Shortly after he had first noticed these discrepancies in the gallery, Noble had brought them to the attention of the curator of Greek and Roman art, Dietrich von Bothmer, and the German scholar had gone to Olympia in

Greece where there was another small horse of about 460 B.C. After examining that steed, Bothmer cabled back instructions for the Met's horse to be removed from exhibition for further study.

The two men eventually visited a foundry in New York, the Bedi Rassy Foundry, where they still used the sand piece-mold process. They brought with them one of the plaster casts of the horse and told Rassy they wanted a bronze cast of it and inquired how that would be done.

Noble reported that "Mr. Rassy took the horse and laid it on its side in a bed of sand mixed with clay. Then he said, 'Now, I would fill the mold with sand up to this point' and he indicated a line that exactly followed that running around the body of our horse. 'I would put lumps of sand mixed with clay all over the upper part; then I'd take them away, take out the model, and put the pieces of the mold back together again. You could cast a solid bronze horse in it.'"

Noble and Bothmer were about to leave disappointed, knowing that the Met's horse wasn't a solid hunk of bronze. Then Rassy launched into a description of how he would cast the horse hollow. He'd make a core out of the sand and clay, then he'd stick iron wire, about as thick as a coat hanger, through it to support the core so the bronze could flow around it. This armature, which was vital, would be made out of an iron wire that wouldn't melt.

Noble told the audience he'd asked Rassy, wouldn't the ends of the wire stick out? Rassy answered that he'd cut them off and make little plugs to cover the holes.

Noble and Bothmer had hurriedly thanked the foundryman and rushed back to the museum, knowing already what was on the horse—a series of tiny plugs that up to that moment everybody thought were ancient repairs. These plugs were exactly where Rassy had said they'd be, on the head and back, and several along the sides.

Then it became a challenge to figure out a way to find the armature that must be hidden deep within the body of the horse. An assistant curator named Brian Cook (now the Greek and Roman keeper at the British Museum) came up with the ingenious idea of attaching a magnet to a string and holding it close to the horse until the magnet was attracted.

It worked. As Noble explained, "In some places the magnet stuck to the horse's body; most of these coincided with the location of the plugs." Thus the internal structure was charted.

Both Noble and Bothmer pored through volumes seeking other exam-

ples of ancient Greek bronze made by the sand-casting technique. There were none.

Yet Noble wasn't finished with his technical analysis. He sought any powerful X-ray machines for industrial usage and at length learned about one company, Radiography Inspection Inc., that used a hefty instrument for, among other things, testing the integrity of nine-inch-thick steel for atomic submarines. The machine, using iridium 192, showed an iron wire armature and a sand core inside the horse. The shadowgraph confirmed without a doubt that the horse was made by the sand piece-mold process. And that, according to Noble, was impossible in Greek antiquity.

"It's the definite proof of the forgery," Noble proclaimed triumphantly as he projected a slide of the shadowy image. "And that is the story of our Greek bronze horse. It's famous, but it's a fraud."

He brought the house down.

The next day *The New York Times* ran the story about his discovery with a front-page lead and a special "Man in the News" about the discoverer. The *National Enquirer* even picked up the story. A spate of comments and editorials followed, some praising us for being so forthright, others condemning the museum for having hyped the affair and inducing the general public to chatter more about fakes than real works of art.

In one of *The New York Times* stories Noble was quoted as saying (somewhat snidely, I thought) that in the museum's own handbook of the Greek collection the horse was described as a "great Greek piece of quiet beauty which removes it from the individual to the typical and makes it curiously restful compared to later creations, even such masterpieces as Colleoni's horse by Verrochio, Donatello's Gattamelata, or the horses by Degas."

But the very day after the presentation, Noble's proof began to collapse. The Met's associate conservator for objects, a woman named Kate Lefferts, who had been at the museum for decades and whom I happened to admire for her gruff forthrightness and sense of humor, called me and said very gravely that she had to see me as soon as possible. I thought something in the conservation department had been damaged.

"It's about the horse—and Noble," she said. "He's dead wrong about it. You've got to keep what I'm going to tell you a secret. And you've got to give me and a team I shall assemble permission to study the horse. I can prove him wrong. Completely."

How?

"The horse is definitely not a sand casting."

Show me, I said.

It was easy. Noble's prime piece of evidence that the bronze had to be a sand casting was the casting line running around the entire creature. She said the line was nothing but the remnants of a protective wax applied by the museum itself in the 1920s to protect the surface when molds had been made for reproductions.

Who would she want to be on her team? A group of experts from the museum, including our research chemist Pieter Meyers, a specialist from the New York Institute of Fine Arts, and scientist Ed Sayre of the Brookhaven Atomic Lab.

I told her to go ahead. But I refused to keep the probe secret and asked her to keep Joe Noble informed every step of the way, which Kate Lefferts did. The press was, however, not told.

Even before Lefferts could start her examination a number of Greek art experts around the world counterattacked Noble. Carl Blumel in Berlin wryly observed that several bronzes of the fifth century B.C. had traces of armatures and all had been cast by the lost-wax technique. In a short time it began to appear that more originals than not had armatures—rectangular, not round wire ones. These included the famous *Charioteer of Delphi* dating to about 470 B.C. and the renowned bronze horses of the fourth century B.C. that the Venetians stole from Constantinople in 1204 and had placed up on the facade of San Marco (today replaced with excellent copies, the originals being shown safely inside the church).

The scrutiny of Kate Lefferts and her allies took almost five years, primarily because she had other work to do. The eventual findings were devastating to the arguments of Noble and Bothmer.

The seam, that casting line, was definitely modern wax and came off easily with xylene. Once this was removed, two holes near the horse's ear emerged—just where a bridle would have been attached. Noble had denied their existence.

Bedi Rassy told the team that Noble and Bothmer had raced away before he could tell them the punch line about how he'd made a hollow copy of the horse. Had they waited a few more minutes he would have told them that in modern times it was customary to get rid of all traces of an interior armature. You never left it inside. Rassy also affirmed that all modern armatures are round. The one inside the condemned Greek horse was clearly rectangular.

Traces of the armature removed from the horse showed that the iron

had badly oxidized, indicating great age, and impossible to produce artificially.

Fragments of the core were extracted through some of the plugs which had been removed and the stuff contained clay and even tiny bits of shells, consistent with the cores in authentic Greek sculptures.

The study of the pitting, wear, and deterioration of the bronze surface showed that the work had been significantly worked by hand with no indication of modern tools.

The corrosion of the horse was totally consistent with ancient bronzes and of such a nature that it would have been impossible for it to have been induced in a short time.

An analysis of the bronze alloy showed a high tin content, with low lead and no zinc at all, like the other indisputably genuine Greek bronzes. Modern bronze has usually a presence of zinc. The alloy in one of Paul Manship's bronzes in the museum's collections was analyzed, and it was totally different from the Greek horse.

One of the bronze plugs on one of the real legs of the horse—the left hind one being a modern repair—was indisputably ancient, with beveled edges fully corroded. This point was the smoking gun that proved the horse was not a contemporary fake. It was hardly likely that a forger would have been able to fashion a tiny plug, corrode it to render it perfectly like something thousands of years old and insert it just so.

Finally, a relatively new scientific test was applied to the core of the Greek horse, called thermoluminescence. Basically, it is a system that measures the amount of natural radioactive energy stored in ceramic core material. In other words, thermoluminescence dates the age of interior as opposed to radiation from the outside, principally the sun. Interior radiation is virtually impossible to muddle with.

To get around any objections that the X ray Noble had used had somehow contaminated the interior, a new twist on the standard thermoluminescence test was tried, one that had been developed at the laboratory for Space Physics at Washington University in St. Louis by Professor D. W. Zimmerman. His bright idea was to find a constant physical property within the core that was known scientifically to be impervious to exterior radiation, a hunk of something with an extremely high natural uranium content. The material had to have been heated up to at least five hundred degrees for the clock, so to speak, to start ticking, which had, in fact, happened when the lost-wax systems had been started way back in antiquity.

Such a fragment was discovered, zircon, which is a thousand times

higher in uranium than any other material. Whereas other matter might be affected by X ray, gamma rays, or iridium, zircon is known not to be affected in the least. Nine particles were obtained from the core. Of them, five were zircon.

Tests on them proved that the core material had accumulated a considerable amount of radiation from the inside—naturally—showing incontrovertible and inevitable atomic decay. Two separate tests came up with two dates for the core, one twenty-one hundred to forty-seven hundred years old and the other thirteen hundred to twenty-seven hundred years old. The youngest and the oldest were discounted and twenty-one hundred applied, giving a date in the second century B.C.

It was then that Bothmer carried out some additional research and found some surprising information which, had it been previously known, might have slowed Noble down before he jumped to his conclusions.

The department files indicated that Paul Manship had told the Greek and Roman department's purchasing agent and general antiquities scout, John Marshall, that a beautiful horse was in the possession of the Parisian antiquities dealer Georges Feuardent. Marshall's first impression was that it had to be "a second-century-B.C. copy" of a fifth-century original, or an archaizing work (like the *Apollo of Piombino* in the Louvre). Yet by the time the piece was offered to the Metropolitan, Marshall had changed his mind to fifth century B.C., perhaps to justify the high price he was asking.

A possible clue to the fact that Marshall was right in the first place is that Feuardent was convinced the bronze had been found on a famous underwater dig that took place in 1908 near Mahdia in Tunisia where a Roman ship loaded with works of art was discovered and many pieces retrieved until a shark bit off the leg of one of the workers. At the time the pieces of the Mahdia wreck were boosted as of the high classical fifth century from Attica. But by the 1960s it was pretty generally accepted that everything on the ill-fated ship dated to about 100 B.C.

Bothmer also pointed out that the only Greek statuette similar to the horse was one found in the ruins of a Roman villa near Volubilis in Morocco long after the horse had been acquired by the museum. The Volubilis steed had been called Roman—everything from the first to the second century A.D., but as Bothmer observed, "At least it has the distinct advantage of never having been called a Greek original."

So, tentatively, almost nervously, Bothmer put back on exhibition the Greek horse so mocked by Joseph Noble and reattributed it to a period of

"classic or eclectic" Greek art, quite possibly of the early second century B.C.

Bothmer was, I think, not telling the entire story. The chances are very good that the horse is a Roman forgery. Knowing the extent of fakery in Roman times it seems more likely that this slim, soft elegant creature was a deliberate phony, which had been fobbed off on some collector in ancient Roman times who had more greed and speed than need.

Of course, Noble seems to have been a bit greedy, too. He apparently so wanted the horse to be phony back when he spotted the spurious seam in 1961, which was about the same time that he was preparing his studies on the fake glazes of the Etruscan warriors, that he bulled ahead perhaps wanting to be known as a crackerjack art administrator and a gifted fakebuster as well.

But was Noble wrong in coming out with his accusations and airing his theories? He might have been guilty of breaking Friedlander's "first law" but I personally think he wasn't wrong. For even if every one of his reasons for branding the piece a fake turned out to be spurious, he got people thinking, analyzing, examining—and the museum learned something about the famous horse that it would never have known.

Of course it might have been better had he simply raised his suspicions rather than laid down such a weighty gauntlet. Suspicions and accusations are perfectly in order. As a matter of fact, there ought to be more of them. They might root out the hundreds of fakes I am convinced are still hanging around.

Besides, Joe Noble's shortcomings as a fakebuster were not a rare phenomenon in the art field. I recall many examples when highly trained and skilled art historians tackled a work out of their field and juggernauted into what, in the end, turned out to be the most ridiculous and unsupportable positions.

It happened once even to one of the most accomplished connoisseurs ever, Sir John Pope-Hennessy, who was chairman of the department of European paintings at the Met, and before that, the director of the British Museum, and before that, the director of the Victoria and Albert and before that, the keeper of metalwork at the V and A. He was uncanny when it came to the attribution of Renaissance bronzes, German late-Gothic wooden sculptures, paintings, and even Tudor furniture. Yet he failed miserably in the test of the Met's notorious calyx krater by the sixth-century Greek vase painter Euphronios. To some ignoramuses today, the vase is still suspicious because of the doubts Sir John launched about it.

The paintings on the vase by the renowned Euphronios comprise some of the most moving and technically accomplished of all surviving vases. This object is one of the supreme triumphs of Greek art. It's intact but for a few insignificant fragments. The work is eighteen inches high and twenty-one in diameter capable of holding more than seven gallons of wine. Its shape is so striking and difficult to build that the potter Euxitheos signed his name as prominently as Euphronios. The shape is a bold, soaring one, with the bowl of the receptacle flowering from a delicate base and culminating in a broad lip that overhangs the base by a daring six inches. But it is the painted scenes that are the most astonishing technical tour de force of all. There are ten massive figures, some taken from the *Iliad*, others from contemporary life. The Homeric scene is on the front of the vase and shows the nude body of the dead Trojan warrior Sarpedon being taken to, one supposes, paradise by the personifications of Sleep and Death. On the back there's a scene with all the vital bustle of a locker room showing a group of Athenian warriors getting into their armor.

The drawing throughout all the complex scenes and figures in thin black, glazed lines is stunningly sophisticated. Every tangent, overlap, junction, and whorl of the myriad lines is executed without flaw. This is all the more surprising since Euphronios had to paint all of these hundreds of lines without seeing what he was doing—he was working almost blindly.

Euxitheos had delivered an intact, damp vase, the color of terra-cotta. Then Euphronios had painted all the figures and the highly complex decorations—palmettes, the hundreds of delicate lines in the armor, the wings, the hair. He worked with an instrument that was something like a pastry bag with a bone or wood nozzle with a hole the size of a hypodermic needle. The solution used to make the relief lines and the colors—light ochre, deep brown, and red—could only be seen after the vase had been fired.

Euphronios positioned the huge, heavy wet clay vase on his knees, hunched over, took the syringe, and worked frantically and completely from memory. He had to draw faster and faster, because the damp clay dried rapidly. And he had to turn and paint in one direction lest he wipe out or smudge some of the drawing he'd completed, all without being able to see.

All kraters of the type have two rectangular spaces for the painted scenes. In every case the scene on the back, in this case the youths arming themselves, is drawn more quickly and less carefully than the front, because by the time the painter got to the back, time was running out on dampness.

Not long after the vase was first exhibited publicly at the Metropolitan

in 1971 and almost instantly generated a fierce controversy about whether or not it had been found in an illegal dig in Italy and smuggled out of the country, rumors began to float around that it was a clever forgery copying a genuine one found in an Etruscan tomb and made to sell to the stupid Americans, particularly the monumentally stupid Americans at the Metropolitan Museum.

With some difficulty I tracked down the rumors and to my surprise and anguish they seemed to lead to John Pope-Hennessy. He was telling rapt audiences at dinner parties that the Euphronios calyx krater, arguably the finest Greek vase of the sixth century that had emerged so far, could not be authentic because the drawing of the young warriors was so hesitant. From the dinner parties the word got to the press and to the general public.

I had a somewhat heated session with the normally genteel curator and explained why what he thought were sure signs of fakery were the very characteristics that proved the vase was impeccable. Eventually, he agreed.

Did it really matter? Actually, not all that much, for only amateur experts mutter that the vase "is really fake, which is why the Italian government has never pushed to have it returned to Italy." Yet in part because of Pope-Hennessy's original theory, that bit of tarnish does remain.

◆ ◆ ◆

Another work of classical antiquity in the Metropolitan that's been unjustly condemned and still has a bad reputation because of the condemnation is a just-under-life-size marble *kouros*, or youth, bought in 1932 by Gisela Richter, the same curator who had been bedeviled by the phony Etruscan warriors.

The kouros statue is almost breathtakingly ugly. It's as malproportioned as a Frankenstein monster, etched with vague and annoying anatomical lines with lumps of flesh seemingly pasted to the surface of the skin. The knees are like wads of dough. If this was supposed to be the mark of beauty, God save the Greeks.

As soon as it was displayed during the Great Depression cries of fake arose. The arguments against the unsightly thing were that it deviated from the Archaic style norm because the body leaned forward too much, as if in a strong wind, the head was too large, and, as Richter complained, "the scheme of grooves and ridges suggesting the anatomical construction of the lower legs was peculiar."

The first to criticize the statue was the great Italian fakebuster Giuseppe

"Pico" Cellini who after a trip in the late 1940s acidly observed, "How can a thing like this be sixth century B.C. when it has a wig like an English milord's and a ribbon about its neck."

The distinguished professor of Greek art at the New York University of Fine Arts, Karl Lehmann, continued the attacks in the early 1960s. He told jokes about the piece to his graduate students. Lehmann claimed that the anatomy was unlike any other kouroi discovered, that the statue was an obvious pastiche of several kouros types and that the breaks were "convenient" in that they appeared only at places where the market value of the objects would not be harmed, a common forgers' ploy.

But are Cellini, Lehmann, and the doubters right? I think not. In the first place the creature is too straightforward and harsh to be a forgery. Why forge the single most aesthetically off-putting Greek statue in the world? Second, after the piece was on view for some years other kouros statues and fragments came out of the ground at a place called Sounion, south of Athens on the seashore, which had the same peculiar, abstract ridges and lumps forming the knees and the legs. Unique features actually.

Gisela Richter hit the nail on the head when she wrote:

> As these fragments were not known when the New York kouros was purchased they could not have been utilized by a forger. . . . If it is important to be able to detect a modern forgery, it is at least as important to recognize a Greek original. . . . Since the Greeks have a tendency to confine their representations to a limited number of established types, the natural reaction in archaelogical circles when something uncommon appears is to suspect it. It is unusual; therefore it cannot be right.

As a student of archaeology in the 1950s I had heard of the controversy boiling up around the Met statue and had gone to visit it from graduate school in Princeton. I had found the sculpture unlikable, stiff, looking scared and uncompromisingly brutal. One of the arguments against it was that it had insteps, impossible at such an early stage in Greek art. Insteps came, it was claimed, decades later. I looked and couldn't find any insteps. The hair and headband seemed convincingly casual to me, certainly not English "milordy." Nothing was hesitant or wishy-washy. I departed convinced that the Ugly Boy had to be original.

The proof was given to me in 1956. It was when I was a participant in the Princeton University excavations at Morgantina in Sicily. The director

of the dig, Erik Sjoquist, a Swedish archaeologist teaching at Princeton's graduate school, told me one evening when discussing fakes of Greek art that he had been present at the site at a small town south of Athens when the Met's kouros was unearthed. He described in precise terms how the statue had been unearthed and what it looked like. He refused with a smile to tell me the name of the village. The excavation had, of course, been illegal and if the town were ever identified, sooner or later the authorities would track down the people responsible, some of whom were alive and well and rich still in the mid-fifties. I have no doubt at all that Sjoquist was telling the truth.

Has the Met kouros been tainted or spoiled by Karl Lehmann's attacks? Somewhat. There is apparently a generation of scholars who studied under him who doubt and continue to mock the piece. One is the brilliant archaeologist who carried out such splendid excavations at Cnidus, Iris Love. As an undergraduate she had written a thesis pointing to the stylistic inconsistencies and errors in the Etruscan warriors: How could it be that a seventh-century-B.C. Etruscan soldier should be wearing a kilt? That was one of her more amusing and crippling observations. She, sadly, still holds that the Met's Ugly Boy is wrong.

◆ ◆ ◆

One might think that pseudo-fakebusters get it all upside down only in the field of classical art, but there are plenty of examples of the Friedlander "sin" being committed throughout every field of artistic endeavor.

One memorable to me is an exceedingly rare and very lovely early medieval ivory bookcover approximately nine by five inches, late Carolingian of about A.D. 850, representing the Crucifixion and below that, the Marys at the empty tomb of Christ. It is today in The Cloisters Collection and is owned jointly with the Louvre.

I had first seen the object in 1968, in a dealer's shop in Paris—Nicholas Landau's fascinating treasure trove—and had been impressed with its finesse. Everything from the dainty figures with their characteristically blunt, lima-bean faces and the draperies that shrouded them like pillow covers seemed to me to be perfect for the period of about A.D. 820–850.

I had wanted to buy the rare piece while I was a junior curator. To test out its authenticity, I had committed the rash act of sneaking the ivory into the main reading room of the Bibliothèque Nationale in Paris where there was a bookcover set into a Carolingian manuscript, a cover decorated with a similar plaque.

Once the attendant plunked the heavy gospel book down in front of me, I slid Landau's ivory out of my pocket and spent several hours comparing them. They were virtually identical, right down to minute passages and details of anatomy. The Landau ivory was slightly larger and had that unusual pairing of the Crucifixion and the Three Marys, but I was convinced it had to be okay.

Yet before recommending it to my boss and the board of trustees, I sent a photograph to my former docent at Princeton, Kurt Weitzmann, who had helped compile key volumes of Carolingian ivories as a student for the grand master of the field, Adolph Goldschmidt. Weitzmann judged the Landau ivory a fake. It copied the Bibliothèque Nationale bookcover too closely for his comfort and seemed to be a pasteup of several ivories of the same school. There were never in early medieval times precise copies of anything, he proclaimed. He convinced me, and we let it go.

Some years later when I had become the Met's director, a bright, tenacious curator of The Cloisters, Jack Shrader, was able to convince both Weitzmann and me that the very elements that seemed to destroy the Landau ivory were in fact powerful arguments in its favor. Shrader gently cut to ribbons the assumption both Weitzmann and I entertained that no genuine early medieval work could be a precise copy of another. In 99 percent of the cases the cliché held. Where it collapsed, however, was among the very ivories of the stylistic school ivories this Crucifixion-Three-Marys plaque represented. In this group, called the Metz School, Shrader was able to point to numerous ivories of the group that were close copies and apparent pasteups, many of which were still on the ancient books for which they had been made. So they had to be genuine.

We were able to purchase the stunning piece, which now travels back and forth between two great institutions on a four-year rotation basis. The reason for that is that when the French learned we'd bought the ivory and could prove it was real, they said that we had helped smuggle it out (which we did not). To quell the possible scandal, I gave the Louvre half ownership.

All of which shows that fakebusters must be cautious about becoming swept into a tropical depression of suspicions, each one like a wave of moisture being pumped into a storm system feeds on the next and eventually develops into a hurricane. Being suspicious is divine, becoming paranoid can cause immeasurable grief to both the fakebuster and sometimes the works of art accused.

Take, for example, the Metropolitan's so-called *Fortune Teller* by the seventeenth-century French painter Georges de La Tour. This is the much-

reproduced painting showing a young, puffy-faced, slack-jawed dandy decked out in a flamboyant military costume being fleeced by a group of four gypsy women who are themselves dressed in bizarre costumes. On the left side two women in profile are slipping a purse out the youth's pocket—the one in the foreground is about to pass it to the one in the background who seems just passing by. It's a classic move enacted throughout the world and through the ages. Just to the right of the unsuspecting cavalier stands a stunning young woman who surreptitiously cuts away part of the immense gold chain hanging around the boy's neck. In front of him a crone chatters on about a large coin she has either just received from the youth or is about to give him.

The painting and drawing are rather awkward. The personages have numerous anatomical oddities; it's hard to tell which hand is attached to which girl on the left. Despite the awkwardnesses, the scene is vibrant. The colors are strange but sparkling—pinks, yellows, a salmon color and shimmering silks and brocades, all of which seem deliberately ersatz, for these thieves are frauds through and through, including their costumes.

The painting is a deft and very funny moment. At its heart is the fact that the viewer perceives how fully the young dolt is being ripped off, whereas the youth is oblivious. For one's immediate attention is first drawn to the animated chattering woman holding out the promise of a coin. Only after one looks for a little while at the painting does one see the clandestine thievery. Each perpetrator is virtually motionless, as every good pickpocket has to be. The light, exceptionally bright, is uncharacteristic for La Tour.

A large and elaborate signature appears in the upper right almost as an intrusion, like some kind of billboard. It reads in Latin: "*G. de la Tour Fecit Luneuilla Lothar*" and means, "G. de La Tour of Lunéville [Lorraine] made it."

The painting was acquired in 1960 from the old-master dealer Georges Wildenstein after protracted negotiations for about a half million dollars, a very high price back then. Two of the museum's trustees, Robert Lehman and Charles Wrightsman, were involved in the negotiations and the latter is said to have gotten so excited about it to Wildenstein that it was impossible for the Met to bargain down the price. The National Gallery in Washington had a crack at the painting but rejected it because of the high price and because its director believed that it wasn't up to works by other French painters of the seventeenth century in the collections.

When the painting was put on view by the Met there were howls of protest from France. The minister of culture at the time, the famous André

Malraux, was furious that it had left France and caused the Louvre official who had signed the export permit to be kicked upstairs and out. There was a slight ruckus in the American press, but the uproar quickly died down.

The condition of the picture is fair, primarily since it was relined probably in the thirties when relining was in vogue. Wildenstein represented that it had been lightly cleaned by one of the firm's restorers.

Following the leading La Tour scholar, Professor François-Georges Pariset of Bordeaux University, the museum dated the picture early, about 1620–21, owing to its odd awkwardnesses and called it a rare example of the master's daylight style of which one other work survived in two versions. This is *The Cheat,* showing another buffoon, the spiritual brother to the dolt in *The Fortune Teller,* getting taken in a card game.

Georges de La Tour (1593–1652) is a one-of-a-kind in art history because of his profoundly mysterious religious paintings all rendered in darkness except for the captivating glow of a candle or two. He used what appear to be peasant types for his models, and his characters display an appealing humility. His paintings are moody and theatrical.

He came to Lunéville, near Nancy, in 1620. Over the next three decades, working his way up to become one of the painters to the court, La Tour produced dozens of paintings the vast majority of which were his singular religious images.

*The Fortune Teller*—totally mistitled, for it should rather be called "The Fleecing" or "The Good Sucker" or something like that—became a favorite picture in the Met's collections and was chewed over by specialists mostly as to the chronology of it and other of his works, for so many La Tours were showing up on the market that it was hard to fit them into the artist's career.

That was until a bright and appropriately suspicious young art historian came along, who was attached to London's prestigious Courtauld Institute then run by Sir Anthony Blunt (who would later confess to being a spy for the Soviet Union). His name is Christopher Wright. He became intrigued with La Tour and was determined to solve the tangled chronology of the painter's works. He started off with a clever idea. He'd go back to the archives of the municipalities where La Tour had lived, primarily Lunéville, Nancy, and Metz, and find out exactly who the man was. He came across heaps of documents with the artist's signature ranging over a virtually unbroken span of thirty years (La Tour apparently acted as a witness in a variety of deals). Wright was hoping he could match up the dated signatures in the

documents to each painting signed by the artist and thereby help establish a more reliable chronology.

In examining the paintings Wright found some fascinating things. Some pictures said to be by Georges were really signed by a son, Etienne. Other signatures were clearly bogus. And, to Wright, the large, ponderously careful one placed so prominently on the right of the Met's *Fortune Teller* seemed unlike any of the signatures on the signed documents or on any other La Tour painting.

His suspicions aroused, Wright entered into an intense study of the history of the Met's painting and began to list what he thought were inconsistencies and weaknesses not to be found in other pictures by the master. The entire painting with its odd subject and clear, overall light, was an anomaly within the artist's career.

The Met refused to declare a word about where the picture had come from—only stating tersely that it had been at Wildenstein's. There was no proof that it had come from France and it seemed as if it had emerged from thin air in 1960.

Among the oddities about the picture that puzzled Wright were the imaginative costumes worn by the actors in the playlet. The scholar who had been asked by the Met to publish the work, François-Georges Pariset, also mystified, had speculated that the costumes were possibly Persian, possibly Sassanid, or "Balkan." To Wright, "such an idea, presumably written as an attempt to explain the oddness of the dress, would be very difficult to accept from a seventeenth-century Lorraine artist."

It so happened that the Courtauld Institute had just started a costume department when Wright was initiating his probe and he asked Diane de Marly, the head of the department, to allow her students to analyze the costumes. They came to the conclusion that the costumes in *The Fortune Teller* "could not have been produced in the seventeenth century."

Diane de Marly followed up the students observations by listing a series of errors and enigmas in the depiction of the clothing. The most damaging point was the discovery that many of the decorations on the shawl of the crone holding the coin had been adapted from those on a carpet lying in the foreground of a painting of the *Virgin and Child* by the sixteenth-century Dutch master Joos van Cleve, on view in the Walker Gallery in Liverpool. That didn't seem like something an original painter of the seventeenth century would have done. A Frenchman copying a Dutch work of a century earlier?

As Wright observed, the "damning piece of evidence in this respect was the fact that the carpet in the Joos van Cleve was obscured in part by the shadow of a little table falling across it. When the carpet was turned into the shawl in *The Fortune Teller* the forger had to fudge the bits of design he could not see clearly in his source."

There was another curious feature about the shawl. In copying the motif of a pair of birds flanking an urn, the painter of *The Fortune Teller* had misunderstood the warp and weft which did not run at right angles. This was strange particularly since, according to Diane de Marly, all other costumes in every certain painting by Georges de La Tour were accurately observed.

Once Diane de Marly and Christopher Wright had spotted these problems many more came to their attention. The leather coat worn by the dandy being fleeced was totally unlike the two that had survived from the seventeenth century. The painter had, apparently, misunderstood the coat and had drawn it in such a way that unless the seam in the front hid a zipper, the cavalier could not possibly have put it on. Very damaging for a supposedly ancient work!

More and more wrong details for the seventeenth century leaped to view. The bravo's sash was situated in such a place that made it impossible for him to draw his sword. His decorated collar with a bunch of odd, sharp points was unthinkable for the first half of the seventeenth century. His hair looked as if it had been permed. His head "shows a perfectly made-up face with plucked eyebrows, bearing exactly the same features as the prostitute immediately to the right. The model for the two figures was surely the same." Wright singled out a photograph from a 1940s fashion magazine as the possible source for the "perm" and the faces.

Worst of all Wright discovered the word *merde* painted in the lace collar of the young gypsy second in from the left. Such a contemporary latrine message was hardly to be imagined as decorating a genuine painting of the seventeenth century.

With all this evidence both Wright and de Marly were leaning to the conclusion that *The Fortune Teller* had to be a modern fake. Wright took the evidence to his mentor at the Courtauld, Anthony Blunt, who refused to go along with the suspicions of either scholar, complaining that the dress department had no right to get involved in connoisseurship and refused to see in any photograph the word *merde*.

In the fall of 1971 I along with my paintings curator and chief conservator of paintings received this apparently condemning news from Christopher Wright when he was in New York studying the various paintings by Georges

de La Tour in the city. I was, frankly, convinced that Christopher Wright was right. Yet the painting looked so convincingly old, and weird. Why would a forger do something weird? Not characteristic.

I got in touch at once with Daniel Wildenstein, the son of the man who had sold the picture to the Met, and posed the undiplomatic question: How do you know this thing isn't a fake?

In a few days I got some fascinating news. I had to swear to keep the information a secret. The Wildensteins had been approached in the early 1950s by a member of the French family who owned the painting, the Gastines family of Solesmes near Nancy and Lunéville where Georges de La Tour had spent his entire career. The family member, a nephew by the name of Celier, had been reading an art book he'd come across while in a German prisoner-of-war camp. Under what imaginable circumstances, I have no idea, but it's too implausible for a made-up tale—he had spotted a painting by La Tour, *The Cheat*, which was similar to one that he had seen hanging in one of the family châteaus. This was *The Fortune Teller*.

After the war a number of barely believable things happened. Celier found the picture miraculously preserved, the Germans having stripped the château of the majority of its other treasures. Celier eventually offered the picture to the Louvre. The museum turned it down because of the high asking price and Wildenstein had been able to buy it. How it had received permission to leave the country was, well, murky, although Daniel Wildenstein assured me that everything was legal. Minister of Culture André Malraux, angry at its mysterious departure from France, had mounted, Daniel claimed, a vicious campaign smearing his father because Malraux had wrongly thought it had been smuggled out.

But how could I tell that *The Fortune Teller* wasn't a fake made up for sale to the Gastines? Was there any documentation?

There was. I eventually received a copy of an inventory of the Gastines' holdings dated 1879 which described the painting as follows: "Item, un tableau representant La Bonne Aventure, signé Georges de La Tour." The "good adventure" presumably referred to the goings-on from the gypsies' point of view and was, to me, a more convincing title than *The Fortune Teller*.

Daniel Wildenstein recounted to me that the painting was in relatively good condition for a seventeenth-century work that had been relined in the 1930s and needed minor retouchings. This job, carried out in New York shortly before the painting was sold, had been done by a restorer who worked for the firm. His name was Albert Dion.

I was convinced again of the authenticity of the picture because of one key factor in the history of the rediscovery of Georges de La Tour. He was a virtual unknown until 1915 when the German art historian Hermann Voss first mentioned him in modern times. The first extensive exhibition was only in 1934 and the first monograph in 1948.

What forger could possibly have faked a huge work before 1879 that was utterly atypical of Georges de La Tour's body of work, all of which would be discovered decades later? The answer, of course, is none. I relaxed. Wright had been wrong.

In time the Met's conservators, both Hubert von Sonnenburg and later John Brealey and the chief chemist, Pieter Meyers, who had proven the Greek horse to be a genuine Roman fake of the second century B.C., discovered that the paint materials were all consistent with the seventeenth century with nothing modern at all showing up except in the word *merde*. They found the presence of a tin-lead yellow paint that had gone out of fashion by the early eighteenth century. That dashed the theory that held that the picture could have been forged in the early 1950s. The *merde* may have been put there by the restorer Albert Dion, whose own paintings were occasionally filled with similar scatological phrases. (Wright thinks he saw the cipher *dion* painted in just after *merde*.) Dion swears not and insists that the word is old. The Met removed *merde* in the 1980s.

But what about Christopher Wright and Diane de Marly's penetrating observations?

If the picture has to be good because of the inventory, why, then, is the signature different from Georges de La Tour's signatures on the documents? The answer to this question is probably that a large, decorative signature, more an inscription than a routine signing of the name would naturally look different. This was not a countersignature on some legal document but a proud artistic declaration.

What about all the mistakes in the costumes? For that there's no easy answer. There are only two plausible explanations and both of them are lame. One is that one does occasionally find throughout art history works of art in which a painter has made mistakes in armor and costume. The other is that the "mistakes" are not mistakes at all, but deliberate eccentricities put in by the clever Georges de La Tour to emphasize the general trickery of the painting and to stress the bizarre character of the gypsies who are fleecing the victim.

Christopher Wright has vacillated and legitimately agonized over the years about whether *The Fortune Teller* is good or bad. When he saw it and

the two other "bright" pictures by La Tour representing *The Cheat* in a grandiose exhibition in Paris in 1972, he felt that it had to be good. He wrote:

> The three pictures presented a solid phalanx of strong lighting, brilliant color and large scale, full of accouterments, flashy jewelry, brilliantly embroidered textiles and sideways glances. It would have taken a great deal of imagination to suppose that all three pictures were not by the same hand and that two of them were not by La Tour. At this time this confrontation convinced me that *The Fortune Teller* must be by La Tour.

Wright should have stopped there and written a fine paper on why the costumes had been done so oddly, but he plunged into the gathering storm of his own making and by 1980 he had changed his mind and returned to his original suspicions. *The Fortune Teller* has to be a fake, he still says, primarily because of all the unanswered costume questions and because of the massive awkwardnesses in the drawing and the placement of figures. The word *merde* buttresses his conviction and when the Met's conservator removed it, Wright was angry, suggesting that the museum was wiping out some valuable evidence.

To support the fake theory, Wright had to work hard. He, too, had learned about the Gastines' inventory of 1879. So Wright theorized that the picture is a modern fake painted after the war and before Albert Dion worked on it for Wildenstein in 1958, based perhaps on a badly destroyed original that had severe damage which the faker had filled in incorrectly and signed maladroitly.

Wright had early on suspected *The Fortune Teller* because its "bright" style seemed unique. Then the two "bright" versions of *The Cheat* showed up. They also were dubbed fakes by Wright. He has been supported in this by Diane de Marly.

If *The Fortune Teller* is a fake, it means that there was an incredibly deft forger working between 1879 and 1958, a forger who created three pictures by Georges de La Tour that stand apart from all his other works and which, miraculously, possess all the right seventeenth-century paints. One of *The Cheat* has been in the possession of a private collector since the 1920s and he can prove it.

The bottom line, to my mind, is that the Met's picture cannot possibly be fake.

Was it damaged or hurt in any way by the condemnations of Wright and de Marly? A bit. It appeared on the TV show 60 *Minutes* in the 1970s, and Morley Safer stated that the painting is a forgery. So it would appear that Max Friedlander's declaration about it being a sin to call an original a fake is at least partly correct.

Did Christopher Wright and Diane de Marly do a disservice to the picture and to art history in suspecting *The Fortune Teller* and writing about it and initiating a huge stink about it. No. They came up with some penetrating observations and spelled out some troubling problems with *The Fortune Teller*, some of which haven't been adequately explained and ought to be addressed by the Met. It may, in time, be revealed that the restorations of 1958 were more extensive than it was at first believed. Wright and de Marly's "sins" were in persisting despite massive and growing evidence that their theories about forgery were, to many, untenable. They simply got caught up too far in a gathering storm of their own making.

# "GUARDI IS STILL ALIVE"

What makes an ideal fakebuster? The mental makeup of a detective; the sensitivity of a seasoned connoisseur; the determination of a fierce, often acidulously antiestablishment independent; a scholar with years of saturation in every field of art; plus some experience as a successful forger. The ideal fakebuster may not exist, but one man comes close. His name is Hubertus Falkner von Sonnenburg and he is now the Sherman Fairchild Chairman of Paintings Conservation at the Metropolitan Museum of Art.

A tall, elegant, and handsome man with a wry sense of humor, Sonnenburg was born in 1928 into a South Tyrol family with an aristocratic background. Early on he wanted to become a painter but by the time he had completed his secondary education he recognized that the flame of creativity was not burning inside him. What he did have was what he described as a "great affection for art, almost a compulsion to be close to it."

In order to do that Sonnenburg enrolled in art history at the University of Munich and gained his doctorate in only four years, a rocket's pace in academic Germany. He was offered a choice teaching post at the University of Hamburg, but to the dismay of his family decided, instead, he wanted to become an art restorer. The history of art didn't bring him as close to the originals as he wanted. Sonnenburg reminisces, "I loved the idea of being with originals. I didn't want to be stuck in a university, in some academic ivory tower, dealing only with the theory of art. I wanted to maintain close contact with art, to be in constant physical touch with art."

His father, who had introduced him to an art conservator, was far from enthusiastic at the idea of his aristocratic son refusing the dignified life of a professor to go into what was considered a trade, involving himself with smelly chemicals, paint, tattered canvases. Who ever heard of an art restorer?

To be taken in as an apprentice and having to pay his own way—his family sold a painting to give him the money—Sonnenburg had to create an "entry piece." Instead of painting a still life or a self-portrait, with over-weening ambition he imitated an early Flemish painting, a Madonna of about 1440, "inspired by Van Eyck, no less," says Sonnenburg.

It worked. Sonnenburg enrolled as an apprentice at Munich's Doerner Institute, which since the war has been the top conservation laboratory in the world. He first studied under preeminent conservator Christian Wolters, a man who stressed the scientific aspects of the field. Sonnenburg observes, "I'm not sure if my teacher Christian Wolters really was fooled, but he seemed to accept it [the Madonna] as a proof of my talent. Anyway, after that, he was never sure what I was up to."

Sonnenburg was no stranger to imitating. When he was a child he had made countless copies of Rembrandt drawings. By this he gained insights into the master, being struck by the roughness and lack of perfection of Rembrandt's drawings compared to the finesse of his completed paintings. Those findings would help him throughout his career. "I copied endlessly in my student days and when I became an apprentice I worked with original pictures exclusively."

He rooted out his first fakes while still only an apprentice. At the Doerner Institute every Tuesday morning was set aside for a public open house where private collectors and art dealers could bring their works of art for free consultation with the staff. If the collector wanted chemical analyses the fees ranged from five hundred to fifteen hundred dollars, but, depending on the amount of time expended and the complexity of the tests, it could cost as much as seventy-five hundred or more if a huge battery of tests was applied.

There was one particular dealer who specialized in paintings depicting hot-air balloon ascensions, something with which Sonnenburg was fasci-nated. The dealer had a large body of work by a primitive of the nineteenth century named Trotin. Sonnenburg cleaned a Trotin that showed a balloon departing from a wooded landscape and found that the picture beneath several layers of varnish was shockingly fresh. It couldn't be nineteenth century.

Sonnenburg then launched into a penetrating study of other works by Trotin and to his amusement and the chagrin of the dealer who'd been peddling the modest pictures, proved that all Trotins were modern, created by a clever, unassuming faker willing, in a sense, to forge one-dollar bills for his livelihood. Sonnenburg discovered among other things that the faker, who was still alive and very active, had drawn his inspiration from nineteenth-century prints and etchings, even copying inscriptions and remarks into his primitive pictures.

"I kept on discovering minor fakers during my apprentice years," Sonnenburg explains "When I'd go on holiday—to Italy and Spain—I became interested in a series of paintings with perfect aging, all the old cracks looking perfect. I used to find them all over the place from flea markets in Madrid to humble street auctions in Milan. They were supposed to be late eighteenth–early nineteenth century, but I couldn't believe them."

Years later when he was working with a German private conservator based in London by the name of John Hell, he was amused to find scads of the same paintings he had seen while at the Doerner, offered for sale in fancy retail stores.

In time he exposed "a whole factory where they were being made." He named them "period paintings" after the German word for "period reproduction furniture." There were hundreds of them all over the world. "I found that certain dealers bought them by the dozen for relatively low prices, damaged them deliberately to make them look older—and more genuine— repaired them and sold them for double, sometimes triple." These works were clever landscapes aping a variety of eighteenth-century Venetian painters, such as Francesco Zuccarelli, Francesco Guardi, and sometimes Bernardo Bellotto.

Not a month goes by these days when Sonnenburg doesn't encounter one of these factory products, each looking more convincing as the years pass. "Lots of skilled collectors and dealers and even curators fall for them."

After five years at the Doerner and two more with John Hell in London —an exacting experience, he recalls—he was getting close to his goal which was to become a new kind of professional conservator who could combine his training in art history, painting, and science.

An entry position opened up at the Metropolitan in 1959, and he started as a basic restorer at a salary of fifty-three hundred dollars a year. I arrived at the museum the same summer, but as a fledgling curator my salary was two hundred and ninety-five dollars less. We soon became acquainted. I

admired Sonnenburg's lively eye and memorable way of picking apart any work of art. He seemed far more trained as a connoisseur than most of the curators.

I also admired him for his fierce independence. He had brought a folding kayak with him from Germany and one of his trademarks became that collapsible, inflatable boat which he paddled in the Hudson or the turbulent East River in the wake of tugs, across the paths of barges and steamers, under the piers, and once even into the midst of a prison break near Hell Gate, the narrow channel notorious for its dangerous currents.

Sonnenburg's rise was meteoric. In two years he was promoted to conservator of European paintings. He took charge of the delicate cleaning of a painting which at that time held the world record for a work sold at auction, the renowned *Aristotle Contemplating the Bust of Homer* by Rembrandt van Rijn. Sonnenburg's technique on that, as with every painting he attended, was to spend a long time simply looking at it. When the first layer of varnish was off, he looked more, until he was satisfied that he knew precisely what to do. Most of the time he carried out only the most necessary fixings, for his philosophy was to "leave well enough alone and never to carry out anything that was not definitely, provably reversible."

When I became the director in 1967, I found Sonnenburg an invaluable resource not for aspects of conservation, but for the most delicate matters of connoisseurship. I would seek his advice before asking the board of trustees to vote money for acquisitions in the many fields other than painting. He was uncanny when it came to judging the condition of works. And uncanny, too, in fingering forgeries.

The most expensive painting ever bought by the Met up to that time was Diego Velázquez's brilliant *Juan de Pareja*, which fetched four and a half million dollars at a sale at Christie's in November 1970. Many people were of vital importance in bringing together the data and the money needed to capture the great image of Velázquez's black assistant. Ted Rousseau started the game with fervent urgings to pursue what he was sure would be our last chance to gain a world-class Velázquez (and he was right). Few works are more world class than a prime work by the Spanish seventeenth-century master. The picture wouldn't be at the museum today were it not for Chairman of the Board C. Douglas Dillon, for without his steel-trap mind and artful powers of persuasion we would never have raised the money or structured the loan we made to ourselves from museum purchase and endowment funds. But it was Hubert who unlocked the secrets that convinced us that the painting was one of the best-preserved by Velázquez in the world.

The biographer of Velázquez, Antonio Palomino, tells how the painter went to Italy for the second time in the mid seventeenth century and once in Rome obtained the rare commission to paint the portrait *Pope Innocent X*. In order, he says, to prepare, Velázquez painted his aide, the black Juan de Pareja in grays and flesh tones and a muted green for Juan's doublet. The exercise was to limber up Velázquez for the difficult task of painting the pope whose florid face and ruddy complexion were well known and who would be wearing the ceremonial robes of bright crimson.

After the "practice" painting was completed, Velázquez instructed his assistant to carry his portrait to the studios of several of his peers, knock on the door, assume exactly the same proud pose as in the picture, and note the reaction. This ploy had a sensational effect. Palomino wrote that those who saw the man and the painting reacted with a mixture of "admiration and amazement." One of the unnamed artists reportedly muttered that the picture was so convincing that he didn't know whom to talk to, the man or the picture, and once he addressed both, had no idea which might respond.

The portrait was shown in an exhibition in the Pantheon, where, Palomino wrote, it was "universally applauded by all painters from different countries who said that the other pictures in the show were art but this alone was *truth*."

The bottom line when going for a masterwork is that after the quality, nothing counts but one thing—not the provenance, not the illustrious collectors who might have owned the piece, not praises heaped upon the piece by critics or historians—only condition. Price, value, worth are based solely upon condition. And condition is the only factor that makes one go for broke. I trusted only one man on earth to tell me about the condition of the *Juan de Pareja*—Hubert von Sonnenburg.

The terms set up by Christie's on the strict command of the seller, Lord Radnor, were that the picture should be examined by the naked eye, not in an unhurried, contemplative scrutiny in a proper scientific sanctuary surrounded by assistants and tons of equipment. There would be no X-ray paraphernalia, no infrared spectrometer or laser analyzers, just the eye, helped by a pocket magnifying glass, honed by experience.

There seemed little doubt that *Juan de Pareja* was the original Velázquez had "tossed off" in Rome in 1650. There were a few holes in its history, but they were not suspicious holes. It had disappeared, most certainly in Italy, when Velázquez returned to Spain in 1652. It surfaced in the eighteenth century in the collection of Cardinal Trajano d'Acquaviva, a consul for Spain, whose family had probably gotten hold of it before Velázquez returned

to Spain. Thereafter, the painting was listed in the Baronello collection in Naples sometime at the end of the eighteenth century. Next it showed up under mysterious circumstances in the hands of Sir William Hamilton, the British envoy in Naples from 1764 to 1798. His inventory called it, erroneously, "a portrait of a Moresco slave by Velázquez" (Juan was hardly a slave except to his own works—he was a painter himself). The portrait appeared next in the collection of Jacob Pleydell-Bouverie, second Earl of Radnor at Longford Castle, Salisbury, in the early nineteenth century. According to a member of that family, the painting was thought to have been purchased at auction for less than seven pounds in 1811.

Sonnenburg's first activity was to read every book on the painter in sight. Next was to learn how many old copies existed. One was in the Hispanic Society of America on 155th Street and Broadway and he spent a number of hours studying every detail of that fairly tedious, almost exact, but lifeless replica, which showed Juan set almost in the center of an almost square frame. He then conducted an examination of the painterly structure and condition of the three Velázquez paintings in the museum's collections and provided us with a thumbnail analysis of what to expect when looking at a Velázquez of the late, mature style.

"In later works he changed," he told me. "From a rather heavy application of paint to what you could call a 'watercolor' technique. This was based on thin washes beneath sudden, stunning blobs of almost raw paint which he floated over a brown ground with a reddish tinge applied to the raw canvas." Invariably, in the late works, the painter chose nubby canvas. He wanted the rough surface of the material to become highlights. Velázquez also wanted the reddish, thin ground to be seen here and there to make it seem like a red glow was coming from deep within the paintings.

Of paramount importance was whether or not the *Juan de Pareja* had ever been relined and thus damaged or even ruined. All of the Met's Velázquezes had suffered from relining, because the tiny mountains and valleys of paint had been flattened with the consequent loss of luster and sparkle.

Sonnenburg argued that he should have considerable input into the ultimate decision on whether to buy or not. He was brutally frank about the fact that if the *Juan de Pareja* had been relined, it was stupid to buy it. We made it official policy that if he liked it, we'd go for it and if he didn't, we'd back off.

In London, through a ruse, we were able to rid ourselves of the guard assigned to dog us, and had about a half hour alone with the painting.

Sonnenburg seized the picture off the easel and held it to the light. No relining. One could see little dots of light through the canvas.

He concentrated on the varnish. It was profoundly discolored, so much so that in reality the picture was probably more colorful than it would be when the varnish was removed. Was that good, I asked? *Definitely*, was his answer. After all, it was supposed to be a study in pure flesh tones. He recalled instantly what had been written in a show catalogue of 1938, when the painting had presumably last been cleaned: Juan's coat was described as dark gray and years later as a "green doublet." The varnish had turned from gray to a greenish color.

He paid particular attention to the highlights and how they had been achieved and their individual condition. Palomino had spoken of how Velázquez had used brushes with extremely long handles to paint all his portraits during his stay in Rome. He used them so he could step as far back from the canvas as possible to place the highlight in precisely the right place for optimum effect. Sonnenburg pointed to Juan's forehead, which was defined only by a huge spot of impasto—crisp in the center, bordered by dragged spurs—applied directly onto the thin underpainting. It was exactly what had to be in a truly superb Velázquez.

Sonnenburg became excited when he found underneath the yellowed varnish what appeared to be a random, almost meaningless, single brushstroke dragged across the empty space to the right of the face. He knew what it was, almost expected it, for it appears on a number of other paintings. Velázquez liked from time to time to try out his loaded brush on the backgrounds to get it ready for his precise touch. It was the sign of both concentration and spontaneity. And proof, if we needed it by this time, that this was no copy. But one couldn't be too sure. There were at least five known versions wandering around.

He ran his fingers over the edges where the canvas was stretched over the strainer, looking for something he seemed to know was there, or should be. He found it. "The canvas is thicker at the top and on the right side. It seems to have been folded." This would prove to be a vital point. It meant, if true, that the painting might have some more original canvas folded under and that Juan's centered position might change after restoration.

In the Doria Palace in Rome, where *Pope Innocent X* is exhibited, we pulled another ruse and vaulted over the barrier in front of the painting in order for Sonnenburg to have the closest possible look at the varnish, the surface, and the condition.

Back in New York with Chairman Dillon, Rousseau and I were on pins and needles awaiting Sónnenburg's word. Would it be yes, or forget it? To him, "*Innocent X* and *Juan* are virtually identical in condition and quality— surely Velázquez's two finest surviving works."

On the basis of this the board voted the needed money and we won the treasure. The picture was taken to the gallery of Wildenstein and Company in New York for secrecy and there Sonnenburg proceeded to discover everything he had predicted he'd find. The removal of the yellowed varnish made Juan's doublet gray again. And he found, carefully folded under, original canvas—3.5 cm (about 1 $\frac{1}{3}$ in.) at top, 5.7 cm (2 $\frac{1}{4}$ in.) at right side, 0.4 cm ($\frac{1}{8}$ in.) at the bottom—all with original paint surfaces. Once the shape had been changed there was an astonishing transformation. The figure, once boxed into a square, neoclassic format, came alive in the expanded space (29 $\frac{1}{8}$ × 23 $\frac{5}{8}$). The highlight of the brow turned out just as he said it would, seemingly floating over the paint surface. From a distance this clear separation of the painted layers, reinforced by the highlights and shadows of the texture of the canvas itself, gave the skin a particularly moist quality. Like no other artist, Velázquez explored the optical interplay of highlights, paint layers, and canvas texture. Sometimes this resulted in a slightly out-of-focus impression, corrected in the eye of the spectator. The suggestive power of the technique made the subject seem about to move.

Only later did I learn that the folded-under areas had been published by José Lopez-Rey in 1963. I suppose Sonnenburg knew, when he felt the folded-under portions in the small gallery at Christie's, that these were those portions of the canvas covered with original paint that the Spanish scholar in his catalogue raisonnée of Velázquez had discovered—precisely the same measurements as Sonnenburg found.

◆ ◆ ◆

Sonnenburg was also involved in one of the potentially richest acquisitions in the Met's history. In the early 1970s I was eager to entice Norton Simon, the millionaire conglomerateur, to leave his exceptional collection of old masters, Impressionists, and Indian sculptures to the museum. I proposed building a series of galleries and workspaces for his diverse holdings. The plan was to show a nucleus on Fifth Avenue and allow him to mount traveling shows for the smaller museums of the United States which Simon said he was dedicated to do, and, in fact, the IRS wanted him to do.

We worked for weeks trying to stitch the agreement together, but

Simon nitpicked and stalled, constantly altering niggling details of the basic agreement. Every week he would ask for something more. To break the logjam I suggested that Sonnenburg have a look at every one of his paintings. I even offered to have him do the necessary cleaning and small repairs. It was not only a carrot on a stick of delicious proportions, but the perfect way to find out how good his things were.

The report was that overall, they were excellent. There was one exception, which happened to be the painting Norton Simon revered more than any other. This was *Titus*, Rembrandt's portrait of his child. Simon had bought the masterpiece at Sotheby's in England for two and a quarter million dollars and had created a stir during the sale by complaining about the irregular manner in which the bids were proceeding. Later I was told by the auctioneer that Simon, doubtless wanting to beat the world-record price at public auction for Rembrandt, established at two million three hundred thousand dollars by the famous *Aristotle Contemplating the Bust of Homer*, had several times bid against himself.

Not long before Hubert was finished with his examination of Simon's several hundred pictures he called my office wanting to see me immediately. I held off my pending appointment and he came in, spread a series of X rays and photographs on my desk and explained that for some years he'd been establishing a record of Rembrandt's painterly process and could prove that the famous *Titus* was a late Rembrandt workshop painting, executed by one of his pupils. There was a distinct difference between the heavy impasto of the face of the boy—a solid mass of paint rather than structured brushwork—and indisputable works by the master.

"What are you going to tell him?" I asked.

Hubert roared with laughter and said, "Nothing! That's for you. That's why you directors get paid so much."

I did nothing. We lost the Simon collection. The willful billionaire was, it turns out, toying with us all along, getting our opinions, having his pictures examined, cleaned, and repaired. I should have told him then and there that his Rembrandt was phony. But he was to get the sad news in time. Years later, after Simon had gained control of the museum in Pasadena and had renamed it for himself, the group of Dutch scholars formulating a catalogue raisonnée of Rembrandt's works tried unsuccessfully to get permission to examine the work scientifically. Simon must have, by then, known his masterwork was phony, but didn't have the courage to admit it. Today the *Titus* still graces the front cover of the catalogue of the otherwise superior Norton Simon collection.

Sonnenburg left the Metropolitan in 1974 to accept the directorship of the Doerner Institute, the dream position in Europe for his profession. He hesitated a long time before making up his mind—he adored the briskness and the open character of America. Before leaving he helped pick his successor, a private conservator in London, John Brealey, who also had trained in John Hell's studio and shared Hubert's philosophy: "Leave well enough alone." Brealey had some of the choicest clients imaginable, including the queen of England and Paul Mellon. He had been responsible for the rehabilitation of the deteriorated paintings by Andrea Mantegna at Hampton Court, a delicate, time-consuming effort called by many experts the single most successful restoration of the post-war period.

Almost at once I realized how severe was the loss of Hubert von Sonnenburg. I asked Brealey while he was winding down his activities in London to help examine a work I was thinking of purchasing at Christie's, Man of Sorrows, showing Christ with his wounds flanked by a kneeling donor and one of the most charming angels ever painted, holding some of the instruments of the Passion. It was said to be circle of Meister Francke, dating to about 1430. It seemed perfect for The Cloisters collection of medieval art.

Brealey had a look and telephoned me that it was in acceptable condition. I went ahead with the purchase at the sale on June 28, 1974, and we won it for about fifty-two thousand dollars. Our agent was the dealer in silver and furniture John Partridge, and Christie's had no idea we were involved. We finally got around to having the picture sent to New York from Christie's five weeks later, the export papers having been secured immediately after the sale. England wasn't at all interested in blocking the export of the Man of Sorrows.

Before flying it to New York I asked Brealey to see if there were any minor condition problems. I'll never forget his stunned reaction after his second inspection. It was, he told me glumly, a total modern forgery in which some of the paints had not been invented until the mid nineteenth century and in which the faker had created all the ancient cracks in the paint by etching them and filling them with black paint.

Christie's had the picture shipped off to the restoration laboratory at London's Courtauld Institute and their specialists agreed with the Brealey findings. The angel was painted in cerulean, invented in 1860. The gold rays coming from Christ's head were modern transfer-gold. All the cracks were phony, with black paint rubbed into them to simulate age. X rays showed significant departures from early fifteenth-century practices, including the

painting of Christ in two sections. The oak panel was nineteenth century. All the paint was probably synthetic—celluloid.

The conclusion of Brealey's report was devastating:

> It is ironic that despite all the misguided ability and knowledge that went into creating this "period painting," the faker overlooked a commonplace elementary technicality: the body-colors (i.e. white) resist the actions of solvents and stand up to abrasion far better than the two other pigments. Yet the comparatively weak films produced by the browns and blacks (the cross, the habit of the donor, and the pubic hairs) are almost perfect in their preservation, whereas the tough body-colors are much distressed: the reverse, in fact, of what should have happened.

We refused to pay for it. Christie's pressed vigorously for their money. They claimed that first of all, their standard disclaimer in the sale catalogue protected them from our suggestion that they had misrepresented the nature of the painting. Second, it was published in their catalogue that any modern forgery would be redeemed only if the buyer came forward with proof within twenty-one days. We had dallied for over a month.

In time we learned that the seller, a Mrs. Hester Diamond of New York, had taken the picture to a well-known New York commercial conservator who had expressed grave doubts about its authenticity. She had bypassed Christie's in New York and had gone to London where she never mentioned the restorer's doubts. We appealed to Christie's with this information, but they held firm. We ultimately came to the opinion that under English law, we would not prevail.

The painting was swallowed into one of the storerooms and wasn't even given an accession number, placing it in a sort of limbo. It was nothing more than an unwanted and unloved piece of contemporary ecclesiastic furniture, a daub, something of no merit, a loser.

◆ ◆ ◆

Sonnenburg reorganized and modernized the Doerner Institute, making it even more the leading art laboratory. He acquired scads of impressive new scientific equipment and brought together into one effective team the scientists, the restorers, and the art historians. At once he began to root out fakes.

At weekly open-house sessions he became suspicious about a number of

old-master paintings by the likes of Albrecht Dürer, Lucas Cranach, Matthias Grünewald, and Hans Holbein. Some passed all the laboratory tests, some did not. Sonnenburg became convinced that they were fakes, but his proof didn't come for two years, when he learned the faker's patterns and sensitivities. The first tip was that the paintings were all similar in style, no matter if the work was by Grünewald or Cranach or Holbein—all artists completely unlike one another. He found a similar aging and cracking on a variety of paintings that shouldn't have had the same characteristics, being paintings of differing dates and hands. The supports for the wooden panels all looked the same.

For a while he couldn't explain how many of these paintings stood up as genuine under X-ray scrutiny. Then he found that in one picture its creator had cleverly transferred paint layers with intermediate layers of gauze and had pasted the paint onto a new support so it would not show up in X ray. Sonnenburg began to find the same phenomenon in widely disparate works.

Gradually, Sonnenburg became convinced that all the works, dozens of them, had been painted by the same person. Within two and a half years he had assembled an extensive photo collection of the bogus paintings of a wide spectrum of fifteenth- and sixteenth-century masters, all clearly by the same maker, along with lengthy scientific data. He set about pinpointing for each one the precise reasons why it could not be what it seemed to be.

He prepared an article for the art publication *Weltkunst* of October 21, 1977, and July 1, 1979, choosing nineteen pictures that summed up the full extent of the forger's ingenuity. He spelled out in detail why the paintings couldn't be ancient, and wrote detailed analyses of how each work had been aged and its paint cooked up. Hoping to smoke out the forger whom he believed was alive and working with a full head of steam, he deliberately lambasted one work, a *Madonna*, as being a thoroughly wretched effort. Sonnenburg was counting on the fact that this deft forger, like every successful one before him, was inordinately proud of his handiwork and might get so upset by "unfair" criticism that he might reveal his identity.

The article appeared and got the hoped-for response. The faker's name was Christian Goller. He was working in Lower Bavaria, not too far from Munich. He admitted that he had done all but one of the works, the *Madonna* Sonnenburg had criticized as bait. He admitted, too, that Sonnenburg had tracked down all of his tricks. Finally, he denounced the fakebuster for slandering him. He claimed he was no forger. He'd never passed off his

works as originals. He never made excessive profits. He was, he said, an honest "imitator."

Goller never adequately explained why his "imitations" of everything from Byzantine icons to Baroque easel pictures and the sixteenth-century German greats possessed all the characteristics normally associated with fakes. None were direct copies. All were made with old pigments and old canvas. They were all artificially and artfully aged, so well that only the most sophisticated laboratory tests revealed anything wrong.

The exposure of Christian Goller's "imitations" had an immediate effect in the museum world. Not long after the *Weltkunst* article appeared and caused a sensation in Europe, Sonnenburg was paid a visit by Ross Merrill, then the chief conservator of the prestigious Cleveland Museum of Art. The director of that estimable institution, Sherman Lee, an Oriental art specialist, had purchased from the New York dealer Frederick Mont a supposed masterpiece by the German Renaissance painter Matthias Grünewald, the creator of the world-famous *Isenheim Altarpiece* in Colmar. Grünewald's works are exceptionally rare and seldom show up on the market. Yet this one did in 1972. The panel represented Saint Catherine of Alexandria. The price was a million dollars.

Mont subsequently offered a pendant *Saint Dorothea* by Grünewald to The Cleveland Museum of Art and Merrill was seeking information— "rather uneasily," Sonnenburg recalls—about whether his German colleague knew of any recent old-master fakes. Sonnenburg was astounded that neither Merrill nor anyone else at the museum knew of his *Weltkunst* article, which was in the hands of subscribers even though it hadn't hit the stands. When Merrill showed him photographs of the two Grünewald saints, Sonnenburg opened up his files and displayed everything he had gathered on Goller. Merrill looked more and more pained as the evidence mounted. Abruptly, he excused himself and disappeared.

Merrill returned to Cleveland, told Sherman Lee and the paintings curator the bad news and subjected the panel of Saint Catherine to a new analysis of paint structure. He found "impurities" in the pigments that had not turned up in the first examination. The negotiations for the "Grünewald" *Saint Dorothea* were halted and intense discussions were initiated with the dealer Mont for the return of the *Saint Catherine* panel. Sherman Lee begged Sonnenburg not to publish the two Grünewalds. He agreed. The upshot was that Cleveland announced to the world that it had been taken and Frederick Mont graciously returned the money. It happened just before *Weltkunst* hit the newsstands.

Goller continued his "imitations" without any charges being lodged against him. He revealed that he was the maker of the two "old masters." He began in 1972 using antique, wormholed maple tabletops as his panels. They were purchased for about fourteen hundred dollars each by a collector of his work who sold the *Catherine* to a Munich dealer for twenty-two thousand dollars. That dealer claimed he was convinced the work was genuinely old.

Goller boasted that he could fool any piece of scientific equipment at the Doerner Institute and all the experts of the Cleveland Museum. Had he chosen to in the case of the *Catherine*, he could have solved the "pigment impurity," which was that the half-life period of the lead white paint didn't match the supposed age of the masterpiece. He could have ground up lead from a sixteenth- or seventeenth-century clock weight to give the pigment its half-life had he cared to do so.

"But Sonnenburg's eye, that's something else," Goller said in admiration.

The eye is still king to fakebuster Sonnenburg and scientific analysis a mere backup and occasionally a pretty faulty one, too. Time after time he was to see all the toughest scientific tests fooled by superior forgeries. Repeatedly, he saw other conservation studios fail to detect forged paintings.

Sonnenburg tells the sad story of two young people coming to the Doerner with a magnificent Bohemian painting of that shining period of the "Beautiful Style," about 1400, with a battery of tests carried out at another German laboratory. Before selling their valuable work for something in the vicinity of a million dollars, they wanted a second opinion. Sonnenburg's diagnosis wasn't good.

He suspected the picture on the basis of style. The typical sweetness he expected to find in the circa-1400 Bohemian work seemed rancid. The blues appeared strange. Tests were conducted on the blues and impurities were discovered in the ultramarines. He was able to prove that the painting was a fake. "The couple got very nasty and from then on hated me. In fakebusting, the chances are that someone will hate you for the truth," Sonnenburg said.

Today he is continually amazed at the exceptional quality of the new brand of fakes, especially the paintings. Some of them resist to the end any scientific analysis. He came across half dozen Gauguins of superior manufacture and one Van Gogh which could never be proven a forgery in the laboratory. The latter is a copy of an oil portrait of *Patience Escalier*, the original of which (25 1/4 by 21 1/4 in.) is to be found in a New York private

collection. The tip-off that the work is a copy came from a number of stylistic weaknesses and incongruities. The drawing of the face and the green coat is markedly more tentative than the strong original. The paint is applied with apparent care, stroke by stroke, whereas in the original the paint was put on ferociously and casually. The copy lacks an overall energy. The face seems lopsided, almost deliberately crude in the attempt to appear to be powerful. The colors are weak when compared with the original, as if they had slightly faded. Yet the copy of the portrait *Patience Escalier* looked very, very old.

The thermoanalytical tests conducted by Frank Preusser on the picture gave no precise date, but indicated that the painting had to date before 1900. Van Gogh died in 1890, but it has always been presumed that his works didn't start selling until years after his death. How could it be that a forgery of one of his late portraits was created as early as 1900? As Sonnenburg says, "The persisting current theory that Van Gogh's works were never copied or imitated during his lifetime is doubtless a speculative misconception." He points to the fact that a copy of one of Van Gogh's last masterpieces, *The Garden at Daubigny* executed in the last year of his life, is known to have been in existence as early as 1895.

Researches made especially by Alain Tarica, the French mathematician and former art dealer and fakebuster, indicate that contrary to accepted mythology, Van Gogh did have pupils, and did sell a number of pictures during his lifetime. One of those pupils was the Dutchman Frank Schouffenecker and another was his doctor in Arles, Paul-Ferdinand Gachet. Tarica believes the moody *Self-Portrait* of the year 1887 in the Orsay Museum, in which Van Gogh stares out of the canvas gloomily, holding his head in one hand, is a work by Gachet. The brushstrokes and the colors of this work are strikingly different, paler, and less dynamic than all the other dozen or so pictures indisputably by Van Gogh in the same gallery. And different, too, from the other version of the same portrait, which seems indisputably by Van Gogh. Tarica also suspects, because of the washed-out colors and the monumental dimensions, that the famous *Sunflowers* purchased at auction in 1987 for $39.9 million by Yasuda Marine, the Japanese insurance company is not Van Gogh at all but a fine example of the work of Schouffenecker when he was a student of Van Gogh's. His arguments are very convincing.

It was after his encounter with the copy of *Patience Escalier* that Sonnenburg began to add a humanistic section, his own nonscientific observations to the data that came churning out of the complex scientific equipment at the Doerner Institute: the computers, the X-rays machines, the optical

emission spectograph pigment analyzer, the color measuring equipment, laser microanalyzer, and the ultraviolet visible spectrophotometer. In the new section were all his observations regarding style and various problems he found that might lead him to suspect a forger had been at work. For there are instances when the human eye, the gut reaction, the sensitivity that comes with years of observation are more accurate than any battery of instruments. There were times, in fact, when he unmasked a fake only by old-fashioned connoisseurship: hard scrutiny and deep introspection.

A few years after Sonnenburg had taken the post at the Doerner, one of his assistants was asked by a dealer to inspect for possible restoration a painting depicting two nude girls in a wood, a work by the German Expressionist Otto Mueller. The assistant carried out some routine cleaning, but was puzzled and a bit troubled by the paint surfaces. So he brought the subject to Sonnenburg's attention. Sonnenburg suggested to the dealer that he send the painting to the Doerner for a complete analysis before he bought it; the price was serious, something like a million marks. Once he saw it Sonnenburg instantly felt it was a fake, but wasn't able to prove it. All scientific tests failed to reveal anything awry. Sonnenburg's staff, this time, were vehemently opposed to his gut reaction.

To solve the problem, Sonnenburg told me he "borrowed a group of paintings by Otto Mueller who as a rule painted on a coarse burlap with glue-bound pigments—unquestionably real ones, which no one could argue about—and I placed them on the walls and on easels in our major studio and put the enigmatic picture in the center. It took weeks of looking, comparing, thinking, contemplating to bring my staff around to my point of view." No technical analysis could have done the same thing. Sonnenburg explained:

> Only by living with the painting and the real ones could we establish the thing was a fake. We saw after a while that the real Otto Muellers all had a matte surface. The paint was however softer on the originals than on the fake. The most fascinating thing was that the colors on the fake Mueller were to a tiny degree dirtier than the genuine ones. There's a strange compulsion on the part of forgers to make a two-dimensional fake look older than it really is—or has to be. No chemist was able to furnish me with an analysis of why the thing was wrong. That forger had done a superb job delicately using rough canvas in just the right way. If we hadn't put a real one and fake side by side we would never have known. It was, essentially, the raking light that proved it. In raking light the human eye has a

marvelous ability to catch something strange and unbalanced, things that even the camera cannot detect.

What proved conclusive in the case of the Mueller were the differences in the degree of mattness of the gluebound paint surfaces, distinguishing the originals by their slightly more pronounced velvety quality. Sonnenburg observes:

> The forger of oil paintings, by contrast, can disguise his tricks under the final varnish level, for it is there that he gets away with his work or fails miserably. People see a van Meegeren today stripped of its tinted varnish and laugh. They cannot believe that anyone could have been fooled by such a blatantly fresh surface. But it was with the final layers where Van Meegeren was so clever.

If Christian Goller with his pair of Grünewalds fooled even the experts at the Cleveland Museum—who were, after all, highly trained professionals —and if the Otto Mueller *Women in a Wood* had seduced the skeptical restorers at the Doerner, wasn't it possible that an even more gifted forger could dupe every expert in the world? Sonnenburg is convinced that it's possible. "Can one ever be sure of anything?" he says. "But the exciting challenge comes in all those cases where everything is problematical."

Today Hubert von Sonnenburg is back at the Metropolitan as chief conservator. After the Doerner Institute he served four years as the general director of the Bavarian state museums as well as running the institute. He left after a raging political controversy triggered by his seconding an assessment by an expert that a landscape said to be by the French nineteenth-century landscapist Charles-François Daubigny, purchased by his predecessor, could not be by Daubigny. A war erupted between Sonnenburg, other directors of Bavarian museums, and various members of the ministry of culture. It was a classic struggle between those who were right and those who were entrenched—and in this case, wrong.

As the story grew more tangled and bloated and suspicious, it turned out also that the "Daubigny" had been purchased for an exorbitant 1.6 million Deutsch marks. In the end the museum establishment prevailed. Sonnenburg resigned, but today few dispute his conviction that the so-called Daubigny is not by the master and fraud investigations are continuing.

When he's not carrying out his multiple conservation duties he is exercising two aspects of fakebusting. As he puts it, "Part of the time I try

to root out the forgeries and part of the time I try to save originals after they have been falsely condemned."

At Christie's a year ago he spotted a painting by Diego Velázquez entitled *Immaculate Conception*, which seemed precisely the same as the magnificent picture on view in the National Gallery in London. He asked about this "copy" of the London work. The Christie's official stated it was not a copy. The picture was relegated to a roped-off area and at first Sonnenburg was unable to study it closely. Finally the firm allowed him to have a close look. He was amazed to find every detail of the original even down to the characteristic test sweeps of the brush on the sides of the canvas, the same kind of unloading of the brush that appears in the *Juan de Pareja*. The painting was "in ruinous condition," making it extremely convincing, yet to Sonnenburg this *Immaculate Conception* didn't ring true. It was estimated at ten million dollars, but was not sold, which convinced him no potential purchaser believed it as an original.

In 1993 another *"Juan de Pareja"* came on the market, again at Christie's, which was unusual in that it was virtually the same size to the centimeter as the Met's marvelous original. All other known copies are the size of the Velázquez when it was folded back for the second frame in the early nineteenth century. To Sonnenburg the details were "superb." At first the auction house was intrigued to learn how it related to the Met's and agreed to send it over to be compared. Then suddenly, Christie's changed its mind, the study was called off, and the painting was sent back to its owner. Sonnenburg is convinced that it is an exact copy made when the real *Juan de Pareja* was sold in the eighteenth century. Who knows how it will be attributed when it next appears?

To Sonnenburg perhaps the most significant thing about a painting when one is pondering whether it is an original, a copy, or a fake is its "spiritual character." The famous *Polish Rider* by Rembrandt in the Frick Collection, New York, which depicts a young, devilishly handsome cavalier, perhaps a fanciful image of a Scythian warrior on horseback, just passing through town with his hand held cockily to his hip, is currently under siege. The so-called Dutch team, now down to one investigator, doubts that it is by the master. But Sonnenburg feels that there is such mystery, such muted drama, such life and the threat of death in the work that its "spiritual character" points strongly to Rembrandt. "I suspect that only Rembrandt could have produced such a masterpiece," he says.

He vigorously defends another recently doubted painting, the *Majas on a Balcony* by Goya at the Metropolitan, the disturbing image of two gorgeous

young women and their two black-robed pimps. The present curator of paintings, Gary Tinterow, firmly believes the work to be a copy of the unquestioned version in the possession of one of the Rothchilds and labeled it as such in the recent exhibition of the Horace Havemeyer Collection. Sonnenburg holds that the *Majas* might well be authentic, but a shadow of its former self, some of its qualities destroyed years ago through overcleaning.

It could be, he says, that Goya was commissioned to paint another version, the one now at the Met. This wouldn't be the only replica of one of his own works made by the Spanish painter. The dresses of the *majas* in the Met's painting are executed in their entirety with the extremely difficult technique of the palette knife. This was done "with incredible speed" and "with incredible sureness," says Sonnenburg. "I cannot conceive of anyone other than Goya doing that, which he has done in other paintings. So far not enough effort has been made to understand our picture."

For a while the painting was removed from display. That was before Sonnenburg returned to the Met. Now it's back on the wall in a privileged location and the label reads, "attributed to Goya." Perhaps that too will change to a solid "by Goya." It should be. It is not a copy.

He also defends what he calls the "admittedly odd" self-portrait by Vincent van Gogh—*Self-Portrait with a Straw Hat*, which is painted on the back of an early dark-period picture of a woman peeling a potato. It is usually thought to be an early Parisian portrait and its awkwardness is explained by the fact that Van Gogh was experimenting with bright, Impressionistic colors. A few years ago its authenticity was challenged by an independent scholar, Walter Feilchenfeldt of Zurich, who is disturbed by its primitive passages and even more disturbed that it is not listed in the first Van Gogh inventory of 1891. He argues that the incongruities in style and the fact that the picture came to the market only in the late 1920s when that group of obvious Van Gogh fakes suddenly showed up in the hands of Otto Wacker, make it profoundly suspicious. But the Met curators disagree. So does Sonnenburg, who had the opportunity to peel the early fake of *Patience Escalier* like an onion.

Sonnenburg's defense of an original can be devastating. Once back at the Met, preparing for the 1992 lecture series "Understanding Fakes," he became intrigued with the wooden panel painting *Man of Sorrows*, the very painting his predecessor John Brealey first had called "okay" and then a "forgery from the ground up, not an authentic circle-of-Meister-Francke work." He studied Brealey's and the Courtauld Institute's findings and found the key conclusions insupportable.

What triggered his suspicions was that the oak panel seemed awfully old and good and that some of the paint appeared to be tempera, not oil paint. The latter was a vital clue because until 1950 it was the accepted wisdom of conservators of early Netherlandish painting that the masters had used a type of tempera.

The examination—by historians, experts in wood, chemists, and conservators—came to the conclusion that *Man of Sorrows* is the classic, high-connoisseurs' fake. The incredibly clever faker or team, as it may more properly have been, took a genuine ancient panel, an authentic painting, and "cunningly restored" it by shaving down about 50 percent of the original surface to add charming details of a date that would be seventy-five years earlier—and of a style that would jack the price up ten times.

John Brealey and the Courtauld Institute specialists were correct in observing certain troubling features. The gilded rays emanating from Christ were of modern gold transfer; the blue paint used in the angel was a modern cerulean; and many of the cracks were etched and filled with black paint. But they were way off on other points. They claimed that the Christ had been painted in two halves, not an ancient Flemish practice. But he hadn't been. They claimed that the paint was celluloid, when, indeed, it is part old oil and part modern tempera. They stated confidently that the wood panel was nineteenth century. The wood turns out to be at least late fifteenth century and the irregular vertical cracks of the paint on much of Christ's body correspond perfectly to the growth rings of the wood. No forger could accomplish that.

Sonnenburg and his team discovered by patient looking and probing that the figure of Christ and the Benedictine donor at his left, the cross and part of the shroud hanging on the cross were original. All else—the money parts, one might say—were incredibly clever additions, including the dazzlingly cute angel holding the column on which Christ was bound for scourging; the remarkable tiles of the floor with their impressive perspective rendering; the entire parapet with its striking diamond patterns and the paired letters CS and PB; the decorative halo surrounding Christ's head; the heavenly rays of gold emanating from Christ; and the striking blue sky—all added in such a way that the overall effect was seamless, brilliant, confident.

As to who could have done such work, no one knows for sure, but there are suspicions. *Man of Sorrows* was first published and illustrated by Edouard Michel, a respected Belgian art historian in 1924. The work was owned by Emile Renders of Bruges, a banker, private scholar, and draftsman. He had gotten it supposedly from a Liège art dealer whose name was never revealed.

Renders was a close acquaintance of an art restorer Jan Van der Veken, an ardent proponent of the theory that the Flemish masters had used tempera and who had reproduced the stolen panel of the Ghent altarpiece, the *Just Judges*. A number of the early Flemish paintings formerly in the Renders collection have been questioned as to authenticity and as to the excessive amount of creative restoration. It is possible, though probably never provable, that Renders had Van der Veken ameliorate the pedestrian *Man of Sorrows*.

What makes Renders so suspect is that in 1928 he wrote what was in its time considered an article of landmark importance dealing with the heated subject of genuine and imitation Flemish primitives. He cited many of his own pictures as being classic examples of the genuine paintings. *Man of Sorrows* was one of the prime examples. He selected a number of details of the picture photographed in raking light to prove one of his major points that the cracks in those areas had come as a result of natural aging. He was dead right, as Sonnenburg has now revealed. Yet, intriguingly, the wholesale repaints, the additions, and the army of false cracks somehow entirely escaped Renders's keen eye. Could he and his friend, restorer Van der Veken, have been preparing the physical and scholarly foundation that would have blessed all his other doctored "masterpieces"? Such a thing has happened before in the world of art fakery.

Hubertus von Sonnenburg, probably the world's premier fakebuster, has one unfulfilled dream. He'd like to mount the most important exhibition of art forgeries ever—far more important and revealing than the recent one in the British Museum, "Fake." Says Sonnenburg, "I'd have the really good fakes, the so-far secret ones. I'd concentrate on the works of Guardi. The fact is, Guardi never died. But I'll never be able to do it. Collectors always pull out at the last moment. There's never been a show of truly great fakes. When it comes down to it, people find it almost impossible to admit that there are any great fakes at all. Oh, how wrong they are!"

# THE "FHAKER" WITH CHUTZPAH

*T*he Greek and Roman galleries in the distinguished Museum of Fine Arts, Boston, are some of the very best in America. In one of the most prominent of these galleries is a cherished work of art, which stands bathed in a series of special spotlights. The label announces that this work is a rare fifth-century-B.C. Greek masterwork of the most compelling "severe style" of circa 460 B.C. The huge marble relief, eight and a half feet long, came to the institution in 1906 and was an instant sensation. I believe it is a fake, a wholesale phony concocted by one of the more amazing forgery gangs ever to have plied the dark trade, lead by the faker with the most chutzpah in history.

The Boston museum doesn't accept that the "Boston Throne," as it is called, is bogus. The curator of Greek and Roman art, Cornelius Vermeule III, a man well known for his assertive and outspoken views about other Greek classical fakes, staunchly defends the piece.

To delve into its fakeness and to find out who made it and why and how it is related to a series of other sensational fakes one has to journey back in time to the magical and duplicitous city of Rome. The time was the height of the Belle Epoque, the 1880s and 1890s, when the Eternal City sparkled with the intellect of philosophers, artists, writers, and above all, archaeologists.

Today there's no comparison to the rabid fascination with antiquity that existed in Rome in the last quarter of the nineteenth century. You'd

have to go back to the Renaissance to find a fervor anywhere equal to it. Indeed perhaps not even in the hothouse salons of the Medici or the Chigi popes who doted on classical antiquity might one find such an eagerness to discover and learn about bygone classical epochs.

This was the time of the beginning and the flowering of the prestigious archaeological schools and academies—Italian, German, Swedish, British, and American. The German Institute was probably the most energetic and well endowed. Huge sums were expended on scholarship. Intellectuals hotly discussed issues that today sound like angels dancing on pins.

There is no parallel, either, for the zeal from 1875 to 1900 to collect works of classical antiquity on the part of the Italian State (which seems bored by antiquity these days) or by the newly emerging and exceptionally wealthy American, German, and Danish museums. The equivalent of millions of dollars a year was spent. The competition was fierce. In late-Victorian days, as we have seen, some foreign museums retained full-time private agents, gentlemen of high birth, exalted intellect, and vast training who spent their days sifting through all the recent discoveries for the very best antiquities. Greek and some Roman art surpassed the old masters in interest.

At the same time, Italy was beginning to feel wronged by those who dealt in antiquities. In the 1860s the first serious discussions were beginning to take place about laws governing the wholesale departure of treasures. There was an export tax, but it was nothing of particular significance. The dealers and these special agents—the *marchands amateurs*—knew that the era of laissez-faire export was coming to an end. They also recognized that the wellsprings were drying up and it was becoming more and more difficult for individuals other than fully trained professors and curators to get permission to carry out archaeological excavations. The epoch of the dilettante archaeologist was coming to a gradual end.

Because of these changes in what had been for hundreds of years a completely open market, it was inevitable that sooner or later a lively trade in forged antiquities would come to pass. When it did, it fell into the hands of two of the most crafty, brilliant, peculiarly twisted crooks that the history of art fakery has ever known. The pair of conspirators and their minions—who were all highly talented—pulled off dozens of jobs that were so beautifully camouflaged and so cleverly foisted on specially chosen "marks" that the fakes resisted disclosure for generations. Their names were Wolfgang Helbig and Francesco Marinetti and together they constituted the bad dream of fakebusting—the exuberant coming-together of hand and mind, theorist

and practitioner. One was a powerful, respected art dealer and a superb forger. The other was a learned archaeologist who either wrote the "programs" for the fakes himself or recruited the right specialist so that his fakes contained a minimum of art historical errors.

This pair of unscrupulous fakers were tracked down long after their deaths by one of the most adept fakebusters ever, Dottoressa Margherita Guarducci of Rome. Now ninety-three, she's an historian of ancient texts who in the course of her sparkling career has written over three hundred books and articles, the most important of which is on the tomb of Saint Peter underneath the Vatican. It was she who first suspected the collaboration of Helbig and Marinetti and who eventually revealed many of their hidden, crooked escapades. And it was she who proved beyond any reasonable doubt that the "Boston Throne" is a fake created in 1894.

The scholar-forger Wolfgang Helbig was born in Dresden on February 2, 1839, and died in Rome on October 6, 1915. He was the son of a teacher in the *gymnasium*. From an early age he was trained in classical archaeology and philology in Göttingen and Bonn, specializing in archaic forms of the Latin language under Friedrich Ritschl. He received his degree at Bonn in early 1861 and traveled to Berlin for postgraduate work. There his docents were the great historian of the ancient world Theodor Mommsen, and the classicist Otto Jahn. Helbig was considered bright, energetic, a pleasure to be with. He was described by his elders as "amusing, wry, anecdotal and of great bountifulness of heart and gentleness."

But he had another side. He could be furtive, tricky, and avaricious. He was obsessed with the world of high society. He yearned to be a star, to gain a place in the firmament of scholarship. As his teacher Otto Jahn grumbled, he could be "light, deprived of character and inattentive which makes him act in immature ways." He seemed to be drawn constantly to feats of daring and "acts of thoughtlessness."

Helbig was also accused of being "a heedless fly" and "a butterfly." Some, though not many, recognized in the affable and charming young man someone who was unpredictable and vindictive. This flighty side, usually well disguised, prevented him from becoming a member of the German school in Athens after his studies were completed in Berlin. It looked for a while as if he would have to fall back on a mundane job on the faculty of a *gymnasium*. In the final moment he managed to obtain a singular scholarship.

Every year the German Institute in Rome selected two young hopefuls who could theoretically, though it rarely happened, become permanent

members of the prestigious foundation. They were called "Capitoline kids" because the institute, one of the spiffiest of all, was housed in luxurious quarters on the Campidoglio. When Helbig arrived in Rome in October 1862 the institute was headed by Wilhelm Henzen with Heinrich Brunn as second in command. As Theodor Mommsen wrote Henzen, "this young one is simpatico . . . but as scatterbrained and fluttery at times as a wagging tail and difficult to discipline."

Helbig, twenty-five years old, handsome with a rather full, clean-shaven face and a black mane of hair immersed himself in the antiquities society of Rome as if he'd been born to it. It was all high scale, too. The archaeologists of the day, sometimes even "Capitoline kids," were invited to the best dinners and salons along with famous artists, writers, actors, and actresses.

Helbig immediately became accepted as a visitor to the most serious excavations of the day—in Etruscan territory, especially Palestrina some twenty miles to the southeast of Rome, where archaeologists were hunting for the earliest traces of Roman civilization. He went there in 1863 specifically to study some early Latin inscriptions. The fruits of his labors were accumulated in an exhaustive study by his former professor, Friedrich Ritschl.

That was Helbig's scholarly side. What the stodgy professors at the institute didn't know—at least in the beginning—was that Helbig also frequented the boisterous Roman eating and drinking establishments that were open virtually all night, the lively and dissolute "osterie, where all kinds of ruffians, thieves, forgers and con-men gathered."

The heedless side of Wolfgang Helbig manifested itself almost at once. He formed a strong friendship with dealer Francesco Marinetti, called by his intimates 'Sor Checco, for Signor Checco, his baptismal name. Helbig quickly became Marinetti's principal partner in the making of classical art forgeries.

Francesco Marinetti was the opposite of the witty, gregarious, flighty Wolfgang Helbig. He was born in Rome on April 24, 1833 and died there on October 31, 1895. He was destined to become the most active and famous antiquities dealer of the last third of the nineteenth century perhaps in all of Italy. He had a solid background in classical studies and art restoration, especially bronzes. Yet despite his learning, he was thought by some to be of suspicious character.

In 1853 at twenty years of age, he opened his own gallery and quickly became a multimillionaire. By 1879 his gallery was the most luxurious in town and he purchased fine lodgings on Via Alesandrina (a street that was later destroyed when il Duce leveled the structures to show the forums of

the imperial age). Marinetti entertained the future emperor of Germany there.

He was not a pleasant man. He worshipped gold; he was a miser; he was gruff, unscrupulous, and unethical. The best thing you could say about him was that he was amoral. He hardly ever talked. Marinetti was physically unattractive to boot—short, with a bulbous, extended stomach. One of his few graces was that he was a natty dresser.

One of the observers of the art and antiquities scene in the 1880s dubbed him the "King of the Hamsters." In 1933, long after his death, when the building on Via Alesandrina where his lavish apartments were located was being torn down, there was a sensational find of a seventeen-kilo treasure of antique coins, gold coins, gems, sacks of topaz, amethysts, and rock crystal. The hoard once owned by the "King of the Hamsters" was valued at well over three hundred and fifty thousand dollars, a fortune.

Marinetti's strong suit was in organization. He established a network of employees who regularly visited every farmer on whose property might appear an ancient find. He paid top prices for the right of first refusal. He bought concessions from the state to dig in Palestrina, where in 1876 some extraordinary early Roman tombs were found. Called the Bernardini tombs, they were filled with sensational gold objects, including three fibulas, or large, solid gold clasps that looked like luxurious safety pins.

Marinetti ingratiated himself with the authorities of the Belli Arti and the officials in charge of excavations and the national patrimony. In time he was accorded the honor of being the official appraiser of the content of the Bernardini tombs when the Italian government bought them from their excavators. In 1889 Marinetti became a *Cavaliere della Corona* of Italy, considered to be on a level with the French *Légion d'honneur*.

He built up a virtual factory of restorers and sculptural finishers, a duo of goldsmiths, and specialists in the repair of ancient bronze. He himself was gifted as a restorer and as a faker, which few people knew, except for his intimate friend Wolfgang Helbig.

Helbig and Marinetti began forging as a team in 1862 with a series of bronze caskets of the fourth and fifth century B.C. These were known as *cistas* (Latin for *box*) and were round, undecorated bronze boxes found at Palestrina. The trick of the Helbig-Marinetti combine was to take plain bronze receptacles and incise their undecorated covers with lively scenes drawn from mythology. Marinetti chose "best-seller" scenes such as Prometheus, Pandora, Andromeda, and Perseus.

One Marinetti bronze *cista* has engraved scenes representing a battle

between the Greeks and the Amazons and several episodes from the saga of Hercules. In this one he showed how clever he could be; the engravings of the Amazons are far more sophisticated than those of Hercules thus making the basket look extremely convincing—who would forge something with a lesser scene? This bronze *cista* was one of Helbig's first ambitious fakes. It was made in 1871, years after he was a madcap "Capitoline kid," but a rising star and second in command of the institute. Helbig drafted a letter for Marinetti to send back to Helbig in which the circumstances of the discovery of the sensational bronze were outlined in specific terms thereby establishing a convincing provenance.

Did he know what he was doing? Could it have been that he'd been duped by Marinetti? Not in the least. The fact is that Helbig by this time was a seasoned archaeologist and could easily distinguish between an ancient and a modern incised *cista*. And he was an intimate friend of Marinetti's.

Why did he do it? Money was certainly a prime reason, for he had developed an extravagant lifestyle. But his involvement might also have been driven by his flighty, unpredictable character. He was inordinately amused by practical jokes. The act was also related to his arrogance. Throughout his career there seems to have been the continual desire to fool the establishment in order to exaggerate his genius.

Helbig guaranteed that Marinetti's letter was published in the official *Bulletin* of the German Institute for 1871. Not too long afterward Helbig was nominated associate correspondent of the institute. The basket was eventually sold to the British Museum, where it remains today. At the turn of the century it was unmasked as a phony.

Another mediocre, undecorated bronze basket of the fourth century B.C. probably found at one of Marinetti's digs at Palestrina was enhanced by him with engravings and is today in the Czartoryski Museum in Cracow where it has recently come under suspicion. Helbig's involvement in that one was to publish it in glowing terms once again in the *Bulletin*. By this time Helbig's reputation as a scholar was such that his act sanctified the object.

The oddest fake *cista* served up by the team of Marinetti-Helbig was created in 1864 just in time for the celebration of the birthday of Rome in late April. It was an ambitious and risky number—it had a unique shape for *cistas*—being oval. Its cover was incised with a subject that was perfect for Rome's anniversary. The scene Helbig had chosen and Marinetti had incised depicted the triumph of Aeneas and the defeat of his rival Turno, the personification of the Tiber River and a curious, bearded, fat and naked

Silenus who was shown lounging on his side near the Tiber. The images could only have been devised by someone with an advanced knowledge of the poems of Virgil. The amusing thing about this bizarre *cista* is that the face of the figure of the portly and flabby Silenus is a portrait of one of Helbig's colleagues at the institute, a certain Heinrich Nissen who, ironically, would later raise some questions about the proper dating of the object.

The fake fifth-century-B.C. receptacle passed muster with one of Helbig's direct superiors at the institute, Heinrich Brunn, a man he disliked and who he felt might be holding up his permanent appointment. Brunn not only didn't see anything wrong with the unique shape but he had no suspicions about the odd drawings. He talked glowingly about the object in the lecture he gave for the anniversary celebrations. The piece was eventually sold by Marinetti through an intermediary named Pasinati to the British Museum where it was exhibited proudly until 1919 when it was exposed as a phony.

This last casket was made at a time when Helbig was experiencing a crisis. His two-year tenure as one of the "Capitoline kids" was coming to a close and he was so confused about his future he even considered becoming a journalist. But despite one member of the institute's central committee in Berlin complaining that he was "absolutely unfit and too unripe" to serve right under the first secretary, the powers on high assigned him to the second-in-command position of the prestigious academy in 1865 when he was only twenty-six years of age.

From the moment Helbig became second secretary his life became a paradise. He found himself the perfect wife, a wealthy Russian princess, Nadejda (Nadina) Schakowsky, who was suffering from terminal elephantiasis. The sedan chair bearers of Rome joked cruelly among themselves that she had to be carried around the city "on the installment plan." But Nadina was witty, spoke seven languages, was an accomplished pianist, and best of all for Wolfgang Helbig, was welcomed into the highest social circles.

The young scholar's fame spread with his marriage and with his growing list of publications, including a peppy guidebook to the museums and antiquities of Rome. Nadina saw to it that the *fior di fiore* of society and particularly diplomats, artists, and archaeologists were invited to the Helbig home. In 1878 Crown Prince Frederick, the future emperor of Germany, visited. Helbig was adept at paying compliments and at flattery and social chitchat. His position at the institute brought many honors; he was appointed a lecturer at the University of Rome, and became a member of the exclusive Accademia dei Lincei.

In Helbig's glory years from 1871 to 1886 there were, however, whispers against him. He was criticized as being too Italian, too independent of Berlin, too arrogant, and not sufficiently respectful to his elders. Things came to a head when the institute's jubilee was celebrated in April 1879. Helbig was in charge of the festivities and he planned an imaginative, slightly wild, expensive series of activities, including the production of a number of *tableaux vivants* from classical mythology.

The dinner was extraordinary, the gala fabulous. Society considered the German Institute festival a triumph, but the activities were condemned in official circles. Theodor Mommsen was especially vexed. In large measure the gossip was unfair. He was forging warm links with his Italian colleagues, of vital importance since permission for excavations came only from a sympathetic Italian officialdom.

Helbig was also a victim of bad timing. By 1883 there were heated discussions about making the German Institute more German. Helbig and his chief Henzen attempted to resist this "reform," arguing that the Italians would resent the nationalistic attitude. The move would rupture the newly made ties with the Italians and make it virtually impossible to obtain permits for new excavations.

Things got so touchy that Wilhelm Henzen announced in 1885 that he would retire the next year. By all rights Helbig deserved to become his successor; he was one of the few efficient people at the fusty academy. But he was also too well connected with Italians; he had just been granted the singular honor of having been asked to participate in a new Italian archaeological institute that sought to be international in scope. This was looked upon in certain quarters as a rival to the German Institute.

Helbig knew by 1886 that he was in trouble. In January 1887 Henzen suddenly died. Helbig, having become convinced he would never be asked to be first secretary, resigned on October 1, 1887. From that moment on he never disguised his hatred for the "Olympians," as the ruling inner circle of administrators in Berlin were called.

He was determined to show them up with a bizarre, almost insane, act of defiance and scholarly chicanery. To do this he turned to his partner in crime, 'Sor Checco. Together they would create one of the most flamboyant fakes ever concocted, an outrageous and daring escapade which despite advertising its false nature in a blatant statement written right on the piece, was nevertheless so clever that it hung around for almost a century before being exposed.

On his own, outside of the institute, Helbig was hardly in financial

straits or shunned. He and his princess bought a spectacular early-sixteenth-century residence, Villa Lante, on the Quirinale, and entertained lavishly. Their salon became the center of intellectual and art historical life in Rome for the next thirty-five years. He gained honor after honor: He was appointed by the Italian government an honorary inspector of the excavations at Tarquinia, a major Etruscan site, and also became an associate of the French Académie des Inscriptions et Belles-Lettres. He, his wife Nadina, and daughter Lili hobnobbed with the Italian royalty housed in the Quirinal Palace.

Nadina's inheritances provided considerable moneys, but Helbig was obsessed with having more and more. He earned it not only from his writings —his guides were best-sellers—but from the clandestine sale of antiquities.

In those days Rome was, as Margherita Guarducci puts it, the El Dorado of Antiquities. Italian soil was an inexhaustible source for the statues, vases, bronzes, jewelry, and gems that the artful dealers plumbed. The export of great treasures became a flood despite laws already on the books against selling antiquities to foreign countries. Dealers and private agents cheated the government on a regular basis while swearing publicly to preserve the national artistic patrimony.

It became the practice for wealthy institutions like the Metropolitan in New York, the Museum of Fine Arts, Boston, the Ny Carlsberg Glyptothek in Copenhagen, and the Berlin Museum to have on retainer agents who searched the art market full time for treasures—legal or not. As we've seen, the Met used John Marshall. Boston felt comfortable with Edward Perry Warren, the Boston Brahmin who was the lover of John Marshall. Berlin favored Heinrich Dessel. And Carl Jacobsen, the millionaire Danish beer maker who started the classical collection housed in the Ny Carlsberg Glyptothek in Copenhagen, dealt almost exclusively with his close friend Wolfgang Helbig. But the ties between the agents and these institutions were flexible, and all occasionally used anyone who happened to have found a great piece.

There was no doubt in the minds of the Italian government officials in charge of antiquities that the activities of these men were pernicious. Their names appeared in the press under embarrassing circumstances. Helbig was one of the targets of a censorious article in the Roman satirical review *Don Chisciotte*:

> As soon as men of this type [Helbig's] are officially recognized and
> sometimes even employed by the government they make a mockery
> of everything the department of antiquities is trying to do. . . . And

behind every mysterious disappearance, behind every statue trans-
ported abroad, behind every manuscript that shows up in a foreign
archive, one can find the name of these "scientists." Able in all
sorts of manipulations, protected by their diplomats who abuse their
privileged positions, they succeed in making disappear beyond the
customs officials of Italy hosts of works of art that should never leave
their ancient places.

Helbig laughed it off and took steps to strengthen his "Society." The
third member of the association was a man known for his impeccable con-
tacts with high society and the diplomatic circle. He was the Polish count
Michel Tyszkiewicz who was suspected of having used the diplomatic
pouches of the Polish embassy for the wholesale exportation of antiquities.
The fourth member of the group was Paul Hartwig, who freelanced for
others, was a member of the German Institute, and an expert in classical
antiquity, especially Greek vases of the fifth century B.C. He had gotten in
trouble with the authorities on occasion for homosexual activities, and was
always in need of some quick cash.

Some discoveries of antiquities eluded the "Society." Out of nowhere
it seemed, from a large construction site for a new Ludovisi family palace in
the summer of 1887 there emerged an exceptional treasure. This was in the
area of Rome that is now the Via Veneto, the vicinity of the American
embassy, and the section just above Santa Trinita di Monte, where there
was a prodigious amount of building activity. Several offshoots of the
wealthy Ludovisi family were digging away, setting the foundations for a
number of luxurious palaces. All Rome was talking about the scope of the
work and not a day went by without a mention in the newspapers of the
building activities and the large number of ancient marbles, vases, and
architectural fragments being unearthed.

Archaeologists began to realize that this area must have been the loca-
tion of the Gardens of Gaius Sallust, the wealthy historian and wheeler-
dealer who was a strong ally of Julius Caesar and who was thrown out of the
Senate for adultery and accused of financial wrongdoing while governor of
Numidia. Smatterings of ancient histories described the gardens as having
numbers of beautiful Greek sculptures, and all the archaeological cogno-
scenti were on pins and needles waiting for the emergence of some spectacu-
lar treasure.

It happened.

The official photographer of the government team that accompanied

every construction gang wrote that "a most singular monument has recently been unearthed in the villa Ludovisi." It was not another Roman sarcophagus or fragment of a statue but a three-sided marble—the finest quality of stone—a rare Greek original of the fifth century B.C.

Though it took five years to be published in a journal by Eugen Petersen, it was recorded by Rudolfo Lanciani, the topography expert who noted every archaeological find in the city, and at once became the talk of the town. It was placed on private exhibition in one of the Ludovisi houses, where every specialist was allowed to have a long look. It is likely that intricate drawings were made of it as well as photographs. Although there's no mention of casts having been made, it's not impossible. Old casts of the piece do exist.

It was immediately recognized that this stone, about five feet wide, was one of the most important monuments of classical art ever found anywhere in Italy, including the Magna Graecia, or indeed, in Greece itself. It dated to approximately 460 B.C., a fortunate period for art when the "severe style" flourished. Some art historians prefer this style to that of Phidias and the Parthenon sculptures themselves because of its forthrightness and grace mixed with the hint of primitivism.

The monolithic sculpture, carved on three outward sides like some enormous marble chair—erroneously called a "throne"—is made out of fine Greek Island marble. On the central side there is carved in delicate, low relief the enchanting image of a young goddess, Aphrodite it would turn out, emerging from the water and being lifted by two women whose shoulders and heads are broken off. Aphrodite is graceful and wears a clinging, diaphanous dress. The flanking figures, also dressed in diaphanous gowns, lift the goddess up by her armpits. The shape of the stone is roughly oval and even despite the breaks at the top it would seem clear that there originally was a kind of slanting roof. There are no architectural decorations.

On the left side is a seated, clothed woman with a round pot of perfume. On the right there's a gorgeous nude hetaera, a prostitute, playing a set of double pipes.

The faces are sensitive and possess a compelling calmness. The gorgeous draperies ripple and flutter across the figures in a way seldom equaled in other Greek art of the fifth century.

The archaeological speculation about where the relief originally was situated boiled down to three possible scenarios. Some said that it had been made in Greece, exported to Italy, possibly to adorn the Temple of Venus Erycina that had been constructed in the second century B.C. near the Porta

Collina in Rome, which in Augustan times came to be known as the Temple of the Venus of the Gardens of Sallust. Others held that it had been acquired by Sallust to decorate his garden. The third theory was that the stone came from a shrine sacred to Aphrodite, at Mount Erice in Sicily.

Had these graceful and mysterious figures (who seemed to be enacting some intensely private, sacred ritual) been found in some part of the excavations that could in any way be described as government-owned, then the piece would have been taken immediately to one of the state museums. But since it had been found in the middle of Ludovisi land, technically, it could be sold to the highest bidder who, presumably, would have to pay a hefty export tax. The Ludovisi family was plunging deeper and deeper in debt because of its profligate spending on palaces and other activities.

The discreet word went out from the curator retained by the Ludovisi family that bids for all the famous Ludovisi antiquities would be entertained. And with that began an effete but no less ferocious struggle by wealthy museums in Berlin, Boston, and Copenhagen dedicated to collecting classical antiquity to gain the Aphrodite marble and as many Ludovisi antiquities as they could. This polite, yet bellicose, struggle took place from 1890 to 1896, and has been chronicled in detail by Margherita Guarducci.

Wolfgang Helbig and his partner Francesco Marinetti came to one inspired conclusion once the Ludovisi marble was published by Eugen Petersen in the 1892 *Römische Mitteilungen:* namely, that no matter that the Ludovisi family legally owned the marble and could do anything they wanted with it, the Italian state would never allow it or, indeed, any significant Ludovisi piece to leave the country.

No one knows who it was who came up with the idea to forge a stone of ambitious size and decoration, one that would seem somehow related to the *Ludovisi Aphrodite* and could be dangled in front of the museums who hungered for Greek originals. It was probably the crafty Helbig.

It's clear that considerable planning was undertaken for the enterprise, which stands in history as very likely the most ambitious forgery ever attempted. Every element had to dovetail with another like the multiple pieces of a fine and complex piece of furniture. A plausible place of origin had to be invented; a name had to be conjured up for the discoverer; and the trail leading to the dealer who would eventually present the piece to the outside world had to be convincingly obfuscated.

First, a piece of Greek marble had to be found and acquired in such a way that the providers would never talk. That was probably easier than it seems, for Marinetti knew the existence of every piece of ancient Greek

marble lying around in the countryside. His "restorers" were continually in need of marble to use to enhance bits and pieces of original sculptures.

Then a talented cutter was needed. That was no problem at all. He was to be Pacifico Piroli who worked for Marinetti but who had his own studio nearby.

Above all, trained specialists who could draft the overall archaeological program for the forgery were necessary. These would be Paul Hartwig, the expert in Greek vases at the German Institute, and the master Helbig himself.

Picking the *Ludovisi Aphrodite* as something to work with point counterpoint was dazzling but touchy. Using it as the foil, and in part the model, significantly raised the level of what the "Helbig Society" would have to achieve. It's hard to imagine a greater challenge than to make an object from scratch that would be a distant relative to the gorgeous so-called throne. It was like coming up with a nonexistent pendant to Botticelli's *Birth of Venus*. But the wealthiest museums, they knew, had become obsessed not only with capturing the "throne," they had elevated its acquisition to the pinnacle of Greek artistic endeavor. Anything related to the work would fetch a superior price. Besides, the stone Marinetti's minions found was an ancient Roman or Greek sarcophagus and could be cut in half to have three sides like the Ludovisi marble.

Perhaps fundamental in the risky pursuit, though, was Helbig's wildness and daring, his flamboyant desire to go to the extreme. There seems to be little doubt that he thirsted for the more dangerous challenges. He had done this over and over in his turbulent career. And the "heedless fly" was, by this time, a man of distinction, honor, and unparalleled successes. Perhaps it didn't occur to him that he could be caught. To a man who had fooled all the experts with his baskets, the creation of a huge Greek original sculpture must have been looked upon as something of a lark.

Planning for the ambitious scam began, it seems, immediately after the publication of the Ludovisi marble by E. Petersen in 1892 and took until 1894 to produce a result. Helbig's "throne," a huge eight-foot-long undecorated Greek sarcophagus was made out of marble from the island of Thasos. No one seems to have cared what type of marble the Ludovisi object was made out of. Greek was Greek, but it was, in fact, a different Greek marble, a point that would cause trouble later on in the game. The stylistic and figural models were the Ludovisi marble and several characters extracted almost wholly from Greek vases that Hartwig chose. They also wanted the feeling of the decoration found on some Attic gravestones for the volute

decorations. The clothing of the disconsolate and joyful women were mod-
eled apparently after a garment called a *peplos* found on sculptures in the
metopes of the temple at Olympia in Greece.

One can imagine the excitement during the creative process. One can
imagine that a large number of drawings and plaster models of various sizes
were made, leading probably to an almost life-size *modello* that could be
altered and refined under the demanding eyes of the experts. Then the
model was pointed off on the Greek sarcophagus. This is where the first
errors crept in. Since the old sarcophagus was chipped and broken in places,
the forgers' full schema could not be translated to the available hunk of
stone. Certain areas had to be fudged. These would, years later, ignite the
first doubts about the piece.

At first glance the piece emerged from the forger's studio looking very
convincing—indubitably ancient Greek and striking visually. It's definitely
related in style to the Ludovisi marble, but not exactly. The Helbig "throne"
is a three-sided relief about eight and a half feet wide and about a foot and
a half higher than the Ludovisi relief. It was bigger, for the sarcophagus from
which it was carved was larger.

The scene on the central part depicts a nude winged youth with his left
arm casually on his hip and in his right hand the top of what the forgers
hoped would be interpreted as a pair of marble balances, which the fakers
never actually supplied. That was another error. The winged figure, suppos-
edly an Eros, is in the act of weighing two diminutive figures which can be
seen standing in two conical fragments of marble that picked up where the
missing parts of the scale left off. Who they are is obscure. One may have
been intended to be Aeneas, the weightier figure, and the other his arch-
rival Turnus. Amusingly, one of Helbig's *cistas* had Aeneas and Turnus as its
subject matter.

Flanking Eros are two women in robes that are patterned loosely on the
dresses of the fragmentary women in the Ludovisi marble. The one on the
left, adjacent to the tiny figure of Aeneas, raises her left hand in a gesture of
joy. The woman on the right, heavily veiled and near the figure who may be
Turnus, looks intensely dejected.

The decoration on the bottom of the central part consists of large
volutes. On the sides of the relief are a nude male lute player on the left and
on the right an old crone squashed onto her haunches with a strikingly
short-shaven head of hair. She holds some kind of an instrument though it's
impossible to tell just what it is. A problem.

Despite the agility of the carver Pacifico Piroli, who would carry out

extensive work a bit later on the neoclassical monument of Victor Emmanuel, he made a number of mistakes. The left wing of the Eros is much bigger than the right. His right foot ought to rest on the bottom fillet of the marble, but apparently the old sarcophagus was chewed off slightly at this precise spot and so the toes were carved *over* the break.

Other curiosities are the widely separated breasts of the sad woman, definitely non-Greek. They were copied from the beautiful figure of Aphrodite on the Ludovisi marble where her breasts are spread apart because she has her arms held apart and she is reaching up around the shoulders of the women who are lifting her out of the waters. In addition, the sad woman's left elbow under the veil is muddled and carved without any regard to anatomy. She has, in fact, two sets of elbows.

The old crone on the right side with her distinctive slave's hairdo was copied, a shade too closely, from a figure on a shallow drinking bowl called a *skyphos* created by the painter Pistoxenos in the fifth century B.C., where she accompanies Hercules while he gets a music lesson. (And he seems to have been the model for the lute player on the Boston three-sided relief.) This crone, unlike the striking figure in the vase, has no right arm. She has, moreover, only three toes on her left foot, the one nearest the edge of the stone. It seems that the stone was too narrow to accommodate the entire figure and Piroli, in trying to carve the foot as if it had been broken in antiquity, messed up. He committed the common fakers' error of creating an ancient sculpture that was never intact.

The lute of the naked player is of a type that has no parallel in ancient depictions, and the pegs which tighten the strings are features more pertinent for modern musical instruments. He is also wearing sandals that have soles only; there are no fastenings whatsoever, a gross mistake.

The most egregious error—or piece of terrible luck—is in the proportions and measurements of the phony. Not knowing, of course, what Margherita Guarducci would prove almost a century later—that the Ludovisi "throne" was no throne but a sacred wellhead made for the Aphrodite shrine at Locri in Magna Graecia in southwest Italy, which had been carved in Locrian measurements, not Roman ones, which are different when it comes to figures. The fakers made their Greek sculpture in Roman feet. The excavations of Locri would not begin, by the way, until 1909.

The process used for some of the aging was another mistake. The tiny slivers of root marks which one finds in any ancient stone were touched up with Mayer's glue, a substance common at the end of the nineteenth century.

Once the reliefs were finished and aged so that the recuttings of the old sarcophagus blended in neatly with the untouched surfaces, it was time to create a provenance. The cover story was that the marble was found in September 1894 not in the massive diggings in the Ludovisi palace, which would have made it part of the Ludovisi property, but in the garden of a certain Signor Bianchi, one of the engineers in the employ of the Piombini-Ludovisi family. This garden was said to be on the site now occupied by the Excelsior Hotel on the Via Veneto. The spot was only about five hundred feet from where the Ludovisi Aphrodite had been discovered on that Sunday back in 1887. The story was that the extraordinary new Greek three-sided sculpture was being used as a humble fountain, of which there are countless throughout Rome.

The cover story had it that a small-time art dealer, Tito Pacifici, found it and bought it. He sold it to another modest dealer, Augusto Valenzi. And he peddled it to the well-known antiquarians Antonio and Alessandro Jandolo, who had a shop on the Via Marguta, way down at the bottom of the Trinita dei Monti.

How to explain the way a huge, unbelievably heavy fifth-century-B.C. Greek marble was found in a garden—having never been seen or remarked upon before despite the fact that the area near Bianchi's garden was crawling with government officials and archaeologists recording every sliver of antiquity—and made its way from the area of the Via Marche down into the heart of town without anyone learning about it was not easy. In fact, its peregrinations were always described with a wink and a shrug.

Perhaps it's not entirely coincidental that Count Tyszkiewicz, one of the "Helbig Society" cronies referred to earlier, would write in his memoirs published in 1896 about the extensive works surrounding the Ludovisi Palaces, "These works have brought to light a considerable number of antiquities, for in spite of the vigilance of the agents of the [construction] company, and of municipal or governmental inspectors, the workmen almost always managed to carry off by night anything they had found by day, and during the fifteen years [of the work] the trade of Rome was enriched by sculptures." Only this fake relief weighs a ton and a half—hardly something a worker would have put aside for a nocturnal snitch.

As always with cover stories certain discrepancies and mistakes arose. The son of Alessandro Jandolo, Ugo, would name another dealer as the first purchaser of the relief. He would swear that his father and uncle had told him that it had been found, not in Bianchi's garden, but in an excavation on the property of the Cappuccin monks at San Isidro on the via Romagna.

That was a mistake, because the monastery was built in 1896, not 1894. Ugo Jandolo also erred in saying that his father and uncle always referred to it as a "sarcophagus," never a Greek masterpiece. Of course, a sarcophagus was what it was before it was recut in the studio of Francesco Marinetti by Pacifico Piroli.

According to the tale, the Jandolos paid 2,000 lire in September 1894. The work was acquired a few days later by Francesco Marinetti and Paul Hartwig, on October 1, 1894, for the astounding sum of 27,000 lire (worth roughly $72,000). At that point, Marinetti and Hartwig agreed to split all profits equally after the 27,000 lire of Marinetti's investment had been paid off. All this was told to the agents, who eventually purchased the relief for the Museum of Fine Arts, Boston. Why they didn't think it odd that Hartwig, a scholar, was in for so much when he hadn't put up any equity is hard to explain.

Three days after Marinetti was said to have bought the piece, Hartwig offered it to the first of several suckers—the Danish beer millionaire Carl Jacobsen, a close friend of Helbig's to whom Helbig had supplied hosts of antiquities. In January 1895 Helbig got in touch with Boston's Greek and Roman curator and told him that "a Greek work, still unknown, had recently issued forth from the ground near the location where the Ludovisi 'throne' had been found." Helbig had never mentioned the "throne" to his friend Jacobsen, no doubt figuring that Boston would be a better client than Jacobsen in this case.

At once Boston's agent Edward Perry Warren got into the act and in March he examined this second "throne" in Marinetti's studio. He fell in love with it and proposed to Marinetti that Boston acquire both for the tremendous price of 275,000 lire (150 for the Ludovisi and 125 for the second one—that amount being worth over $700,000, probably the highest sum ever offered up to that time for an antiquity).

Marinetti, playing hard to get, refused to part with his "throne" for a picayune 125,000 lire. Nothing happened until the fall, a year almost to the day when the "throne" was first put up for sale. Then Helbig suggested to Warren in Paris that it might be better for all to separate the second work from the Ludovisi Throne. He hinted that the Italian government was planning to buy the Ludovisi Collection and was initiating procedures to pass a law preventing the exportation of most antiquities.

Francesco Marinetti suddenly died and his goods went to his brother, Alfredo. Hartwig, increasingly nervous about the fake and his role in its

Embedded in every art forgery, no matter how ambitious or paltry, is a stupid mistake left by the faker—a physical property that didn't exist in ancient times, or a kind of aging that cannot be natural, or an amusing error in style—a blunder that anybody with concentration and common sense might be able to spot. Here are a few:

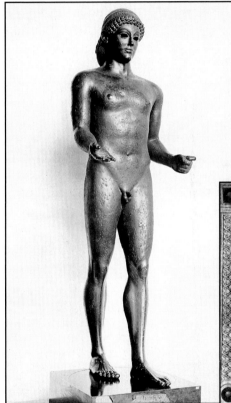

1

The *Apollo of Piombino*, a Greek bronze supposedly of the sixth century B.C. When I first saw it at the Louvre, I thought the muscles and smile too weak to be those of an original Greek sculpture. It was later found to be a first century B.C. forgery. (Chapter 2)

2

The Bolognese painter Guido Reni, while not a forger, seems to have executed a total repaint job on two of the most renowned frescoes of the High Renaissance. This is one: *Niccolo da Tolentino* by Andrea del Castagno of 1456 in the Duomo of Florence, a job that no expert or scholar has yet detected. (Chapter 4)

3

4

A "fourteenth century" reliquary in the British Museum, created by one of the most gifted forgers of the Victorian Age, Louis Marcy. The tip-off: a real medieval reliquary wouldn't have so many battlements. (Chapter 5)

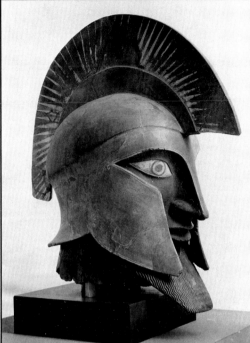

Three "Etruscan" warriors, sixth century B.C., at the Metropolitan Museum of Art. Admired for decades as exemplars of the spirited and bellicose Etruscan civilization, the pieces were found to be prime examples of modern Italian sculpture of the 1910s and 1920s. (Chapter 6)

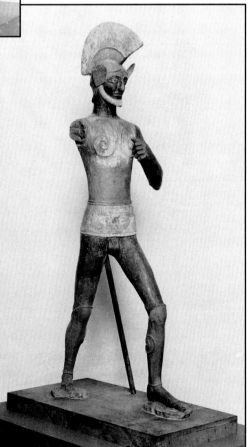

7

8

Three Catalan works of the "twelfth to thirteenth century" in the Metropolitan Museum of Art. My first reaction had been "too good to be true." I was right. The animals look idiotic, the black lines surrounding the figures are too thin and feeble, and some of the paint can only be twentieth century. (Chapter 7)

9

10

A painted wooden Madonna and Child about eight inches tall standing on a pedestal with three kneeling angels holding the pair up, said to be German, late fifteenth century. I bought it for the Cloisters in 1962, only to discover it was too elegant and sweet to be genuine. (Chapter 9)

11

One of the Met's most famous objects, the so-called *Rospigliosi Cup*, said to have been made by the finest goldsmith of the Renaissance, Benvenuto Cellini. Yet there are no dents, bruises, or knocks—no sign at all that it is four hundred years old. (Chapter 14)

12

Enamel plaque of the *Annunciation* in the Cloisters, thought to be fourteenth century when it was purchased. The physical properties of the enamel, sadly, date much later. (Chapter 9)

Gold glass from the Topić Mimara Museum in Zagreb, touted as early Christian—yet the style shows the unmistakable hand of the maker, Mr. Topić Mimara, especially the piggy eye. (Chapter 11)

Red chalk drawing by "Goya" of King Carlos IV and Queen María Luisa of Spain in the Topić Mimara Museum. Once again, the figures have those distinctive Topić Mimara stylistic signatures: Check out the piggy eyes and the clawlike hands. (Chapter 11)

14

15

Two sketches of Henri Leroy. The one above is by Jean-Baptiste-Camille Corot and hangs in the Fogg Museum at Harvard. The one below, whereabouts currently unknown, is by the late master faker Eric Hebborn. The academic correctness gives the phony away. (Chapter 13)

16

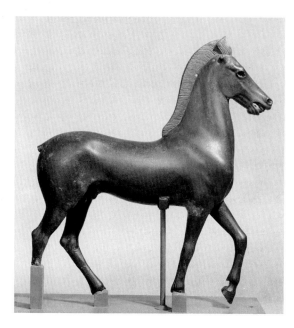

17

The Greek bronze horse at the Metropolitan Museum. Once said to be seventh century B.C., then called twentieth century A.D., now claimed to be Greek of the early second century B.C. In fact, it is very likely an ancient Roman forgery. (Chapter 15)

*The Fortune Teller* by seventeenth-century painter Georges de La Tour at the Metropolitan was falsely accused of being a fake. The clue to its genuineness is its very wackiness—and the presence of tin-lead yellow, a paint no longer used after the early eighteenth century. (Chapter 15)

18

A copy of an oil portrait of Patience Escalier by Vincent van Gogh. Although it couldn't be proven a forgery in the laboratory, several stylistic weaknesses and incongruities, such as the seeming care with which the paint was applied, give it away. (Chapter 16)

Once deemed a "forgery from the ground up," the wooden panel painting *Man of Sorrows* was later discovered by the Metropolitan's Hubert von Sonnenburg to have been a genuine ancient panel that was "cunningly restored." On the right, what's real; below, what's been added. The angel doubled the price. (Chapter 16)

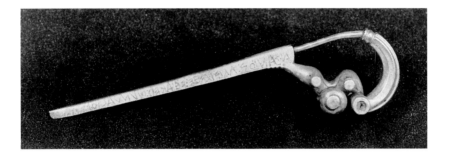

The *Palestrina Fibula*, whereabouts unknown in Italy, was lauded for more than a century as Roman from the seventh century B.C. The proof that it is bogus lies in the inscription: See the word *fhaked*? If not, hold the picture up to a mirror. (Chapter 17)

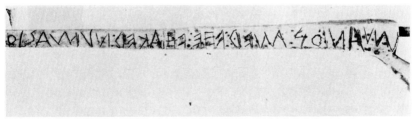

The "Boston Throne" at the Museum of Fine Arts (three views shown),
thought to be Greek, fifth century B.C., mate to the *Ludovisi Aphrodite* in
Rome's Terme Museum. Although at first glance it looks convincing, the
forger made a number of mistakes: The proportions and measurements
are wrong, the figures have non-Greek stylistic features, the aging process
required a substance common in the end of the nineteenth century, and
the entire piece is carved from the wrong kind of marble. (Chapter 17)

25

26

A sketch of the Getty kouros I had com-
missioned when the museum refused per-
mission to publish a photograph.
Discovered by the Getty's curator of
Greek and Roman art, Jiri Frel, the kouros
was once believed with certainty to be
Greek of the sixth century B.C. It now car-
ries a label that says sixth century B.C., or
modern. Among other problems, the mar-
ble is from one place but the style is from
somewhere else. (Chapter 18)

28

Another fake desired by Jiri Frel for
three-and-a-half million dollars, where-
abouts now unknown: an Archaic stele
with a male figure holding a flower. The
silly eyes are the clue. (Chapter 18)

A lot of fakes have yet to be uncovered. To me, this little Greek bronze of the fourth century B.C. at the Metropolitan is too perfectly formed and there is none of the brash provocativeness of a genuine Greek prostitute. (Epilogue)

This marble head of Achilles by the fourth-century Greek master Scopas was purchased by the Getty for two-and-a-half million dollars in the 1970s. In 1987 an article in the art magazine *Antike Welt* by Professor German Hafner of Mainz University revealed that the helmet was copied from a mistakenly restored one of the nineteenth century—real Greek fifth-century helmets come to a distinct peak in the center; this one is a smooth curve. (Chapter 19)

31

Plaster "model" for Michelangelo's *David*, said to have been snatched from the fire of 1690 in the Palazzo Vecchio. In fact, it was cooked in a regular kitchen oven in Paris in 1985 by con man Michel de Bry. (Chapter 21)

creation, pressed to have it sold and demanded that whoever bought it would have to promise that it would be hidden and unpublished for a number of years.

Finally in December 1895 Warren and Marshall voiced their firm intentions to buy the relief. Helbig, a master manipulator, told them that a third partner had come in on the deal, an anonymous individual who was going to obtain all the necessary customs clearances. This anonymous character, as it turns out, was Helbig himself.

Warren tried again to gain both "thrones" as a major acquisition, but Helbig insisted that the two had to be kept distinct. Buy the one that could be exported and perhaps the other might come on the market, he pleaded. This was what he had planned all along, of course.

While Warren vacillated, all at once Berlin sent a letter stating that the emperor himself had demanded the museum purchase the Helbig marble —the sum of 200,000 lire was mentioned, though not guaranteed. That did it. On January 26, 1896, Boston agreed to buy Helbig's marble for 165,000 lire or $410,000, an astounding amount.

The loot was split in the following way: 27,000 lire to Alfredo Marinetti for his brother's original investment, plus another 3,000 for the "customs taxes"; another 30,000 to Marinetti for his half share of the profits; 75,000 to Hartwig (which comprised 45,000 for his role in making the fake and 30,000 as additional profit); and, finally, 30,000 lire to Helbig as the anonymous third partner.

The piece was shipped to Lewes in England where Edward Warren had a fabulous country home. It remained there until 1906 when it was at last placed on view in the prime position in the newly completed Greek and Roman galleries of a proud Museum of Fine Arts, Boston.

Two years later a distinguished scholar raised questions about its authenticity. Over the decades an ever-increasing drumbeat of doubts has shattered the placid atmosphere of Boston's museum. In 1959 the Greek and Roman curator, Cornelius C. Vermeule III, encouraged the German historian Ernest Nash to reveal in the famous *Mitteilungen* or *Bulletin* of the German Institute all the hitherto unpublished letters of Warren and Marshall pertaining to the acquisition of the "throne." He did so "to eradicate the notion which has persisted in some quarters that the relief is a forgery. By shaking this belief to the foundations, new published evidence can best serve the honor and memory of those several nations involved in the rediscovery and acquisition of the 'Boston Throne.' "

In his massive article Nash, who seems to have been oblivious to all problems of artistic style, published all the cover stories and in doing so only succeeded in raising more doubts.

Since then Margherita Guarducci has weighed in with her conclusive evidence that the Ludovisi "throne" was made for a sacred well at Locri. She even found the original foundations for the Aphrodite three-sided relief which are perfect in size for it and which do not have room for the "Boston Throne" or anything else.

Despite her questions—why a relief that can be judged genuine only if it is proven physically linked to the *Ludovisi Aphrodite* was carved in Roman instead of Locrian measurements; why its marble comes from a different Greek island; why there are so many mistakes in execution; why it was so closely associated with the crooked circle of Wolfgang Helbig and his unscrupulous partners—the Museum of Fine Arts, Boston, has kept the faith.

Vermeule relies primarily on scientific reports about the relief to support his continuing belief in its authenticity.

Helbig died in Rome in 1915. In all the years of mounting controversy over the "Boston Throne," he never uttered a word. Nor did Paul Hartwig, who lived until 1919. From 1894 on, Helbig, working mostly with the carver Pacifico Piroli, dashed off a number of Greek marbles that he peddled to his "dear friend" Carl Jacobsen, founder of the Ny Carlsberg Glyptothek in Copenhagen. One was a copy of the so-called *Diadumenus* by Polyclitus (after a very fine Roman copy excavated at Delos in 1894) and another was a female herm, actually partly real with a completely new head. Both are persuasively by the same hand that created the "Boston Throne."

These clunkers are, other than the *Ludovisi Aphrodite*, the closest pieces in style to the Boston relief. It's never a good sign when the only pieces that can be compared to an original Greek masterpiece are phonies. Both of these were unmasked as fakes shortly after they were sold but until Guarducci studied them were never linked to the Boston sculpture. The relationships are obvious and compelling.

Despite its magnificence, the "Boston Throne" was not Helbig's greatest triumph of fakery. That honor goes to something frightfully cheeky which was also unmasked by the intrepid Margherita Guarducci. It appeared out of nowhere at the precise moment, back in 1886–7 when Helbig was yearning to be appointed the head of the German Institute and was spurned by the stuffy "Olympians" in Berlin. Determined to strike back at them and the members of the institute the great majority of whom he held in contempt,

Helbig decided to make a forgery that would literally "stick it" to his enemies.

But it wasn't to be as simple as a stab of stark revenge. Helbig wanted nothing less ambitious than to "discover" for the world a unique and exceptional treasure of archaeology, dating to the sixth century B.C. that would be newsworthy and beautiful but would also be furnished with an inscription that would be singled out as the earliest example of writing in the Latin language. It seems he wanted to confirm the theory of his major supporter, Theodor Mommsen, that the ancient Roman historian Polybius was right when he wrote that in 509 B.C. that the Latins and the Carthaginians made a peace treaty—for which they would have had to have a written language. Helbig was determined to supply an example of that earliest script.

Finally, perhaps more crucial than anything else, he wanted this earliest Latin to be a sort of code that once deciphered, would telegraph its true nature.

What kind of object did Helbig choose to have made? Not a statue. For "talking statues," or sculptures with inscriptions were not common. Not a vase, although that was tempting. Seven years earlier a vase had been excavated which had caused a stir in archaeological and intellectual circles. This was datable to the very late fifth century and carried the earliest known written script in Latin. It was called the *Duenos Vase* after the name of the artist who had signed it, "Duenos made me." The piece had been published by the German scholar Heinrich Dressel, who had gained considerable renown from his findings.

Helbig reasoned that another vase suddenly coming along might be suspicious. Added to that, it wasn't daring enough for his heady game. Helbig chose to make a fibula or brooch—a glorified, large, ceremonial safety pin, something a chieftain might have worn and taken with him into his tomb. The material was pure gold with a long sharp pin on a gold spring which would be tucked into a sheath or channel. This channel would be wide enough so that the "earliest" Latin inscription could be incised and easily seen.

Faking up a fibula would also fit in neatly with one of Helbig's pet theories and would fold in plausibly with recent discoveries in archaeology. Not too long before, a series of gold fibulas had been found which had gained much attention—three in the so-called Bernardini tomb in Palestrina, another in the Barberini tomb also in Palestrina, and two more in a tomb in Etruscan Chiusi. Helbig's theory, which he'd expounded ad nauseum, was that there were many links between the early Latins and the Carthaginians.

Finally, gold was a fine forger's material because it doesn't corrode very much, can easily be patinated, and is difficult to test for age.

The fibula, about five inches long with a spring with rivetlike protuberances (looking remarkably like some industrial revolution machine, a point that nobody spotted at the time) was made by one of the two goldsmiths on Francesco Marinetti's payroll.

The models were the recently discovered fibulas at Palestrina—Helbig was to claim his find came from there. The sheath, a model for which existed elsewhere on a modest bronze example, was large enough to hold the Latin inscription, which was incised backward, a common practice in the seventh and sixth centuries B.C.

Helbig, though not an artisan, decided nonetheless to make the engravings for the inscriptions himself. This was a crafty move, for he realized that there was a chance, if Marinetti's goldsmith incised the letters, someone might recognize the trained, professional movements of the hand. Plus, Helbig had to write this one himself because this was to be a weapon in a personal vendetta. The work was carried out in the last weeks of 1886 when Helbig realized that he would never make it as head of the German Institute.

No one at the institute who examined the newly surfaced "treasure" had any doubts about its authenticity. When asked about the provenance of the fibula, Helbig was vague, saying only that "a friend of mine recently showed me a gold fibula acquired by him in 1871 at Palestrina and furnished on its sheath a Latin graffito inscription." Helbig and Heinrich Dummler, an historian of epigraphy, who was not in on the conspiracy, presented the object to the members of the institute in January 1887 in a short lecture. Dummler made an effective spokesman.

The revelation, as expected, caused a sensation among archaeologists, and the word spread rapidly throughout the scholarly world. The object and the extreme importance of its inscription were published by Dummler and Helbig later in the year in the *Römische Mitteilungen*, the archaeological bible. Of course, the very appearance in its august pages guaranteed to the fibula a kind of scholarly immortality.

But at once doubts filtered out about the piece. The Italian scholar Giacomo Lignana, in the same issue of *Römische Mitteilungen*, published an open letter in which he spelled out his suspicions that the amazing new discovery wasn't all that amazing. He wrote testily that the inscription, which translates as "Manios made me for Numerios," possessed elements that seemed to mimic "the most recent discoveries in epigraphy." The unusual dative, he pointed out, came from one recent find; the word *made* was

written almost like the word in the Duenos vase and had been given what is called in epistemology a "double beginning" in order to make it seem a bit more archaic. Odd.

He was dead right, but few listened to him. It seems to be that the world of scholarship was rooting for Theodor Mommsen and his theory about Polybius. Throughout the discussion, Helbig remained silent. When he did speak out, he even made a few silly miscues; his story about when and where the fibula had been found changed as more doubts began to appear. First, it had been discovered by a friend in Palestrina in 1871; then he claimed it had been "found in a tomb near Palestrina, of the same type as the Bernardini," in which had been unearthed in 1876 a gorgeous gold fibula, albeit with no writings. After that he stated it had not been found in 1871, but had been stolen in 1876 by a workman digging the famous Bernardini tomb in Palestrina and had been given to Francesco Marinetti. If anyone at the time picked up these inconsistencies, it never came out.

Once the embers of doubt had grown cool, the fate of the fibula was rosy. Eventually, it was presented with bombast by Marinetti to the state and was lain in honor next to the genuine gold from the Bernardini tomb. For this the crooked dealer received a distinguished decoration.

Throughout the next five decades the inscription's reputation as the earliest example of the written Latin language became a scholarly truth. The fibula and its inscriptions were published hundreds of times as gospel. A few doubts floated to the surface in 1905, 1915, and 1919, but the majority of the world's most learned archaeologists and historians of epigraphy, including Margherita Guarducci herself, accepted the piece.

As late as the 1970s and 1980s the fibula was accepted by a significant majority of the scholarly community. Then, in 1977 Guarducci, who had begun to investigate Helbig, decided to start from the beginning, to take the object in her hands, to subject it to a battery of scientific tests, to probe the character of the man who discovered it, and to chart the career of Francesco Marinetti.

She enlisted the aid of the canny Roman fakebuster Giuseppe "Pico" Cellini, who at once isolated the fake corrosion and spurious, modern patination above and below the inscribed letters. To Cellini the "smoking gun" was that when he bent the pin of the brooch it was pliable. That was it, for ancient gold gets brittle, or "sour," as goldsmiths say.

Guarducci's findings proving the fibula to be a phony have caused a clamor in the archaeological world in the past several years. The general reaction from the scholarly community has been, "How could we have been

so fooled?" This came after her revelation that the preeminent handwriting analyst in Italy had found dozens of parallels between every letter in the "Manios" inscription and writing in Helbig's letters, dozens of which have been preserved in the archives of Copenhagen's Ny Carlsberg Glyptothek.

Despite the crushing evidence, it must be noted that one or two specialists are still clinging to the belief—rather, hope—that the fibula or at least its inscription can be real. How a real inscription can magically appear on a fake gold fibula is a bit hard to rationalize, but scholarship can sometimes be stubborn.

Today the Helbig fibula is recognized for what it is: a bizarre practical joke. Yet, in spite of all the recent investigations, the countless hours of tests, the scrutiny of each line in the inscription, no scholar has found the truly hilarious thing that I stumbled upon one afternoon when I happened to take a photograph of the fibula to the mirror and read the inscription by it. I became convinced that the inscription was not written backward, as it might have been in antiquity, but in mirror reversal.

I took a photograph of the inscription to my mirror. When I put it to the glass, I saw, "Manios: med: fhe: fhaked Numasio." There in plain English, standing out like a giant billboard in the direct center of the object, is the word *fhaked*.

Why no one ever saw this before, I cannot say. Perhaps because most of the scholars were foreigners. Perhaps because the specialists were reading and thinking in ancient Latin. Maybe one or two did find it strange to come across a near-English word, *fhaked*, but then put it out of their minds as impossible for anyone to have been so bold.

But of course, until 1984 when Guarducci obtained the testimony of the handwriting expert, no one knew that it had to have been Wolfgang Helbig himself who scratched each word into the gold sheath.

The immediate question is: Did Helbig understand English? Of course. And colloquial English, too. The proof comes in at least two letters preserved in the archives of Carl Jacobsen in Copenhagen.

For a practical joker, a "heedless fly," a man full of vindictiveness, bitter at being refused the post he so coveted, the fibula with its *fhaked* message, accomplished the mission its creator dreamed beyond imagining. It fooled his enemies, it increased his fame, it was a sharp prick in the inflated balloon of German scholarship, and it proclaimed exactly what it was from the very beginning: a *fhaked* treasure.

# THE CURIOUS SPURIOUS KOUROS

*T*he conservation studio at the J. Paul Getty Museum in Malibu is housed in the former ranch house of the late oil baron. I visited there for the first time in May of 1986 researching a story on the Getty acquisitions since 1980, when the flood of really big money had begun. I'd spent the greater part of the day videotaping the galleries, but what I really wanted to see was something I had heard about from sources in Italy. The Getty had purchased the single most desirable work of ancient art conceivable, an intact Greek sixth-century-B.C. *kouros*, or youth. It was something they had been searching out for years and they had just won the prize.

My guide was acting curator of Greek and Roman art, Arthur Houghton Jr., and I badgered him about the kouros. His father had been the president of the Metropolitan when I was director and I suppose the relationship influenced him. He confided to me that the Greek kouros had just been lifted upright out of the box it had resided in for some months and was on display in the conservation studio. I begged to see it. He took me into the spacious, beautifully lighted studio, and across the room was a huge coffee-colored sculpture of a naked youth, glistening in the fine light. I had a welter of thoughts all at once—many of them, to my surprise, not very complimentary. The piece seemed too pristine to be twenty-five hundred years old. Its surface, the color of weak tea, looked strangely preserved and carefully damaged. The style was stiff, cautious, mechanical, especially the regular cascade of fourteen rows of hair; with its strange, unpleasant, doughy

curls in the front of the brow. There seemed to be a number of styles present: the stomach, one, the feet, another. The marble and the figure didn't seem to fit together, but I couldn't explain why.

"Have you paid for this?" I asked.

Houghton looked stunned.

"If you have, try to get your money back. If you haven't, don't. If you're paying on time, stop the next payment."

What did I know about Greek Archaic art? Houghton wanted to know.

Plenty. I described my experiences digging at Morgantina in Sicily where I'd seen everything from Archaic to high classical emerge from the ground. Nothing I'd ever seen in my archaeological experiences fit this. It seemed to be a setup.

I told Houghton and his second in command, Marion True, a vase specialist, that I had met Pico Cellini in Rome not too long before and he had mentioned the Getty kouros to me. He told me that he had been shown photos several years before when the Getty was considering the purchase of the statue and had dismissed it with the words:

> It's a hermaphrodite! Half man, half woman, and clumsily broken to boot. If I recollect correctly, I first came across the statue some forty years ago. I know that it was unsuccessfully offered to several international museums, including the Boston Museum of Fine Arts. When the director of the Getty, John Walsh, came here last year, I told him it appeared to be a notorious fake, but they bought it anyway! I don't reject it because of its style, but because of its styles —the hair looks like an Egyptian headdress, the mouth like a Louis XVI commode handle. The figure has a lopsided belly button and is even circumcised, a feature rare in, if not totally absent from early Greek art.

Houghton scoffed.

On the same visit I had the opportunity to interview director John Walsh. He had been one of the more nettlesome curator-educators at the Met while I was director and had resigned in solidarity with a curator I had fired for insubordination. Despite the fracas Walsh had been decent. Later, after I had done some favor for Walsh while he was at Columbia University, he had sent me a warm handwritten note of thanks. Back in the spring of 1986, neither of us considered the other an enemy.

During our meeting I asked him about the kouros, bringing up the rollicking comments of Pico Cellini. He dismissed them. He had met the man, he said disdainfully and, finding "no merit" in anything he said, he had dismissed Cellini's allegations. Walsh felt that science had proven the authenticity of the kouros. The piece had been subjected to fourteen months of scientific tests—one of a special, indisputable nature—all of which showed that it was impossible that the stone had been artificially aged. Many specialists in the field of sixth-century-B.C. Greek art had been consulted and had thoroughly approved. When I asked who they were, he said he couldn't divulge their names. It was becoming awkward. Why would scholars and Greek experts insist upon anonymity? I wondered. Walsh did admit that some of the experts had been suspicious. Walsh declined to say where the piece had come from only that there was "solid proof" that the statue had been in a Swiss private collection for over fifty years. I told him that it sounded like the standard, tired cover story. Walsh refused comment. Walsh's press aide began to fend off my questions for him.

I asked if I could obtain a set of photographs for publication, but was told that none were available. I wanted to know the name of the Swiss private collector and Walsh said that he'd promised the man's name would never come out. I asked the name of the dealer; that was confidential.

The man who had discovered the controversial kouros was the curator of Greek and Roman art at the Getty, a Czechoslovakian specialist by the name of Jiri (pronounced Yeeree) Frel. I knew him well, having okayed his being hired briefly by the Metropolitan Museum fifteen years ago and having personally gotten him his working papers. I had heard that Frel had gotten into some sort of trouble and asked Walsh about the rumors—something about tax difficulties involving donations. Walsh dismissed the rumors. "He's now our most valued senior research curator, working for us in Europe." Walsh's press aide clarified that Frel was on sabbatical.

I didn't mention I knew that Frel was furious at the Getty's management and board of trustees whom he had once complained to me were nothing but "idiots, puffed up phonies" who knew nothing about culture or fine art and who refused to allow him to build up a distinguished study collection. Another complaint was that the trustees would only purchase expensive pieces, mistaking price for quality. If a piece were inexpensive the board would reject it.

When I pointed out to Walsh that the title "research curator" normally meant putting a difficult staff member out to pasture, he gave me a patroniz-

ing smile and told me, "not at the Getty, where research is revered." When I asked how I could get in touch with Frel, he said he didn't know. I left wondering what was going on.

I've seldom met a more electrically persuasive man in my life than Jiri Frel. I had first heard about him in 1971 when the curator of the Met's Greek and Roman department, the crusty German Dietrich von Bothmer, implored me to hire him so that he didn't have to return to Czechoslovakia where the "Dubček Spring" was being crushed by Soviet tanks. He had been working temporarily at Princeton's Institute for Advanced Studies. I was delighted to bring Frel into the Metropolitan family and obtained working papers for him through special connections in the Congress. To satisfy the immigration authorities, we took the singular step of drafting a contract with him for a three-year tenure. This was something never done before at the museum.

He signed on as an associate curator. He urged me to help him obtain special expatriate papers which, I was to learn later, carried no extradition procedures. A crook's dream.

Frel worked at the Louvre and earned a bit of extra change cataloguing the antiquities in the Rodin Museum collection. It was in Paris that he met J. Paul Getty, for Jean Charbonneau, the curator of Greek art at the Louvre and one of Frel's French supporters, was at one point Getty's chief advisor for antiquities. It was also in Paris that he met Homer Thompson, the head of the American School in Athens. And Thompson recommended him to Princeton. Jiri Frel was, as they say in Italy, a man *"in gamba,"* always working on someone or some project, always turning dross into gold.

Bothmer fondly remembers his making "a series of brilliant discoveries especially in the area of sculpture—he had a different, fresh way of looking at things. Once, climbing around on a ladder, he discovered that one of the male statues had a wound under his arm and was therefore able to identify the piece as a famous 'wounded warrior.' "

I was especially struck with his way of making instant decisions about whether a work was real or fake. And Bothmer agreed. His work at the museum was exemplary, the only shadows being rumors of his constant messing around with women. There was a special telephone code that the secretary of the Greek and Roman department used to alert her friends in the museum's library when Jiri had left his office bound for the stacks. I had heard that he had an affair with the wife of a local professor and had urged her to change her name to his until the divorce settlement with his second wife had finalized.

About a year after we had worked so hard to save Frel from the Communist thugs at home he blithely informed Bothmer and me that his doctor (who turned out to be the father of the woman with whom he had had an affair) advised him to move to California for his health—he had ulcers and had to live at sea level. I testily pointed out that Manhattan was at a lower sea level than Malibu, but he laughed. Why Malibu really? I asked. He told me—and I shook my head at his brass—that on his most recent trip to Europe, paid for by the Met, he had stopped in to see his "old friend Paul Getty," who had offered him the post of chief curator of the Greek and Roman department. He had accepted on the spot. I was so angry that I demanded his pseudo father-in-law send a certificate about his health and only then would I allow him to duck out on his contract. Frel did and left the museum under a cloud. I had many dealings with him while he was at the Getty and it was not long before his charm recaptured me again. I visited the new Getty building several times and never failed to see him.

At times Frel could be intensely aggravating, as was the case when I was in tense negotiations with J. Paul Getty over the joint purchase of a fourth-century Greek bronze athlete from the Munich antiquities dealer Heinz Herzer, a piece that had been found in a fisherman's net off Fano on the Adriatic coast of Italy, and smuggled out of the country.

The deal was to have Getty put up all the cash—some $4.2 million—and the Met would give him something he desperately wanted but could never hope to find on the market, the indefinite loan of some Pompeiian wall paintings. They were rare and exceedingly valuable, worth more than even the costly bronze. Frel kept ratcheting up his demands, insisting that we throw in a host of Greek and Roman sculptures. Each week it seemed he demanded more. Finally, I had to complain to Getty about his outrageous pushiness. The deal fell through because of the price, but three years later Getty died and Frel persuaded the museum's board to buy the sculpture—at the same price Getty himself had refused.

Frel would give me guided tours of the Getty storerooms where he would boast loudly, punctuated by much laughter, about having manipulated this or that antiquity out of Italy or Turkey. I was frank with him about what I thought was his needless risk taking. He relished the dangerous and shady side of antiquities and told me that his network of art dealers and private collectors in Switzerland could camouflage the provenance of every purchase. And he had, he claimed, the best possible defense against any governmental problems: he always had an intermediary—art dealer or agent—

handle anything hot so that by the time the Getty bought the antiquity the institution would be an "innocent third party."

But by far my most indelible moment with Jiri came at the opening of the Getty Museum in 1974. When we were chatting idly about his acquisitions, he exploded in rage. His trustees were nothing but "fucking incompetents" and "California thugs and idiots," "intellectual cripples." He ended the tirade with a threat that he was planning to "show them how stupid they are in ways that they can't imagine." And he followed that by the prediction—it was so curious that I wrote it down when I got back to my hotel: "One day California will thank me for having gotten the "lesser" objects, for they will prove to be better than the costly ones." I was to find out exactly what he meant several years later when I had become the hound to his fox. And when I did, I realized that his motives were not too far from those of Wolfgang Helbig a century earlier.

Back in 1986 I left the meeting with John Walsh convinced that he was concealing a series of messes cooked up by Jiri Frel. I learned that Frel had dumped his recent wife and had taken his son by the third to Paris with him. I also began to hear rumors that he was buying into a surprising number of fakes and was on the take.

Shortly after my encounter with the kouros and John Walsh I received a phone call from the journalist who handled art auctions for *The Times* of London, Geraldine Norman, a stellar fakebuster in her own right. We had never met but I knew about her from her investigative articles on our infamous Euphronios kalyx crater when I was director of the Met. She had been less than sympathetic to our story that we had no idea the vase might have been smuggled out of Italy where it was said to have been found in an Etruscan tomb. She had been unwaveringly persistent, tough, but accurate and fair. She had impressed me as being the only journalist out of dozens who had bothered to listen to our point of view and print it as well.

Norman came to the point abruptly. She had been working on a story about what she was convinced was a fake painting at the Getty, an Annunciation by the Flemish Renaissance painter Dirk Bouts, and had heard from a dealer contact that she should drop that and investigate the Greek kouros. She had heard from her dealer friend Robert Hecht, who turned out to be the man who had sold me the Euphronios, that I, too, was sniffing around the kouros. She suggested we work together and publish stories in both *The Times* of London and *Connoisseur* with a double byline about the painting and the kouros. I was intrigued. My only cautionary remark was to say that

I didn't believe the Bouts was a fake, only a sloppy painting of the fifteenth century, which was in bad shape and which might have been overly restored.

At once we became partners in the investigation of the Getty Museum and Jiri Frel. When in a few weeks I met her in England I knew I had made the perfect choice. She was a frank, marvelously witty, intelligent woman whose skepticism of people in lofty positions in the art world matched mine. Journalistically, I have never encountered anyone else as punctilious or ethical. She insisted upon at least two corroborative witnesses to any statement she obtained. Our partnership worked because we knew about differing, mutually cohesive subjects. I knew the museum world and Norman was an expert in the art market with multiple contacts throughout the art dealing and private collecting worlds. Our investigations would last more than three years.

Norman had learned that when the kouros had been presented for acquisition at the Getty board of trustees meeting in late 1984, one trustee had become violent about it, making a scene in the storeroom where it was shown—in pieces and on its back—carrying on about how it was a forgery. The trustee happened to be the only art expert on the board, the Italian art historian Federico Zeri, who had been one of J. Paul's most trusted art advisors and for a fee (which he was still getting) had found various pictures for the billionaire's collection. Apparently, Zeri had held up the purchase of the statue for a year, forcing the Getty to get more outside opinions supporting the authenticity of the six-foot-nine-inch-tall athlete. According to Norman's sources, these opinions were often conflicting, yet Harold Williams, chairman of the Getty trust, a lawyer who had been one of conglomerateur Norton Simon's right-hand men, had pushed vigorously for the purchase. Williams, Norman's sources claimed, had developed a vendetta against Zeri, he was so annoyed by his intransigence.

Only weeks before the board voted to acquire the Greek statue for seven million dollars (the price having started out at nine million, nine hundred thousand), Zeri was forced by Williams to leave the board after he was criticized for spouting off about the confidential matter on Italian television. To make matters more tumultuous, around the same time, Jiri Frel had left California under that cloud.

What specific cloud?

Norman didn't know. But she had some suspicions. It had something to do with donations. Why was it, she asked, that the acquisitions of the Getty's antiquities department far outstripped all other departments and that

most of them were gifts? She asked me to look at the *J. Paul Getty Museum Journal* of 1984, where a host of Greek and Roman acquisitions were listed. As a former museum employee I might spot something she was failing to detect.

Ten minutes after I had received a copy of the book I knew what Frel had been doing. Within a week Norman and I had figured out the full dimensions of his activities. It was all pretty odd and highly inventive stuff. In 1984 alone Frel had brought in to his department 164 items, mostly donations, some valued in the hundreds of thousands of dollars. No other curatorial branch of the Getty had received any donations at all. How strange for a museum that had a purchase fund of upward of sixty million dollars a year to be getting so many gifts. I knew that a tax-exempt institution like the Getty had to document every purchase in its tax forms and was constrained to reveal the names and addresses of everyone who donated a work of over five thousand dollars in value. The tax forms, I knew, were all on file in one handy location in New York. Within a day or two I and Helen Howard, a researcher I hired who had busted the recording-industry scandal of the fifties known as *payola*, had pored through them and made a tally of Frel's frenetic gift activities. There had never been anything like it in the history of art museums in America from the founding of the first institution in the mid nineteenth century. From 1973 until 1985 Frel had gathered up 6,453 donated works of art given by dozens of donors evaluated at a total of $14,441,228. The amount included $1.7-million worth of potsherds, items that one scholar told me "are almost as cheap as shells on the beach." In my decade as director of the Metropolitan, all the curators—some eighty of them in twenty-two departments—had harvested a mere six million dollars' worth of gifts of works of art. Some years Frel had generated gifts amounting to far more money than had been given that year by billionaire Getty himself.

On the surface there was nothing wrong with Frel's gift-accumulating talent, except for a slightly rancid odor in having accepted a number of gifts from dealers. Many of them, the largest in value, had come from a man who was thought to be one of the kingpins in America of smuggled antiquities, Bruce McNall. He was a coin specialist, something of a child prodigy, who had, he claimed, put himself through UCLA by buying and selling Greek and Roman coins. He dabbled, naturally, in movie making (*Buckaroo Banzai* was one of his triumphs) and bred race horses. He was said to have bought most of Texas billionaire Bunker Hunt's antiquities. He controlled a coin auction house by the name of Numismatic Fine Arts for which the movie

mogul Sy Weintraub had put up the cash. McNall also owned a private, very exclusive gallery on chichi Rodeo Drive in Beverly Hills, the Summa Gallery —by appointment only.

Years later McNall, who bought the Los Angeles Kings hockey team and encouraged superstar Wayne Gretsky to join up, was convicted by the federal government for defrauding banks by falsifying loan documents, in part by borrowing against fraudulent businesses. He went bankrupt, owing hundreds of millions of dollars, and is awaiting sentencing.

At first Frel's flamboyant gift-garnering activities seemed innocent. Many of the two dozen donors I interviewed told me that Frel was simply a persuasive salesman who would do anything to obtain study materials that his board considered beneath the Getty's image. That corroborated what Frel had told me himself. A zealot was all he was. But the more I probed, the less innocent his image became. I was able to establish that Frel and some of his staff made many of the appraisals of the gifts themselves, something totally taboo in the museum profession. An antiquities dealer sharpened my suspicions that Frel was up to no good: "Sure, Frel wanted donations of things he couldn't get approved by the board, study materials. But he wanted other things as well, things that were too hot. I mean pieces recently excavated in Italy and smuggled into Switzerland."

I tracked some of the donations back to when they had been sold at auction and saw that Frel had consistently—and sometimes drastically— kited the values when the pieces had been donated, sometimes tenfold. Through Geraldine Norman's auction house contacts, for example, we learned that two busted-up, ugly, and quite insignificant ends of a Roman sarcophagus of the second century A.D. (paltry leavings) which fetched around four thousand dollars had been evaluated for *forty* thousand when they were given to the Getty and appraised by Frel. A badly chopped-up Roman copy of a Greek original portrait of the philosopher Cleanthes that had sold at Christie's for just under nine hundred dollars was given to the Getty half a year later and listed by Frel as being worth forty-five thousand dollars. There were dozens of other such instances of inflated evaluations.

Who was benefiting other than the donors, who were having a field day with deductions, I couldn't figure. All the donors I spoke with, as well as a Getty employee, were emphatic that the curator did not seem to be on the take. His lifestyle was "pizza parlor," said one. None of the donors I reached said he had ever asked for a fee. His only excess seemed to be women.

But soon a couple of cracks began to show up in the facade of the modest-living curator whose only sin was in yearning to collect those antiq-

uities that his insensitive and ignorant board of trustees thought were be-
neath the institution. A lawyer with whom I had served in the 1966 Lindsay
administration eventually got in touch with me and told me that Frel had
boasted that he alone could sweep through the lawyer's entire collection
without bothering with board approval for a commission of 10 percent of
the value of his collection. In cash. (The lawyer was horrified and declined.)
Another art dealer who knew McNall claims to have solved the enigma of
why and how Frel managed to get so many gifts. He told me that Frel would
find some work in a shop in, say, Zurich and would fall in love with it. But
the price would be too small, he knew, to interest the trustees. Frel would
make a singular deal with the delighted dealer. He would instruct the dealer
to quadruple the price and then throw in for free a host of lesser things,
sometimes whole suitcases filled with potsherds which smugglers had forced
the dealers to buy when they brought in something exceptional. The "free"
items would come to Los Angeles with the Getty object and pass through
customs and would be stored at the Summa Gallery. Then they were farmed
out to various donors, many of whom Frel had met at the gallery.

The scheme was foolproof. Unless Frel received a percentage from the
donors, no one was out except the federal government and of course the
Getty, which was supplying extra funds without its knowledge. If only half
of the fourteen million dollars constituted kited prices on the items Frel
wanted, he had pulled off a landmark fraud.

Some of the donors refused to talk to me. Others swore they had never
seen the pieces the Getty tax forms said they had given to the institution.
One, a car dealer in Los Angeles, told me that his mother had acquired his
dozens of Greek antiquities when he was a child. He had sneaked them
under the barbed wire when he had escaped from Czechoslovakia. All forty
of them? I asked. Well, yes. Which ones did he especially favor? I asked. He
couldn't remember a single one.

At the same time Norman and I were unraveling the tangled web of
phony donations, we were digging into Frel's other strange activities. Nor-
man dredged up an amazing amount of information from her sources. It
seemed that Frel had a penchant for purchasing fakes, and, seemingly, many
in his special field of expertise, Greek Archaic art. We heard of an Archaic
stele with a male figure holding a flower, a fragmentary Archaic relief suppos-
edly of the sixth century B.C. depicting one warrior putting a bandage around
the head of a companion, and a head said to be the crowning glory of his
career by Scopas, who was a contemporary of Lysippus and Praxiteles, active
between 380 and 330 B.C.

The year 1979 was in many ways the highpoint of Frel's career at the Getty: There were more donations than ever before—some three million dollars' worth; he published several articles and catalogues; and he acquired two extremely expensive fakes, fakes that were so costly that the trustees readily agreed they had to be masterpieces of mankind.

One is a fragment of a relief in fine Parian marble with a lustrous surface measuring about a foot and a half square with two heads of Greek warriors of the Archaic period—about 530 B.C.—enacting a poignant episode in the course of a battle. One warrior is reaching over to bind the head of his companion, whose profile eye is closed, indicating that he is expiring from his wound. Frel entitled it *Death of a Hero* and called it one of the most significant examples of Archaic art in the world.

The only person truly smiling is not the warrior being bound up with an Ace bandage but the forger, perhaps one still alive somewhere in Greece or Italy, still cutting away. There are other fragmentary reliefs that seem to have the same stylistic peculiarities—and mistakes. For the *Hero* is a grand classic of a forged Greek antiquity, the kind of thing that is trundled out for first-year graduate students as the epitome of the word *phony*. Frel must have known. Today Vermeule, who once published it as a masterpiece, says, "I can no longer believe it. Those terrible lips! Those eyes! If there's ever another edition of my book, the *Hero* shall not be included."

◆ ◆ ◆

Norman and I got an early break in our investigation of the kouros. A source inside the Getty sent us a packet of documents relating to the piece: the dealer's invoice, the results of the months of scientific examination, and a few of the testimonials obtained by Frel from various scholars who had gone to Malibu and examined the statue. From October 1983 until late February 1984 just before his enforced departure from the museum, Jiri Frel corralled fellow specialists in Greek art to visit the Getty, examine the kouros, and give him their views either in writing or orally, which he transcribed. The conditions were not perfect; the sculpture had not yet been placed in an upright position. Frel seldom allowed these scholars to be alone. He was always there fluttering about, peppering the air with his opinions. He praised the sculpture nonstop. It was hardly the way to conduct a dispassionate scrutiny. The scholars whom Frel allowed in to see the kouros far outnumbered those who had suspicions. In the early months no one but Federico Zeri came right out and condemned it. If others had, it seems unlikely that Frel would have chronicled their views for presentation to the trustees.

Anytime a scholar would come to town, study the kouros, and like it, he or she was persuaded by Frel to sit down in his office and write exactly why on museum stationery. Looking at the file of letters, it seems at first that the Getty Greek and Roman department had the largest international staff in the world.

Some of the letters were ecstatic. Andrew F. Stewart, professor of Greek art at Berkeley, gushed in mid-November 1983:

> It was an honor and a privilege to be the first "outsider" to view it, and a rare opportunity to see a perfectly preserved, absolutely first-rate original essentially undiscovered by the academic world. I completely agree with you that it is probably Megarian, and thus represents a breakthrough in the discovery of a hitherto unsuspected school of Archaic sculpture, from a locality usually derided for its lack of achievement in such matters. It is a rare prize, and of course you must buy it.

His final observation was, "The last time a complete kouros appeared on the market was 1937, and given the international climate at present, who knows when we will see another?" Stewart was referring to the closing down of the lively antiquities-smuggling trade, particularly active in south Italy and in Turkey, by the UNESCO treaty and other means.

It's interesting that this first recorded written benediction of the kouros described all of the standard riffs of a classic art scam. The sculpture was almost perfectly preserved and completely unknown in the academic world. It was an example of a hitherto unsuspected style and school of Archaic sculpture. We saw the same "amazing" things with Van Meegeren's "Italian" Vermeers and Wolfgang Helbig's *Palestrina Fibula*. We saw them even in that earliest of all known fakes, the Egyptian bowl found also at Palestrina and made by Phoenician forgers.

As it turns out, Stewart was not the first "outsider" to be shown the prize. Another Californian, associate professor Sheldon Nodelman from San Diego, holds that distinction. Nodelman, who describes himself as "formerly of the Departments of Classics at Yale University and of the Department of Art and Archaeology at Princeton University," went to the Getty in September 1983 and wrote down his thoughts a month later. He, too, stressed that the style had no exact parallel. He observed that the condition of the statue was far finer than even the most perfectly preserved kouros, the so-called Anavyssos boy in the National Museum in Athens. Because of

that, Nodelman thought that the statue had been buried soon after it was made. The Anavyssos kouros is named after the place in Greece where it was found around 1930.

After him was Dr. Frank Brower of the Institute for Classical Archaeology at Mainz, Germany, who visited the museum in October or November. He differed from the opinion voiced by Nodelman. "Its state of preservation is exceptional," he wrote, adding, "Doubtless, the statue stood for some time in the open air, exposed to the weather. It may have served as a dedicatory monument, placed above a grave. . . ."

Another scholar, John George Szilagi, composed on Getty stationery a paean of praise in Latin: *"Hoc novum artis Graecae mirculum animo recepi"*— "I received into my soul this miraculous Greek work." On its condition he wrote. *"Integritate rarissima faciliter superat"*—"The statue is of the rarest preservation."

Professor Ernest Berger of the Antiques Collection of Basel was also impressed with the sensational state of the piece, writing, "The almost complete condition of preservation of the statue [is] unique." To Berger the "coarse white marble" was from the island of Naxos. The closest piece Berger could think of was the Anavyssos kouros in the Athens National Museum. Amusingly, since Frel had insisted to his colleague that the new acquisition was almost identical in style to one from Megara, Berger adjusted his thinking so that the kouros was a "link" between the two types.

Martin Robertson, past professor of classical archaeology at Oxford University, was crazy about the kouros and wrote a long letter in April 1984 to director John Walsh (by that time Frel was on his way into his velvet exile in Paris). He, too, was struck by the remarkable state of preservation and, finding no convincing parallels to the style, placed it in a transition group halfway between the early Attic kouros from Tenea in the Munich Museum and the Attic Anavyssos kouros in Athens. He dated it about 530 B.C.

> The Munich and Athens statues both come from Attica and are certainly Attic work. The style of the new piece is close to them, but seems not quite the same. This can be felt in the treatment of the face and the distinctive modeling of the collarbones and breast which relate it to a magnificent torso in Athens from Megara. That is certainly of earlier style, but the resemblance suggests that that area may well be the place of origin of the new statue.

Dr. Luigi Beschi of Florence liked it and called it Boetian or Megarian dating to just before 530 B.C.

Dr. Franz Willemse, formerly the head of the German Institute in Athens, believed in the work and called it Megarian strongly influenced by Attic styles.

Dr. Angelos Delivorrias, director of the Benaki Museum in Athens, saw the work as Attic but "coming from the countryside rather than the city of Athens."

Nicholas Koutoulakis, the Swiss art dealer and intimate friend of Frel's who sold him the fake *Hero,* confirmed that the kouros had been out of the ground for at least fifty years and recalled that the Greek antiquities dealer named Roussos once had a kouros in his possession around 1930.

Dr. Margot Schmidt, curator of the Antiquities Museum in Basel, Switzerland, placed it between Attica and Megara and dated it just after 530 B.C. According to Frel, she remembered that a certain Professor Ernst Langlotz spoke with her about the piece in the 1950s. Later on she would deny that Langlotz had ever talked with her about it.

Some scholars, like Dr. Brunilde Ridgway of Bryn Mawr had conflicting views, but still came out in support. She found a number of stylistic anachronisms: the fists were of a form that appeared on early kouroi, while the feet were remarkably sophisticated and seemed later in date than the fists. Nonetheless, she felt it to be a "wonderful object" and that she'd seen a number of unusual kouroi in archaeological excavations and they were incontrovertibly authentic.

The written opinions of specialists all suggested stylistic tendencies that seemed to have links to both Megara and Attica—a unique combination. Normally, when scrutinizing a work, whether classical, medieval, or modern, such wandering styles suggest a pastiche. Yet the authors of the letters were all positive that the piece was authentic.

As were Getty's scientists. The statue was subjected to a series of penetrating tests. All of them proclaimed that the sculpture was authentic and the surface could not have achieved such age by artificial weathering of any kind. The scientists relied heavily on the findings of Dr. Stan Margolis of Davis University, a widely known sedimentary geologist who had never worked on a work of art before. Margolis identified the marble as "dolomarble," meaning that it was 95 percent dolomite. He took a number of acetate peels of the surface and came to the conclusion that the marble was definitely from the island of Thasos (not Naxos) and had experienced a process called dedolomitization, which could take place only over centuries, as water rich in calcium leached out magnesium ions. Thus the stone was gradually turned to calcium carbonate. It was a kind of natural breakdown.

His conclusion and that of all the members of the Getty laboratory was that "the marble kouros can be regarded as genuine." All these scientists—Frank Preusser, Jerry Podany, and Zdravko Barocv—were fiercely independent and of superior professionalism. They devoutly believed in their tests and findings.

If there was one weakness in their outlook, however, it was not bias or wish fulfillment but the simple fact that the test Margolis carried out had never been performed before, on any work of art of any date. There was no body of statistics involving a series of other results on a variety of Greek marbles either ancient or modern or reworked, and thus no index of comparison. The test also had the weakness that calcium carbonate could be misidentified as calcium oxonate. And Margolis's test results were solitary, totally unlike the vast body of test results assembled for decades by conservators and physicists on the varnish and various paints that chart all sorts of painterly vicissitudes.

The experts who didn't like the kouros were blunt, vociferous, and argumentative. Federico Zeri deemed it merely one among a host of obvious forgeries or completely misattributed works Frel had tried to drag before the board of trustees. He cited the Roman sarcophagus—fragmentary at that—with a gryphon and a lighthouse with firebrands flaming at the summit, "the kind of thing that fetches 25,000 lire at most in Roman antiquities shops," which Frel had proposed to the Getty board because it was cheap at three hundred thousand dollars and represented the exceedingly rare scene of the famous lighthouse of Alexandria. Zeri disdainfully pointed out that the lighthouse was the one at Ostia and he'd personally seen at least a half dozen of the same kind of sarcophagus lying around Rome. The piece was withdrawn.

This "ridiculous error" was followed by the presentation of a "horrid fake." The piece was something that museums and collectors interested in classical antiquity crave: an Attic grave stele of the Archaic period of the sixth century B.C., Frel's special area of expertise. The marble, which was decorated with an acanthus and scroll motif on the top, was just short of lifesize and depicted a youth in profile holding a sprig of flowers. He was broken off just above the knees. Zeri said:

> Frel had closed off one of the public galleries for the board meeting and the trustees trooped through. When I saw the ridiculous, nonsensical thing I was astounded, especially when Frel breezily announced that it cost a "mere" two and a half million dollars. It

struck me at once that it was a member of the same family as the "Boston Throne" and those silly archaic statues that the Carlsberg Glyptothek bought in the late 19th century. The face was a simpering child's. The so-called "archaic smile" was vapid. The hair fell in regular thrums and ended in silly spit-curls. Ridiculous! I objected so violently that it was withdrawn from consideration. By this time certain members of the board—especially the new chairman Harold Williams—began to look upon me as a disloyal force in the "family" of the Getty Museum.

Zeri first encountered the kouros in December 1983 when he and the other members of the board were taken to the storeroom to view it, in pieces. It was obvious that the chairman and the curator expected no opposition to the purchase. "Frel kept dancing around it, calling the sculpture a 'masterpiece' and 'the greatest example of ancient art in the world' and he kept on exulting that the statue was such an incredible bargain—only twelve million dollars." Zeri admits that his first impression was not so bad. Then the closer he got and the more he looked, he began to accumulate doubts.

The surface was strange—so even and with a curious color like tea. You know how it is when something is no good, a detail will suddenly rise up and be a red flag. Well, in this case, it was a funny detail. The fingernails. They were so amazingly natural in the way the nails met the cuticles, too natural for something so old. I was bothered, too, by an inexplicable fault in the marble at the side of the face and in the hair right in the middle of the forehead. I suspected that a flawed piece of stone had been used—and this would have been impossible in ancient times.

He tallied up objection after objection. The hair, unlike the fingernails, was "incredibly abstract." The curls were "inept." "I began to wonder how it could be that so many abstract and blocked-out stylistic elements could exist side by side with naturalistic elements."

Zeri remembers being calm but persistent. Others recall that he made a spectacle out of himself and had flown into a full-blown rage. It seems the observers were right. Harold Williams was shocked and profoundly angered by his reactions, but could do nothing. The kouros was not purchased that day.

Every time in the following months when the kouros came up for purchase, Zeri would shoot it down. The price began to fall—nine, then

seven million dollars. Zeri accelerated his objections and demanded further documentation and expertise brought to bear on the curious stone. He demanded to know where the sculpture had come from. What was its pedigree? "I was told that a body of experts had examined the kouros. They showed me letters. Huh! Three only. One from someone I never heard of in San Diego. There was a letter dating to the 1930s from a German scholar that was supposed to pin down its history—but the letter was exceptionally vague." This was a letter later revealed to be from Ernst Langlotz, a German scholar of Archaic art active in the 1950s. Still later it was discovered by Geraldine Norman to have a fake signature.

He badgered them to call in "real experts," people he could trust, art dealers like Robin Symes in London and Jerome Eisenberg in Los Angeles. But he was rebuffed. Zeri wanted to know what Cornelius Vermeule at Boston thought. "My objections triggered the scientific tests—but I must tell you that technical and scientific examination never amounts to very much especially when it comes to ancient marbles. Pico Cellini called it a fake and they dismissed his view. Vermeule sent a letter in which he said he really didn't like flying to California and, anyway, from the black and white photographs he could easily tell that the kouros was 'wrong.' "

Dr. Evelyn B. Harrison of the Institute of Fine Arts in New York City is gentle and dry and devastating. Her opinions, thoughtful. Her eye is "fierce," and her detective skills monumental. She is one of the rare fakebusters in the classical archaeological field and what she says about a piece or an issue is usually taken very seriously. That's what makes it a bit strange that she was allowed to examine the kouros "in the flesh" only six months after it was purchased, was not sent a photograph beforehand, and her remarks were not put in the official packet of documents distributed to the trustees. Instead, Harrison's feelings are set down in an address, "Making and Faking Greek Sculpture," given in 1990 to the Washington Archaeological Society. She described how she had first encountered the kouros in January 1985 lying on its back and that seeing it was a "very immediate experience . . . and not at all what I expected."

She had been sent a copy of Stan Margolis's findings and although she had had doubts about his conclusions, she was satisfied that the tests had established that at least the marble was dolomitic and thus had to be Thasian. Harrison was prepared to see a statue that would cry out all the stylistic characteristics of the north Aegean. But it didn't.

What she was looking at was definitely the familiar Thasian marble she knew so well. But instead of recalling Archaic works from Thasos, the kouros

was the epitome of a mixture of some well known Attic and Boeotian kouroi, none of which she knew had ever been carved of Thasian stone. "In spite of various alterations of surface and color, the kouros did not give the impression of being something old; somehow it looked new."

Alarmed, Evelyn Harrison stalked the Getty creature like an ace detective picking up clues at the scene of an inept crime. The breaks were weird. Those in the right arm were supposed to be recent while those in the left were ancient, but Harrison could see no difference. The anatomy was puzzling. The abdomen was very well executed, whereas the pectorals were unmodeled. The collarbones were "feeble." She was bothered by the unconvincing manner in which the upper arms seemed squeezed against the sides, a feature prominent in two well-known Attic kouroi—one was the famous Anavyssos kouros in the Athens National Museum and the other, far earlier in date, also Attic, which had been found at Tenea. Yet, whereas the sculpting of the face and lower torso of the Getty piece compared closely to the later statue, its slender proportions and distinctive sloping shoulders were very close to the earlier one.

The anatomy got even more confused, Harrison felt, when she took a look at the statue from the back, for the back compared to even earlier kouroi. In indisputable kouroi that showed one side seemingly earlier in style than the other, it was invariably the back that was freer and later. As Harrison wryly observed, "The sculptor of the Getty kouros seems to have got things the wrong way around, with naturalistic modeling in the face and front of the torso and an extraordinarily old-fashioned back." The hair of the back was most strange. It was almost identical to the stiff hair in the Metropolitan kouros, not only "in the grid of the beaded strands and their conical ends, but in their number, fourteen." That number was found only in the New York statue and in fragmentary kouroi found later at Sounion. Worse, this hair formed a solid mass that "has neither the flatness of the hair of the New York kouros nor the pliancy of hair in later works." To Harrison, the way the hair met the body "recalls sculpture of the early twentieth century." The hair had other nonancient peculiarities, too. The sculptor had been punctilious in trying to get rid of all the traces of his chisel and the point used to shape the beads of the hair. "This must have been a tremendous amount of work, and ancient sculptors did not normally go to all that trouble."

As if that weren't enough, she found no sharp edges anywhere on the face, not even the eyelids and the edges of the lips, "which are given sharp, clean edges in normal Archaic works." The proportions of the body were

troubling—slimmed down, elegantized—perhaps easier to understand, Harrison said, in a kouros "designed as a love-object for a modern collector." Harrison referred obliquely to a scandalous event in the history of smuggling. Shortly after the Met's kouros was spirited out of Greece in the early 1930s by a dealer named Roussos, he did the same to the huge Anavyssos boy. He was caught in Marseilles, tried, convicted, and jailed in 1937. But he managed to have his sentence reduced after he arranged for the Anavyssos kouros to be sent back to Greece. At the time there were rumors that another statue very close to the Anavyssos statue had been peddled to the Louvre, but the curator of classical Greek art had spurned it because he thought it was a blatant fake. The name Roussos would suddenly come up—very conveniently—in the history of the Getty statue.

This forger, who Harrison presumed had to have been the maker of the Getty piece, committed blunder after blunder. He'd chosen a hunk of Thasian marble that had so many flaws that in antiquity it would never have been used. In the Getty boy there's a flaw in the front of the face right in the center of the hair on the brow, which forced the carver to trim back the central lock. Harrison argued that this would have been at best peculiar in ancient times.

Then there was the issue of the knees. Why, she asked, had any sculptor, ancient or modern, given "the knees such a flat, unnatural form which has no parallel in even the earliest of our kouroi? I have sometimes wondered if he didn't say: 'Oh, well, why worry about them; we're going to break them anyway.'" Those knees would show up later in a most embarrassing kouros.

She was also anxious about the androgynous look of the creature. The fact is that all authentic kouroi have homosexual innuendoes; they were supposed to have them. But the homosexual appeal of the Getty kouros with his sweet girl's face was far from the ideal as set down by Aristophanes in The Clouds, namely, "a well-nourished chest, bright skin, big shoulders, short speech, big buttocks and a small penis." The Getty creature has the last two, Harrison stated, but his chest and shoulders were the opposite. The manner of combining male and female in the Getty kouros seemed to be modern: "It finds a dramatic parallel in the Athena Parthenos created by Alan Lequire for the Parthenon in Nashville" which the sculptor deliberately made half male and half female. "The Getty kouros with his girlish face and apologetic shoulders looks harmless and ingratiating. Like his ancient cousins he seems designed to please a wealthy client, but in the modern manner."

Harrison admitted that despite the impossible knees, the many inconsistencies, the contradictions of style, and the oddities, the full proof that

the Getty kouros was a bold fake might never come out. She correctly observed that some "suspected fakes and stolen originals remain in a common limbo; they are figures without a landscape." But, Harrison observed, "unless there is some such break in the case of the Getty kouros, we will never be able to visualize him against the Mediterranean sky or even in the picturesque environment of a workshop in Rome, the outskirts of Paris or somewhere in Greece."

Another naysayer was the Metropolitan's Greek expert, Dietrich von Bothmer who in 1984 was asked his opinion about the authenticity of the Getty statue, but only after it was signed, sealed, and delivered. He voiced some of the same objections as Harrison.

> I was puzzled at a number of the kouros' contradictions—the hands and the feet, the structure of the legs and on the rear of the thing. In the back the diagonal rhomboidals were counterpoised against squared-off shoulder blades—odd. The toes—so finely and naturalistically fashioned—bothered me as do the knees. My problem is that I find none of these features in any Attic kouroi with which I am familiar. I'm also uneasy about the surface and what it looks like under ultraviolet.

Bothmer was the only curator in the United States with a real kouros and who knew what one looks like under the black lamp.

All the opinions were supposed to be kept confidential by the Getty, but Bothmer's leaked out to the dealer who had sold the kouros to the Getty for seven million dollars. This was Gianfranco Becchina, who rushed to Florence in the summer of 1983 to seek out Bothmer and upbraid him for his nasty comments on the boy's anatomy. The associate curator who would take over from Frel, Arthur Houghton, had told Becchina about Bothmer's anxieties because he was beginning to get worried about the supposedly iron-clad documentation that Frel had found in the possession of the dealer.

As Bothmer puts it:

> I was staying at the Excelsior Hotel in Florence and Becchina met me there and became slightly inebriated and challenged me— "What do you know about such things as kouroi, anyway?" I answered very politely, "A good archaeologist could look at the kouros and tell everything about it—where it came from, its style, its date, etcetera. Mr. Becchina, I am a fair and honest archaeologist. Let me tell you what I think about it in terms of a parable. If a student of

mine in an art spotting test is shown a slide of an English early Gothic-style church portal and if he sees slightly off to the side a sign saying, *Eintritt*, well, he might have doubts that the church really was English. Wouldn't he? You see all the stories I have heard about the provenance of the kouros are fairy tales. When you tell me where it came from and where it has been all these years, then I shall be delighted to discuss the style and anything else about it."

Geraldine Norman and I interviewed half a dozen people who said they knew about the provenance of the kouros. One story was that it was found on a small island off the west coast of Sicily, where in the early 1980s a spectacular marble life-size sculpture of a charioteer was discovered in a private excavation sanctioned by the Italian government. This statue dates to the early fifth century B.C. All attempts to substantiate the kouros coming from the same place came to naught.

I found a private dealer who claimed that he had been asked to help place the Getty kouros but passed on the opportunity because he was supposed to put up a large amount of money for his share. According to him the kouros had been found in 1982 with several smaller and less "triumphant" cult statues at an excavation site of a fancy resort being added to by Valtur, a subsidiary of Fiat in the Aegean. The pieces were whisked away to Yugoslavia, according to this informant in crates marked CONSTRUCTION EQUIPMENT and hence to Switzerland. It didn't take long to find out that the Aegean resort owned by Valtur had never been expanded.

Then from a source inside the Getty museum we were sent copies of some documents that Frel had supposedly discovered and put forward to provide a clear provenance. They were supposed to include the proof—at least according to the Getty—that the kouros had been in a Swiss private collection at least since the 1950s and in all likelihood since the early 1930s. The collector was Dr. Jean Lauffenberger of Geneva and his letter to Becchina stated that his father had bought the statue "in 1930 or 1931 from a certain Roussos, a Greek dealer . . . who claimed to have sold Greek monuments to museums in Boston, New York, and Paris. Almost no one has seen this statue because my father told me to protect it as a treasure whose value would increase. In 1950, at the insistence of Dr. Rosenberg, I let Professor Langlotz, the renowned specialist in Archaic sculpture, see it."

Ernst Langlotz a renowned German scholar mentioned earlier, was much admired by Jiri Frel. Frel had spent considerable time poring through his extensive archives when he had just joined the Getty and had become

enamored with Langlotz's theory that someday the "missing link" between the early Tenea kouros and that found at Anavyssos would come to light. The German letter, dated March 12, 1952, thanked Dr. Lauffenberger effusively for having been able to study the "marble youth." As for what it was, Langlotz wrote, "stylistically it stands closest to the Anavyssos youth, though it belongs to a somewhat earlier phase of this style." Langlotz had first heard about this statue from Herman Rosenberg, an antiquities dealer of Lucerne who was apparently chasing the Lauffenberger kouros. His letter to the doctor on March 20, 1952, gushed that Langlotz judged the statue "to be a masterpiece of Archaic sculpture of the greatest rarity; as for myself, I still hope that you will reconsider your decision not to sell it."

Then there was a letter to Lauffenberger in April of 1955 from an art restorer and antiquities dealer in Basel by the name of A. E. Bigenwald. He had been asked to fix the kouros so that it could stand up on its own and observed, "I can think of no aesthetically satisfactory possibility other than inserting steel rods in the stumps of the legs. Since the piece is quite heavy, it might also be necessary to prop it at the buttocks. With today's drills there is practically no danger that the stone will split. Nor can I imagine that this kind of treatment would in any way diminish the value of the object."

Another letter to Lauffenberger in 1971 was from an official in the Bank Robinson of Basel on behalf of one of the principal officers, M. Blanc, stating that there was still interest in purchasing the statue. Nothing came of the overtures.

Just after the 1983 letter Lauffenberger sent to Becchina, he received one from an art dealer in Ascona by the name of Herman Rosenbaum. The short letter was in French. In translation, "I am very disappointed to learn that you sold your kouros to someone else without telling me, as you had agreed before the death of our friend, Dr. Rosenberg; a promise you had repeated several times again and again."

Finally, the packet of letters included one to Frel from a certain Jacques Chamay of the Museum of Art and History of Geneva dated January 13, 1984, which stated, "I have received your note with the photo of the kouros, which certainly brings on my admiration and my surprise. . . . I did not require long research to understand the piece better. I know it. I looked at it in Geneva several years ago in a collection of a Geneva physician."

The correspondence was vital to the Getty for it established, if not a find spot, at least an implied one: Greece. The mention of the name *Roussos* —the man imprisoned for having stolen a number of antiquities from Greece in the 1930s and who saw to it that the magnificent Anavyssos kouros was

returned in exchange for a lighter jail sentence—lent to this world of shady stories surrounding shadier acts of theft a probable provenance to the kouros. The Getty administration took the Lauffenberger letters very seriously, and their law firm hired a Swiss attorney to investigate every one of the documents. They believed in their authenticity.

There was a momentary flurry of anxiety about just when Lauffenberger, and the dealer Becchina, had acquired his huge statue and how that date tied in with the smuggling activities of Roussos. As Bruce Bevan of the Getty's law firm Musick, Peeler and Garrett put it to associate curator Arthur Houghton six months before the kouros was finally purchased, Swiss counsel believed that Becchina seemed to have legal title as had Dr. Lauffenberger.

> However, any knowledgeable dealer would be aware of the Greek antiquities laws and aware of Roussos and his notorious arrest for smuggling the Athens Kouros to France in 1937 in an effort to sell it to the Louvre. These facts would seem to cast doubt upon the *bona fides* of any dealer acquiring Greek antiquities discovered after 1900. On the other hand, if the elder Lauffenburger [sic] acquired the statute [sic] from Roussos in 1925–30 as the present Dr. Lauffenburger [sic] avers, presumably he would not have been aware of the potential illegalities as would a dealer. . . . If the elder Lauffenburger [sic] had valid title, then Bechinna [sic] automatically acquired and could transfer valid title despite his superior knowledge of the legal difficulties concerning antiquities.

It was really legal angels dancing on heads of pins since the contract with Becchina had a warranty from the dealer ensuring that the Getty could get its money back if anything turned out to be incorrect with the title to the kouros.

Norman and I smelled something rancid about the Lauffenberger correspondence. Like so many fakes it seemed too slick, too convenient. Like the kouros itself, which had a highly suspicious lack of any ancient tooling, the papers seemed cautious, clean. I was especially suspicious of the convenient appearance of the crooked dealer Roussos, since the Getty statue looked closer to the Anavyssos boy than anything else. For months Norman tracked down the correspondence and the people who might have known Dr. Lauffenberger and his fabulous kouros.

Geraldine Norman rooted out some extraordinary information. She learned that Dr. Lauffenberger's brother, a Protestant priest who knew the

collection extremely well, had never seen or heard of a large kouros. She contacted a Professor José Doerig of Geneva whom Lauffenberger had at one time asked to catalogue his collection and though he never did begin the task, he knew the works intimately. He vowed that he'd never seen anything like a six-foot-nine-inch kouros in the apartment.

Lauffenberger had been married three times. His first wife recalled no large statue. His second was deceased. The third refused to say anything. One of his daughters did not remember a life-size statue and referred Norman to Lauffenberger's former curator, a certain Madame Cotier who also refused comment and referred Norman to her husband who was the executor of the Lauffenberger estate. He didn't say much other than "Something had happened at a certain period of Dr. Lauffenberger's life that would cause reverberations if it came out."

Norman spoke to two close friends of Lauffenberger, one who lived in the same building and who had visited many, many times and the other who was his professional partner. Neither had seen nor heard of the large Greek statue. Both knew his collection almost to the point of exhaustion.

The letters proved to be as strange as any of the inconsistencies apparent in the kouros itself. We were to learn eventually that the signature on the vague description of the statue by Ernst Langlotz was phony. A year and a half after the purchase of the Greek marble, curator-in-charge Arthur Houghton happened to compare the signature to one on a Langlotz letter in file at the Getty regarding the phony *Hero*. The two signatures of Ernst Langlotz were not only different from each other but completely at odds with one that was unassailably correct. Houghton also learned from a close associate of the dealer Herman Rosenberg, who supposedly had gotten Langlotz in to view the statue in Lauffenberger's apartment, that the signature on his letter was not genuine.

Moreover, the letter of 1983 from another dealer—Herman Rosenbaum—griping that Lauffenberger had not, as promised, sold the sculpture to him, was odd. His former assistant, when interrogated by the Swiss lawyer acting on behalf of the Getty, took him to the house of Rosenbaum's widow and saw the typewriter on which the short missive had been written. The only problem was that the notepaper seemed very old, with a telephone number that had been changed ten years earlier.

The letter of 1971 signed by Mario Roberty on behalf of a lawyer by the name of Franz Huber, which suggested that the Bank Robinson was serious about the possibility of making a loan to Lauffenberger with the

kouros for collateral was vouched for by Roberty. However, Norman learned that the bank was in liquidation and its head, M. Blanc, was about to go to prison for fraud. There were no records in Franz Huber's files that Lauffenberger, the Robinson bank, or Blanc ever numbered among Huber's clients.

Despite all the oddities, it did seem that there was a kouros linked to Lauffenberger. The packet of letters contains that firm avowal of Jacques Chamay, the classical curator of the Musée d'Art et d'Histoire in Geneva, stating to Frel that he had seen the kouros in the Lauffenberger collection. When Geraldine Norman pushed him, he held to his opinion. But Chamay had seen a photograph sent by Frel and we had no idea what that photograph looked like. There is no question that Chamay saw a kouros, but which kouros?

The letter from the art restorer A. E. Bigenwald to Lauffenberger in 1955 stated that he thought of supporting the kouros by "inserting steel rods in the stumps of the legs." We found it strange that Bigenwald didn't seem to know that the Getty kouros possessed legs and feet. I began to suspect that there were perhaps two kouroi and Frel had come across the one in Lauffenberger's collection and had conspired with Gianfranco Becchina in some convoluted manner to use it as a cover-up.

At the time in 1987 when Norman and I published several articles questioning those letters, I thought Jiri Frel had cooked up at least the Langlotz and Rosenberg ones. Arthur Houghton told me outrageous tales about how Frel would invent wholesale provenances for pieces that had been recently smuggled out of Italy and Turkey, deriving much pleasure out of making documents that "proved" the piece had once been in the old "Esterhazy Collection" or the like. I also learned that Frel would routinely place the signature of Jerome Eisenberg, a local antiquities dealer and appraiser, on museum evaluation forms.

While I was in the midst of my initial investigations and soon to publish my doubts about the authenticity of the kouros along with the acidulous views of Pico Cellini, the Getty, to ward off the oncoming blows, announced the acquisition of the kouros in August of 1986 and promised to exhibit the statue in the fall. The New York Times ran a front-page story in which the reporter—actually the then art critic John Russell—stated that in importance the sculpture would rank up there among the finest museum acquisitions in the country. The story quoted a few of the scholars who had blessed the piece and named me and Pico Cellini as naysayers. Russell went on at length about the "unprecedented analysis" of both artistic and scientific data

and quoted the Getty officials as stating the piece had left Greece a half century before and "was sent for sale from a private collection in Switzerland."

The last part was odd because of what Arthur Houghton had unearthed about Langlotz's signature and the likelihood that the Getty statue and Lauffenberger had never been, shall we say, very close. In fact, Houghton had resigned in a fracas with director John Walsh about his handling of the spurious papers in late May. Of course, this never came out in the press, for Houghton believed it was not right to tell tales out of school. He spoke to me and Geraldine Norman at great length and made it possible for us to bring all the elements of the tangled story together.

The Russell article did say that the statue was disputed, but he came down unequivocally in favor of its being genuine and a masterpiece of world art. He'd been one of the first to see the sculpture upright and he all but admitted that he'd fallen for it. It was "outstanding for the sensitivity of its carving"; "an unforgettable work of art," something possessing a "perfected sense of proportion." He dismissed the thought that the piece could be a fake.

> All probabilities were against it, however, in that the faker would have had to be a person of great historical sensitivity and familiar with the sculptures produced in the Greek island workshops in the 6th century B.C. He would have to be a carver of genius. He would have to be able to outwit forms of scientific analysis that have been developed only very recently. And he would have had to be a crook.

My partner and I were convinced that this is exactly what had happened. More and more scholars agreed with us.

Olga Palagia, the curator of the National Museum in Athens whom Frel had not invited to send a letter when he learned of her views, was contemptuous of the piece. She called it a fake patterned after the Anavyssos kouros, perhaps during the time the splendid large figure was wandering around France. How was she so sure that the Anavyssos kouros was real and the Getty false? I asked. She laughed and told me that archaeologists had found at Anavyssos the base for the statue with the precise measurements for its plinth. Was there perhaps another base out there with the precise measurements of the plinth of the Getty boy? I asked. She laughed.

When, in time, the Getty organized a seminar on ancient marble, with the kouros as the real subject of the discussion, Palagia was one of the few

naysayers invited. However, she was not, as were the supporters, offered the courtesy of a round-trip ticket, so she didn't attend.

There was only one person alive who knew about the sudden appearance of the kouros in modern times and that was the exiled Jiri Frel. Norman and I tracked him down to a suburb of Paris, Le Pecq. We staked him out in a car owned by a friend of mine living in Paris, which had a cellular phone. Frel's flat was in an upper-middle-class building in a peaceful, wooded area of the charming little town. We had been told by a French colleague who seemed to know everything about everybody or be able to learn it in minutes that Frel was living with his son Sasha and a young woman who worked at the Louvre. I phoned, the woman answered, and I was told Frel did live there but was away for a few days. Convinced he was hiding in the apartment, I finally screwed up enough courage to knock on his door. I was allowed into the vestibule and talked for several minutes to Frel's friend but though I sensed his presence, was not successful in smoking him out.

While scouting around the premises, I happened to notice a brand-new Saab Turbo Commander—a very expensive automobile in Europe, I knew —parked in the driveway. I wasn't all that surprised to see through the windshield a letter addressed to Jiri Frel lying on the dashboard. I was soon on the cellular phone talking to my French friend. Within the hour this indefatigable prober had the information that the Saab belonged to a private Swiss company owned by a prominent family; that they were involved in antiquities and a bank that was under a cloud because of suspected relationships with the Mafia. It was apparently illegal for a corporate car to be out of Switzerland.

In a few minutes my alert French friend called to say that he had managed to chat with a member of the family that owned the car. At first she claimed she had lent the car to Frel so that he could sell library computer software. Then, in mounting confusion, she claimed that Frel had the car because in fact she and he were having an affair and to please never tell her husband.

Jiri Frel's undertakings and the kouros affair soon began to look like acts out of *Alice in Wonderland*. Just before Norman and I went out to California to interview John Walsh and Harold Williams, the chairman of the Getty trust, about Frel's activities and the status of the kouros, Norton Simon, an old adversary, telephoned me out of the blue. The millionaire ex-conglomerateur was partially incapacitated by a stroke but was still manipulative and wily. I hadn't spoken to him in nearly a decade and that was in anger when he threatened to sue me and the Metropolitan Museum in

some meritless claim. Simon's links with the Getty were intimate. He had helped to install Harold Williams, his former tax lawyer, as chairman. His wife, the former actress Jennifer Jones, served on the Getty board. Williams was a member of the board of Simon's foundation.

It was quite clear that he had heard about our investigations of Frel and the kouros and was seeking to deflect any publication of what we had found. Simon tried to bribe me. It was subtle, so much so that it took several calls from him for me to figure out what he was trying to do. At length he offered to buy *Connoisseur* magazine—I was at the time the editor of the publication, which was owned by the Hearst Corporation. He wanted me to think about running the magazine from Los Angeles and at the same time becoming the head of what he kept referring to as "the Mecca of culture in the West," a combination of the Getty and his own museum in Pasadena. He explained that Williams was having troubles with Walsh and that despite the fact that I was wild and universally hated by the Getty for "doing what you are doing," I was recognized as someone with executive experience in the museum world and a man with an "eye." He went on to explain, effusively, that the Getty had the money (then something like three billion dollars after the sale of the Getty oil company) but he had the old masters. His plan, he went on, was for his foundation to sell the Getty his greatest pieces. I knew Simon and Williams had purchased two paintings jointly, which I figured was to establish the precedent of the Simon foundation eventually selling the Getty Museum its major treasures.

Simon invited me up to his home in Hollywood Hills to talk confidentially with him and Harold Williams about the "mutually beneficial deal." He seemed stunned when I informed him that I wouldn't be dissuaded from the story but would sure appreciate it if he could get me an exclusive interview with his buddy Williams. Simon told me to call him back in a half hour and when I did I was amused to find that the private home number on which I had talked to him at least four times in the past two weeks was answered by an insurance company whose representative swore the firm had possessed that number for at least fifteen years.

Norman and I struck out in Los Angeles. The institution was shocked by our questions that demonstrated we knew virtually everything about Frel's donations scam and the curiosities surrounding the kouros. Both Walsh and Williams refused to meet us. The chairman of the Getty trust issued a bland statement that Frel had been relieved of his post in April 1984 for "serious violations of the museum's policy and rules regarding donations to the antiq-

uities collection." He explained that Arthur Houghton had brought certain practices to his attention and that after an extensive investigation with outside counsel, Frel had been sacked. He went on to say that "there was no evidence of personal financial gain on his part."

Williams's measured lawyerly statement was somewhat at odds with what his nemesis Federico Zeri recalls, that at an emotional and tumultuous meeting just after the Getty's lawyers had completed their examination of the donations Frel had garnered, Williams had talked about "criminal actions" on Frel's part. Zeri is positive Williams made the hectic statement. Zeri wrote everything down after he learned no minutes were to be handed out to the board members, and he remembers calling out to the consternation of some other board members, "What criminal activities? Murder?" I saw Zeri's old notes and have no reason to think that the professor was involved in creating fiction.

Not too long after Geraldine Norman and I had been in France unsuccessfully trying to beard Frel, she got a call from an incredulous Federico Zeri who told us that through an acquaintance in Rome who had an apartment to sell he had learned that a certain Dr. Jiri Frel was ready to put down three hundred and sixty thousand dollars. He had obtained Frel's current address, which had been registered under another name. The apartment was the narrow Via delle Colonelle in the vicinity of Santa Maria Maddalena near the Pantheon.

I happened to be in Italy and raced to Rome, where I met up with Norman and Patricia Corbett, the European correspondent for *Connoisseur*. The three of us waited for several days on the street. Late the third night we saw the lights on in the apartment. The next day Frel came out.

I took a photograph and said, "Hello, Jiri, let's talk." After berating Norman for having revealed things about his private life in her articles, he agreed to talk to the two of us. All the rest of that day and long into the evening he danced and dodged, never saying anything revelatory, always repeating the same lies even when we demonstrated to him that we knew they were such.

He looked stonily at me every time I'd ask a question: Had he made money on the donations? Had he forged another's name to appraisal forms? Had he taken commissions? Where had he gotten the money for the new Rome apartment? What about the Saab Commander? Where had the kouros really come from? The only answers, which were inadequate, were that the Saab was a loan and the money for the apartment was "someone else's." He

did launch into a tirade about the Getty's board: "Those trustees are just oilmen or lawyers. They understand nothing about art. What I really did was bigger than they really know."

He seemed totally convinced that the kouros was okay and implied that he had been on several trips into the Greek hinterland to try to find out where it had come from. When Norman asked about the Lauffenberger papers and told Frel about Lauffenberger's brother, ex-wife, and various friends who had never seen the piece in the doctor's apartment, Frel looked up and said mischievously, "Ah, what if I were to tell you that I saw it actually not at his apartment, but at the house of his mistress?"

At dinner Frel's mood grew darker by the minute. Toward the end of the meal when I brought up his purchase of the fake "Hero" and Scopas head, he picked up an empty bottle of mineral water and hit me hard on the shoulder a number of times. I interpreted this as anger at having been found out. That was the last time I ever saw the curious Jiri Frel.

The kouros was published in the *Burlington* magazine in January 1987 by Marion True, who succeeded Arthur Houghton as curator of the Getty. The article is about as candid an expository exercise as has ever been written about a problem piece. True faced the charges of forgery directly and asked the fundamental question: Could this thing not be a "pastiche made by a modern forger with access to Thasian stone"? She came to the conclusion that it couldn't be because of the surface—that dedolomitized calcium carbonate that could not possibly be replicated by artificial means—and by the study of proportions. True based the latter upon the fact that it was unthinkable that the proportions of the Getty kouros could be so close to the fragmentary kouros in the Athens National Museum from the Ptoon sanctuary known as No. 12 which follows a special canon developed in ancient Egypt and evident in a painted grid on a number of unfinished Egyptian statues. Only recently was it shown that this grid was far more widespread in Greek sixth-century-B.C. sculptures than ever thought. As True put it:

> To accept that a modern sculpture, translating this grid system into three dimensions, could create a unique, compositionally coherent statue that agrees in its abstract proportions, but not in its actual appearance, with the incomplete kouros from the Ptoon sanctuary, National Museum No. 12 is impossible.

Two and a half years later, Marion True was so rocked by the discovery of a kouros bombshell that she took the kouros off exhibit and admitted that

she had to rethink all her earlier conclusions. An independent scholar and antiquities dealer, Jeffrey Spier, who lives in London, was rummaging around Basel in April 1990 when he spotted in a cubbyhole of the freeport storage of the airport the most astonishing apparition: a headless torso with the legs knocked off at the knees. He instantly recognized that it shared many startling stylistic similarities with the Getty statue.

Marion True was on her way to give a lecture in Athens and made a beeline for Basel on the way back. When she saw the torso she felt "like someone had kicked me." The stylistic features were virtually identical to the very ones that the naysayers had singled out as forgers' mistakes. There were the same narrow, sloping shoulders, the odd, quadrilateral fists, the same insensitively carved hands. And the same unique and strange knee still preserved on the torso that had so troubled Evelyn Harrison.

The bottom line was that the Getty statue is closer in style to this obvious fake than it is to anything arguably ancient in Greece, whether the kouros of Tenea, that at Megara, the one from Anavyssos, or even Marion True's favorite No. 12 from the Ptoon sanctuary in the Athens National Museum. And in the field of discovering fakes such a phenomenon, if not absolute proof of forgery, sure spoils the party.

The torso was purchased by the Getty and two years of tests were conducted on it. Among other things that came to light was that the calcium carbonate crust which the scientists had emphasized over and over could not possibly have been artificially created and was not in fact carbonate, but oxalate. This ancient crust was then re-created in a laboratory, not in as sophisticated a manner as on the Getty kouros but close enough so that it tended to render useless the scientific dogmas issued up to that time. Once again Federico Zeri and Pico Cellini proved to be right: When it comes to marble few or no scientific tests can establish true age.

In the spring of 1992 the Getty kouros was packed up and shipped to Greece where it was the subject of a seminar attended by a number of scholars. Some of those who had already examined the piece and had adored it changed their minds. At the end of the session the vast majority of specialists believed it to be phony. The Roussos-Lauffenberger "theory" didn't even come up; Olga Palagia informed me, "It's been totally discredited."

Although the rumors have it that the torso was made in Rome in about 1980 and was part of a larger ensemble and once had a head that was lopped off because it was judged to be too ridiculous for sale, there's one curious detail that may link it, at least, to Lauffenberger. The torso definitely has

stumps of legs, which is how the restorer A. E. Bigenwald described the kouros once in the possession of Dr. Jean Lauffenberger. That may have been what was seen by professor Jacques Chamay and Jiri Frel. That is, if one believes that anything in the Lauffenberger package was real. I personally tend to think that it was all part of Frel's elaborate scam.

Will the truth ever come out? Will we ever know what Jiri Frel was up to when he either collected or tried to collect for the Getty the atrocious stela, the pathetic sarcophagus with the lighthouse at Alexandria, the ridiculous "Hero," the comical Scopas, and the flabby, prettified kouros? Probably not. Was Frel himself fooled? Doubtful.

I think what happened at the Getty is already out. Aside from the still-unknown equation of financial benefit, which has not been established, it seems likely that Jiri Frel went after these fakes, knowing that they were fakes because of his resentment of his bosses on the Getty board, those he felt were obscene know-nothings who perpetually equated money with artistic quality. Like Wolfgang Helbig, he played games with them and showed them who was boss. He shoved down their throats $14.4 million dollars' worth of his precious "little" but divine study pieces, although the trustees of the Getty trust had no idea they were paying for them. At the same time he gave them what they wanted: twelve and a half million dollars' worth of expensive, "worthy" objects.

After a hiatus of four years the Getty kouros was once again placed on exhibition. But this time the label was more muted and far more honest, stating that the statue could be sixth century B.C.—or modern.

# CON BRIO

*I*n art fakery you can have the best-looking Vermeer or Greek kouros or fibula ever forged, but without the right scam artist, the sort of fellow who can sniff out the most vulnerable sucker and use his powers of persuasion on him, then even the most brilliant of fakes won't ever be sold. One of the brashest con men of art in history is Michel de Bry, who claims he's no longer active after a recent run-in with the French police. He is allegedly French, although his son-in-law, who prefers to keep his name unpublished, says that de Bry's past is "obscure" and that he is adamant about keeping the details of his life a secret. No one really knows his real name.

One curious story supplied by his son-in-law is that he was the man who sold the fabulous *Gospels of Henry the Lion*, dating to 1173, which is one of the most lavish of Romanesque manuscripts ever to have been illuminated. The manuscript was bought at auction in 1986 by the German government for $12.7 million from an unknown seller thought to have been Queen Frederika of Greece, a direct descendant of King Henry's. However, during the weeks before the 1986 sale, I learned that in 1948 or 1949 the manuscript was offered by a "runner" to Fred Adams, director of the Morgan Library, for the then stupendous price of half a million dollars. The man who took in the black-and-white facsimile for the Morgan to examine was a man Adams seems to recall had a name like "Debris." In the frontispiece of the facsimile that he left at the Morgan Library is the note "Property of the Queen of Greece," which may be one of de Bry's typical subterfuges, for he

has a tendency to pin illustrious names on the works he handles. De Bry was for years a legitimate producer of music programs for French radio, but the income from that job doesn't explain his wealth. The apartment where he still has his headquarters is in a fancy building in Paris on the fashionable Boulevard des Courcelles which divides the eight and the seventeenth arrondissements and runs adjacent to the beautiful Parc Monceau.

The art in his extensive collection there can only be called fanciful. De Bry is particularly proud of something he refers to as the *Treasure of Bar Kokhba*. Bar Kokhba was a Jewish national hero during the second war between the Jews and the Romans. The treasure is contained in a terra-cotta vase and consists of antique jewels, seals, and earrings. De Bry swears that on one of the seals he has discovered what the cabala has been seeking for twenty centuries: the Hebrews' secret name for God. He refuses to tell what the name is, out of piety, he says.

His collection is also graced by a large ruby with an engraved portrait of Emperor Augustus by no less than the single most renowned gem cutter of ancient times, Dioscurides, none of whose other works has survived. De Bry states that "Louis, King of France, bought it in Constantinople and it is recorded in the inventories. Then it disappeared. Now, I have it." He claims that the Bibliothèque Nationale desperately wanted this rare *objet de virtu* for the nation when it suddenly appeared on the art market in the mid 1980s, but he snagged it instead. This tale is greeted by silence from the French national library.

De Bry also owns a sapphire ring that belonged to Alexander the Great. And the mirror that François I looked into moments before he died. And the "missing" monumental portrait of Charlemagne in porphyry. And a harpsichord supposedly given by Catherine de' Medici to Elizabeth I.

He also has two sculptures by Michelangelo. One is the head of Pan with goatlike horns wreathed by a garland. A horrid grin, revealing two scraggly teeth, is set into a cruel face. To de Bry the teeth are proof positive that Michelangelo was the author of the piece. He points to the famous story in which Lorenzo the Magnificent found Michelangelo carving the Pan in 1489 when the artist was fifteen. Lorenzo was immensely impressed by the talent of the youth but observed that an aged Pan shouldn't have all his teeth, whereupon Michelangelo carved but two.

The second Michelangelo is said to be the model he made for his gigantic *David*, which stands in the rotunda of Florence's Accademia. That would make it one of the most important monuments in Western art since it could offer unique insights into the creative struggle through which the

youthful genius was going before he started carving the enormous piece of marble which, as everyone knew at the time, was not the right shape and was seriously flawed.

In de Bry's collection in Paris was also one of the rarest antiquities in private hands, the marble head of *Achilles* by the Greek sculptor Scopas. To understand how important a genuine head in marble by Scopas would be, one must go back in time briefly to the heyday of classical art, to the fourth century B.C., in the apogee of the Hellenistic period.

Three famous sculptors rocked the foundations of art in the Hellenistic period by fundamentally changing the image of mankind that had endured for centuries. One is the court sculptor of Alexander the Great, Lysippus. He is praised in surviving documents more than virtually any artist of ancient Greece and was noted for having brought movement, realism, and drama to the human figure. The second artist is Praxiteles, whose large, graceful Hermes found by the Germans at Olympia was one of the rare Hellenistic originals to have made it through time. The third sculptor-genius of the fourth century is Scopas. He was born on the island of Paros, where there was an abundance of superior marble. He is mentioned by ancient writers as having given the property of emotion to his images of mankind. He was cited by historians as having worked on the flamboyant tomb of King Mausolus of Halicarnassus and for having created all the sculpture that adorned the pediments and metopes of the temple of Athena Alea at Tegea in the heart of the Peloponnesus. Although King Mausolus's lavish tomb was singled out as one of the Seven Wonders of the World, the temple was looked upon as truly majestic. It is mentioned by ancient historians almost as many times as the Parthenon itself.

Scopas's dates were roughly between 395 and 335 B.C. He was active during a time of extraordinary stress and tumult even for turbulent Greece. During his life the Spartan hegemony collapsed and Philip of Macedon, along with his son Alexander, began a reign of terror culminating in the crushing of Greek liberty in the battle of Chaeonea in 338 B.C. The works of Scopas capture the terror and grandeur of the period better than any single artist. His figures writhe and suffer. The men groan and bleed. His famous *Maenad* lauded by poets in ancient times—probably the small marble today in Dresden—is caught up in a frenzy of emotion and throws her half-naked body back in a movement of heady sexual release.

These figures are truly Michelangelesque. They seem frozen forever in a pleasingly anguished *contrapposto*. The heads of the male figures glower from deep-socketed eyes and from noble, craggy brows. They look like *furiosi*.

And that, of course, is why they are so appealing today. Naturally, there aren't very many of them left.

The temple of Athena Alea at Tegea was excavated in the late nineteenth century. Some of the finds caused a sensation, especially the fragments of Scopas's metopes and several over-life-size heads, which though battered, are strikingly powerful. It became the rage in the nineteenth century to make plaster casts of the two most attractive heads: *Patroclus*, now in the Athens National Museum, and *Telephos*, still at Tegea.

Among those who collect Greek art nothing would be considered a hotter discovery than a genuine sculpture by the legendary Scopas. De Bry always claimed that the head had been in the eminent collection of the industrialist Bessoneau. But there's no Bessoneau in any archives or documents. De Bry seems to have found the miracle object in a small Parisian antique shop, where it was thought to be a replica, and bought it for less than three thousand dollars. It's likely that de Bry scuffed up the piece and may have added some drill holes that are not dissimilar to those that appear in genuine Roman sculptures. As we have seen, there's nothing like an ancient reworking of an older piece to make it doubly convincing.

De Bry's genius lay in convincing two experts that the head was Scopas and genuine. One was the distinguished French professor of archaeology François Chamoux, who presented the stone as signature Scopas to his colleagues in a lecture at the Louvre in 1978. Alas, almost no one else believed in the attribution.

Disappointed, de Bry consigned the head to a modest picture dealer in Paris with whom he had conducted business and who regularly came to his headquarters on the Boulevard des Courcelles. This was a man named Jean Michel who today goes by the name Michel Scopas and who now lives in Guadeloupe where he paints replicas of paintings Paul Gauguin created in Tahiti. Jean Michel, having slim contact with the heavy hitters in the antiquities collecting field, showed a photograph of the Scopas to a Swiss colleague in Geneva, a dealer by the name of P. Sedlmayer. Sedlmayer became excited. He went on at length about how the head was just the thing for a certain curator, a curator who worked for the richest museum on earth, the Getty. The man was Jiri Frel. Sedlmayer pressured Michel to get a full set of photos to him as soon as possible. Michel's wife got on the train and brought them down the same day.

Frel journeyed to Switzerland, saw the photographs, and flipped. He assured Sedlmayer, Michel was not present, that the Getty would buy it and didn't seem at all fazed when the price of three million dollars was men-

tioned. The high cost, in fact, seemed to appeal to him. Frel then rushed to Paris, met de Bry and Michel and told them that before the Scopas could be sent to the Getty for certain purchase it would be helpful for a gentle trap to be set for someone who might exert great influence on the Getty board of trustees. It was agreed that Chamoux would present a second lecture on the head, this time at the Sorbonne University, and Frel would see to it that his man of special influence would be in the audience.

This was the art critic of the *Los Angeles Times*, William Wilson, whom Frel would describe as a man who "has for years followed the development of our collection of antiquities with understanding and a helpful spirit." The fact that the chairman of the Times-Mirror company, Franklin Murphy, was on the board of the Getty didn't harm. That Wilson wasn't exactly the world's most advanced expert in ancient Greek sculpture didn't harm either.

Wilson flew to Paris especially for the lecture and was impressed with Chamoux's attribution. He was one of few in the audience who was impressed. On January 15, 1979, he wrote a glowing article about it in the *Los Angeles Times* strongly recommending its acquisition and concluding breathlessly, "Is the shade of J. Paul Getty at this moment whispering into the ears of the museum trustees, 'Grab it, fellows!'?"

Frel instructed that the head be sent immediately to California; it was carried by de Bry personally to Malibu. Michel came too. There's a little confusion about which "Scopas" head left France for the Getty. Michel— and independently de Bry's son-in-law—claim that another nearly identical *Achilles* was lying about in the studio on the Boulevard des Courcelles. When Michel came back from Chamoux's lecture at the Sorbonne, he was surprised to see what looked identical to the head he'd just left in the lecture hall at the university.

To get the head out of France—and de Bry always insisted in the subsequent court proceedings that he never called it fourth-century-B.C. Greek or Scopas, just a modest Roman copy of a Greek original, de Bry approached an archaeologist he knew would brand it a fake or a Roman copy. According to his son-in-law, he said joyfully, "This expert is really dumb and will say it's a fake and I can get it through customs." That expert, Jean-Pierre Roudillon, remembers that he saw the sculpture and states, "It took me ten minutes to figure out that it was a replica and I took my three hundred and eighty francs appraiser's fee and that was that."

The export license labeled it a Roman copy and valued it at sixty thousand francs, about fourteen thousand dollars. It sailed through French customs and arrived at Malibu in de Bry's luggage. The marble was not

purchased right away—evidently the volume of Frel's proposed acquisitions put it on the back burner temporarily—so de Bry and Jean Michel traveled to Malibu a second time to present it and to haggle. Eventually, a price of two and a half million dollars was settled on.

To be certain that he would have the strongest possible case, since the "wild man" of the board of trustees, Federico Zeri, was becoming increasingly suspicious about Frel's bizarre, overpriced antiquities, Frel took the risk of showing the head to an associate professor at Berkeley known for his studies on Scopas (alternate spelling, *Skopas*). This was Andrew F. Stewart. Like Chamoux, he turned out to be perfect. In his booklet published in 1982, *Skopas in Malibu*, Stewart recounts that he had heard rumors about the head as early as 1977 and subsequently became aware of François Chamoux's attribution. In early January 1979 Stewart received a "peremptory" phone call from Frel who told him that the head was at the Getty and would be there only five days. By the next afternoon Stewart found himself standing in front of the head. It had by then, he recalled, become in his mind an object of almost legendary stature. He wrote, "At once I was sure of two things: it was indeed beautiful, and it had almost certainly come from the pediments of Skopas' great temple of Alea Athena in the southern Greek town of Tegea."

After a few minutes of uncharacteristic silence Frel turned to Stewart and asked in his abrupt way, "Well—Scopas?"

Stewart said that he thought it was.

"Good," Frel replied, "then if we get it, you shall publish it."

Frel's motives we know, but how come a mature, professional scholar like Andrew Stewart was bitten so quickly and so hard? Here was a scholar with little actual object or excavation experience who had for so many years delved into the remains of the genius Scopas that when a completely unknown work by the artist appeared out of the blue, he seems not to have questioned it.

Being expensive, having been praised by the art critic of the *Los Angeles Times*, carrying the blessings of François Chamoux and Andrew Stewart, and blessed, too, by Jiri Frel, the "Scopas" head was bought almost casually by the board of trustees for the two and a half million dollars. Although it cannot be established independently that Frel ever actually pocketed a percentage, Jean Michel described that de Bry drove him to distraction worrying whether to give Frel a commission of 15 or 10 or 5 percent. Finally, de Bry wrote out the fee structure in a contract with Michel and designated for him 17 percent for his work "in making for me a relationship with the

Getty and more particularly with the honorable Dr. Frel." The letter carried the instructions that Michel keep 7 percent for himself and split the remaining 10 percent with Sedlmayer and Frel.

Michel eventually decided it might be dangerous for his tax situation to be known to have handed out large amounts of money, especially to Frel, and in March 1979 got de Bry to write to him that de Bry, not Michel, was responsible for the commissions. Michel made $187,500; he didn't know if Frel got the share de Bry had been talking about, but he assumes he did.

Once the head was acquired, Frel announced to the world the acquisition of an over-life-size head in marble carved "unquestionably by Scopas." And he emphasized that this was no stray Scopas head—it was the very head of Achilles which in ancient times graced the exact center of the western pediment of the temple of Athena Alea. It was the single most important part of the most central and individualistic and important decoration of all in the vaunted temple of Athena. Here's how Frel described the piece in his scholarly checklist of antiquities of 1979. The references in brackets are Frel's way of indicating the authors of various opinions:

> The De Bry Head. Repaired in antiquity, probably in the second century A.D.: a hole in the center of the neck carved for readjustment on the body [so already de Bry], upper lip, small part of lower left eyelid, hair above left temple and slightly recut nostrils [Morgan]. The Attic helmet and the whole physical type corresponds exactly to the head in Athens, poorly preserved and of much inferior carving. The slightly more perceptible weathering of the left side, the cursory indication of the right occiput, and the chipping, especially on the left chin, confirms that the head is to be seen from ²/₃ left, bent forward looking up. Thus it belongs to the same group of warriors as the Athens head and it must be the central figure, Achilles [Frel]. After knocking down Telephos, he is possibly looking at the Nike who gave him victory and stood as an akroterion on the temple [Stewart]. The preservation is magnificent. The quality of carving points directly to the hand of Skopas, which is not true for other heads from the Tegea pediments. About 350–340 B.C.

In his booklet, Stewart states firmly that the head is closest in style to the Scopas head in the National Museum of Athens and agrees with Frel that it is Achilles, the star of the entire decorative show at Tegea, the pinnacle of the creative powers of this compelling Greek sculptor. Stewart claimed extravagantly that its "quality and power suffice to place it at the

forefront of all surviving architectural marbles of the late classic period." At the end of his introduction, he wrote, "My two-year love affair with the Getty Museum's head from Tegea has been brief but intense; I hope it will prove to have been fruitful."

Frel wrote in his foreword to Stewart's book, certainly not without irony, "Who would expect to find in a remote French provincial house the over-life-size marble head of Achilles . . . carved in all probability by Skopas himself?"

My answer is, only suckers.

Stewart's dream and Frel's chicanery were shattered in 1985 by the publication in the art magazine *Antike Welt* of September 1987 of a devastating article by the classicist Professor German Hafner of Mainz University in which he dismisses the "de Bry" head as a mere Beaux Arts replica. Although the German scholar points to a welter of problems, his *coup de grâce* is a smoking-gun error of style which signals the fact that the "de Bry head" had been fashioned by a copyist of the nineteenth century. He singles out the curve of the prominent visor covering the brow of the "de Bry head." It is smooth, a French curve. The shape is all but identical to the curve of the helmet in the head in Athens, *Patroclus*, which positively came from Tegea. The only problem with the softly curved visor, Hafner observes, is that when the authentic Athens head was made, it wore another type of helmet and visor. The original one was shaped with a distinct peak in the center of the visor—like all Greek helmets of the fifth century. This feature is apparent in numerous sculptures and even in real helmets that have survived. The Athens head had apparently suffered harsh damage and the center of the visor had been obliterated. The gaping hole had been filled in by an untutored restorer sometime in the late nineteenth century and the visor had been fashioned into a smooth curve. Whoever made the "de Bry-Getty head" had incorrectly assumed that the photograph or cast of the Athens head he was working from was correct.

Once Hafner's article was published, Stewart fought back hard and valiantly. He tried to discredit Hafner's eye, but in time his, and Frel's, glowing attribution of the head to Scopas and antiquity collapsed. The Getty removed the object from its prime exhibition spot and relegated it to the storeroom. Subsequently, the museum, in an unusual move, went to court in Paris and sued Michel de Bry in an attempt to retrieve all or part of its two and a half million dollars. As of today the litigation is still grinding through the courts. De Bry staunchly maintained in court hearings that he never mentioned the name Scopas to the Getty, Frel did.

The great Scopas scam was put into the shadows, however, by de Bry's actions with Michelangelo's "model" for his spectacular *David* in Florence. *The New York Times* was the first newspaper to announce the discovery of this incredible work of art—on the front page. It was on March 6, 1987 and the story's lead was, "An eight-inch plaster model believed to have been used by Michelangelo to make his sculpture of David, the monumental statue in Florence, that is among the world's most famous works of art, has been discovered after having been lost for nearly 300 years, a leading Renaissance scholar said yesterday."

The scholar was the late Frederick Hartt, an emeritus professor at the University of Virginia and a specialist in the Renaissance. He described how he had presented photographs of the model and the facts of the case to five Renaissance scholars at New York's Academy of Sciences. He described his impression on first seeing the model in Geneva a year before, thinking momentarily that he was looking at a "fragment of Greek sculpture from the fifth century." Then he spotted a similarity to the *David* and saw the remnants of the sling hanging over the back of the figure. "I started to tremble, the discovery was so great. I kept asking myself, 'Can this be real? Am I wrong?' I didn't sleep that night. I kept asking all the most inconvenient questions I could ask, and it passed every test."

The *Times* ran a photograph of the model, which had been broken. Missing were the head, the arms, and most of the legs. There was enough, however, to indicate to everybody with half an eye a stunning resemblance to the huge statue in the Accademia of Florence.

A foundation in Switzerland called the Davos Foundation owned the piece. No one has hazarded a guess as to where the statue had been all these three hundred years, but since about 1921 the piece, it was said, had been in the private collection of the renowned Swiss-French composer Arthur Honneger who had the figure set on his piano for inspiration while he composed his beautiful oratorio of 1921, "King David." Honneger died in 1955 but his daughter, Pascale, recounted that she had given the statue to a certain Michel de Bry in exchange for a death mask of her father. She added that her father had never imagined that the model was anything more important than a copy. No one in the family, she added, ever imagined it was an original work by the Renaissance genius.

Hartt explained at length why after a year's study he was convinced that the little statue had to be an autograph work by Michelangelo and definitely the first idea for the *David*. One of the key points was the peculiar burning and charring of the little piece. He had managed to root out from

the almost hidden archives associated with the Palazzo Vecchio in Florence six references to a small model of the *David* beginning in 1553 and ending in 1666. These inventory entries stopped after a famous fire of 1690 had severely damaged the private rooms of the Medici, the Guardaroba Segreta.

Many treasures had been salvaged, but some, including the Michelangelo model, disappeared.

The consensus of the Renaissance experts in attendance at Hartt's New York presentation was polite and wary. Some said that the statuette was captivating. Douglas Lewis, curator of sculpture at Washington's National Gallery, remarked that it seemed "ravishingly beautiful," but that without a close look at the piece itself no one could be certain if it was Michelangelo's initial flash of inspiration or a "very high-class student or colleague's copy."

The story caused the desired sensation in the art market and museum circles. Hartt announced that he would be writing a "coffee-table" book on the piece for the prestigious art publishing house Abbeville Press, and there was the likelihood that the piece would go on world tour before eventually being sold to benefit the Davos Foundation's efforts to fund budding composers. That was the packaged story. The real story which I uncovered through interviews with de Bry's son-in-law and Jean Michel and from the court records of one of several lawsuits that eventually swirled around the *David* is, to my mind, one of the classics in the field of art con-games and fakes.

Where the twenty-centimeter statuette came from exactly isn't known, but it certainly was never in the Honneger collection. Pascale Honneger at length owned up to the fact that the torso was given to her by de Bry. An art dealer by the name of Gianni Ongaro claims he found it in a flea market in the south of France and gave it to de Bry for his expertise, whereupon de Bry ran off with it. If so, it could have been a version of the *David* made in the eighteenth or nineteenth century.

It was customary for students studying sculpture in the Accademia in Florence in the old days to pass a final examination by making a small replica of either the *David* or some other sculpture in the collections. There used to be a small gallery behind the chamber in which the *David* is displayed with some dusty vitrines loaded with these diminutive efforts. They are appealing principally because they are by no means slavish copies, in no way comparable to airport art or to the hundreds of plaster, plastic, and glow-in-the-dark *Davids* that one can buy throughout Florence. If this were the case, one can imagine that someone, possibly de Bry, manipulated the statuette in order to deceive, possibly hacking off the head and arms and legs. It's very convenient that these elements, which would offer very power-

ful stylistic indicators that the work was or was not by Michelangelo, happen to be missing.

Although Gianni Ongaro would no doubt object to the suggestion, the model could be an outright fake, too. There are some oddities about it that suggest that it was cooked up in recent times as a fake. Who might have commissioned it is not known, obviously not de Bry since Ongaro can prove that he brought it to de Bry's attention. First, it's mundane plaster, not the more exalted gesso—powdered alabaster or marble mixed with plaster— which would have been more likely in the High Renaissance. Second, the statuette is a cast; there are cast lines on the sides in various places. One might have expected Michelangelo to have cut his *modello* right into the plaster and would not have needed a wax version to guide him. Third, it's very difficult to fill in the missing parts of the anatomy and determine what the figure looked like when it was whole. When one tries to do so, the result is radically at odds with the huge statue primarily because of the curious angles of the stumps of the neck and limbs. The head tilts at a different angle; the left arm holding the upper part of the sling is held much farther away from the body than is the case with the huge statue; and the left foot is raised fairly high in the air on some added rock or piece of turf, whereas in the large statue the feet are level with one plane. Fourth, the closest works to the de Bry "model" is not the *David* in Florence but two works in the Louvre. One is a drawing by Michelangelo of a nude male, and the other is a late-sixteenth-century bronze statuette, which was made after the giant *David*, in which the chest and stomach are almost identical to de Bry's plaster model.

As to provenance, de Bry was faced with the task of finding a place where the statuette had been for a generation or so. It would be most fitting for the provenance to be somewhere in Switzerland to avoid the burden of French taxes if he sold it (de Bry was hoping for at least thirty million dollars). From his lifelong involvement in classical music, de Bry had known and championed the composer Arthur Honneger and was acquainted with his daughter Pascale. A master at persuasion, de Bry proposed to Pascale that to help him out with some routine fiscal matters she pretend that her father had owned the *David* since 1921 and that she had decided to give it to de Bry to be sold. An appropriate share of the proceeds would go to a charitable foundation he would establish, the Davos Foundation, for the encouragement of young musicians. To sweeten the pot in exchange de Bry gave her a death mask of her father. She agreed.

After he had established where his treasure had been since the early

part of the century, de Bry had to find the perfect expert who might vouch for the work. He chose Frederick Hartt for very special reasons. There were Michelangelo experts much closer to Paris than Charlottesville, Virginia, but Hartt was judged the essential "mark." It's clear that de Bry researched him with care. He must have found out that his quarry was considered by his colleagues as book-smart, but object-dumb. De Bry also knew that Frederick Hartt was getting old, was retired, and wanted to move to Washington, where housing is expensive. It seems that de Bry had figured out how much Hartt would need for the move.

It was on May 22, 1986, on Hartt's seventy-second birthday, that his phone rang at home in Charlottesville, Virginia, and a man with a pleasant French accent wished him happy birthday. Hartt was amazed and flattered. The gentleman, M. Benamou, de Bry's *valet-de-chambre* declared, "I am calling from France on the part of a foundation which has a document of Michelangelo, and the representative would like me to come to see you in Charlottesville to show you this 'document.' " In his book for Abbeville Press, Hartt reported that he wanted to put the man off, he didn't want to be bothered by having to look at some piece of nonsense, some "document" like a fragment of an unknown sonnet or a letter with Michelangelo's signature. He briskly outlined to his caller the policy he had established "out of self-protection, to reward me for my time and effort, and to discourage frivolous questions." He demanded a thousand dollars up front, all expenses paid plus a percentage of the selling price. Not all that unusual for a put-upon scholar. *"C'est normal,"* Monsieur Benamou purred.

Benamou flew in to Charlottesville the next day. Hartt, who was expecting a piece of paper, was startled to see a lavish set of photographs in color and black and white depicting a work of art. He had forgotten that in French, *document* could also mean a work of art. Once he took the pictures to the bright light flooding in from a window in his study, Frederick Hartt was smitten, genuinely and without guile. Benamou's timing was deft. He allowed Hartt a minute for his eyes to start popping and then slid a photograph of the real huge *David* on the table. That did it.

Hartt wrote, "It was immediately clear that the statue and the fragment were closely related." His mind reeled with thoughts. He knew at once this small thing before him was different from the *David*, physically another type, something far from the smooth, idealized beauty of the huge sculpture, with anatomy taken from a life model without reference to the statue, standing in another pose, the slingshot not in the same place . . . "therefore not a copy but an original study from a living model." Hartt recalled instantly the

drawing in the Louvre which was said to be a young marble cutter in Carrara. All the ungainly grace, the bony structure, the vibrant muscles "like a basketball player's" were the same. Hartt was overwhelmed by the magnificence of the material and the tiny details. The substance he guessed was marble stucco. What captured his gaze were the "exquisitely finished" wrinkles under the arms, the circles around the nipples, and the meticulously patterned locks of the pubic hair." In fact, the only feature close to the enormous original *David* is this stylized spray of pubic hair.

In a flash Hartt's defenses crumbled. As he would later write, "This was the only true, small-scale, finished model by Michelangelo in existence as distinguished from the six or seven authentic, fairly rough bozzetti (sketches in clay or wax). And it was the actual model he had used for the creation of the most beloved of all his statues, the marble *David* in the Accademia in Florence." He describes how he literally began to shake.

Benamou called his boss and softly intoned, "Yes, he is overwhelmed." One can imagine de Bry's reaction, something akin to what the grizzled deep-sea-fisherman feels when he's got what he senses has to be the world-record marlin on the line. De Bry got on the line and invited Hartt to fly at once to Geneva (it was actually Paris but Hartt changed the city in his book to help out de Bry either with his tax situation or with laws about unlawful export), but Hartt grumbled that he had a deadline for an edition of a book and said he was afflicted with arthritis and begged off. This gave the superlative scam magician the divine opening. *"Je viens,"* de Bry said, adding after a minute or two of exchanging admiring views about the *modello* words that Hartt said he never forgot; "Sleep on it, if you can sleep."

Events moved fast. Hartt, suddenly appalled at the thought that de Bry would subject this almost unbelievable treasure to the rigors and risks of a trans-Atlantic flight ending in the local Charlottesville-Albemarle airfield, which was too small for commercial jets, told de Bry he'd come to Paris to examine the *modello* in his hands. He did so in early June, and in three days of penetrating scrutiny his initial feelings were strengthened. M. Benamou provided a pair of white gloves to the art historian to hold the precious *modello*.

There is no doubt that Fred Hartt truly believed that the charred and broken piece was the life model Michelangelo had produced for the Florentine city fathers to show that he could carve the huge abandoned hunk of marble into what is perhaps the single greatest sculpture in the Western world. His notes made at the time make it clear that he subjected the *modello* to a dispassionate scholarly eye. He never hesitated, despite the many easily

perceived incongruities in the statuette. He never wavered even when confronted with what he thought were "incredible and untrue" pieces of nonsense in the de Bry collection: the awful Augustus gem, the "Bar Kohkba treasure," and the other daubs. He had found his dream and nothing was going to take it away from him.

Then, under the seductive glow of the spectacularly rediscovered Michelangelo, and no doubt wound up in Michel de Bry's web, Hartt's venal, nonscholarly side began to flower. He signed the first of several contracts with de Bry, promising to make a historical, artistic, and technical study of the "said model," to have it published by Abbeville Press and photographed by the American art photographer David Finn. In exchange, one contract reads, "M. de Bry promises to reserve to Mr. Hartt a nett [sic] percentage of 5 percent, which will be paid entirely and immediately after the complete settlement of the sale." Not insubstantial, for the modest assessment of the treasure was now approaching forty million dollars.

When Hartt returned from Paris, he passed through New York and wrapped up a book deal. The publisher suggested that some scientific tests be made to ward off possible attacks on his daring attribution. De Bry casually consented to have slivers of the material cut out and sent to a lab at the University of Bordeaux. For some reason he was confident that no scientific instrument would reveal anything dangerous. The reason why would later on turn out to be most entertaining.

Hartt also started negotiations to give a lecture at the National Gallery in Washington to announce the miraculous discovery to the world. He got an appointment with the gallery's then director, J. Carter Brown, to tell him about the new find and to urge him to start raising the funds to make a bid for the *David* at the forthcoming auction de Bry had planned. Hartt didn't mention to Carter Brown that he had a 5-percent stake in the piece.

A year into the game, Hartt had become curiously blinded; a year had gone by and the mountebank still had not sent him his thousand-dollar fee or, for that matter, his flight expenses.

Hartt had become quite obsessed with money. When he learned that de Bry had changed his mind and was thinking of not selling the *modello* at public auction, he became enraged and fulminated, "We shook hands on 5 percent; value estimated at between forty and fifty million dollars . . . if the price in a private sale drops to a figure below twenty million dollars, my percentage must increase in proportion to the amount I would have received at a public sale."

Hartt encouraged de Bry to write him two letters about their financial

agreement in order to conceal his true role. One reaffirmed that the auction route would be the best way to go to entice the Getty, the "Japanese," and "your dear National Gallery," and Hartt would get his 5 percent. That first missive slyly states, "Enclosed is a letter whose existence in your hands may one day or another have its uses!" And that second letter of early July 1986 states among other things, "Dear Professor . . . I have been very sensitive to the fact that you have refused all financial interest . . . even if, as you say, the publication you are preparing should be the crowning of your career." Hartt was pleased.

In October 1986 there was untrammeled joy when a representative of Sotheby's told de Bry that if Hartt's attribution held, then the *modello* would be worth forty to fifty million dollars and recommended a private sale to "avoid hysteria." He claimed that a private offering by Sotheby's would make even more money than a public auction. At this point both de Bry and Hartt reaffirmed once again in a letter the falsehood that the professor had no financial stake.

Hartt kept pressuring J. Carter Brown at the National Gallery to plan a special exhibition. The professor told de Bry that everybody at the gallery had been convinced that the *modello* was authentic and was a grand monument of history. But he was being overly optimistic. The curator of sculpture, Douglas Lewis, was contemptuous, seeing a possible fraud, especially with the burned parts of the torso. When his skeptical views reached Hartt, the professor wrote him a biting letter. He pointed out that the *modello* had probably been damaged in the disastrous fire that wiped out twenty-seven rooms of the Palazzo Vecchio where he was sure it had remained since Michelangelo had given it to Lorenzo de' Medici. He stated that although Bordeaux University had not completed its analysis of the fragment of the object, he did know that the *modello* "was found to have been damaged by fire a long time, more than a century after its creation and buried for a period of similar length. It defies reason to suggest that the present *modello* could be any other than that listed in the inventories but could have been an earlier substitution." This was nonsense. No such findings had emerged. The National Gallery turned down Hartt's request for an exhibition. The officials were beginning to suspect that Hartt was losing it mentally with his ill-starred crusade in favor of the little plaster. Besides, the gallery could hardly show something that would soon be up for sale.

While the little torso was being researched by Hartt and photographed by David Finn in such a way that not only illustrated scholarly points but elevated the object to a new height of grandeur, the business aspects of the

impending sale fell into chaos. A charlatan and convicted con man by the name of Michael van Rijn, a Dutchman who in the fall of 1986 had been convicted in absentia in Paris of art frauds involving fake businesses and an alleged forged Chagall lithograph, entered into a secret agreement with de Bry to purchase half interest in the Michelangelo. His part was to be twenty-seven million dollars. Van Rijn had an antic deal in mind. He claims he had discovered the existence of a special Japanese cult that had a statue with hollow arms into which the acolytes stuffed incomparable art treasures, presumably for religious strength and purity. Van Rijn had confided to certain people that he had already sold the cultists a drawing by Leonardo which was lovingly rolled up and thrust into the hollow arm. The little Michelangelo *modello* would be perfect for the arm.

Unfortunately, van Rijn's three-million-dollar down payment check for the eventual twenty-seven million bounced and the torso was sealed in a vault in a London private bank while de Bry, Van Rijn, and Gianni Ongaro fought out its ownership in the courts. In mid-1995 Ongaro won possession. He is overjoyed that once again he has this world treasure of art in his hands. Of course the David *modello* is likely not by Michelangelo and was messed up by Michel de Bry so extensively that it is tantamount to being a fake.

Where Frederick Hartt really went wrong was his blind acceptance of de Bry's canard that the *modello* had been snatched from the horrendous fire of 1690 in the Palazzo Vecchio. Long before the final results of the Bordeaux thermoluminescence tests, he had written to the skeptic Douglas Lewis the erroneous information that the statuette had been burned a century after it was made and certainly not in modern times. When the Bordeaux tests came back there was nothing about the date of the gesso or a time when it could have been burned. Strange. Because there is a type of carbon 14 and thermoluminescence that can pinpoint the approximate time of a fire. In fact, the scientists at Bordeaux emphasized that they had failed to make a dating. This should have been a red flag but Hartt didn't see it. If the de Bry plaster had not been in the fire and had not been scorched, then it couldn't possibly be by Michelangelo. The burn marks are proof positive of authenticity.

In his lavish publication, Hartt kept referring to the archives of the Palazzo that mentioned some kind of a model by Michelangelo—variously called stucco and gesso and wax—and linked it to de Bry's statuette. He even published the measurements of the model mentioned in the archives —three quarters of a Florentine Braccia, or about 51.3 centimeters. Al-

though the de Bry *modello* is only twenty centimeters (7 7/8 in.) high, Hartt stated that that was in perfect accord with de Bry's *David*. If so, the head and the rest of the legs would have been immense, and the thing would have been grotesque.

In a sharp point-by-point counterattack directed at whoever might come along in the future to criticize his elaborate theories, Hartt wrote that to disprove the authenticity of the model one would have to demonstrate that the forger or manipulator of a later replica or version:

1. Knew of the drawing in the Louvre.
2. Had heard mention of the real model in the Guardaroba Segreta of the Pallazo Vecchio.
3. Had impregnated the outer layers with clay.
4. Deliberately broke off the head and limbs.
5. Maliciously damaged the *modello* by fire.

Of course, the answer to each is *yes*, and particularly to number five. As Michel Scopas told me, in the spring of 1985, about a year and a half before Hartt was approached by de Bry, Michel happened to drop in at the apartment on the Boulevard des Courcelles. He smelled something burning, an "odd, dry smell." He went into the kitchen and found de Bry pulling something out of the oven. It was the little *David*, which Michel had previously seen in a fairly good state. Now the statuette had a slight burn on its left flank.

"Is this how it would look if it had been in a fire?" De Bry asked him.

Michel told him no, it didn't look charred enough. At this de Bry shoved the sculpture back into the oven, turned up the heat, and left it there for about half an hour. When it came out the second time, Jean Michel told him, "Now that really looks good."

When he was asked if the little statue had any significant burn marks on it when he discovered it in the flea market in the south of France, Gianni Ongaro has stated that he really can't recall. He is confident that once he places the object for sale he will see dozens of potential buyers flocking to his door. After all, Frederick Hartt has blessed it in his landmark book which will be distributed to all interested parties. Ongaro plans to market the statuette in keeping with the price he hopes—and expects—it to attain, which is something in the vicinity of eighty million dollars.

W hat's still out there that's fake and undiscovered? Hanging on the walls of distinguished museums around the world, bathed in miniature klieg lights in the most expensive vitrines money can buy? Lovingly displayed by dozens upon dozens of private collectors? Or being cooked up in clandestine studios in Paris, in marble-cutting factories in Rome, in the foothills of Taiwan, on mainland China, in the Black Forest, in California, or Mexico? Thousands of things. As I travel the world of museums, art galleries, and private collections I spot the suspicious characters with that instant fakebuster's flash and put them on a list. I even see the fake Impressionists of my old mentor-in-forgeries, Frank X. Kelly in galleries.

Some of my favorites are:

A graceful and coy little Greek bronze of the fourth century B.C. depicting a dancer pulling part of her garb across her face in the Greek and Roman department of the Metropolitan Museum of Art. It's supposed to be the very image of classical antiquity. To me, it's cute and impossible. She seems simply too good to be true with her luxurious, perfectly formed draperies and the come-hither gesture. There's none of the brash provocativeness of a genuine Greek prostitute. I suspect that she was modeled after a real Tanagra terra-cotta figurine, enhanced in the wax, and then cast in bronze.

There's a life-size standing portrait of a man called the emperor Geta which is the ugliest work of art in the Met. It's so unattractive that when I

was director I wanted to relegate it to storage for fear that young visitors would have bad dreams. His patina is the color of offal. His anatomy is bulbous, syrupy, soft, waxy, and unconvincing. His pinhead is set incongruously into this ungainly body with too-long legs and the stomach muscles of an octogenarian. I'm convinced this is a phony concocted by that master of masters, Wolfgang Helbig and made by a team of fakers in Orvieto.

The Met's silver head of a Sasanian kingpin in the department of Ancient Near Eastern art gives me the willies. It is said to be Shapur II principally because of the shape of the crown which appears on coins and a rock relief in the desert near Naqsh-i-Rajab in Iran. If so, the huge silver head, slightly over life-size, would date to about 309–379.

I wonder. I detect what I interpret as what can only be forgers' mistakes in this piece and begin to think it's twentieth century, one of the more ambitious phony Sassanian silver objects made in the 1950s. It gives the impression of being something inflated from a coin or a face in one of the many original silver plates in museums such as the Hermitage, the Metropolitan, and the Bibliothèque Nationale.

The Cloisters has a few pieces I believe to be phonies still on exhibition, some of them I was responsible for acquiring. One I now believe is a marble Florentine relief of the early fifteenth century.

When I was the curator of The Cloisters I found in a Florentine dealer's shop a striking angel carved in stone by the fourteenth-century sculptor Tino da Camaino. The dealer refused to sell it to me without my buying a six-foot by three-foot marble relief depicting Christ seated in a mandorla flanked by Saints. The date of the relief was said to be about 1435 and by a Florentine master. I smacked my lips over both pieces and was giddy with the idea of snatching them from Italy. The Italian government seized the Tino but approved the export of the Christ. I remember the relief cost about a hundred thousand dollars—which was not a pittance either. The provenance was murky—some private chapel outside Florence that no longer exists. Thinking about the deal now which greatly benefited the city of Florence and which brought considerable honor to the dealer, I'm convinced I was set up and my own greed brought me down. I went up to The Cloisters recently and confronted the relief. What a travesty! The style is like soft wax, characterless, bland, safe and sound and, to my mind, completely phony.

Of course the Metropolitan Museum is not the only institution in the world with seeming forgeries on display as originals. One is Madrid's National Archaeological Museum and the fake a famous Archaic Greek head

of a horse. It possesses all the stylistic characteristics of some of the pieces created by the Helbig-Marinetti school of ancient art.

The National Gallery in London has one of the painterly triumphs of the High Renaissance, a spectacular large oil painting by Paolo Uccello, depicting with his signature clunky "office" perspective a fierce battle with knights on powerful horses wearing well-worn armor smashing at each other with some of the toughest-looking weaponry ever pointed. The large, somewhat damaged picture is noteworthy for its absolute accuracy of anatomy and armor—so much so that one wishes that Uccello hadn't been so pedantic. This one is undisputed and magnificent.

Close by is another, smaller Uccello which is the antithesis of the satisfyingly brutal battle. This second one depicts Saint George poignarding a dragon with a lance held almost languidly under an arm. There's an elegantly dressed young woman holding the dragon on a leash. The wings of the dragon are decorated with what looks oddly like the emblems common on British fighters in the Second World War. The feeling of the Saint George is quiet, detached, cautious—and dead. The warrior's anatomy is fumbled. He has virtually no waist at all. The horse is a cotton-candy version of the marvelous steeds in the huge and unruly battle scene. The stark profile of the young woman is almost a parody of Italian Renaissance portraits. When one walks from this incredibly charming picture to the large Uccello and tries to tally up similarities in details that appear in both—from anatomy of man and horse and armor—one finds nothing at all that's comparable.

The prestigious Morgan Library in New York possesses a silver-gilt fragment of *Three Kings* supposedly from a large fourteenth-century altar, but which was probably made as a fragment and betrays nineteenth-century style beneath the bogus Gothic.

In the Cleveland Museum there's a lovely seated *Madonna* of Burgundian stone that looks highly suspicious. As is the standing French *Madonna* of about 1500 in the Vassar College Museum. This is one of some two dozen similar *Madonnas* that populate museums around the world.

The Brooklyn Museum has one of the most distinguished late-Egyptian art collections outside of the Cairo Museum. One of the high points is a stone plaque with a reverse-relief scene of the schismatic and possibly mentally disturbed Pharaoh Ikhnaton and his famous wife Nefertiti. They are shown looking lovingly at each other. It's called the *Wilbour Plaque* from the name of the donor. The piece is thought to have been a sculptor's sketch of the king and queen; there are numbers of them especially from the period of Ikhnaton. But strange how it has been chipped and damaged only in places

far away from the two heads in profile, and strange that the drawing style is so lyrical, something that does not seem to occur in the real Ikhnaton-Nefertiti carvings.

In the gracious small Museum of Fine Arts in St. Petersburg, Florida, one of the finest pieces is a large pre-Columbian terra-cotta seated figure of the classic period of the Vera Cruz style—about A.D. 600–900. It presents all the best characteristics of the Vera Cruz Classic Style, noted by scholars in countless publications and apparent in over three thousand terra-cotta statues in museums and private collections throughout the world. It's blocky and confident, highly refined yet with a pleasing touch of the raw and primitive. The colors are muted. The arms are long and expressive. The decoration around the head consists of sinuous bands like flattened snakes, a primary mark of the special style. Most distinctive of all, the imposing figure wears what appears to be goggles, a detail that has puzzled some specialists who believe that what looks like a pair of glasses must be part of some ritual costume. But they are goggles. I believe the piece is a forgery, that it was made along with some thirty-five hundred similar, large-scale and compelling works of the Vera Cruz Classic Style by a most intriguing forger named Brigido Lara. He faked what amounts to an entire civilization. His undertakings would be comparable to one faker inventing, say, the better sculptures made in France in the entire eleventh century.

Lara and his thousands of prime creations most certainly would never have come to light had he not been arrested in 1974 as a smuggler of precious national patrimony. He was apprehended by the Mexican police near Vera Cruz with a large pre-Columbian terra-cotta statue of the finest Classic Style. He was jailed but kept insisting that he wasn't a smuggler of antiquities but the creator of the piece he was carrying under his arm and thousands of others like it as well. At first the authorities laughed, but after months of protesting, Lara finally managed to persuade them to let him have the clay and instruments he needed. Overnight he made a statue in his prison cell that was even better than the one with which he'd been caught. He was released and was hired by the Mexican cultural authorities as a restorer and maker of replicas to sell in museum shops.

After he went legitimate Brigido Lara became his own fakebuster, identifying over the years thousands of examples of his handiwork. Whenever a foreign museum or private collector dismisses his claims, he asks them to test for the presence of one ingredient he always supplied to his clay mixture —Resistol 850, the common household glue of Mexico.

Some of Lara's works are truly astounding. There's a huge terra-cotta of

the wind god Ehecatl and an even more dramatically impressive Xipe, the priest in a victim's flayed skin crying out some incantation in the Rockefeller Collection of the Metropolitan which seem to epitomize the fire and energy and cruelty of pre-Columbian art.

In the Dallas Museum of Fine Art there are three spectacular seated figures which are among the most moving and expressive pre-Columbian human figures in existence. They fooled the canny dealer John Wise and the astute collector film director John Huston in part because the middlemen set up their mark by making a delightfully amateur film of the moment of discovery in the illegal dig. Huston, naturally, fell for the filmic proof of authenticity.

Lara started to work as a child as a restorer supplying missing pieces for authentic works dug up by smugglers. Still in his teens, he worked as the star of a Mexico City factory making bogus Olmec and Mayan pottery. By the time he was in his early twenties he had perfected his style: the Lara Vera Cruz Classic Style.

Lara's figures are patterned loosely after those found in burial mounds around El Zapotal not far from where he was born. Those figures date from A.D. 600–900 and are noteworthy for their size and the flamboyant masks and headdresses made of writhing serpents and banded ribbons, although none of their decoration is as ambitious as Lara's. Lara would go instantly to the site of a new discovery. He would memorize the stylistic characteristics and would collect abundant clay samples from the same place. He gathered up dozens of clay and cinnabar varieties, the latter the red powdered mercury the ancient Olmecs used in their figures. He formed a precious collection of patinas. He fashioned his own wooden sculptor's tools which were identical to the ancient ones. He did this by studying the minute indications on authentic pieces.

Lara constructed the body first, then he would attach the decorative elements. His "ancient" outdoors kiln was nothing more than a bunch of twigs encircling the clay image. He'd set them on fire and the statue would be baked in the same way as centuries-old sculptures. His patina was a conglomeration of Portland cement, fresh lime, hot sugar water, and his own urine. The sealer combined dirt and Resistol 850.

Today Lara is gathering photographs of his Vera Cruz Classic Style sculptures which are sent to him from collectors and museum officials from all over the world who are slowly beginning to hear about him and his productions. He is sending the word out to the universe of scholarship identifying and proving that pieces once considered the symbol of ancient

Vera Cruz are in fact his children. "Look for a figure with a large iguana wrapped around the body," he will say and soon a photo of that will come in.

Why did all of Lara's work remain undetected? He was highly inventive and avoided all the forgers' mistakes. He never copied anything. He never made a deliberate fragment. He frequently added brilliant restorations to his own creations and thus made his creations triply convincing. From the beginning he fashioned his Classic Style works in a different scale from those of the known pieces, thus they were assumed to have come from special excavations conducted by illicit diggers. Finally, Brigido Lara's pieces are actually more dramatic than the sincere and authentic Vera Cruz works of A.D. 600–900.

Yet no matter how gifted, Lara's inventions are nothing but mockeries, dead things. As the great art critic Walter Pach said of fakes back in 1927, "A work of art is a thing of life. The imitation is dead. It fools you 'temporarily' . . . but try to live with one. The deadness would soon become hateful. And the longer one lives with works of art, the more one feels them to be full of the life and love that begot them."

The only solace is to live and learn, and never be swayed by need, speed, or greed. Above all, collect art the only way it should be collected, purely for love. Then if you get stung you won't really get mad. Unlike me.

# �𝑛OTES

## Introduction

*p. 15* The Christie's catalogue for the Botero: May 17, 1993.

*p. 16* Alain Tarica, a French mathematician, former art dealer, and fakebuster living in Paris told me about the Botero fakers in Paris going to three layers of paint for the subsequent series of phonies.

*p. 16* The Christie's catalogue for the Anders Zorn: May 28, 1993.

*p. 17* For writings by Pico Cellini, consult the magazine *Paragone*, 6, No. 65, May 1955 for a summation of his views on the "Boston Throne." Also, *Due Appunti per La Storia delle Falsificazione*, Rome, 1955. Also the articles on the Metropolitan's kouros in *Il Giornale dell'Arte*, IV, 1986, and VI, 1988.

## Chapter One: Fakebusters, Fakers, and How to Tell a Fake

*p. 20* It was Hyatt Mayor, the late curator of prints at the Metropolitan Museum of Art, who talked about the hummingbird feeling.

*p. 20* The steps in examining works for acquisition are described in *The Chase, The Capture, Collecting at the Metropolitan*, New York, The Metropolitan Museum, 1975.

*p. 22* Anthony Grafton's *Forgers and Critics: Creativity and Duplicity in Western Scholarship*, London, Collins & Brown, 1990. An essay which started with a Walter Edge Public Lecture at Princeton University and deals mostly with literary frauds, but spells out the general environment of fakery so brilliantly that many of Grafton's points apply to art and archaeological phonies too.

*p. 23* Grafton, op. cit., p. 50.

**Chapter Two:** The Giddy Ancient World

*p. 25* Fritz Mendax, *Art Fakes and Forgeries*, London, W. Laurie, 1955.

*p. 25* Sippar stone object: In *Fake? The Art of Deception*, edited by Mark Jones, Berkeley and Los Angeles, University of California Press, 1990, catalogue for the exhibition at the British Museum in 1990, #34, p. 60.

*p. 27* Shibaka stone. Ibid., p. 60.

*p. 28* I got the ancient Greek word *nothoi* from Anthony Grafton, *Forgers and Critics: Creativity and Duplicity in Western Scholarship*, London, Collins & Brown, 1990, p. 12.

*p. 28* Book of Daniel reference, ibid., p. 79 ff.

*p. 29* The deer sacred to Artemis is cited by Grafton in a footnote (8) in his first chapter, "An Overview."

*p. 29* The story of the miraculous shield comes from Fritz Mendax, op. cit., chapter on ancient fakes.

*p. 30* Pasiteles tale, Mendax, op. cit.

*p. 33* My personal notes are dated fall 1956.

*p. 35 ff.* On the Hermes statue, see a capsule history in *The Sculpture and Sculptors of the Greeks*, by Gisela Richter, fourth edition, New Haven, Yale University Press, 1970, p. 199. Richter was convinced the piece was an original and cites where to find the dissenting opinions in the archaeological literature.

**Chapter Three:** The Shrouded Middle Ages

*p. 38* I came across the story of the bogus writings on the histories of the Roman emperors in Anthony Grafton, *Forgers and Critics: Creativity and Duplicity in Western Scholarship*, London, Collins & Brown, 1990, pp. 19, 56, 80, and in

several footnotes. It's a delightful section of a thoroughly entertaining volume well worth the scrutiny of anyone who yearns to become an art fakebuster.

*p. 39 ff.* The anecdote about King Abgar is to be found in Fritz Mendax, *Art Fakes and Forgeries*, London, W. Laurie, 1955.

*p. 39* The best summation of the *Donations of Constantine* and the percentage of forged Merovingian documents is to be found in Grafton, op. cit., p. 24.

*p. 41* The story about Einhard appears in Mendax, op. cit.

*p. 43 ff.* The account of the fraudulent statue of the Virgin Mary in Bern is to be found in a study of German sculptors of the fifteenth and sixteenth centuries, M. Baxandall, *The Limewood Sculptors of Renaissance Germany*, New Haven and London, Yale University Press, 1980, pp. 58–60.

*p. 43 ff.* For Otto Demus's keen analysis of the flowering of art and architecture in Venice in the thirteenth century, see his penetrating essay entitled, "A Renascence of Early Christian Art in Thirteenth Century Venice," in *Late Classical and Medieval Studies in Honor of Albert Mathias Friend, Jr.*, Princeton University Press, 1955, p. 348 ff.

*p. 46* Elisabetta Lucchesi Palli in *Die Passions-und Endszenen Christi auf der Ciboriumsaule von San Marco in Venedig*, Prague, 1942.

*p. 46 ff.* The story about the unmasking of the holy shroud of Turin is not mine but is owed entirely to the fascinating series of articles and books written from 1986 to 1993 by David Sox, an American journalist who currently lives in England. If one is interested in gaining further intriguing details about this fracas, start with David Sox, *Relics and Shrines*, London, George Allen and Unwin, 1985, and his *The Shroud Unmasked*, 1993.

**Chapter Four:** Tricks of the Renaissance and Shams of the Baroque

*p. 52* Grafton, op. cit., p. 28 (the 10,576 Latin inscriptions, etc.).

*p. 52* For the grisly Tulliola story see Grafton, op. cit. pp. 26–28.

*p. 52* Mark Jones, editor, *Fake? The Art of Deception*, Berkeley and Los Angeles, University of California Press, 1990, p. 138.

*p. 53* For the stories of Pietro Maria della Brescia, and especially the porphyry cup, see Fritz Mendax, *Art Fakes and Forgeries*, London, W. Laurie, 1955; Otto Kurz, *Fakes: A Handbook for Collectors and Students*, New Haven, Yale University

Press, 1948; and "Art Forgeries from the Renaissance to the 18th Century," *Royal Society of Arts Journal 121*, 1973.

*p. 54* For Tomasso della Porta, and Tullio Lombardo as a sometime forger, see Kurz, op. cit., who has compiled a marvelous set of tales about the High Renaissance fakers, full-time and part-time.

*p. 54* For Giovanni da Cavino and Benvenuto Cellini, see Kurz, op. cit., with all the original citations in Ascanio Condivi and Giorgio Vasari.

*p. 55* For Michelangelo, see Kurz, op. cit.

*p. 55* For the passage by Leandro Alberti on the cupid, thought erroneously by some to be by Michelangelo, see Kurz, op. cit., p. 96.

*p. 56* For the tale about Michelangelo and Domenico Ghirlandaio, see Giorgio Vasari, *Lives of the Artists, Michelangelo* and A. Condivi, Florence, 1553.

*p. 56* For Erasmus's slipping over the edge, see Grafton, op. cit., p. 48.

*p. 57* For Denys Calvaert, see Roberto Weiss, *The Renaissance Discovery of Classical Antiquity*, New York, B. Blackwell, 1988.

*p. 57* For El Greco, see Kurz, op. cit.

*p. 58* For Dürer, see Mendax and see Kurz.

*p. 58* For the story on Guercino fakes, see the enlightening book by Prisco Bagni, *Guercino e il suo Falsario*, Bologna, Nova Alfa, 1986.

*p. 58* For Terenzio da Urbino, see H. Schmitt (Frank Arnau), *Three Thousand Years of Deception in Art and Antiques*, translated by Maxwell Brown, London, 1961, where Giovanni Baglione is also cited.

*p. 60* For the intriguing story about Luca Giordano's several paintings in the style of Albrecht Dürer, see W. R. Valentiner in the magazine *Art in America*, Vol. 1 (1913) p. 195 ff.

*p. 60* For the material on Peter Paul Rubens and the quotes by Rubens regarding his reworking of the Italian copies for the Duke of Lerma, see Mendax, op. cit., p. 149 ff. Kurz, op. cit., also has some revealing information.

*p. 62* As for the fakes cooked up by Nicholaes Pieters and the "Friday Market men of Antwerp," Mendax, op. cit., has a splendid series of pages. The quote on the sow is taken from a contemporaneous chronicler by the name of Abraham Weijerman and appears in Mendax.

p. 62 On the story about the court case in Holland, see Mendax, op. cit. p. 146 ff.

p. 63 For Cavaceppi, see, M. de Cagiano Azevedo, *Il Gusto nel Restauro*, Rome, 1948, and especially the following works by Seymour Howard: *Bartolomeo Cavaceppi, Eighteenth Century Restorer*, New York, 1982; "Boy on a Dolphin: Nollekens and Cavaceppi," *Art Bulletin*, Vol. 46, No. 2 (1964) pp. 177–189; and the soon-to-be-published article "Iconology, Intention, Imagos, and Myths of Meaning," *Porta Memoriam Jan Bialostocki (1921–1988)*, Princeton, N.J., Princeton University Press. There's also an exhibition catalogue with some interesting information compiled by Carlos Picon, now curator of Greek and Roman Art at the Metropolitan, *Bartolomeo Cavaceppi*, exhibition catalogue, Clarendon Galleries, London, 1983. There's also a book by the restorer himself, B. Cavaceppi, *Raccolta d'antiche statue, buste, bassirilievi ed altre sculture restaurate da B. Cavaceppi III*, Rome 1772.

p. 63 Mark Jones, op. cit., pp. 139–40.

p. 63 For Pietro Pacilli, see *Why Fakes Matter, Essays on Problems of Authenticity*, edited by Mark Jones, London, British Museum Press, 1992, p. 55.

p. 64 ff. For tales of near-chicanery see the enlightening article by J. Fleming and H. Honour, "Francis Harwood: An English Sculptor in XVIIIth Century Florence" in the *Festschrift Ulrich Middeldorf*, Berlin, 1968, edited by H. Kostgarten and P. Tigler. Also J. T. Smith, *Nollekens and His Times*, London, 1828, facsimile published by Century Hutchinson, London, 1986. Finally, for an amusing contemporaneous series of insights, see P-J Grosley, *New Observations on Italy and Its Inhabitants . . . by Two Swedish Gentlemen*, London, 1769, Vols. I–II.

p. 65 For the quote by Horace Mann, see Seymour Howard, op. cit.

**Chapter Five:** Victorian Shenanigans

p. 68 The perceptive quote by Mark Jones, *Why Fakes Matter: Essays on Problems of Authenticity*, London, British Museum Press, 1992, p. 161.

p. 68 For the phony Egyptian necklace bought by the New-York Historical Society, see C. R. Williams, *Gold and Silver Jewellery*, New-York Historical Society, 1924, p. 222, pl. 36.

*p. 69* For the tasting abilities of Wakeling, see Richard Wakeling, *Forged Egyptian Antiquities*, London, 1912. Also mentioned by George Savage, *Forgeries, Fakes and Reproductions*, London, Barrie and Rockliff,1963.

*p. 69* For the Sarmatian fakes, refer to Mark Jones, *Fake? The Art of Deception*, Berkeley and Los Angeles, University of California Press, 1990, pp. 166–67, the entry by Roger Moorey of the Ashmolean Museum, Oxford.

*p. 69* A. A. Iessen, "The So-called 'Maikop Belt,'" *Arkheologicheskii Sbornik*, 1961, pp. 163–67.

*p. 69* The monumental volume on the Scythian treasures is by N. Kondakof, J. Tolstoi, and S. Reinach, *Antiquites de la Russie Meridionale*, Paris, 1891.

*p. 70* The tale about the bronze boy in the Bargello is recounted in the chapter referring to the fakers of Renaissance items in George Savage, *Forgeries, Fakes and Reproductions*, London, Barrie and Rockliff, 1963.

*p. 70* Regarding the authenticity of chastity belts (of which I am inclined to disbelieve completely), see E. J. Dingwall, *The Girdle of Chastity*, London, Routledge & Sons, 1931.

*p. 71* The Moabite pottery fakes is recounted by Charles Clermont-Ganneau in *Les Fraudes Archaeologiques en Palestine*, Paris, 1885.

*p. 72* What happened to Moses Shapira(o) is told in Mark Jones, *Fake?* p. 27.

*p. 72* For Tanagra phonies in general refer to R. G. Reisner, *Fakes and Forgeries in the Fine Arts*, Bibliography, New York, Special Libraries Association, 1950; Adolf Reith, "Archaeological Fakes," London, Barrie & Jenkins, 1970; also R. Higgins, *Tanagra and the Figurines*, London, Methuen, 1986.

*p. 74* For Corot, see the monumental work by A. Robaut, *L'Oeuvre de Corot*, Paris, 1905. There's an interesting tale recounted by the late "master-forger" Eric Hebborn in his book *Drawn to Trouble*, New York, Random House, 1991, p. 220 ff., of some three thousand fake Corot drawings bought by Dr. Jousseaune (first name unknown).

*p. 76* For Marcy, start with Mark Jones, *Fake?* p. 134; also Otto von Falke, "Die Marcy-Falschungen," *Belvedere*, Vol. 1, 1922, pp. 8–13.

*p. 78* For the Botkin enamels, see, M. P. Botkin, *La Collection Botkin*, St. Petersburg, 1911; D. Buckton, "Bogus Byzantine Enamels in Baltimore and Washington, D.C.," *The Journal of the Walters Art Gallery*, 46,

1988; and S. Boyd and G. Vikan, *Questions of Authenticity Among the Arts of Byzantium*, exhibition catalogue, Dumbarton Oaks, Washington, D.C., 1981.

*p. 79* For the "Billies and Charlies," see Mark Jones, *Fake?* pp. 186–88.

**Chapter Six:** The Golden Age of Fakes—Now!

*p. 81* The quote from *McClure's* magazine is to be found in George Savage, *Forgeries, Fakes and Reproductions*, London, Barrie and Rockliff, 1963, in the section dealing with the twentieth century.

*p. 84* For Otto Wacker's Van Goghs, see J. B. de la Faille, *Vincent van Gogh*, Bruxelles, 1939; de la Faille, *Les Faux Van Goghs*, Paris and Bruxelles, 1939.

*p. 85* The Mona Lisa story is marvelously told in Lawrence Jeppson's entertaining book, *The Fabulous Frauds: A Study of Great Art Forgeries*, London, Arlington Books, 1971. Jeppson's volume may be the single best one on the general subject of art fakes.

*p. 86* For Malskat, see Jeppson, p. 200 ff.

*p. 87* For Paul Revere, see especially, D. L. Goodrich, *Art Fakes in America*, New York, Viking, 1973. Also, C. S. Brigham, *Paul Revere's Engravings*, The Worcester American Antiquarian Society, 1969.

*p. 88 ff.* For the Etruscan terra cottas bought by the Metropolitan Museum, I have used Jeppson's book (op. cit.) extensively. This particular story has never been told better or more accurately. I also used the standard work: D. von Bothmer and J. V. Noble, "An Inquiry into the Forgery of the Etruscan Terracotta Warriors" in the *Metropolitan Museum of Art, MMA Papers*, No. 11, 1961. In addition, I talked at length with the Italian fakebuster Pico Cellini, who was one of the first to suspect the false Etruscan statues. I also conversed for many hours with the late Harold Woodbury Parsons, the *marchand-amateur* who first learned that the warriors had been created by Fioravanti and Riccardi.

*p. 127* Conversation with Tanya Moore, October 10, 1995.

**Chapter Nine:** A Real Pro

*p. 139* For Shrader's comments, see *Notable Acquisitions, 1965–1975*, New York, The Metropolitan Museum of Art, 1975.

**Chapter Eleven:** Fakes by the Ton

*p. 150* The coffee-table volume describing the Topić Mimara Museum is *Muzej Mimara, Zbirka Umjetnina Ante I Wiltrud Topić*, Zagreb, 1987. Fortunately, the various speeches and essays have been translated into English.

*p. 152* Thomas Hoving, *King of the Confessors*, New York, Simon & Schuster, 1981, now out of print.

*p. 153* Elizabeth Parker and Charles T. Little, *The Cloisters Cross, Its Art and Meaning*, New York, H. N. Abrams, 1994, p. 13.

**Chapter Twelve:** If a Fake Is So Good That It Fools All
the Experts, Then . . .

*p. 163 ff.* Regarding Han van Meegeren, I used the following sources: P. B. Coremans, *Van Meegeren's Faked Vermeers and de Hooghs* (translated by A. Hardy and C. Hutt, London, 1949); John Godley, *Van Meegeren: Master Forger*, New York, 1951; Godley writing in 1967 as Lord Kilbracken; A. B. de Vries, *Jan Vermeer of Delft* (translated by Robert Allen), London, 1939; H. Schmitt (Frank Arnau), *Three Thousand Years of Deception in Art and Antiques*, translated by Maxwell Brown, London, Jonathan Cape, 1961; Ann Waldron, *True or False, Amazing Art Forgeries*, Toronto, 1983; *The Forger's Art*, edited by Denis Dutton, the essay "Han van Meegeren *fecit*," by Hope B. Werness, University of California Press, 1983. The last is the clearest and best summary of this faker ever printed and it also reveals some of Van Meegeren's Nazi writings.

*p. 166* The quote is published by Werness, op. cit., p. 16.

*p. 168* A. Bredius, "An Unpublished Vermeer," *Burlington* magazine, 61, October 1932.

*p. 174* Ibid.

**Chapter Thirteen:** Has Any Faker Fooled Them All?

*p. 179* For the tiara of Saitaphernes, see George Savage, *Forgeries, Fakes and Reproductions*, London, Barrie and Rockliff, 1963; and Mark Jones, editor, *Fake? The Art of Deception*, Berkeley and Los Angeles, University of California Press, 1990.

*p. 189* Erich Hebborn, *Drawn to Trouble, Confessions of a Master Forger*, New York, Random House, 1991.

*p. 191* Op. cit., p. 216.

*p. 193* For Bastianini, see especially George Savage, op. cit.; Fritz Mendax, *Art Fakes and Forgeries*, London, W. Laurie, 1955, p. 180 ff.; Mark Jones, op. cit., pp. 196–98; and Laurence Jeppson, *The Fabulous Frauds: A Study of Great Art Forgeries*, London, Arlington Books, 1971, p. 5 ff.

**Chapter Fourteen:** Deep Suspicions

*p. 201* Yvonne Hackenbroch, "Rheinhold Vasters, Goldsmith," *The Metropolitan Museum of Art Journal*, Vol. 19/20, 1984–85, pp. 242–48. This article has an abundance of information on the *Rospigliosi Cup*.

*p. 204* Charles Truman, "Rheinhold Vasters—the Last of the Goldsmiths? A New Gorgon Arises to Turn Dealers and Collectors to Stone," *The Connoisseur*, 200, March 1979.

*p. 205* For Spitzer, see Hackenbroch, op. cit. p. 169 ff.

*p. 206* Truman, op. cit. p. 157.

*p. 206* For the André jewels in the Widener Collection and Rudolf Distelberger's findings, see Paul Richard, *The Washington Post*, Sunday, April 3, 1994, p. G4 ff.

*p. 207* Hackenbroch, op. cit., p. 248.

**Chapter Fifteen:** The Pseudo-Fakebusters

*p. 210* *The Metropolitan Museum of Art Bulletin*, Volume XXVI, Number 6, February 1968, pp. 241 ff. is a record of all the presentations at the forgery seminar.

*p. 222 ff.* Gisela M. A. Richter, *The Sculpture and Sculptors of the Greeks*, 4th edition, New Haven, Yale University Press, 1970, p. 147.

*p. 227* For Christopher Wright's theses, see C. Wright, *The Art of the Forger*, New York, Dodd, Mead, 1985, passim.

*p. 231* Wright, op. cit., p. 88.

**Chapter Sixteen:** "Guardi Is Still Alive"

*p. 239* For the quote, later published, see Hubert von Sonnenburg, *The Metropolitan Museum of Art Bulletin*, 1970–71, special publication on the Velázquez, "The Technique and Conservation of the Portrait."

*p. 244* The Brealey quote is from his report in Metropolitan Museum of Art archives dated June 7, 1974.

*p. 249* Interview with Sonnenburg on Monday, February 6, 1995.

*p. 252* For the challenge against the Met's Van Gogh, see Glenn Collins, "Is It or Isn't It? A Van Gogh Languishes in Limbo," *The New York Times*, Sunday, July 8, 1990.

*p. 252* For the lecture series and Sonnenburg's investigations and findings about the *Man of Sorrows*, see *The Metropolitan Museum of Art Bulletin*, Winter 1993–94, "The Changing Image, Studies in Paintings Conservation," p. 8 ff.

**Chapter Seventeen:** The "Fhaker" with Chutzpah

The sources for this chapter on Helbig, Marinetti, the "Boston Throne," and the Palestrina fibula are the following:
Giuseppe "Pico" Cellini. "Ne Sutor Ultra Crepidam," *Paragone*, 65, 1955, pp. 42–7.

———. *Falsi e Restauri*, Archivio Guido Izzi, Roma, 1992.

Margherita Guarducci. "La Cossidetta Fibula Prenestina, Antiquari, Eruditi e Falsari nella Roma dell'Ottocento" (con un Appendice di esami e di analisi a cura di Pico Cellini, Guido Devot, ed altri), *Atti della Accademia Nazionale dei Lincei*, 1980, Memorie, Classe di Scienze Morali, Storiche e Filologiche, Serie VIII, Volume XXIV, Fascicolo 4, pp. 413–573.

———. "La Cosidetta Fibula Prenestina: Elementi Nuovi," *Atti della Accademia Nazionale dei Lincei*, Serie VIII, Volume XXVIII, 1984, pp. 129–74.

———. "Il 'Trono Ludovisi' e l'Acrolito Ludovisi': due pezzi insigni del Museo Nazional Romano," *Bollettino D'Arte*, Volume 33–34, 1985, Settembre–Dicembre, Serie VI, pp. 1–21.

———. "Il Cosidetto Trono del Boston," *Bollottino D'Arte*, Numero 3, Serie VI, 1987, pp. 49–62.

———. "Una Falsa Ermetta di Marmo Rosso Antico (Appendice alla Storia della Fibula Prenestina'), *Accademia Nazionale dei Lincei*, Vol. XLII, fascicolo 7–12 (Luglio–Dicembre) 1989, pp. 283–88.

———. "Nuova Appendice alla Storia della 'Fibula Prenestina'," *Atti della Accademia Nazionale dei Lincei*, Serie IX, Volume II, Fascicolo 2, 1991.

————. "Per La Storia Dell'Istituto Archeologico Germanico, I. 1887: La Fibula Prenestina e Wolfgang Helbig," *Mitteilungen des Deutschen Archaeologischen Instituts, Roemische Abteilung,* Band 99, 1992, pp. 307–13.

————. "Cronache e Commenti Per La Storia dell'Istituto Archeologico Germanico," *Rivista di Filologia e di Istruzione Classica,* 1994, pp. 1–8.

*p. 263 ff.* The quote from the satirical review *Don Chisciotte* is in Guarducci, first citation above, p. 498.

*p. 273* For Nash, see "Uber die Auffindung un den Erwerb des 'Bostoner Thrones'," *Mitteilungen des Deutschen Archaeologischen Instituts, Roemische Abteilung,* Band 66, 1959, pp. 104–37.

**Chapter Eighteen:** The Curious Spurious Kouros

*p. 279* The conversation with Pico Cellini is recorded in an article by Ann Headington, "The Great Cellini," *Connoisseur,* September 1986.

*p. 284* The information on Frederico Zeri came from extensive interviews that Geraldine Norman and I conducted near Rome on January 14, 1987.

*p. 284* Regarding the price of the kouros, Getty archives contain a draft contract dated May 18, 1984 for the purchase of "one Greek Naxian marble statue (approximately six feet, eight inches tall) of a Greek youth (known as a 'Kouros' type), ca. 535 B.C." The dealer's name is listed as Gianfranco Becchina of Basel, Switzerland.

*p. 285* The tax manipulations are fully reported by Geraldine Norman and Thomas Hoving, "The Getty Scandals," *Connoisseur,* May 1987 and in various articles in *The Times of London,* especially, "The Spectrum," February 13, 1987.

*p. 285* The tax forms are officially called PF 990s and can be viewed at The Center of Foundations in New York City.

*p. 288* The relief of the two Greek warriors is illustrated in Cornelius C. Vermeule, *Greek and Roman Sculpture in America, Masterpieces in Public Collections in the United States and Canada,* Los Angeles, University of California Press, 1981, colorplate 2, p. 30.

*p. 288* For Frel's comments on the warriors relief, J. Frel, "Antiquities in the J. Paul Getty Museum, A Checklist, Sculpture, I. Greek Originals," The J. Paul Getty Museum, May 1979, p. 2.

p. 288 Vermeule told me his current opinion of the *Hero* in an interview in early 1987.

p. 289 Professor Nodelman had this to say: "Its acquisition would present scholars and the public with a world-class masterpiece of a kind otherwise unexampled in North America (aside from the special and problematic case of the New York kouros)."

p. 290 Professor Szilagi wrote his letter on "a. d. X. Id. Febr. A. D. 1984," or "the tenth day before the Eudus of February," as the Getty's translator states.

p. 291 The first scientific tests on the kouros conducted by Dr. Frank Preusser of the Getty were reported in June 1984.

p. 292 ff. The interview with Federico Zeri took place near Rome on January 14, 1987.

p. 294 Dr. Harrison has supplied me with a typed version of the lecture and the quotes come from that document. The lecture was the "Third Richard Hubbard Howland Lecture," delivered on March 7, 1990.

p. 297 The quote from Dietrich von Bothmer, former curator of Greek and Roman Art at the Metropolitan, comes from a two-hour-long interview on January 24, 1987.

p. 300 The June 18, 1984 letter from Bevan to Houghton was supplied to me by Mr. Houghton.

p. 302 The second article by Norman and Hoving is "It Was Bigger Than They Knew," *Connoisseur*, August 1987, p. 73 ff.

p. 302 The *New York Times* story appeared on August 12, 1986.

p. 303 The Russell *Times* quote, op. cit., p. C18, column 2.

p. 304 The French colleague who learned about the Saab and the true owner is Alain Tarica of Paris, a mathematician and art expert.

p. 307 For the article by Marion True, see "A Kouros at the Getty Museum," *Burlington* magazine, January 1987, vol. CXIX, no. 1006, pp. 3–11.

p. 307 Spier told me on February 3, 1995 that he has become convinced that the torso—and the Getty kouros—were carved by a Roman sculptor by the name of Onore. All attempts to track down Onore have failed so far.

*p. 308* True's initial reactions are recorded in an article by Suzanne Muchnic in the *Los Angeles Times*, July 14, 1990, p. F4. There's also a story by the same reporter on July 7, 1990 stating that the kouros had been pulled from display.

*p. 308* I was briefed on the Athens seminar by Evelyn Harrison on June 4, 1992. The results of the conference are briefly reported in the Athens newspaper *Ta Naia*, May 28, 1992. According to Harrison, "The results of the conference was a feeling stronger than *doubt*. With one exception—Brunhilde Ridgway, everyone present, including many who had written letters on its behalf back in 1984 and 1985, thought it is a fake." According to Ridgway, with whom I spoke on June 5, 1992, "I don't know. I cannot condemn it or support it."

## Chapter Nineteen: Con Brio

*p. 310 ff.* The sources for Michel de Bry's possessions are conversations with Arthur Houghton Jr. and Geraldine Norman, both of whom visited the apartment in Paris.

*p. 312* For the Scopas head, see J. Frel, "Antiquities in the J. Paul Getty Museum, A Checklist, Sculpture, I. Greek Originals," p. 6, "The De Bry Head." Also Andrew Stewart, *Skopas in Malibu, The Head of Achilles from Tegea and Other Sculptures by Skopas in the J. Paul Getty Museum*, The J. Paul Getty Museum, 1982. All Stewart's quotes may be found in this rare volume.

*p. 319* The book for Abbeville Press by Frederick Hartt is *David by the Hand of Michelangelo, The Original Model Discovered*, New York, 1987.

*p. 322 ff.* For the information on the contract and the letters from Hartt to de Bry, I was able to obtain the London court judgment of 1988 (H-no. 6100) in the libel suit lodged by Frederick Hartt against *The London Independent* and Geraldine Norman. The judgment publishes every document in the liaison between de Bry and Hartt.

*p. 325* The strange story about Michael van Rijn and the Japanese cult was related to me personally by Mr. van Rijn.

## Epilogue

*p. 331 ff.* For the story of Brigido Lara, see Mimi Crossley and E. Logan Wagner, "Fake! A Brilliant Forger of Pre-Columbian Statues Tells All," *Connoisseur*, June 1987, p. 98 ff.

# INDEX

12:   *The Metropolitan Museum of Art, Cloisters Collection, 1965 (65.3)*

13, 14:   *Topić Mimara Museum, Zagreb*

15:   *Fogg Art Museum, Harvard University*

16:   *From Eric Hebborn,* Drawn to Trouble: Confessions of a Master Forger, *Random House, 1991, p. 224.*

17:   *The Metropolitan Museum of Art, Fletcher Fund, 1923 (23.69)*

18:   *The Metropolitan Museum of Art, Rogers Fund, 1960 (60.30)*

20, 21:   *The Metropolitan Museum of Art, Cloisters Collection, 1974 (1974.392)*

19, 22, 23, 28, 30:   *Author's collection*

24, 25, 26:   H.L. *Pierce Fund, Courtesy Museum of Fine Arts, Boston.*

27:   *Illustration by Christopher Polentz*

29:   *The Metropolitan Museum of Art, Bequest of Walter C. Baker, 1971 (1972.118.95)*

31, 32:   *Photographs by David Finn*

Thomas Hoving is the author of the *New York Times* bestseller *Making the Mummies Dance* as well as *Tutankhamun: The Untold Story* and *King of the Confessors* and two novels. He is the former Director of the Metropolitan Museum of Art and the former Editor-in-Chief of *Connoisseur*.